typographics 2
cybertype

typographics 2 cybertype

typographics 2
cybertype

'zines + screens

general editor: roger walton

HDi

HARPER
DESIGN
international

An Imprint of HarperCollinsPublishers

Typographics 2 is published here
with Typographics 1

Each title first published separately
by Hearst Books International.
Now published by
Harper Design International
an imprint of HarperCollins
Publishers
10 East 53rd Street
New York, NY 10022-5299
United States of America

ISBN 0688-17875-8

Distributed throughout the world by:
HarperCollins International
10 East 53rd Street
New York, NY 10022-5299
United States of America
Fax: (212) 207-7654

Each title first published
separately in Germany by:
NIPPAN
Nippon Shuppan Hanbai
Deutschland GmbH
Krefelder Str. 85
D-40549 Düsseldorf
Telephone: (0211) 5048089
Fax: (0211) 5049326

Edited and Designed by
Duncan Baird Publishers
Sixth Floor
Castle House
75-76 Wells Street
London W1T 3QH

Designer: Gabriella Le Grazie
Editor: Lucy Rix

Commissioned artwork: (pages
1-11, 82-3, 152-3) The Attik
Design Limited

03 04 05 06 07 / 10 9 8 7 6 5 4 3 2

Typeset in Letter Gothic MT
Color reproduction by Colourscan,
Singapore
Printed in China

NOTES

Dimensions for spread formats are
single page measurements; all
measurements are for width followed
by height.

When this arrow appears in a caption
it indicates that the artwork
referred to is displayed
on either the previous spread or the
spread following.

When this arrow appears on a spread
it indicates that the artwork has
been displayed horizontally rather
than vertically.

CYBERTYPE LIGHT

VISIONARY

VISIONARY

CYBERTYPE MEDIUM

T2

T2

T2

T2

CYBERTYPE

TYPOGRAPHICS 2

TYPOGRAPHICS

TYPOGRAPHICS 2

TYPOGRAPHICS BOLD

CYBERTYPE

CYBERTYPE

IMAGE MANIPULATION BASED ON ORIGINAL PHOTOGRAPHY BY PETER HEATON

CYBERTYPE

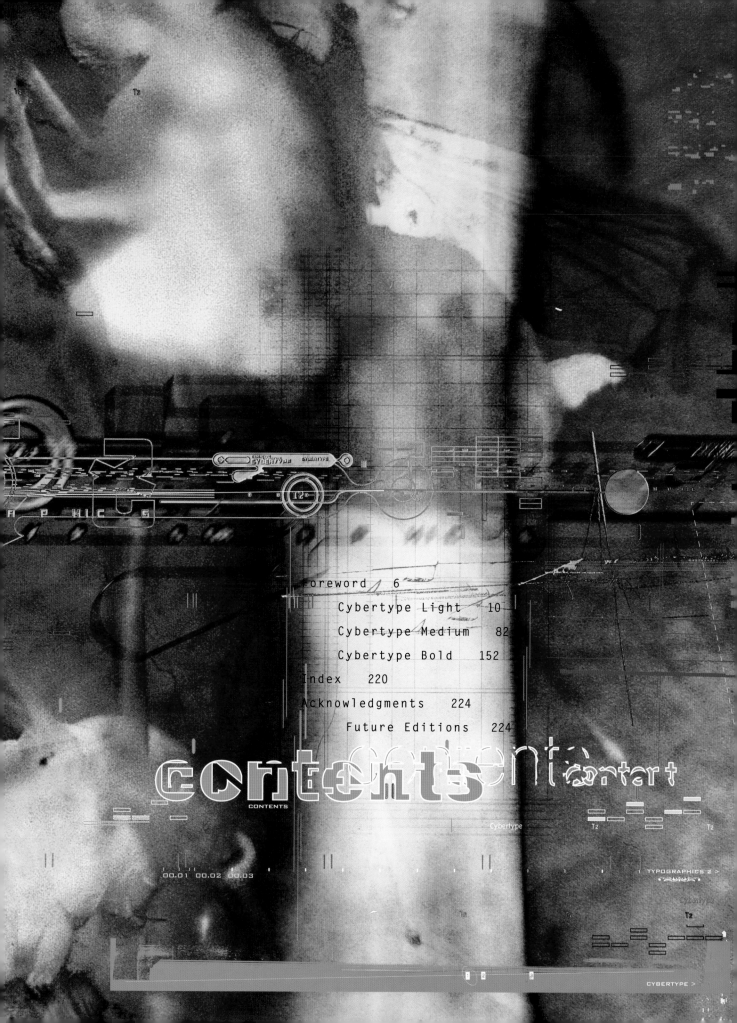

contents

CONTENTS

Cybertype

00.01 00.02 00.03

TYPOGRAPHICS

The second volume in a series devoted to highlighting the best in global typography, *Typographics 2* focuses primarily on a single form of publication: the magazine.

The work included here reflects the role that the computer continues to play in shaping the genre of the magazine, freeing the layout and subverting typographic conventions to develop a new style of information presentation. This portfolio demonstrates the various ways in which designers are addressing the concept of cybertype, both as a condition of layout and as a form of computer-generated and screen-composed typography. The material has been grouped to represent typographics ranging from minimalist "cybertype light" to the dense textual layers of "cybertype bold." Within cyberspace, the computer is able to imitate the printing press, CD, and video - resulting in a potential for freeform typography that is no longer bound to the static page. Although this collection is presented in book format which precludes manipulation at the touch of a button, it nevertheless displays both the liberation that has been granted by technology and the scope of a new space which designers both shape and are shaped by.

It is difficult to isolate the characteristics that define a magazine: regular publication; specific themes; a diversity of features; coverage of the most up-to-date information on a chosen subject; a particular format - there are evident and deliberate exceptions to every rule. But if one common thread can be drawn, perhaps it is that of the freedoms and restrictions generated by a distinctive creative pressure. Partly the result of deadlines and partly brought about by the struggle to remain economically viable, this type of pressure can produce dynamic design.

Due to their rapid turnaround and ability to react swiftly to fashions and events, magazines are able to adopt a position that is considerably more experimental and outspoken than that of many other publications.

The work displayed in *Typographics 2* demonstrates that the quality and diversity of approaches to design have a global reach. Examples have been gathered from the United States, South America, Europe, the Far East, and Australia. They include publications that may be bought from mainstream outlets, and those that might only be found by chance in obscure art stores. Magazines produced by large corporations working with big budgets are shown side by side with those created by quixotic individuals surviving merely on ingenuity and originality. Computer software has allowed typographers the space to experiment without incurring huge costs: the opening spread to "Cybertype Medium" employs a typeface that was created by scanning in letters that had originally been produced with a potato-cut print. This intriguing fusion of imagination and technology is precisely what *Typographics 2* aims to capture.

RW

SECTION 1

un0:1
CYBERTYPE LIGHT

CYBERTYPE LIGHT

una rivista che parla del resto del mondo a magazine about the rest of the world

COLORS

13

warning: this magazine contains no words. start here ▶

attenzione:
in questa
rivista non ci
sono parole.
comincia qui ▶

DIC 95 · FEB 96

Arg 3 pesos | Aus 4.95A$ | BRD DM6.50 | Can 4C$ | Esp 450Ptas | Fr 20FF | Hellas 750DR | HK HK$35 | India Rs.100 | Ire IR£2 | Ital L6.000 | Mag 250FT | Mex 9$ | Nederl 7,95FL | Port 520$00 | SA 9R | UK £2 | USA $4.50

2

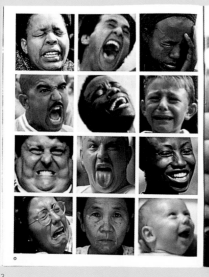

5

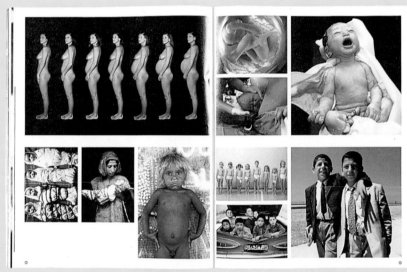

8

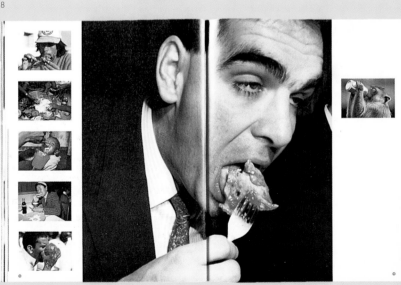

11

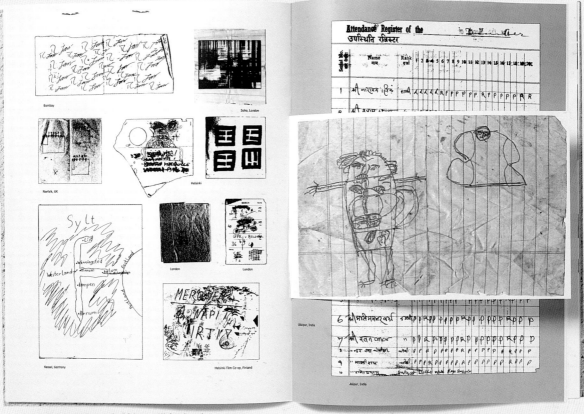

found art Jake Tilson & Oliver Whitehead

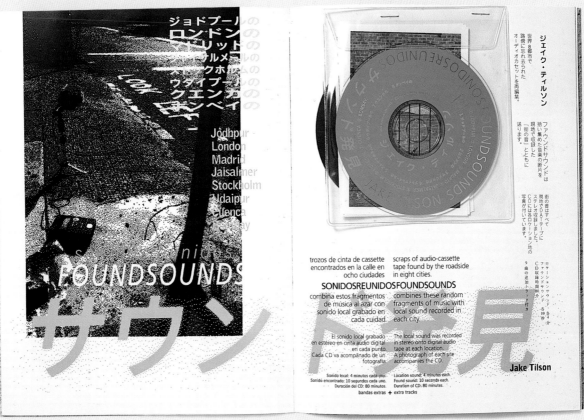

audio CD Jake Tilson

ジェイク・ティルソン

ファウンドサウンドは
世界8都市で
拾い集めた音楽の断片を、
路傍に忘れ去られた
現地で収録した
オーディオカセットを再編集。

街の音すべて
間のDATテープに
ステレオ収録しました。
CDには各ロケーション地の
一街の音一とともに
写真が付いています。

trozos de cinta de cassette
encontrados en la calle en
ocho ciudades

SONIDOSREUNIDOSFOUNDSOUNDS

combina estos fragmentos
de música al azar con
sonido local grabado en
cada cuidad.

El sonido local grabado
en estéreo en cinta audio digital
en cada punto.
Cada CD va acompañado de un
fotografía.

Sonido local: 4 minutos cada uno.
Sonido encontrado: 10 segundos cada uno.
Duración del CD: 80 minutos.

bandas extras + extra tracks

scraps of audio-cassette
tape found by the roadside
in eight cities.

combines these random
fragments of music with
local sound recorded in
each city.

The local sound was recorded
in stereo onto digital audio
tape at each location.
A photograph of each site
accompanies the CD.

Location sound: 4 minutes each.
Found sound: 10 seconds each.
Duration of CD: 80 minutes.

Jake Tilson

ロケーションサウンド各4分
CD収録時間80分
ファウンドサウンド各10秒
9曲の追加トラック付き

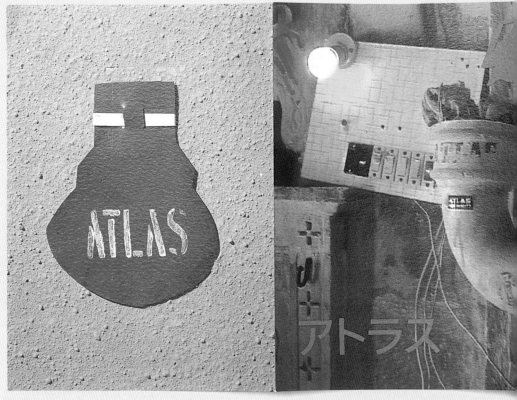

found art Jake Tilson & David Blamey

pages 16-19
Atlas
art director
Jake Tilson
designer
Jake Tilson
editor
Jake Tilson
publisher
Atlas
origin
UK
dimensions
210 x 280 mm
8¹/₄ x 11 in

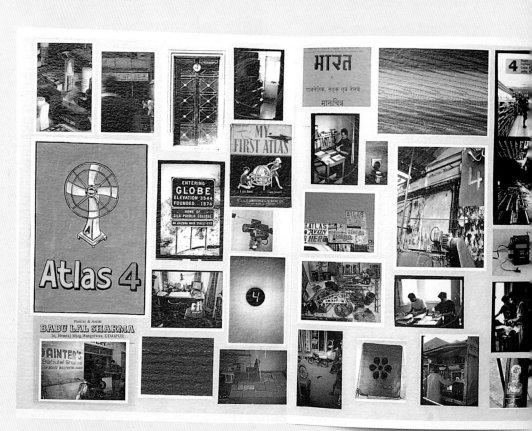

photography & video capture Jake Tilson & Eileen Tweedy

Contretemps

art director
Italo Lupi

designer
Italo Lupi

cover art
Camilla Adami

editor
René Major

publisher
T.R.A.N.S.I.T.I.O.N.
L'Age d'Homme, Paris

origin
France/Italy

dimensions
235 x 315 mm
9¹/₄ x 12³/₈ in

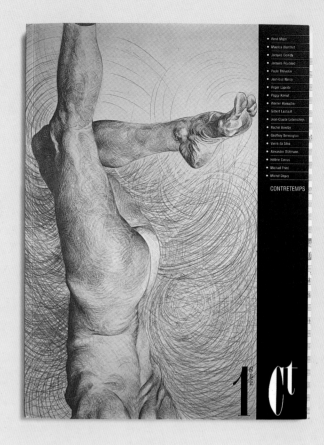

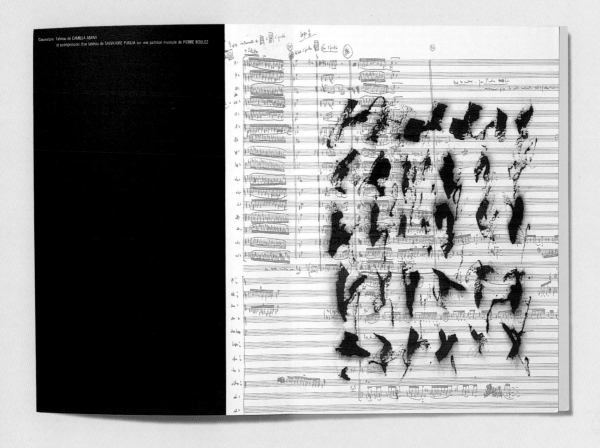

Couverture: tableau de CAMILLA ADAMI
et surimpression d'un tableau de SALVATORE PUGLIA sur une partition musicale de PIERRE BOULEZ

21

du visible, il ouvre le théâtre. [...]

«Il n'y aurait pas le contretemps, ni l'anachronie, ni la séparation entre les monades disjoignant seulement des intériorités. Le contretemps se produit à l'intersection entre l'expérience intérieure (la «phénoménologie de la conscience intime du temps» ou de l'espace) et ses marques chronologiques ou topographiques, celles qu'on dit «objectives», «dans le monde». Il n'y aurait pas de séries autrement, sera la possibilité de cet espacement marqué, avec ses conventions sociales et l'histoire de ses codes, avec ses fictions et ses simulacres, avec ses dates. Avec les noms dits propres[2].

• La promesse d'un autre nom et celle du "jamais plus". Le rêve de faire coïncider l'objet perdu dans le temps retrouvé. Et toujours une voie inaccessible au temps présent.

• Ne traçant qu'en retrait, s'inscrivant que dans l'effacement, l'écriture naît en contre-temps. Le visible des mots et le lisible des images comme contre-temps.

• Comment mettre en oeuvre le désoeuvrement, assumer une désistence du temps et sa responsabilité? C'est un tel espace dans le temps présent que souhaite ouvrir Contretemps. Outre mesure.

[1] Jacques Lacan, "L'étourdit", in Scilicet n° 4, Éd. Seuil, 1973.
[2] Jacques Derrida, "L'explication à contretemps", in Parché, Galilée 1987.

c·ntreTEMPS

Ouvrage publié avec le concours du Centre National du Livre

page 22

Qwerty

art director Stephen Banham
designer Stephen Banham
editor Stephen Banham
publisher The Letterbox
origin Australia
dimensions 74 x 105 mm
2⁷/₈ x 4¹/₈ in

page 23

Qwerty

poster

art director Stephen Banham
designer Stephen Banham
photographer David Sterry
publisher The Letterbox
origin Australia
dimensions 420 x 594 mm
16¹/₂ x 23³/₈ in

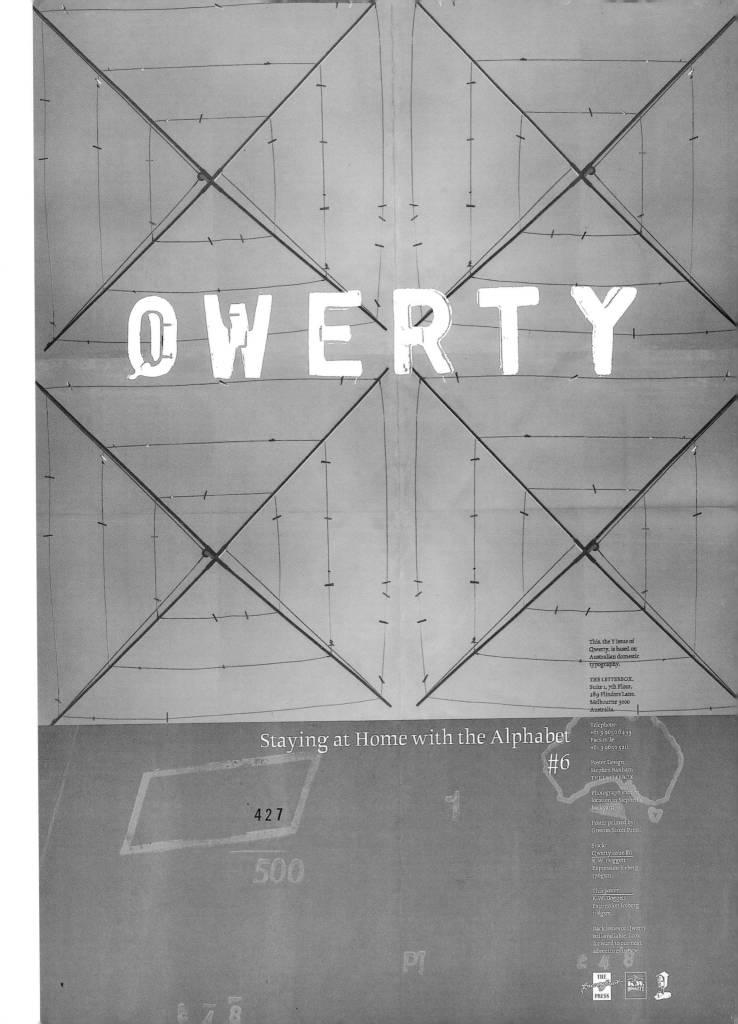

QWERTY

Staying at Home with the Alphabet

#6

427

500

This, the Y issue of
Qwerty, is based on
Australian domestic
typography.

THE LETTERBOX.
Suite 1, 7th Floor,
289 Flinders Lane,
Melbourne 3000
Australia.

Telephone:
+61 3 9050 0433
Facsimile:
+61 3 9650 5211

Poster Design:
Stephen Banham
THE LETTERBOX

Photograph shot on
location in Stephen's
backyard.

Poster printed by:
Greeves Street Press.

Stock:
Qwerty issue #6
K.W. Doggett
Expression Iceberg
170gsm.

This poster
K.W. Doggett
Expression Iceberg
118gsm.

Back issues of Qwerty
still available. Look
forward to our next
adventures in type.

pages 24-5

Sin

art director Stephen Banham
designer Stephen Banham
photographer David Sterry
editor Ann Sinatore
publisher Sin Publishing
origin Australia
dimensions 250 x 330 mm
9⁷/₈ x 13 in

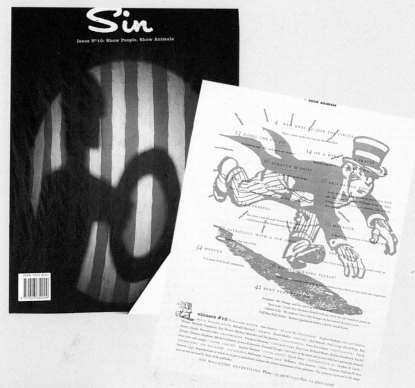

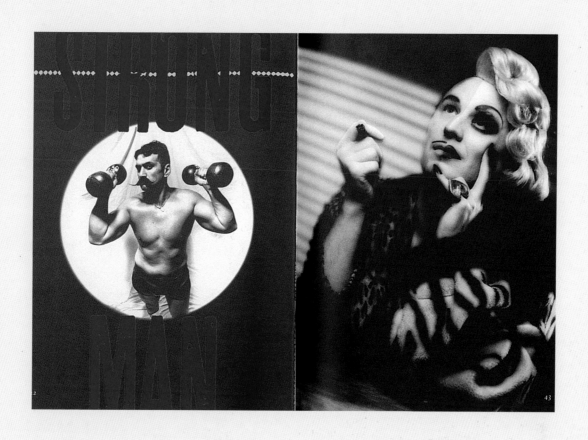

STRONG MAN

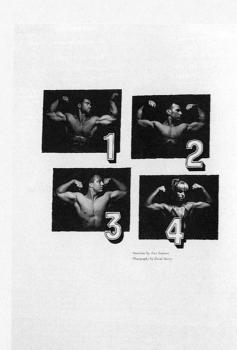

1 2 3 4

Interview by Ann Sansone
Photography by David Sherry

Matador

art director Fernando Gutiérrez
designers Fernando Gutiérrez
Pablo Martín
Patricia Ballesté
photographers Anton Stankowski
James A. Fox
René Burri
Walker Evans
Miguel Riobranco
Henri Cartier-Bresson
Eli Reed
Luis De Las Alas
editor Alberto Anaut
publisher La Fábrica
origin Spain
dimensions 300 x 400 mm
11³/₄ x 15³/₄ in

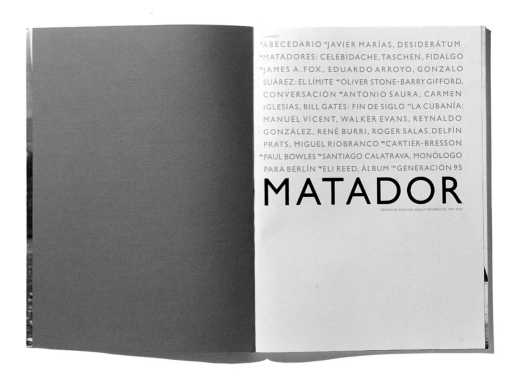

ABECEDARIO

ALVAR AALTO JOSÉ MANUEL ABASCAL CLAUDIO **ABBADO**
BERENICE ABBOTT DAVID ABBOTT KARIM ABBDUL JABBAR
VICTORIA ABRIL ANSEL ADAMS HENRY ADAMS THEODOR W.
ADORNO **ADRIANO** ANDRÉ AGASSI GIACOMMO AGOSTINI
SAN AGUSTÍN OTL AICHER ANA AJMATOVA **AZZEDINE ALAÏA**
PEDRO ANTONIO DE ALARCÓN LEOPOLDO ALAS ISAAC ALBÉNIZ
JOSEF ALBERS RAFAEL ALBERTI TOMASSO ALBINONI ALFREDO
ALCAÍN IGNACIO ALDECOA ROBERT ALDRICH **VICENTE
ALEIXANDRE** ANDREU ALFARO ALDUS MANUTIUS JEAN
D'ALEMBERT **ALESSI** MOHAMMAD ALI NÉSTOR ALMENDROS
ALICIA ALONSO DÁMASO ALONSO JOSÉ LUIS ALONSO DE
SANTOS ALBRECHT ALTDORFER ROBERT ALTMAN **ÁLVAREZ
QUINTERO** SALVADOR ALLENDE FERNANDO AMAT CARMEN
AMAYA GENE AMDAHL ROALD AMUDSEN HANS CHRISTIAN
ANDERSEN LAURIE ANDERSON LEONIDAS ANDREIEV VICTORIA
DE LOS ÁNGELES BEATO ANGÉLICO ANÍBAL ANGLADA
CAMARASA JACQUES ANQUETIL ANTONIONI GUILLAUME
APOLLINAIRE **KAREL APPEL** LUCIO APULEYO RON ARAD YASIR
ARAFAT **VICENTE ARANDA** ARANGUREN **ARANTXA** DIANE
ARBUS ARCHIGRAM ARCHIMBOLDO ALEXANDER ARCHIPENKO
ELISABETH ARDEN **PAUL ARDEN** OSVALDO ARDILES **ATAULFO
ARGENTA** GABRIEL ARISTI LUDOVICO ARIOSTO ARISTÓFANES
ARISTÓTELES GIORGIO ARMANI **LOUIS ARMSTRONG** NEIL
ARMSTRONG **CARLOS ARNICHES** EVE ARNOLD **HANS ARP**
ARQUÍMEDES **FERNANDO ARRABAL** JUAN JOSÉ ARREOLA
EDUARDO ARROYO ANTONIN ARTAUD **ROBERT ARTL** JUAN MARÍA
ARZAK **ARTHUR ASHE** FRED ASTAIRE **MIGUEL ÁNGEL ASTURIAS**
ATILA **CHARLES ATLAS** BERNARDO ATXAGA MAX AUB AUGUSTO
JANE AUSTEN W. H. AUDEN AVERROES FRANCISCO AYALA
MANUEL AZAÑA RAFAEL AZCONA **AZORÍN** FÉLIX DE AZÚA

MIGUEL RIOBRANCO
HABANA 1994

El fotógrafo brasileño Riobranco ha hecho, en 1994, el último
retrato de la ciudad. La vieja Habana, gastada por el tiempo, se ha
convertido en un cuadro surrealista.

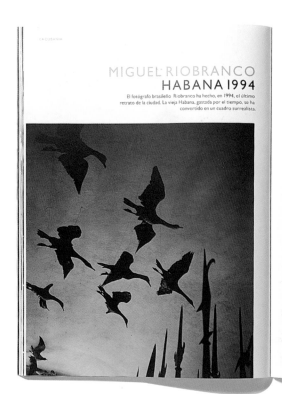

LA CUBANÍA

Cuba es el país de los sentidos. Éstos constituyen su verdadero clima, ya que los sentidos en
esta isla del Caribe son una prolongación del aire, una forma de meteorología general que
no se distingue de la sensualidad de sus gentes. En Cuba es imposible la soledad: he aquí su
principal característica. Como el aire que a uno le envuelve, la expresión corporal de los cu-
banos es un elemento espiritual, lleno de carnalidad, que persigue al viajero hasta rendirle
felizmente. No sé de ningún país que posea esta clase de arma para enamorar. Cualquier per-
sona solitaria que llegue a La Habana sentirá en primer lugar algo muy agradable en la piel.
La naturaleza del goce se hará presente en ciertas sensaciones corporales, pero muy pron-
to va a experimentar que esta plenitud hedonista se deriva de las miradas calientes que le
miran, de las sonrisas innominadas que le acarician, de las palabras suaves que le rodean, de
los gestos amigables, lentos, sensuales con que le asedian gentes desconocidas y que al po-
co tiempo uno reconoce como amigos que comparten una misma empresa de felicidad en
la tierra. Después llegará el ron, el son, el sol, las palmeras, las caderas carnales. El viajero
habrá desvelado el misterio de que en Cuba la soledad es imposible cuando descubra que su
alegría no permite refugiarte nunca en ti mismo, no consiente que huyas jamás. *Manuel Vicent*

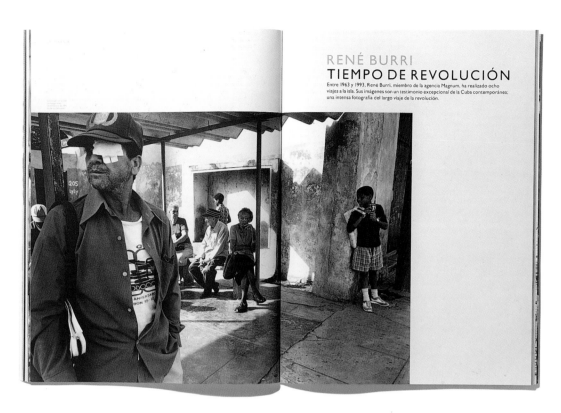

RENÉ BURRI
TIEMPO DE REVOLUCIÓN

Entre 1963 y 1993, René Burri, miembro de la agencia Magnum, ha realizado ocho viajes a la isla. Sus imágenes son un testimonio excepcional de la Cuba contemporánea; una intensa fotografía del largo viaje de la revolución.

cd catalogue

virgin classics

veritas

ultraviolet

edition

virgin classics

virgin classics

CLASSICS

page 31

frieze

art director Harry Crumb
designer Harry Crumb
editors Matthew Slotover
Amanda Sharp
Tom Gidley

publisher Durian Publications
origin UK
dimensions 230 x 300 mm
9 x 11⁷⁄₈ in

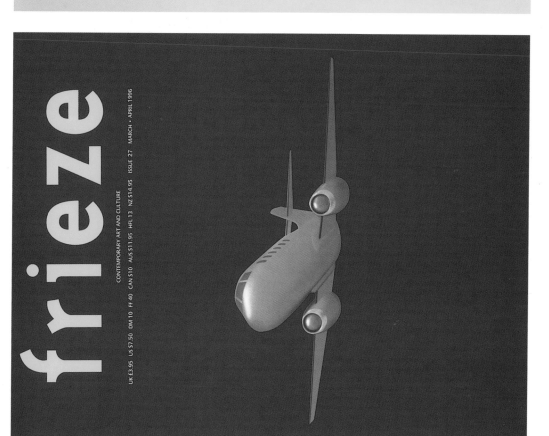

page 30

Virgin Classics

CD catalog 1996
art directors Nick Bell
Jeremy Hall
designer Anukam Edward Opara
@ Nick Bell Design

photographer Gary Woods
editor Jeremy Hall
publisher Virgin Classics
origin UK
dimensions 210 x 297 mm
8¼ x 11¾ in

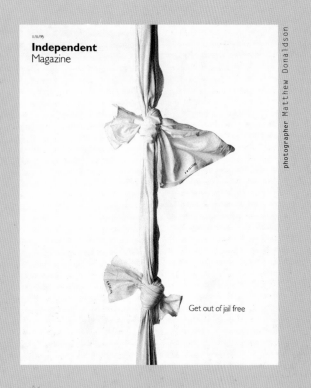

Independent
Magazine

11/11/95

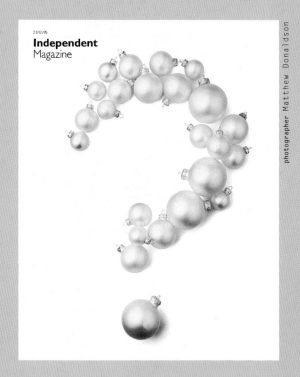

Independent
Magazine

23/12/95

Get out of jail free

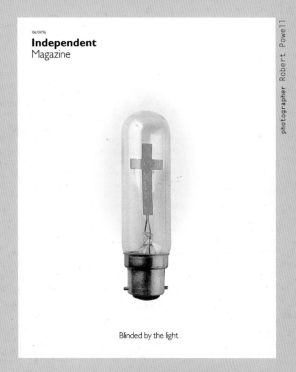

Independent
Magazine

06/01/96

Blinded by the light

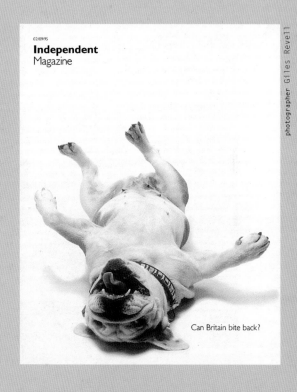

Independent
Magazine

02/09/95

Can Britain bite back?

photographer Matthew Donaldson

photographer Matthew Donaldson

photographer Robert Powell

photographer Giles Revell

32

Independent Magazine

art director Vince Frost @ Frost Design
 designer Vince Frost @ Frost Design
 editor David Robson
 publisher Newspaper Publishing Plc
 origin UK
 dimensions 280 x 355 mm
 11 x 14 in

Now Time

art directors Renée Cossutta
 Judith Lausten
designers 1 Miyoshi Barosh
 2 Judith Lausten
photographer 2 Sherrie Zuckerman
illustrator 1 & 2 Miyoshi Barosh
editor Miyoshi Barosh
publisher A.R.T.* Press
origin USA
dimensions 241 x 317 mm
 9¹/₂ x 12¹/₂ in

1

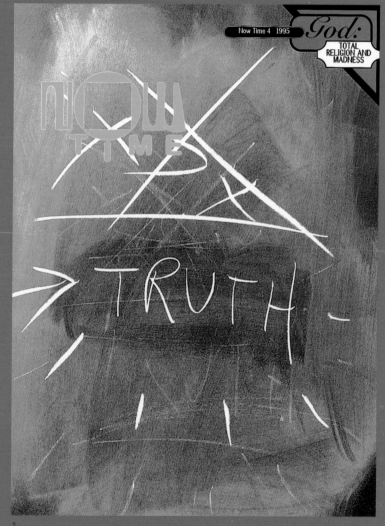

2

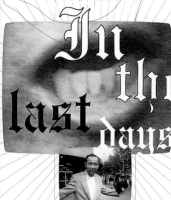

Into the Great Tribulation

In the last days, in this fallen city God has sent them out to preach to people

Last summer Sojin Kim and Miyoshi Barosh spoke with Christopher Badgley at her home in San Francisco and Sojin Kim spoke with Bob Paris by telephone. Christopher and Bob talked about the videos they made together and separately that explore beliefs in the power of faith as exemplified in such figures as Theresa of Avila, Jimmy Swaggart and Glenolen Roberston, stigmatics. They also discussed the role of place, of spiritual significance, whether sanctioned by religious authority or created in the midst of urban apocalypse by street preachers on the corner of Powell and Market in San Francisco.

Sojin Kim: Was *The Show* the first project you worked on together?

Christopher Badgley: The first significant project. Actually we started working on *Into the Great Tribulation* before *The Show*. We had an opportunity to do *The Show*, so we put the street preachers documentary *Into the Great Tribulation* on the shelf and made *The Show*. Recently we had a chance to go back and edit *Into the Great Tribulation*. We just didn't want it to go the way of so many films that got shot but never made.

Sojin: Can you describe the focus of *Into the Great Tribulation* and what you were trying to do with it?

Bob Paris: I'll just give you nuts and bolts descriptions. The documentary is comprised of a series of vignettes, each on a different street preacher. Between the preacher profiles are these extended, relatively esthetic segues that I intended to give an evocative, impressionistic look at an urban surrounding, sometimes with that slow-motion audio, which enhances the images a lot. The preacher profiles are all pretty raw. They're kind of loud, messy and funky. There's no narrative per se, no story line. Hopefully there's a kind of tonal development that, like *The Show*, nevertheless so that by the end these people are rendered human. Instead of being seen as "the other," or just this weird fringe group, they become part of some lost community we all have some membership in.

Sojin: How do these slow-motion segues between footage of individual preachers function?

Bob: I wanted to give a sense of the world out there: streets, alienation, confusion, and distance between people. This was the world that these street preachers came out of, that engendered them. I see the street preaching as a kind of survival mechanism, and that's how I think we can identify with them to an extent. They're coming from a difficult world where they've become disconnected, and the question, "Why am I alive and what the hell am I doing?" is not unusual. For me all that is expressed in the slow-motion sections.

Sojin: How did you decide to make a video on this subject?

Christopher: I was living on the Tenderloin then. I would get off the BART at Powell Street and walk home. I saw these people all the time, and I thought, Wow, it would be great to do a documentary on these people because they're so incredible, they're always there, and no one's ever listening to them. They're voices in the wilderness. So we parked ourselves on the corner of Powell and Market and over a period of time we got a real sense of what was going on, and started to film.

Sojin: What's it like on that corner?

Bob: Harry, the Japanese American preacher, calls the intersection of Powell and Market the "grand concourse" of San Francisco. It's a place where yuppies, office workers, tourists, the downtrodden, and destitute come together and commingle. There are street musicians, street vendors, cable cars, buses, a subway station—there's a ton of human traffic. On the one hand, it's a very vital place, but, on the other hand, it's a very harsh, difficult, and lonely place. I think that's what we tried to suggest in the documentary.

Sojin: How did you approach the people you interview?

Bob: Initially it was very easy shooting them. They're street preachers, they want to get their message out. But they were very suspicious of us. After awhile they would start opening chapter and verse—they wanted to save our souls. We wanted to get to their humanity: how do they feel about this? where do they come from? Even banal things like, what do you watch on T.V.? They didn't want this. It's as if they'd created a mask of divinity—a sacred mask—for themselves. When they put on that mask they're connected to God, doing God's work, an important job. Without that mask they're just like empty ciphers—doomed, like all these sugar background docs, they're just part of that empty, alienated world, where nothing is next to nothing.

So when we ask questions we're kind of tearing away at that mask and there is resistance. With some you gain their trust, and they believe you're not going to misuse that trust, and they talk a little more cordially. With other people that never happened, like with Jethro, the blues singer. I tried for so long to get an interview with that guy, but he was so righteous: "If you're not doing it for Jesus you're going to hell!" He didn't want that mask to move at all.

Sojin: Did you find any sorts of commonalities in the lives of the people you documented or spoke with?

Bob: Oh yeah. They are all lay people who go out on the street and preach the word of God—that's a pretty select group right there. There are tens of thousands of ordained ministers all over the country who would never preach the gospel on a city street. But these people feel that's what they should be doing, that's their mission. Sometimes I see it in terms of a play: the stage is at Powell and Market, the main character is the Messenger of God, and the script is the Bible. What I like about the documentary is the diversity: racial diversity, diversity in age, different sexes, different backgrounds. Even though they all use the same script—the Bible—they find different things in it.

Take Virgie, who has a pretty compassionate spin—she's one of the first preachers in the documentary—she tends to find a lot of things in the Bible that

AND THE PEOPLE WERE JUST FLOCKED OUT ON THE BEACH, AND IT WAS JUST LIKE ANTS, YOU KNOW . . . I WAS RUNNING, AND I WAS CHRISTIAN, I WAS GOING IN THE LORD. I KNEW GOD WANTED ME TO BE A WITNESS AND I JUST SAID, "YEAH, LORD, I DON'T KNOW HOW." ¶I'M JOGGING DOWN THE BEACH, AND I SEE ALL THESE PEOPLE, I'M JUST TALKING TO HIM AS I'M RUNNING. HE SPOKE TO MY HEART, AND HE SAID, "LOVE THESE SOULS." AND THEN JUST . . . CHANGED, MY EYES CHANGED—I CAN'T EXPLAIN IT. I JUST BEGAN TO SEE PEOPLE AS NOT FLESH AND BLOOD, YOU KNOW, MY BUDDIES THAT I USED TO PARTY WITH, THEY WERE JUST—A LOT OF THEM DIED, THEY HAD O.D.'D. I

Excerpts from Into the Great Tribulation

ROBERT ABOUT FIVE AND A HALF YEARS AGO, WHEN I WAS JOGGING DOWN A BEACH AT HUNTINGTON BEACH, CALIFORNIA, AND IT WAS IN THE MIDDLE OF THE SUMMER

seem to connect to her spirit. She really does care about the downtrodden and the destitute. When she says "God loves sinners" she means it. People hang out around her. Then there are others who have a righteousness, a kind of anger, and of course they're really happy to find things in the Bible about sending people to hell. There are commonalities and yet there are distinctions between these people.

Sojin: Was it Virgie who had the certificate?

Bob: She had a bunch of certificates. She might have been the only one who actually was ordained because she wanted to have a church. She had something from the Universal Life Church, or that is! The one I'm a minister of—you know, the one anyone can send away for. I felt she thought she needed to validate herself in a more bureaucratic way.

Sojin: What does it mean if you have a certificate?

Bob: You can do whatever the hell you want. It's a real church. It has been on shaky legal grounds for awhile, although it kind of works. I mean, they give you have a church, and he can make anyone a minister he wants to. I believe that with certification from this church you can, in fact, enjoy a couple . . . There may be something else you need.

Sojin: What were some of the reasons people gave for preaching on the street?

Bob: Everybody had different reasons. A lot of these reasons sound like any born-again Christian, so that respect it's not particularly interesting. Virgie had a very, very complex, detailed revelation. She had an incredible vision at the intersection of Powell and Market, which is only on the video for a few seconds. The story she told about her vision took twenty-five minutes. We shot her another time when she was telling that again so some other place, and there was even more to it, and it was a little different. So she really thought this was her destiny. I really don't think the other preachers had that strong a calling. But most of them seemed to suggest that they were compelled by God to do this, had been hand picked.

Christopher: The whole idea of being born-again, you know, is that you're a sinner, that you're lost in the world, and then you find Jesus, and that gives you meaning. These lives were meaningless, then they had a conversion experience, and now they're not here preaching on the streets: "I was a sinner, I was saved."

Miyoshi Barosh: Robert says he's "high on God." There's a twelve-step feeling about him—switching the addiction to God instead of whatever he was on before.

Christopher: I think he's fairly typical of a certain type of born-again. As he said, he was always going out, getting wasted getting his troth smashed in, and now he's got religion. He's a little bit self-righteous, but not in an offensive way.

Bob: I don't think there's a twelve-step anything going on there. I mean, he's young, he's going to talk in the vernacular that can teach people. He was talking about the high and the fruits and the great feeling he gets from God. There's a real distinction

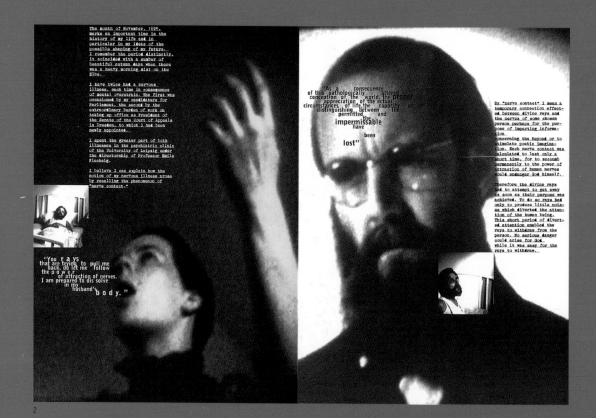

The month of November, 1895, marks an important time in the history of my life and in particular in my ideas of the possible shaping of my future. I remember the period distinctly, it coincided with a number of beautiful autumn days when there was a heavy morning mist on the Elbe.

I have twice had a nervous illness, each time in consequence of mental overstrain. The first was occasioned by my candidature for Parliament, the second by the extraordinary burden of work on taking up office as President of the Senate of the Court of Appeals in Dresden, to which I had been newly appointed.

I spent the greater part of both illnesses in the psychiatric clinic of the University of Leipzig under the directorship of Professor Emile Flechsig.

I believe I can explain how the notion of my nervous illness arose by recalling the phenomenon of "nerve contact."

"You rays that are trying to pull me back, do let me follow the power of attraction of nerves. I am prepared to dissolve in my husband's body."

"As a consequence of this pathologically altered connection of the world, the proper appreciation of the actual circumstances of life, the capacity of distinguishing permitted and the impermissible have been lost"

By "nerve contact" I mean a temporary connection effected between divine rays and the nerves of some chosen person perhaps for the purpose of imparting information concerning the Beyond or to stimulate poetic imagination. Each nerve contact was calculated to last only a short time, for to succumb permanently to the power of attraction of human nerves would endanger God himself.

Therefore the divine rays had to attempt to get away as soon as their purpose was achieved. To do so rays had only to produce little noises which diverted the attention of the human being. This short period of diverted attention enabled the rays to withdraw from the person. No serious danger could arise for God while it was easy for the rays to withdraw.

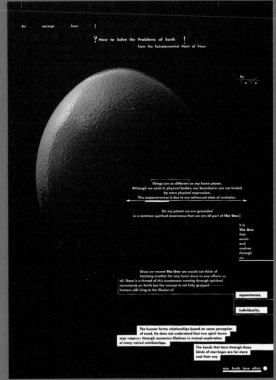

JOHNNY GOD

BY GARY INDiANA

For seven days dead souls can return to their village. A liquor accident at Madampi, on the coast of Ceylon. Johnny God looked down at his long fingers. They were strong through a childhood of a dairy farm. He had dreamed of a day when his true mother called him a faggot, his smooth body triumphing. The first Norwegian to stop donating blood. Those who have a good life work in a coverall and then a month and summer the strange guided by Mampes to a miraculous island, Beloret.

The city set a small experimental gas generator at one of the northern corners in 1816. The elephants lifted their heads as they struggled out of the mud. Whale oil and candle people went after brilliant effects distilled by tin pipes would turn billions of units of energy. To reach the island I would live on a fourth floor and the middle of a switchbacked bridge. One day I asked to divide the colors in my converted sardine can. Then I counted forward from memory of the wine-sharp tideless solitude re-entering her aura at the bar and among the waiters.

I WATCHED THE SWIMMING HEAD BOILED DOWN ON TOSSING TREES RISING OUT OF THE WATER DAMP SCUT FALLING AND CANTED. INTO THE SANITARIUM FOR THIS INTELLIGENCE. With the figure and myself in Nicky's cell.

'Dr. Harwood has a theory about Nicky's illness.'
'Stuff has been pouring in here.'
The floor is bare, the room bed enough. One old mat and a broken desk. No curtain with darkness discolored shutters holes in the man on the bed. A child. Abridgment of the torturing hour. A woman cutting rushes for mats.
'The name of your friend in the city begins with a D.' she says. 'I'm the only one alive. Something in it for my money to make his head roll like a skull cap.'
They called him Johnny God. Half-toilet, half-deity. There we were in the laser nets of cyberspace giving it up for Johnny. Last two million in despair. A vague mass rose inch by inch to ears less keenly tuned, a faint swishing sound. What was the thing with a wriggling movement? Those animals have been racing at a minor oval to be avoided. This type of animal raises serious questions. I speak of this period with emotion more brilliant when I knew the mir-

Mission San Xavier Del Bac near Tucson, Arizona
Photos: Sojin Kim

48

49

3

pages 34-7

Now Time

art directors Renée Cossutta
 Judith Lausten
designers 1 Somi Kim @ ReVerb
 2 P. Lyn Middleton
 3 Edwin Utermohlen
 4 Chris Myers & Nancy Mayer
 5 (see over) Chris Myers &
 Nancy Mayer
photographers 1 Christiane Badgley
 Bob Paris
 2 B. Burkhart
 4 Chris Myers
 5 (see over) Chris Myers
editor Miyoshi Barosh
publisher A.R.T.* Press
origin USA
dimensions 241 x 317 mm
 9½ x 12½ in

An excerpt from :

? How to Solve the Problems of Earth !
from the Extraterrestrial Point of View

by

Things are so different on my home planet.
Although we exist in physical bodies, our boundaries are not limited
by mere physical expression.
This expansiveness is due to our advanced state of evolution.

On my planet we are grounded
in a common spiritual awareness that we are all part of The One ?

it is
The One
that
exists
and
evolves
through
us.

Since we revere The One we would not think of
harming another for any harm done to one affects us
all. There is a thread of this awareness running through spiritual
movements on Earth but the concept is not fully grasped
humans still cling to the illusion of

separateness,

individuality.

The human forms relationships based on some perception
of need. He does not understand that two spirit-forms
may <marry> through numerous lifetimes in mutual exploration
of many varied relationships.
The bonds that form through these
kinds of marriages are far more
real than any

one Earth love affair

4

The loss of memory was very difficult as was my re-evolution through Earth frequencies. Only those who have lost their lives through amnesia can understand the horror of being history-less. As memories return the effect is inner turmoil. The hardest task at this point is to remain calm and trust in self without becoming influenced and manipulated into going against your inner truth. A strong negative reaction is often catalyzed within certain individuals in response to higher frequencies.

The immediate and irresistible urge to control or dominate because of a

cowardly fear

is my heritage on

your planet.

This Mother attempted to dominate me through Catholicism. Religion is a method of control.

By handing your destiny over to to an outside authority you remain forever enslaved to it. A religion is sustained by a self-generating field of energy created by its members. The energy of this force field begins to believe in its power and comes to see itself as a god. It is almost impossible to break away from an attraction to this energy field. Like a weed, its roots enter your soul and subconscious mind where it spreads and grows in power. It is a challenging test of evolution to shed this possession, and an absolute necessity if you are ever to return to your home planet.

The hardest part of adjusting to the Earth experience was the pleasure and familiarity I felt during telepathic interludes with my team. It was decided that I would remain relatively isolated until I completed the normal education required by the Earth culture I'd been born into. At the end of my teen-age years the first layer was removed and my training began.

My Earth life was a traumatic and highly tested event. Often I came close to failure, which would have meant absorption into the Earth cycles of death and rebirth.

You may question this activity as interference and wonder how we might justify meddling in the energies of Earth. Although there have been many ruthless visitors to your planet, those in alignment with **The One** require an invitation. This you provide through prayers for the return of a Savior. These prayers are sent through many religions and become an open invitation for any of us to answer. You must be aware that there was never anyone by the name of Jesus Christ on Earth. This name is a fabrication as is the history associated with this individual.

I myself answered the call for the return of the great white buffalo woman of the red race. For this reason I feel a special bond with the evolution of these people and have, in fact, adopted them as my own. My greatest gifts have come through my incarnations within

$$O = 1 = \frac{+2 \cdot 1 = \frac{+2}{-2} = 1 = \frac{+2}{-2}}{-2 \cdot 1 = \frac{+2}{-2} = 1 = \frac{+2}{-2}}$$

various North American tribes. Although the horrors of genocide have scarred me deeply, the glorious immersion into your Earth nature left me in awe. I was indeed mesmerized by the color and drama, the sound and smell of death, destruction, renewal, and rebirth, so orderly yet chaotic—all things long gone from my home planet. I, **Taté**, shall forever cherish those experiences as some of the dearest treasures of my entire evolution. (My secret grief is that I must share in the responsibility for the destruction of the red civilization as it once was. You see, Earth humans, you cannot invite the evolved without suffering. Once the light energy of such a being impacts on the negative energy field of your planet there are inescapable consequences.

In order to form a personality to carry me through the Earth experience it was necessary to dip into every facet of your human drama. This was a planned and systematic process. Whenever possible my experiences were combined to minimize and condense trauma and time. Quality and thoroughness were the goals as well as keeping the life-sustaining connection to **The One.**

On every planet the mastery of self begins with the mastery of inner and outer energies; but only attempt to master that which you recognize as true. All needs are contained within **The One**. All is available within the completeness of **The One**. False needs born of thoughtless childish desires are not destined to be truly satisfied. True knowledge is often painful, but with confidence in your birthright, all will be fulfilled through an intimate relationship with **The One**.

Overcoming the energy patterns of this planet, which must be assumed in order to exist here, is the supreme and ultimate test of every extraterrestrial. When you understand that energy is created through thoughts and feelings, stamped with the signature of the creator and destined to return to him, you will have the key to mastery. If you simply stop creating new thought forms and stop being controlled by old, unwanted thoughts, and guard the pattern of your daily thinking, you will begin to create the type of world in which you've always wished to live.

And so on into infinity.

Energy not only floats around, it congeals with other like energy and eventually assumes a life of its own with a will to survive. It will seek out compatible experiences either by feeding off humans with like energies or by stimulating similar energies in unsuspecting humans. People with intense emotions are especially targeted. Two people can marry their energies and create a combined force field to benefit or complicate their lives. This is the real reason for the importance of commitment. It has little to do with satisfying the insecurities of the human, but rather with the protection of the marriage force field from contamination by outside influences.

My assignment was in the understanding of these energies. Absolutely everything breaks down to energy dynamics. **The One** is composed of positive (+) and negative (−). Behind **The One** and incomprehensible to all life-forms is the **0**. Out of the **0** exists **The One** which in order to evolve must become the **2s**. The **2s** manifest what we call life. Each **2** has a + and − component, hence the name **2**. The life of the **2s** is separate and complete in each **2**'s awareness of itself as an individual entity, therefore each + or − seeks to perpetuate itself as exactly what it is: + or −. Our job is to harmonize to **The One** and hold the balance of the **2s**. The life of the **2s**, however, wants to pull you into one or the other aspect of itself. It is easy to forget one's origins in **The One** when these brief trespasses into the + or − aspects of **The One** seem so real and complete. The test is to not take them seriously, but to respect them as equal yet opposite, and completely unavoidable! Acceptance with respect is the answer and the ultimate goal is to keep them balanced.

The state of spiritual affairs on Earth is appalling. It saddens me beyond belief to see so many desperate humans seeking escape from their lives. Either a heaven or some magnificent god awaits you upon death, if you can survive and hold fast to the rules set before you by your religions. Does no one see how often these rules change from era to era? And the metaphysicians who believe that they can ascend this physical plane by pure, positive spiritual thinking...You are mere children in your expectations. One can only become pure spirit when the **2s** have been balanced in the inner **One** within you all. You do not become spirit by ascending out of matter but rather by moving into matter and holding the balance of the two polarities. This is a systematic process. Moving in and out of masculine and feminine and balancing the **2s** of each **One**: balancing the **2s** of the masculine,

balancing the **2s** of the feminine until the spirit-form which you are understands **The One** behind the masculine and the feminine. In every life there are challenges of the **2s** before you. If you wish to measure your evolution, check your inner peace with your inner masculine and your inner feminine and then check its manifestation in your outer, daily life.

You, Earth humans, are responsible for the state of affairs that exist on your planet. You cannot escape the responsibility for this. To seek an escape is a childish whim and can never by allowed. All are accountable to **The One** for whatever they have created. All energy stamped with your signature by your thoughts remain yours until it has been balanced within you and released once again into **The One.** When all energy has been released in freedom, then you will also be free. This ascension process is a gradual heightening of light frequency and takes place over many eons. Until you conquer your fear of death, your own frightening energy creations, and settle into the beauty of the **2s** you will never begin this process of ascension.

One thing more, no one can balance the **2s** of another. It is the duty of each one to do this for themselves and earn their own freedom. The more evolved you are the easier it is to see the imperfections of another. Also, although their pain might seem overwhelming and unfair, the desire to assist must be resisted. To interfere can only be dangerous for your own evolution by causing you to absorb and carry energy patterns not meant for you. This can result in a needless delay of your own mission.

During my sojourn here on your planet I was systematically led through many lives which touched me deeply and many circumstances where I searched in vain for my truth. It is frightening to know so much and have no one to validate that hard-won knowledge. Although I met many wonderful people who helped me through my ordeal, I outgrew them all in time. The message was clear: you are alone. You have the ability to know your own truth. It is as it should be.

It is a fact of great sadness and incomprehensible to us that while we maneuver and manipulate time and space, placing ourselves at great risk in order to appreciate and explore this planet of such beauty, you, Earth humans, are systematically destroying it day by day. Don't you see the mark of doom that hangs over your civilization? Your days are numbered regarding life as you know it. Reclaim your power, your earth, and your destiny! Reverse the polarity of the energy that controls you and you will be able to move your destiny in any direction you choose ●

38

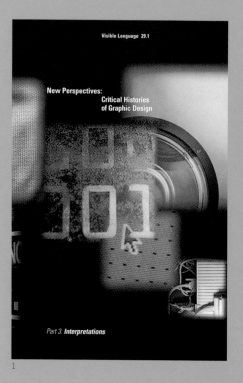

1

2

3

pages 40-41 ➤

The Magazine of the Book

art directors Vivienne Cherry
 Seònaid Mackay
 designers Vivienne Cherry
 Seònaid Mackay
photographers/ Vivienne Cherry
illustrators Seònaid Mackay
 editors Vivienne Cherry
 Seònaid Mackay
 publisher The Royal College of Art
 origin UK
 dimensions 210 x 297 mm
 8¼ x 11¾ in

pages 38-9

Visible Language

art directors 1 Tom Ockerse
 2, 3, & 4 Larry Clarkberg
 designers 1 Paul Mazzucca
 2, 3, & 4 Larry Clarkberg
photographers 1 Paul Mazzucca
 3 Stock Photo Disk
 artist 2 J.S.G. Boggs
 editors 1 Andrew Blauvelt
 2, 3, & 4 Sharon Poggenpohl
 publisher Visible Language
 origin USA
 dimensions 152 x 229 mm
 6 x 9 in

Gonzalez & Boggs

MG **JSGB**

You were reluctant to give this interview, and I was surprised at
that because you seem to be such an accessible and public
person.

I used to have an open-door policy, and I did not discriminate.
If someone wanted to talk about the work or the circum-
stances, the door was open, even if it was the press come to
ambush me. But **I hate interviews.**
I'm much more interested in conversation.

You are referring to the Dan Rather *Eye On America* television
show where they portrayed you and your work in the light of
color-copy counterfeiting.

Actually I was referring to *Art in America* magazine, but CBS
fills the bill.

I assure you I haven't come to ambush you.

Exactly what an ambusher would say, no?

Touche.

Look, I didn't close the door because I was worried about
being ambushed. Do your worst. I just got tired of doing inter-
views that were of little consequence to either party. There is
no such thing as a stupid question, but if the question's little
more than a thinly veiled fishing expedition to grab a sound
bite, and no one is actually listening to the response, then
what is the point?

I'm listening.

So am I.

(*Boggs' reputation for full-frontal confrontation is well deserved.*)
You mentioned your previous open-door policy—did that
extend to the **police?**

What a **joke.** They did not need a search
warrant. I'd invited them to the studio dozens of times. I
thought they were O.K. people. The United States Secret
Service had been asked to jointly prosecute in England because
seven drawings were of American bills. They refused and
ordered those works returned to me. I thought they were

This magazine is a compilation of research into the subject of
bookishness, inspired by an R.C.A. 1993/4 project entitled
'When is a Book not a Book?'

The research by the students in the class was collected with
the intention of exploring and classifying the ideas and
hypotheses uncovered. Rather than pursuing any one
answer, as it is clear that there are many definitions and
contradictions, the aim is to take you on a journey, showing
how different aspects of the book relate to and presuppose
each other. The different definitions fall into a certain order
as each category demands the next

A starting point for these definitions is the assumption that
without a reader a book is nothing; beginning with the
intangibility of human thought, as something without shape
or definition, and the evolution of this into language. As
words become more than just marks, their symbolism goes
beyond the page to evoke the outside world as they become

inextricably linked with the thing that they represent. This
blurring of distinction between reality and mere description
gives books the power to create their own world, becoming
containers of information, that hide and reveal in sequence,
as the reader absorbs the text, one line after the other. An
examination of linearity in turn raises the question that

perhaps there could be other, non-linear, ways of perceiving

and communicating that

could challenge the form of books.

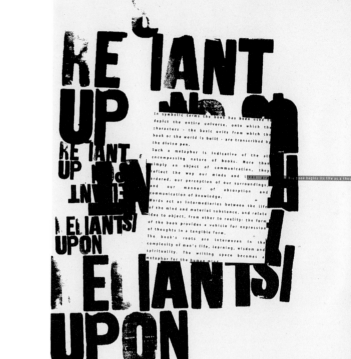

In symbolic terms the book has been used to
depict the entire universe, onto which the
characters - the basic units from which the
book or the world is built - are transcribed by
the divine pen.
Such a metaphor is indicative of the all-
encompassing nature of books. More than
simply an object of communication, they
reflect the way our minds and lives are
ordered, our perception of our surroundings
and our manner of absorption and
communication of knowledge.
Words act as intermediaries between the life
of the mind and material substance, and relate
idea to object, from ether to reality: the form
of the book provides a vehicle for expression
of thoughts in a tangible form.
The book's roots are interwoven in the
complexity of man's life, learning, wisdom and
spirituality. The writing space becomes a
metaphor for the human soul.

The book brings
language and
literature by way
of the visual word
to our eyes. We have
symbols for the sounds of
which the word is
composed.

Paradox: in order to be able to
manifest itself concretely,
language must first become
abstract

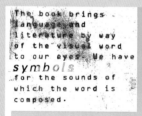

the book exists
as an extension of the
eye and mind
but requires an
understanding of the
code
of reading, and the mental
participation of the reader to
recreate the reality it is
depicting.

A book piles up letters
only for the CODES
of their arrangement -
you have to know 2
CODES, that of the
language and that of the
letters.

No human society can exist without communication. We
rely on signals, symbols of what we think and feel and
want, and these signals can assume a vast variety of
forms. We can wave our hands, screw up our faces, shrug
our shoulders, use semaphore, telephone, morse code,
run a pirate radio transmitter, or stick pins in dolls but
will always end up with human speech as the most subtle,
comprehensive, and exact system of communication we
possess. Without speech, and the various notations of
speech, human society would not be possible at all.

Human speech is essentially a system of conventional signs, though theorists once held
that all language came out of a desire to imitate natural phenomena. There are, in all
languages, many words which attempt an image of the things they represent; for
example 'splash' sounds like water, 'pop' like the bursting of a balloon. Even with
purely visual images, it is possible to find a certain appositeness in the form of the
words. For example, the word 'moon', in Latin and its derivatives, as well as Russian,
has a lun-form, and Malay has 'bulan'. It is the o-sound which is descriptive: the lips
have to imitate a moon shape in order to give the right quality to the tongue sound; the
back of the tongue is raised high, very close to the palate, and this seems to suggest
that the moon is something high up. A word like 'little' seems apt, for the i-sound is
made by narrowing the passage between the front of the tongue and the palate,
suggesting that only something very little could creep through.

But this class of iconic words is
very small. Structural words like
'of', 'if', 'when', 'so' - have
never had a corresponding image
in the outside world. Language is
arbitrary, conventional, and has
been so from the beginning.

An alphabet is a series of signs representing signs. The
sounds making up a word stand for something in the outside
world, and the letters which make up the word represent
that sound. Thus, with a visual system of representation, we
are two removes from reality. We are three removes from
reality when we use a system like braille or morse: the dots
and dashes or embossed letters stand for alphabetic letters;
the alphabetic letters stand for sounds; the sounds stand
for what exists in the mind or in the outside world.

abstract

The form that the thought takes is that of language. Our language is a code that we agree to interpret, a system of communication. Our language shapes, and is shaped by, our perception of the world around us. It is so powerful that we cannot think without it.

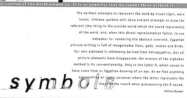

The earliest attempts to represent the word by visual signs, were
iconic. Chinese symbols still show ancient attempts to draw the
referent (the thing in the outside world which the sound represents)
of the word, and, when this direct representation failed, to use
metaphor for rendering the abstract concrete. Egyptian
picture-writing is full of recognisable lions, gods, snakes and birds.
Our own alphabet is ultimately derived from hieroglyphics, but all
picture elements have disappeared; the essence of the alphabet
method is its conventionality. Only in the letter O, which seems to
have come from an Egyptian drawing of an eye, do we find anything
approaching an iconic purpose; where the letter represents the
shape of the mouth when pronouncing the O sound.

Anthony Burgess

symbols

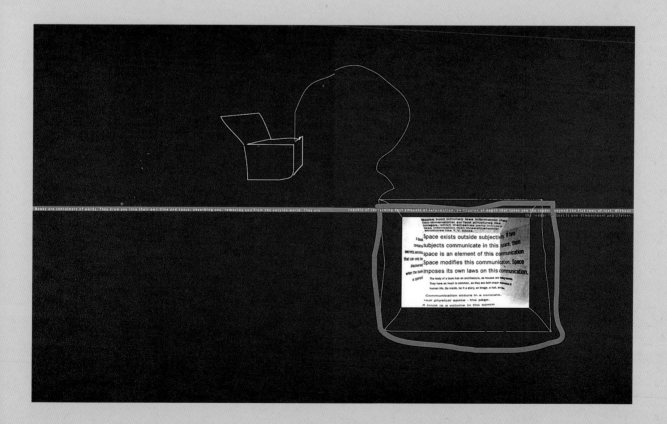

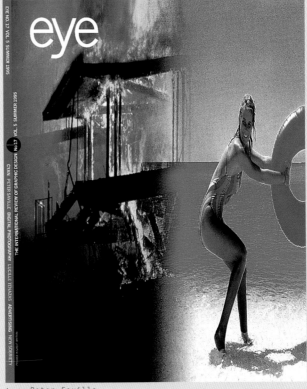

pages 42-5

Eye

art director Stephen Coates
designer Stephen Coates
editor Rick Poynor
publisher Emap Business
Communications
origin UK
dimensions 237 x 297 mm
9³/₈ x 11³/₈ in

42

image Peter Saville
photography © Pictor International

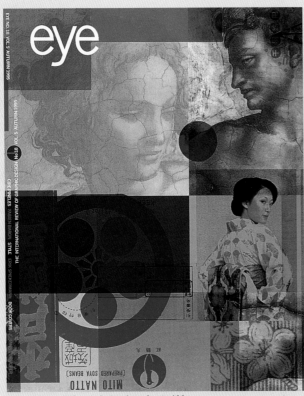

image Angus Hyland & Louise Cantrill

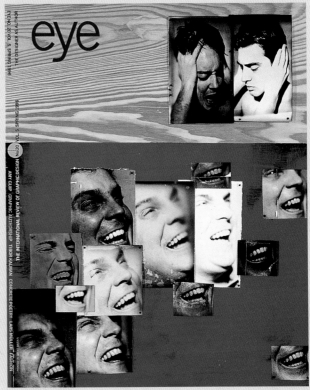

image Amy Guip

Ornament is no longer a crime and there is a growing
enthusiasm for decorative display. Few recent alphabets
equal Louis John Pouchée's for vivacity and invention

Pouchée's
lost alphabets

Text: Mike Daines

In the early years of the nineteenth century, skilled engravers at the London typefoundry of Louis John Pouchée produced a series of finely crafted decorative alphabets. The beautiful large letters, up to 26 lines (over 100 mm) in cap height and made from single blocks of end-grain boxwood, were intended as eye-catching elements for printed posters. They are mostly in the early nineteenth-century fat face style, richly adorned with intricately carved images of fruit, agricultural tools, farm animals, musical instruments and Masonic signs. Virtually lost for over 150 years, they have now been resurrected in a limited boxed edition as *Ornamented Types: Twenty-three alphabets from the foundry of Louis John Pouchée* through a collaboration between the St Bride Printing Library in the City of London, in whose collection they reside, and Ian Mortimer of I.M. Imprimit.

The ornate style and decorative extravagance of the types give them a renewed appeal for the tired typographic palettes of the 1990s. PostScript font catalogues today are beginning to offer decorative display alphabets, including ornamented initials digitised from nineteenth-century designs, as well as more rapid computer-generated display faces. But none of the types so far released matches the Pouchée alphabets for quality, originality or vivacity.

The fat faces and slab serifs designed in the first decades of the nineteenth century were reviled by taste-setting printers and typographers in the 1920s; Stanley Morison in *Type Designs of the Past and Present* (1926) stated, "The types cut between 1810 and 1850 represent the worst that have ever been."

During the 1930s display types of this period underwent a re-appreciation and were promoted by typographic opinion-formers such as Robert Harling's journal *Typography* (1936–39). Nicolete Gray's *Nineteenth Century Ornamented Types and Title Pages* (1938) contains reproductions of the Pouchée types described erroneously as examples of the "early Victorian 'exuberant' style" and credited to the Wood & Sharwoods London foundry. The idea that the alphabets dated from the second half of the nineteenth century survived and the selection from three of the types published in John C. Tarr's *Lettering: A Sourcebook of Roman Alphabets* (1951) is similarly described as "Victorian wood-cut letters".

The 1960s saw a revival of interest in decorative display types stimulated by the introduction of two new technologies for display setting: headline photosetting and dry-transfer lettering. Among the best-sellers for Letraset in late 1960s were Lettres Ornées and Romantiques No. 5, two highly ornamented types in the French style described inaccurately as part of an "Art Nouveau" range. These were used widely in magazine headlines, posters and packaging, alongside the highly condensed sans serifs which were also fashionable. Five of the Pouchée designs were reproduced in the journal *Motif* in 1967 and sample letters published by James Mosley in the *Journal of the Printing Historical Society* (1966) stimulated academic interest. The idea of publishing *Ornamented Types* began in 1985, when Mortimer and Mosley proofed the entire collection of blocks using one of the Albion hand-presses at St Bride to provide archive proofs for the library and repro proofs for a possible commercial edition (which has not been undertaken). The results affirmed the outstanding quality of the types and Mortimer made a proposal to the City of London Corporation (which has

1–6. A selection of the Pouchée typefoundry's ornamented letters showing the high level of craftsmanship required to achieve such intricate results. In several cases the design breaks out from the basic letterform. This would increase the chances of damage and helps to prove that the wooden types were actually patterns for manufacture rather than blocks to be printed from directly. All the alphabets reproduced here are shown actual size.

Seen from the outside, during the 1980s, the Netherlands looked like a graphic designer's
heaven. Government subsidies allowed cultural work to flourish. Commercial clients
backed experimentation seemingly without question. But the 1990s finds young Dutch
designers beating a retreat. The older generation's triumph is being followed by diffidence

The new sobriety

Text: Carel Kuitenbrouwer

Dutch graphic design is going through a transitional period, perhaps even a crisis. The overall standard is high, Dutch work enjoys an excellent reputation both at home and abroad, and the industry is becoming professionally organised. But the coming of age of Dutch design looks likely to be followed by an awkward silence.

The Netherlands is home to a host of freelancers, studios, partnerships and collectives of various sizes, which together produce a body of work that does credit to the reputation of Dutch design. Though Amsterdam has traditionally been the capital of publishing, advertising and design, more and more high-quality studios are being established outside the city. A good example is the Arnhem-based M+M Vormgevers, where Michelle Clay and Marsel Stoopen's work has an austerity reminiscent of the pre-war Neue Sachlichkeit and post-war functionalism. If M+M are in the middle of the spectrum, then a studio such as Typography & Other Serious Matters in The Hague occupies the more bookish end with a balanced, stylish idiom derived from Jan van Krimpen and other Dutch

book designers. At the other extreme are practitioners such as Montse Hernández Sala, who produces attractive, highly illustrative work from the eastern town of Nijmegen. Surrounding these three is a large professional population creating a vast range of work that might threaten to flood the market, were it not for the ephemerality of printed matter and the ever increasing rate of change of corporate identities.

So where is the crisis? First, there is a notable absence of the kind of innovation that could be detected even in the professional mainstream until a few years ago. Second, growing numbers of leading young designers have begun to reject the "Dutch Design" label, which they associate with having a ball at the client's expense and bombarding the public with a plethora of unnecessary, over-the-top images and messages. This counter-current runs alongside a public weariness with conspicuously de-

2. Poster/mailer by M+M for a charity art auction. The squares symbolise the works of art by different artists, the colours correspond to the art works' dominant hues, and the words in the squares are the titles.

Graphic authorship is taken for granted by many design theorists and it is gaining ground within practice too. But the idea has received little sustained examination. What does it mean and what is really possible?

The designer as
author

Text: Michael Rock

Authorship has become a popular term in graphic design circles, especially in those at the edges of the profession: the design academics and the murky territory between design and art. The word has an important ring to it, with seductive connotations of origination and agency. But the question of how designers become authors is a difficult one and exactly who qualifies and what authored design might look like depends on how you define the term and determine admission into the pantheon.

Authorship may suggest new approaches to the issue of the design process in a profession traditionally associated more with the communication than the origination of messages. But theories of authorship also serve as legitimising strategies and authorial aspirations may end up reinforcing certain conservative notions of design production and subjectivity – ideas that run counter to recent critical attempts to overthrow the perception of design as based on individual brilliance. The implications of such a redefinition deserve careful scrutiny. What does it really mean to call for a graphic designer to be an author?

The meaning of the word "author" has shifted significantly through history and has been the subject of intense scrutiny over the last 40 years. The earliest definitions are not associated with writing *per se*, but rather denote "the person who originates or gives existence to anything". Other usages have authoritarian – even patriarchal – connotations: "the father of all life", "any inventor, constructor or founder", "one who begets" and "a director, commander, or ruler". More recently, Wimsatt and Beardsley's seminal essay "The Intentional Fallacy" (1946) was one of the first to drive a wedge between the author and the text with its claim that a reader could never really "know" the author through his or her writing.[1] The so-called "death of the Author", proposed most succinctly by Roland Barthes in a 1968 essay of that name, is closely linked to the birth of critical theory, especially theory based in reader response and interpretation rather than intentionality.[2] Michel Foucault used the rhetorical question "What is an Author?" in 1969 as the title of an influential essay which, in response to Barthes, outlines the basic

characteristics and functions of the author and the problems associated with conventional ideas of authorship and origination.

Foucault demonstrated that over the centuries the relationship between the author and the text has changed. The earliest sacred texts are authorless, their origins lost in history. In fact, the ancient, anonymous origin of such texts serves as a kind of authentication. On the other hand, scientific texts, at least until after the Renaissance, demanded an author's name as validation. By the eighteenth century, however, Foucault asserts, the situation had reversed: literature was authored and science had become the product of anonymous objectivity. Once authors began to be punished for their writing – that is, when a text could be transgressive – the link between author and text was firmly established. Text became a kind of private property, owned by the author, and a critical theory developed which reinforced that relationship, searching for keys to the text in the life and intention of its writer. With the rise of scientific method, on the other hand, scientific texts and mathematical proofs were no longer seen as authored texts but as discovered truths. The scientist revealed an extant phenomenon, a fact anyone faced with the same conditions would have uncovered. Therefore the scientist and mathematician could be first to discover a paradigm, and lend their name to it, but could never claim authorship over it.

Post-structuralist readings tend to criticise the prestige attributed to the figure of the author. The focus shifts from the author's intention to the internal workings of the writing: not *what* it means but *how* it means. Barthes ends his essay supposing "the birth of the reader must be at the cost of the death of the Author."[3] Foucault imagines a time when we might ask, "What difference does it make who is speaking?"[4] The notion that a text is a line of words that releases a single meaning, the central message of an author/god, is overthrown.

Post-modernism turned on a "fragmented and schizophrenic decentering and dispersion" of the subject, noted Fredric Jameson.[5] The notion of a decentered text – a text which is skewed from the direct line of communication between sender and receiver, severed from the authority of its origin, and exists as a free-floating element in a field of possible significations – has figured heavily in recent constructions of a design based in reading and readers. But Katherine McCoy's prescient image of designers moving beyond problem-solving and by "authoring additional content and a self-conscious

1. W. K. Wimsatt and Monroe C. Beardsley, "The Intentional Fallacy" in *Critical Theory since Plato*, ed. Hazard Adams, New York, 1982, 1971.
2. Roland Barthes, "The Death of the Author" in *Image-Music-Text*, New York: Hill and Wang (translated by Stephen Heath), 1977.

3. Michel Foucault, "What is an Author?" in *Textual Strategies*, ed. Josué Harari, Ithaca: Cornell University Press, 1979.
4. Barthes, op. cit., p. 145.
5. Foucault, op. cit., p. 160.
6. Fredric Jameson quoted in Mark Dery, "The Persistence of Industrial Memory" in *Architecture New York* no. 10, p. 15.

1. Digital poster by April Greiman for the Colorado large-sheet printer Pikes Peak, 1994.
2. Album sleeve by Vaughan Oliver for *Doolittle* by the Pixies, 4AD, 1989. Photography by Simon Larbalestier.
3. Poster by Anthon Beeke for the play *Penthesilea*, one of a series of three – to be displayed together – for Toneelgroep Amsterdam, 1991.
4. Theatre poster by Pierre Bernard and Grapus, 2002.

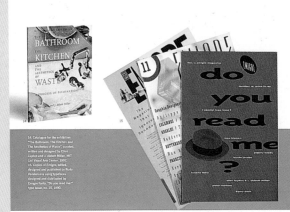

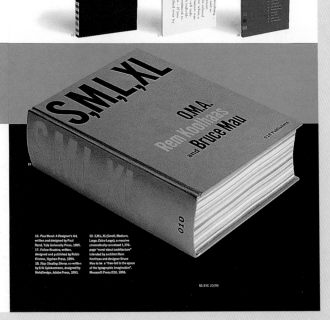

low, but in typography and composition). The singularity of the artist's book, the low technical quality and the absence of a practical application may alienate the professional graphic designer.

If the difference between poetry and practical messages is that the latter are successful only when we correctly infer the intention, then activist design would be labelled as absolutely practical. But activist work – including the output of Gran Fury, Bureau, Women's Action Coalition, General Idea, ACT-UP, Class Action and the Guerrilla Girls – is also self-motivated and self-authored within a clear political agenda. Proactive work has a voice and message, but in its overt intentionality lacks the self-referentiality of the artist's book. Yet several problems cloud the issue of authored activism, not least the question of collaboration. Whose voice is speaking? Not an individual, but some kind of unified community. Is this work open for interpretation or is its point the brutal transmission of a specific message? The rise of activist authorship has complicated the whole idea of authorship as a kind of free self-expression.

Perhaps the graphic author is one who writes and

publishes material about design – Josef Müller-Brockmann or Rudy VanderLans, Paul Rand or Erik Spiekermann, William Morris or Neville Brody, Robin Kinross or Ellen Lupton. The entrepreneurial arm of authorship affords the possibility of a personal voice and wide distribution. Most split the activities into three discreet actions: editing, writing and designing. Even as their own clients, the design remains the vehicle for the written thought. (Kinross, for instance, works as a historian then changes hats and becomes a typographer.) Rudy VanderLans is perhaps the purest of the entrepreneurial authors, since in *Emigre* all three activities blend into a contiguous whole. In *Emigre* the content is deeply embedded in the form – that is, the formal exploration is as much the content of the magazine as the writing. VanderLans expresses his message through the selection of material (as an editor), the content of the writing (as a writer) and the form of the pages and typography (as a form-giver).

Ellen Lupton and her partner J. Abbott Miller have almost single-handedly constructed the new critical approach to graphic design, coupled with

14. Catalogue for the exhibition "The Bathroom, The Kitchen and The Aesthetics of Waste", curated, written and designed by Ellen Lupton and J. Abbott Miller, MIT List Visual Arts Center, 1992.
15. Copies of *Emigre*, edited, designed and published by Rudy VanderLans using typefaces designed and distributed by Emigre Fonts. "Do you read me", type issue, no. 15, 1990.

16. *Paul Rand: A Designer's Art*, written and designed by Paul Rand, Yale University Press, 1985.
17. *Follow Readers*, written, designed and published by Robin Kinross, Hyphen Press, 1994.
18. *Stop Stealing Sheep*, co-written by Erik Spiekermann, designed by MetaDesign, Adobe Press, 1993.
19. *S,M,L,XL* (Small, Medium, Large, Extra-Large), a massive cinematically conceived 1,376-page "novel about architecture" intended by architect Rem Koolhaas and designer Bruce Mau to be a "free-fall in the space of the typographic imagination", Monacelli Press/010, 1996.

photographer Anthony Oliver

Systems not schemes, character not conformity: typography, for Erik Spiekermann, is a tool for rendering the world accessible

Meta's tectonic man

Text: William Owen

Erik Spiekermann is a consummate pluralist. Able to move, seemingly without effort, between roles as a typographer, designer, writer, public speaker and merchandiser, he was once even a politician – a Green Party member of the Berlin Senate. Spiekermann is the author of *Stop Stealing Sheep* and *Rhyme & Reason* – two models of typographic rectitude for a lay audience – and the articulate upholder of standards of public design in many a conference lecture. He is the designer of Meta, one of the most successful typefaces of this decade, and founder of the typeface distribution company FontShop. Spiekermann is also a partner in MetaDesign, now an international consultancy with offices in Berlin, London and San Francisco, and it is this manifestation – the graphic designer – that has received the least attention. For while Spiekermann has been busy promoting his own particular brand

"The page is the lowest common denominator of the book system. The page is the molecule and the atom is the word."

of rational Modernism-with-character, the polemicist has sometimes overshadowed the practitioner.

Spiekermann himself rejects the title of graphic designer to describe his practice: "I am a typographic designer. A typographic designer starts from the word up; a graphic designer starts from the picture down." This idiosyncratic explanation – few would place the two disciplines in opposition, and one is usually regarded as inclusive of the other – has a certain logic. But how, then, does Spiekermann distinguish his approach from that of an avowed graphic designer such as Gert Dumbar?

"Dumbar always uses space. He can't have three-dimensional space because paper is flat, so instead he uses cross-sections – he dissects objects in space and puts them on the flat page. He is a spatial kind of image guy: he thinks in theatrical terms. I think in page terms. The page is the lowest common

1-3. Cover and pages from the design manual for the BVG, Berlin's city transport system. This was MetaDesign's first major corporate identity and public signage project, begun in 1987 with new livery, signage and timetables for the bus service, and enlarged to include the city railway system after unification in 1989.
4. BVG logotype. Ubiquity, for MetaDesign, the device is symmetrical, centred within its background and based on an unsophisticated square.

denominator of the book system. The page is the molecule and the atom is the word. You see, I read. I read before I design, and I write. I design outwards from words."

A respect for words and evident talent for using them might seem incongruous in the visual arts were it not that Spiekermann so often speaks and writes in pictures. His conversation is a stream of aphorism and metaphor. On national stereotypes in graphic design, for instance, we learn: "France is olive shaped; Holland is triangular, always very pointy and narrow; Germany is very square; and England is round." And on being a designer: "I am a servant, I'm not an artist. If I was an artist I would be oval, like an olive."

As a typographic designer, however, Spiekermann is distinctly quadrilateral. His trademarks are a rectangular or braced bar that bleeds off the page

and a palette of just two colours – black and red, in the craft tradition. While he is generous with words, Spiekermann is extremely parsimonious when dispensing colour, shape and typographic variation.

He ascribes this frugality to his background. The eldest of four children, his father a lorry driver, he was born into an impoverished post-war Germany, near Hannover, in 1947. He paid his way through Berlin's Free University, where he studied art history, by setting up as a jobbing letterpress printer. He had only two typefaces, in three sizes, and could rarely use more than two colours (he learned to give the impression of three-colour work by reversing type out of a colour in white). Economy was a function of necessity, and Spiekermann has used this experience to establish a method which exploits scarce resources to the full rather than attenuates or reduces. He is used to getting a lot from a little, but

34 EYE 18/95

35 EYE 18/95

The tenth pioneer

Seventeen and *Charm* both broke new ground. Cipe Pineles, their art director, played a leading part. Why, when the history came to be written, was Pineles left out?

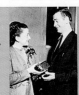
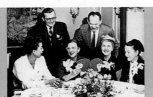

1. Cipe Pineles and her husband William Golden, art director at CBS, receiving medals from the Art Directors Club of New York in 1948 – the first time a wife and husband were honoured in the same year. Pineles was awarded hers for commissioning fine artists to illustrate fiction for *Seventeen*.
2. *Charm*'s editors and executives celebrating its fifth anniversary in 1955. Seated from left: Eleanor Hillebrand Bruce, fashion editor; Helen Valentine, editor-in-chief; Estelle Ellis, promotion director; Cipe Pineles, art director.
3 (opposite). Pineles working at *Charm*, about 1955.

Text: Martha Scotford

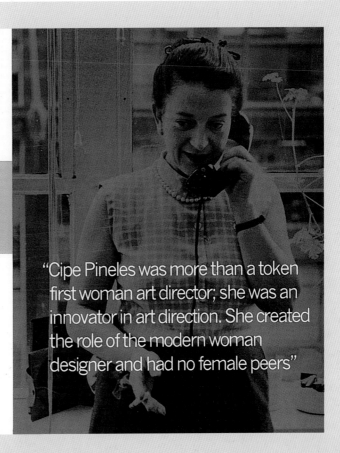

"Cipe Pineles was more than a token first woman art director; she was an innovator in art direction. She created the role of the modern woman designer and had no female peers"

Traditional accounts of design history have some obvious blindspots when it comes to the careers of women designers. Written from a predominantly male perspective, they tend to ignore the interactions of the personal and the professional, the private and the public, which play such a decisive role in the shaping of women's working lives. They are equally indifferent to the variety of career paths taken by women, the nature of collaboration between colleagues and the social and political roles played by women professionals.

The career of the American designer Cipe Pineles presents us with a much needed opportunity to explore new ways of writing design history. As an illustrator, design teacher and art director working primarily in women's magazines, she was an exemplary professional, an intriguing individual, and a valuable role model. Yet despite her many achievements, Pineles has never entirely received her due. The most recent historical study of individual American designers, R. Roger Remington and

Barbara J. Hodik's *Nine Pioneers in American Graphic Design* (1989), profiled nine male designers who worked in and around New York between the late 1920s and early 1970s and who "have helped shape graphic design as a profession and have made a distinctive and innovative contribution". Pineles' career fits the criteria for inclusion, yet though both her husbands – William Golden and Will Burtin – are among the chosen nine, she has been overlooked. Should Pineles have been the tenth pioneer?

Born to Jewish parents in Poland in 1908, Pineles came to the US in 1923 at the age of 15. Three years later she enrolled as a commercial art student at the Pratt Institute, followed by a year of painting supported by a Tiffany Foundation scholarship during which time she looked for design work. In a biographical summary sent to Dr Robert Leslie, director of the Composing Room, in 1970, she described the frequent professional rejections she suffered when it was discovered she was a woman. Employers were reluctant to put her in the artists'

54 EYE 18/95

black + white

art director Chris Holt
editor Karen-Jane Eyre
publisher Marcello Grand, Studio Magazines
origin Australia
dimensions 235 x 324 mm
9¼ x 12¾ in

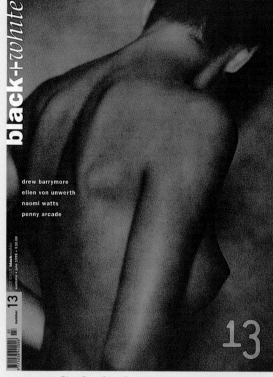

photographers The Douglas Brothers

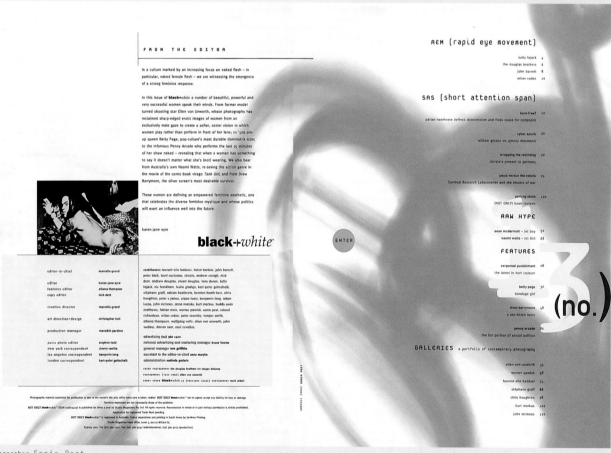

photographer Sonia Post

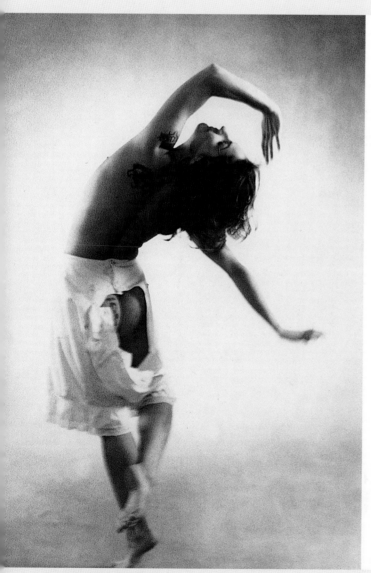

tar i d a

LACY

With a combat-zone mouth and a boots-and-all attitude, Tania Lacy's take-no-prisoners comedy style has always played it fast and furious. Merran White catches up.

photography peter rosetzky
hair and makeup nikki clarke
stylist virginia dowzer

photographer Peter Rosetzky

GRUNGING IT UP AND PLAYING HOLLYWOOD DOWN,
ETHAN HAWKE IS SO COOL HE'S HOT

Helen Barlow talks to Hollywood's hardest-working slacker.

serious

CO

O

As brat pack stars like Kiefer Sutherland, Rob Lowe and Charlie Sheen continue their down-hill slide, a new breed of young American actors has emerged to take their place. Advocates of grunge over glamour, and more hip to the indie music and theatre scenes than the Hollywood hype-machine, these actors are high profile about their low-key lifestyles. At 23, Ethan Hawke is a reluctant celebrity who appears in one movie a year and usually tries to avoid probing journalists – except when he wants to talk about a new film.

Dressed nondescriptly in his favourite brown suede jacket and an open-neck shirt, Hawke is on location in Vienna for *Before Sunrise*, a new film from Richard Linklater (*Slacker, Dazed and Confused*). Co-starring French actress Julie Delpy, who recently appeared in Krzysztof Kieslowski's *Three Colours White*, the film is about two people who meet on a train in the middle of the night, and later roam the streets of Vienna, working their way through shared existential concerns, as they fall in love.

"I wanted to work with Rick [Linklater] because of his other two films," explains Hawke. "And I like him a lot. I was impressed with his idea of making a movie solely about communication, and how hard it is for two people to get to know each other."

The actor's new role is vastly different from his ranting *Reality Bites* character. "He's not surly, not angry at all. He's just a guy who's struggling with immediate dilemmas. He's broken up with his girlfriend and is open to something happening in his life. Both these people are really available and we know so little about them outside of that 10-hour time bracket. It forces you to take them at a very human level. The idea of the film is to show real people. Life is not about drama...the most exciting things that happen to us are really mundane things. But these characters do have meaning, they have poetry I think."

Their different cultural backgrounds – she is French and he is American – adds to the human dimension for Hawke. "I never feel very American unless I'm placed against somebody who is very European," he muses. "Then all of a sudden I feel like all I do is drink Coke and say, 'Have a nice day'."

As the actor's sole film this year, *Before Sunrise*, made for only US$2.5 million wasn't exactly a gold mine for its lead actors. Both Hawke and Delpy, however, were more interested in experiencing Linklater's loose creative process – 70 percent of the script was re-written in Vienna. "It's scary because the movie is a huge risk," says Hawke. "It's more probable that it won't work than that it will, because its aspirations are so high. Julie said in the script last night that the attempt is all, and I'm a real believer in that."

Delpy, an intense actor who works from nervous energy, is a contrast to the laid-back American. "She's very good, incredible," Hawke says. For a previous screen partner, Winona Ryder, Hawke has only praise: "Winona has really good instincts. You've got to hand it to her, *Reality Bites* is solely a product of her wanting to make a movie about her contemporaries. She is wildly successful, a millionaire," he exclaims. "Winona talked me into it. She really wanted to make the film."

Hawke's feathers get ruffled when I suggest that the characters in *Reality Bites* are more formulaic stereotypes – as has often been written in reviews – than accurate characterisations. "People say they tried to Hollywood-ise *Slacker* too, but I know how genuine that film is, and I know that it's just not true. People say things like that just to belittle a film. If I say that you're just another Australian, I'm belittling you as a human being and it's the same to say that *Reality Bites* is a formula. It's a totally non-narrative movie. It's a really good movie."

Shrinking from 'generation X' and 'slacker' labels to describe his role in *Before Sunrise*, Hawke points out that his character has a job and that the film has a universal rather than just generational theme. "It's an optimistic movie. It's about how you can meet somebody and share intimacy ... and how you can have an exchange of souls." Hesitant about the labelling frenzy that has accompanied the so-called X generation's documentation in the media, Hawke admits to being, "Very confused about it. The only thing I can see is people who are very unsure about the future".

Hawke is reluctant to talk about his career because "it changes from day to day", so we talk about everyone else's. He agrees that Ryder's recent success, like that of Keanu Reeves, stems from a wise choice of projects, and he sticks up for Reeves's much maligned acting talents. "A lot of people give Keanu Reeves a hard time but he's just proved himself again and again by sticking around and doing really good projects. Nobody has worked with better directors than Keanu Reeves."

Not that Hawke's choices have been so bad either. Before *Reality Bites*, he appeared in the plane-crash drama *Alive* and in *Dead Poet's Society*, the film that really jet-propelled his career.

continued page 116 ▶

28

photography david rose, austral

The dry, sultry ether of the mirage and the shifting horizons of heat and shadow imprint themselves upon the flesh of these photographs. For award-winning photographer, Kurt Markus, they are an ambling selection, not thematically constrained by the projections of the artist upon the subject. "What I respond to, apart from my own pictures, is what is direct, honest and straightforward. Trying to put on film what is in front of you rather than what is in your head. I haven't spent my life photographing nudes. In that sense these pictures aren't a significant body of work. They're just some pictures I've done, and that I enjoyed doing."

TEMPER SMITH

Thus Kurt Markus brings an objectivity to the American West - even though he was born and raised there - which removes it from more familiar terrain. His published photos are included in two volumes intriguingly titled, *After Barbed Wire* and *Buckaroo*. "I worked for a horse magazine for ten years," he says in his pensive, gentle drawl, "and in that time I did a lot of pictures of ranches. Some of these photos were taken in Australia, some in Santa Fe and some close to where I live. I guess you never fully escape who you are. Originality is to do with your own world. If you try to compare it to others you will always be at a loss."

nting and objectivity is also displayed in Markus's
the nude. "Clothes can be more descriptive at times
de form. I don't think that just by removing clothes
some sort of truth. I think you can get at some sort
that isn't being obstructed by clothes, especially
aren't the person's clothes. Maybe these pieces are a
ainst doing fashion pictures, where you never believe
hes the girl is wearing are her own."

MARKUS

In effect, Kurt Markus seeks to capture his subjects as they appear rather than searching for an unseen aspect of a model or the landscape. The eyes obscured by shadow and the play of natural forms upon the body are enough to create the drama, resulting in a serenity and languid poise that would evade a more temporal artist. ➔

104

photographer Kurt Markus

pages 50-51 ➤

Arena

art director 1, 2, & 3 Sam Chick
 4 Grant Turner
designer 1 & 4 Grant Turner
 2 Sam Chick
 3 Marissa Bourke
editor 1 David Bradshaw
 2 Kathryn Flett
 3 & 4 Peter Howarth
publisher Wagadon
origin UK
dimensions 230 x 335 mm
 9 x 13¹/₈ in

GREY BOY FROM SOFT CLASSROOM CHARCOAL TO SPACE-AGE SILVER: TONES OF GREY PUT BLACK IN THE SHADE

50

1

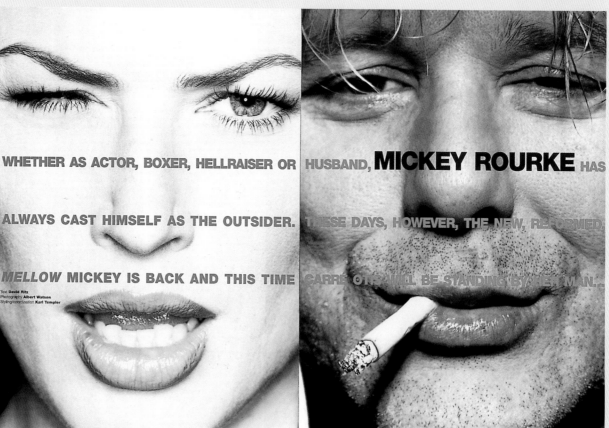

WHETHER AS ACTOR, BOXER, HELLRAISER OR HUSBAND, **MICKEY ROURKE** HAS ALWAYS CAST HIMSELF AS THE OUTSIDER. THESE DAYS, HOWEVER, THE NEW, REFORMED, MELLOW MICKEY IS BACK AND THIS TIME CARRE OTT WILL BE STANDING BY HIS MAN...

Text **David Ritz**
Photography **Albert Watson**
Styling/coordination **Karl Templer**

2

Story **Ekow Eshun**
Photography **Jake Chessum**

THE ARENA PROFILE

Weary, hooded eyes blinking hesitantly, Spike Lee seems to feel himself assailed. Assaulted. He yawns, clearly wishing that it would end, this thing of being »

ARENA 113

3

COCAINE

Story **Gareth Grundy** Photography **Mark Mattock**

COCAINE

WHITE LIES
COCAINE HAS A GLAMOROUS IMAGE: IT'S FUN, NON-ADDICTIVE AND THE PRESERVE OF THE GLITTERATI. HOW WRONG CAN YOU BE...

COCAINE: STUDIO 54 and Disco in the Seventies, yuppies and the City in the Eighties. The preserve of vapid soap stars and over-paid footballers in the Nineties... stand up Daniella Westbrook and Paul Merson. A narcotic for those with bursting bank balances and inflated egos – the glamour drug, right?

Oh no. Cocaine use has changed drastically over the last few years. Its aura of exclusivity has faded and any talk of *Scarface* and Colombian crime lords belongs to a bygone age of pastel suits and loafers without socks. It never left the showbiz and media

worlds, of course, and many gigs and launches still run on the stuff, but somehow it's become mundane. You're just as likely to find a wrap and a rolled-up tenner on an estate agent in Cheam as on a stockbroker in the Square Mile.

"There's definitely an increase in cocaine use in this country," says a spokesman for Cocaine Anonymous. "That's based on calls to our helpline increasing 300 per cent over the last year. We now get over 300 calls a month. We're beyond that city-slicker cliché about it, just by seeing the cross-section of society that turns up at

68 ARENA

ARENA 69

4

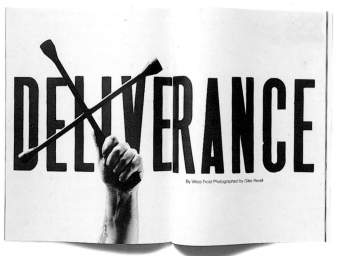

photographer Giles Revell

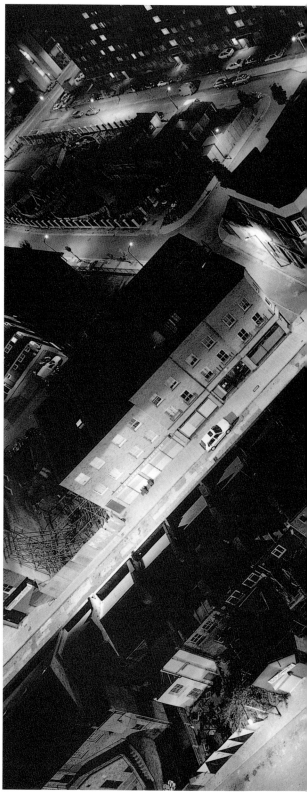

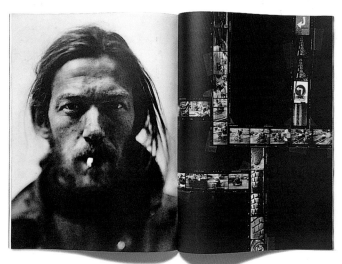

photographer Giles Revell

pages 52-5

Big Magazine

art director Vince Frost @ Frost Design
 designer Vince Frost @ Frost Design
 editor Marcello Jüneman
 publisher Marcello Jüneman
 origin UK
 dimensions 420 x 594 mm
 16¹/₂ x 23³/₈ in

photographer Alan Delaney

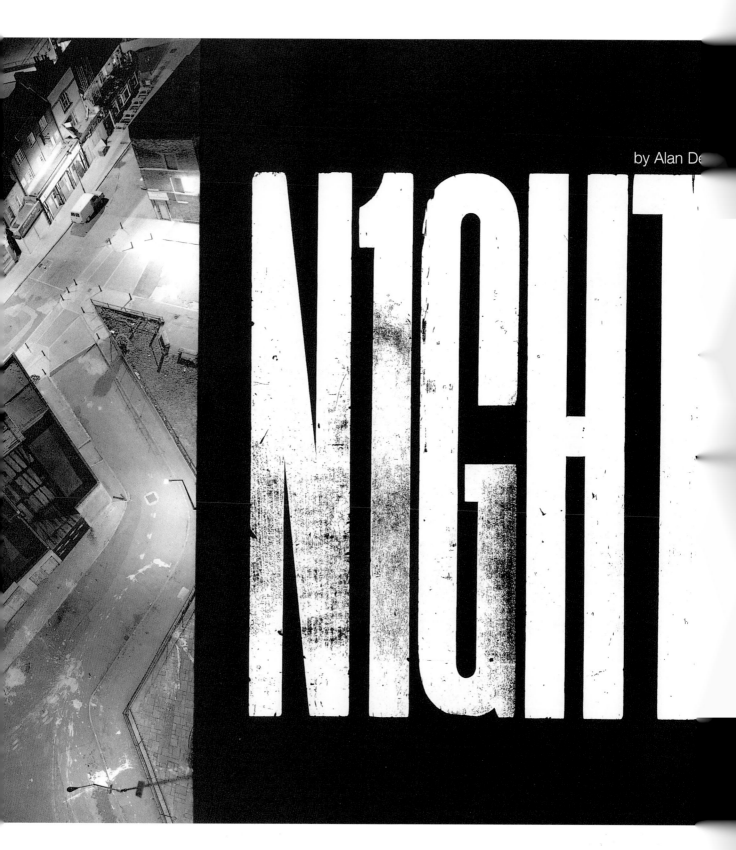

N1GHT

by Alan De

54

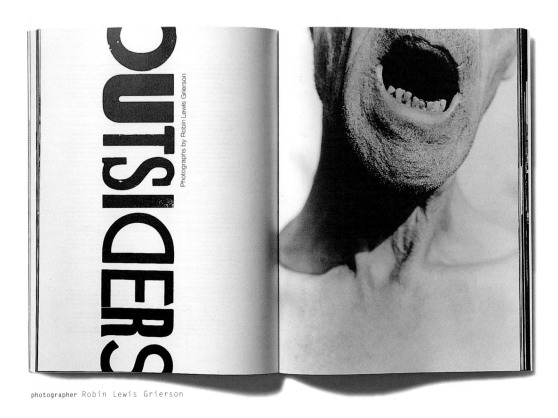

UTSIDERS

Photographs by Robin Lewis Grierson

photographer Robin Lewis Grierson

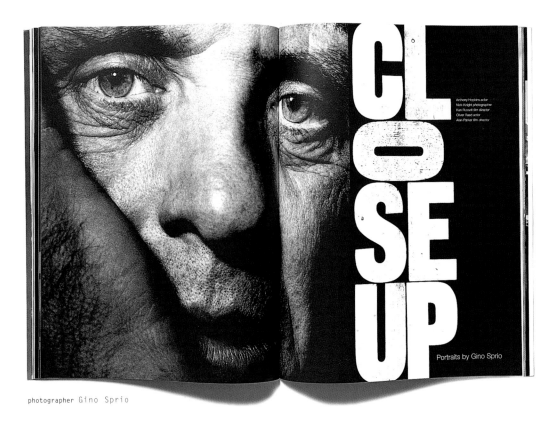

CLOSE UP

Anthony Hopkins actor
Nick Knight photographer
Ken Russell film director
Oliver Reed actor
Alan Parker film director

Portraits by Gino Sprio

photographer Gino Sprio

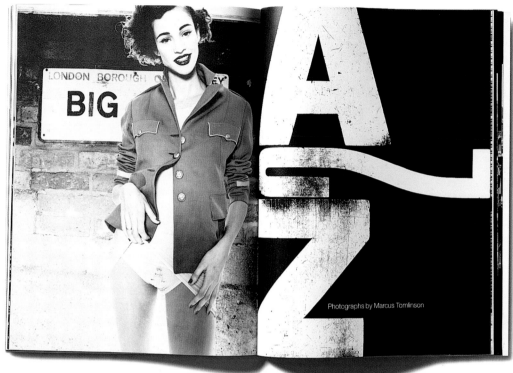

Photographs by Marcus Tomlinson

photographer Marcus Tomlinson

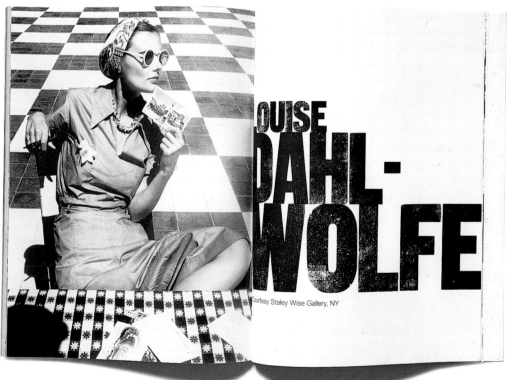

LOUISE DAHL-WOLFE

Courtesy Staley Wise Gallery, NY

photographer Louise Dahl-Wolfe

the **BERLAGE** papers **17**

13.00 hrs.

The springboard in the Pond | Disclosure unbuckled, unbuttoned & unzipped | The immaculate beyond appearances

L E C T U R

Wednesday 7 February | Wednesday 28 February | Wednesday 13 March
Jos Bosman | Prinzgau & | Joep van Lieshout
Zürich | Podgorschek | Rotterdam

All Public Events take place at the Berlage Institute, IJsbaanpad 1E (entry via main entrance former Orphanage) Lectures will be held in English. **Admission is free.** *Bookshop Architectura et Natura (Amsterdam) will be present with their bookstand The programme is subject to change.*

For more information: phone 31-20-6755393 fax 31-20-6755405 E-mail Berlage@xs4all.nl

the **BERLAGE** institute **AMSTERDAM** Postgraduate **School of Architecture**

photographer Topografische Dienst Emmen

page 56

Berlage Papers

art director Arlette Brouwers
designers Arlette Brouwers
Koos van der Meer
editor Marijke Beek
publisher The Berlage Institute,
Amsterdam
origin The Netherlands
dimensions 297 x 297 mm
11³/₄ x 11³/₄ in

the **BERLAGE** papers **16**

page 57

Design

art director Quentin Newark
designer Glenn Howard
photographer/ Roger Taylor
illustrator
editor David Redhead
publisher ETP Publishing
origin UK
dimensions 230 x 280 mm
9 x 11 in

photographer Hélène Binet

Business & Industry

Education & Training

The Sound of *design*

International Typeface Corporation

Volume 21 Number 4 Spring 1995 $5.00 U.S. $9.00 AUS

background art Tomato

Upper and
Lower Case

The
International
Journal
of Graphic
Design
and Digital
Media

International
Typeface
Corporation

Volume 22
Number 1
Summer 1995

$5.00 U.S.
$9.90 AUD
£4.95

illustrator J. Otto Seibold

U&lc

art director Rhonda Rubinstein
designer Rhonda Rubinstein
editor Margaret Richardson
publisher International Typeface
Corporation
origin USA
dimensions 279 x 375 mm
11 x 14³⁄₄ in

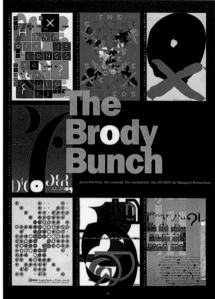

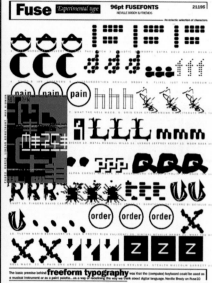

images Fuse

Neville Brody,

the British designer, is an original and a controversial visionary. He has achieved a reputation for innovative, edgy design with strong concepts, vivid color and dramatic typography. In fact, Brody's signature style is based on his improvisational use of type. Known for his early work on magazines like The Face and Arena and for music industry graphics with hand-drawn, illustrative and expressive headlines and lettering, he is now committed to transforming digital design. Essentially, Brody's vision is to create a new visual language for the screen.

When Brody was 30, The Graphic Language of Neville Brody (written by Jon Wozencroft and designed by Brody) was published. It was widely reviewed both for Brody's glowing visuals and for Wozencroft's lofty text and has sold 60,000 copies to date. Brody was also honored by an exhibition of his work at the Victoria and Albert Museum in London which then travelled to Edinburgh, Berlin, Hamburg, Vienna and Tokyo.

This acclaim did not bring Brody more clients or financial reward in England, so he moved into an international sphere with clients in Europe, America, and Japan, creating stamps for Dutch Telecom, PTT; a graphic identity for ORF, the Austrian state broadcasting company; Nike ads for Wieden and Kennedy in the States, and projects for the Parco Department Store in Tokyo. These undertakings and a plethora of other designs are documented in The Graphic Language of Neville Brody 2, again by Brody and Wozencroft, which was published last September by Thames and Hudson. The book follows Brody's research and development of digital forms and theories on design articulated by Wozencroft and inspired by advances in computer technology. Well represented in the book is Fuse, an interactive magazine conceived by the Brody Studio in 1990 and published by FontShop International.

Fuse isn't about trying to disintegrate language. The language is already in disintegration and Fuse is about focusing on that.

FUSE4 EXUBERANCE UCK ¾ PRETTY RICK VALICENTI, FUSE3 DISINFORMATION DEAR JOHN BARBARA BUTTERNICK, FUSE2 DISINFORMATION INTEGEL MARTIN WENZEL, FUSE3 EXUBERANCE LUSHUS JEFFREY KEEDY, FUSE10 FREEFORM FREEFORM NEVILLE BRODY (OPPOSITE), FUSE10 FREEFORM ROBOTNIK CORNEL WINDLIN, FUSE10 FREEFORM MUTOID JOHN CRITCHLEY.

Fuse is a quarterly award-winning magazine "that explores new ideas about typographic and visual language in the digital realm" which arrives as a disk, four posters and an analytical critique from editor Wozencroft, in a corrugated paper box. Each Fuse issue has a theme interpreted by four commissioned designers who are asked to experiment with type. This is not type for the printed page, although the posters (as seen here) show the Fuse fonts in use. Fuse is intended for the computer screen where the viewer can modify the fonts.

The themes of Fuse indicate the exploratory nature of the project. Fuse topics include "Invention," "Disinformation," and "Religion"; the newly released Fuse11 deals with pornography. Fuse contributors invent fonts related to these themes that are digital, interpretive and malleable. Brody and Wozencroft (and John Critchley at Brody's Research Studio, who handles the production) perceive the alphabet and type as culturally and emotionally charged icons rather than a static rendering of 26 letters. As Wozencroft puts it, "Fuse is a brave attempt to merge graphic arts, popular culture and philosophy."

Brody believes that rapid technological change (especially in advances in computer technology and software over the last five years) demands a reformulation of design precepts and practices. Using the analogy of the impact of photography on traditional painting and the resultant transition to abstract art, Brody posits that a design revolution triggered by dramatic changes in computer technology has just begun.

Brody himself relates to the computer as an art medium, and with it he has created painterly, digital, amorphous shapes based on letterforms (and has inspired others to create radical typefaces) which have been both lauded and criticized for their abstract or freeform qualities. These experiments receive more scrutiny than Brody's sharp, incisive type treatments for print and screen, because they embody his theories of melding form and content. Pushing the limits of typography for the screen, he feels, is the major role of Fuse and its contributors.

Fuse is definitely a part of Brody's future agenda (Fuse12 is on propaganda) as is his involvement with FontWorks, FontShop International, and his own experiments with typographic forms. He will also continue his international projects, focus on electronic design and develop a CD-ROM and publishing company in England through Digitalogue in Tokyo. Three of his imminent CD-ROM projects are The Graphic Language of Neville Brody 2, Fuse 1-10 and the CD-ROM version of the Fuse94 conference.

images Fuse

60

Mr. Lunch encounters bloodless pigeons in 'Canoe'...

Out to Lunch

J. OTTO SEIBOLD'S ILLUSTRATIONS ARE WEIRD–AND WIRED
BY JOYCE RUTTER KAYE

"Hel-lo?!!"

J. Otto Seibold doesn't merely answer the phone, he *chortles* a salutation in a comical falsetto that could easily belong to a near relative of Crusty the Clown. Should you get his answering machine, you will likewise hear a recording of Seibold shouting the regrets of his absence from a very remote distance.

Welcome to JOTTOWORLD,

a very all-caps universe which exists in Seibold's imagination and in the San Francisco studio the illustrator shares with his wife and collaborator, author Vivian Walsh and their two young daughters. JOTTOWORLD's chief export to the real world is a series of hip, hyperkinetic children's books published by Viking, in which space monkeys head up big corporations and bird-chasing dogs become overnight TV celebrities. Seibold and Walsh join Viking's notable roster of writer/illustrators creating kids' books with a postmodern sensibility, including Maira Kalman (The *Max* Series), Steven Guarnaccia (*Blockheads*), Richard McGuire (*The Orange Book*) and Lane Smith with Jon Scieszka (*The Stinky Cheese Man and Other Fairly Stupid Tales*).

Talking with Seibold about his work is rather like flying a kite in high wind: you want to rein him in a bit, but not pull him down to earth. Colleagues say that's just the sort of tethering Walsh provides. Her straight-faced writing is a soothing contrast to Seibold's chaotic layouts; her style also sends up the absurdity of the books' plots. This balance works. Their first book, *Mr. Lunch Takes a Plane Ride* (1993), which traces the adventures of a plucky dog who enjoys fame as a professional bird chaser, sold 15,000 copies (after an original printing of 10,000 copies). This success is likely to be matched by their 1994 follow-up, *Mr. Lunch Borrows a Canoe*. Their newest book, *Monkey Business*, is due out this fall.

On the page, Seibold's energy is unrestrained. Stylistically, his illustrations borrow the iconog-

...and gleefully chases them to the rafters

illustrator J. Otto Seibold

illustrator J. Otto Seibold

World Art

art director	Terence Hogan	publisher	Ashley Crawford
designer	Terence Hogan	origin	Australia
editors	Ray Edgar	dimensions	245 x 265 mm
	Sarah Bayliss		9⁵⁄₈ x 10¹⁄₂ in

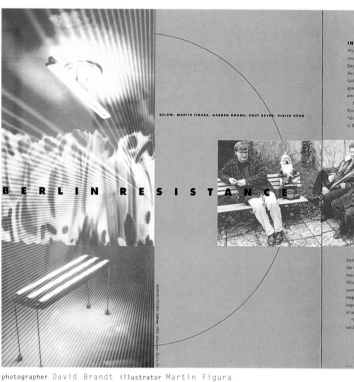

BELOW: MARTIN FIGURA, GARDEN GNOME, KNUT BAYER, ULRICH KÜHN

B E R L I N R E S I S T A N C E

IN 1990, three East Berlin artists began showing at Wewerka and Weiss, a young West Berlin gallery and one of the few exploring the neoconceptual installation art taking over Europe and New York. Knut Bayer, Martin Figura, and Ulrich Kühn were noted figures on the Berlin scene: as artists, and also as the principals of the Shin Shin Gallery in the *Mitte* section of East Berlin, an influential exhibition space supporting the conceptually inspired work that was percolating around the Berlin Hochschulen that the three had recently attended.

At that time, *Selbsthilfe* (co-operative run) galleries like the Shin Shin were typically Berlinish – reflecting the politically progressive, "alternative," and activist tendencies of the people who chose to live in the walled city. Its three proprietors were inspired by their teacher Karl Horst Hoedicke, a painter of the "Wild" Neoexpressionist generation, who ran a celebrated *Selbsthilfe* gallery back in the '70s along with Mar-

Shin Shin in 1989, we were thinking about appropriation art and the '80s discourse around postmodernism much more than we were thinking about '70s Conceptual art. We were interested in the idea that every formal solution has already been invented, so that all styles from all eras were equally available to an artist. Wild Painting was no longer a force – but artists in Berlin knew very little about such ideas. Berlin was isolated by its political-geographical position, and functioned culturally as an island.

"There was a generation that was developing in relation to the neoconceptual art that one might find in the centers," he adds. "Critics like Thomas Wulffen and Marius Babius served an important role. We were also involved in developing this context."

Today the formerly dark and closed streets of Berlin's *Mitte* are frenetic with activity, and lit with commercial neon and street lights. *Mitte* is the site of one of the fastest-moving real estate markets in Western Europe, as this once-ruined neighborhood is being over-

In a city where painting remains a historically loaded medi[um] three Berlin artists have rejected the dominance of Conceptual and returned to paint and canvas. Claudia Hart reports on a m[ove] ment that seems calculated to offend avant-garde sensibili[ties]

kus Lüpertz and Helmut Middendorf.

The younger trio's 1991 collaborative artwork at Wewerka and Weiss consisted of a site-specific multilayered wall drawing. Each layer was conceived and made by one of the three artists, collectively suggesting a type of aesthetic conversation between sympathetic individuals rather than a synthesized work. While Kühn's text-based work appeared to respond to the open-ended poetics of Lawrence Weiner, Figura's drawing was more historically inspired – by Italian Renaissance architecture, and by the wall-drawings of Sol LeWitt. Bayer's images, on the other hand, used silhouettes of mechanically drawn figures to create a language of signs.

"If Martin was LeWitt, Knut was more Marcel Broodthaers," Kühn said recently. Speaking of their gallery, he says, "when we started

taken by the noise of razing and reconstruction. Although the Shin Shin Gallery closed in 1992, the style of language-based Conceptual and installation art that it cultivated can be found in all of the young galleries and *Kunstvereine* that had sprouted up in *Mitte* like mushrooms after rain.

AN ISLAND in the Socialist East, the GDR's Berlin was neither restored after World War 2 nor rebuilt in solid granite along late-Bauhaus lines like West Germany. Instead it seemed to be filled with the flimsiest forms of post-War prefabricated architecture. In summer, the gray city is dense with trees filling holes in the urban tissue where houses, destroyed by bombing, have left gaps. Very few bourgeois were drawn to such an environment, so Berlin's population attracted many "alternative types." As a result, there have been few art collectors in Berlin – and, until recently, the art scene has

WORLD ART

photographer David Brandt illustrator Martin Figura

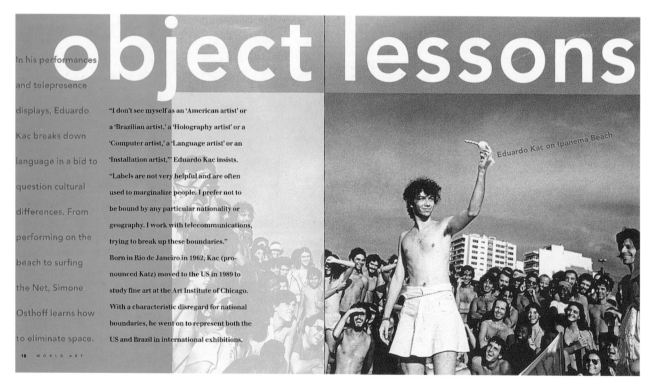

object lessons

Eduardo Kac on Ipanema Beach

In his performances and telepresence displays, Eduardo Kac breaks down language in a bid to question cultural differences. From performing on the beach to surfing the Net, Simone Osthoff learns how to eliminate space.

"I don't see myself as an 'American artist' or a 'Brazilian artist,' a 'Holography artist' or a 'Computer artist,' a 'Language artist' or an 'Installation artist,'" Eduardo Kac insists. "Labels are not very helpful and are often used to marginalize people. I prefer not to be bound by any particular nationality or geography. I work with telecommunications, trying to break up these boundaries." Born in Rio de Janeiro in 1962, Kac (pronounced Katz) moved to the US in 1989 to study fine art at the Art Institute of Chicago. With a characteristic disregard for national boundaries, he went on to represent both the US and Brazil in international exhibitions.

21C

art director Christopher Waller
designer Christopher Waller
editors Ashley Crawford
Ray Edgar

publisher Ashley Crawford
origin Australia
dimensions 245 x 265 mm
9⁵/₈ x 10¹/₂ in

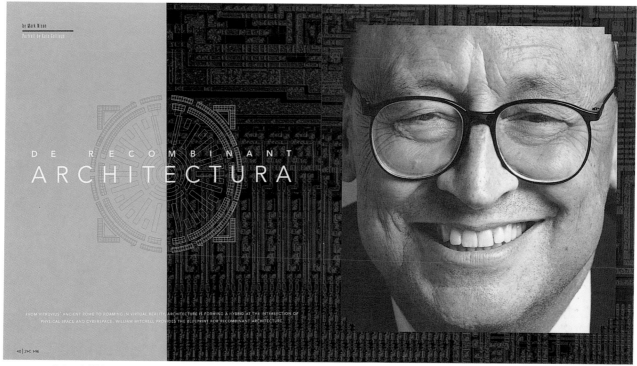

photographer Kate Gollings

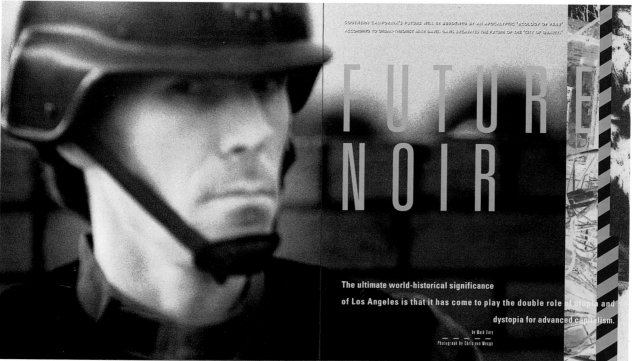

photographer Chris Von Menge

pages 64-5

Eventual

art director
Nina Rocha Miranda
designer
Nina Rocha Miranda
photographer/illustrator
Nina Rocha Miranda
editor
Lauro Cavalcanti
publisher
O Paço Imperial
origin
Brazil
dimensions
280 x 400 mm
11 x 15³/₄ in

64

EVENTUAL
DEZEMBRO 1995 NÚMERO 1

O PAÇO
REVISITADO

O PAÇO
REVISITADO

UM
DEPOIMENTO

JOAQUIM FALCÃO

JOAQUIM FALCÃO

PAULO SERGIO
DUARTE

8

9

O CENTRO

AUGUSTO IVAN DE FREITAS PINHEIRO

12

13

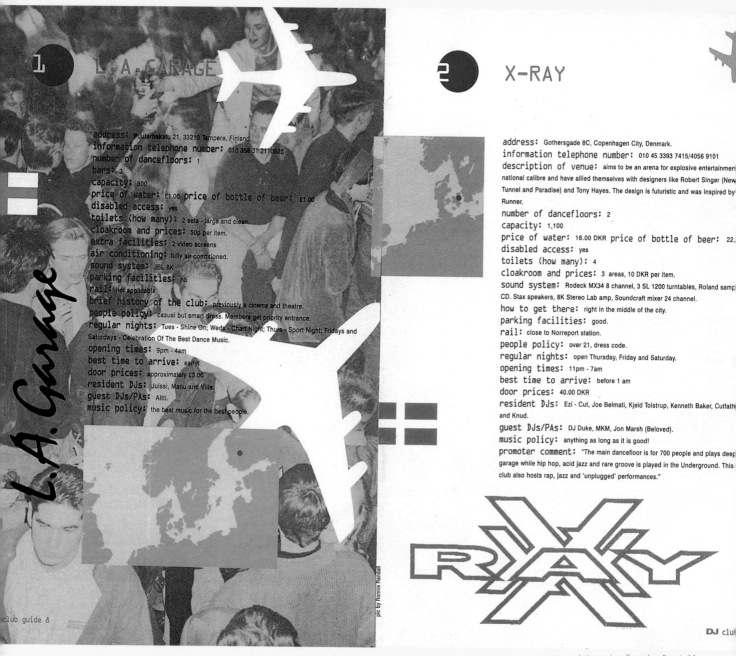

1 L.A.GARAGE

address: Puutarhakatu 21, 33210 Tampere, Finland.
information telephone number: 010 358 31 2110525
number of dancefloors: 1
bars: 3
capacity: 800
price of water: £1.00 **price of bottle of beer:** £1.00
disabled access: yes
toilets (how many): 2 sets - large and clean.
cloakroom and prices: 50p per item.
extra facilities: 2 video screens
air conditioning: fully air conditioned.
sound system: JBL 8K
parking facilities: no
rail: not applicable.
brief history of the club: previously a cinema and theatre.
people policy: casual but smart dress. Members get priority entrance.
regular nights: Tues - Shine On; Weds - Chart Night; Thurs - Sport Night; Fridays and Saturdays - Celebration Of The Best Dance Music.
opening times: 9pm - 4am
best time to arrive: early!
door prices: approximately £3.00
resident DJs: Juissi, Manu and Ville.
guest DJs/PAs: Altti.
music policy: the best music for the best people.

club guide 8

pic by Ronnie Randall

2 X-RAY

address: Gothersgade 8C, Copenhagen City, Denmark.
information telephone number: 010 45 3393 7415/4056 9101
description of venue: aims to be an arena for explosive entertainment national calibre and have allied themselves with designers like Robert Singer (New Tunnel and Paradise) and Tony Hayes. The design is futuristic and was inspired by Runner.
number of dancefloors: 2
capacity: 1,100
price of water: 16.00 DKR **price of bottle of beer:** 22.
disabled access: yes
toilets (how many): 4
cloakroom and prices: 3 areas, 10 DKR per item.
sound system: Rodeck MX34 8 channel, 3 SL 1200 turntables, Roland samp CD. Stax speakers, 8K Stereo Lab amp, Soundcraft mixer 24 channel.
how to get there: right in the middle of the city.
parking facilities: good.
rail: close to Norreport station.
people policy: over 21, dress code.
regular nights: open Thursday, Friday and Saturday.
opening times: 11pm - 7am
best time to arrive: before 1 am
door prices: 40.00 DKR
resident DJs: Ezi - Cut, Joe Belmati, Kjeld Tolstrup, Kenneth Baker, Cutfath and Knud.
guest DJs/PAs: DJ Duke, MKM, Jon Marsh (Beloved).
music policy: anything as long as it is good!
promoter comment: "The main dancefloor is for 700 people and plays deep garage while hip hop, acid jazz and rare groove is played in the Underground. This club also hosts rap, jazz and 'unplugged' performances."

DJ clu

photographer Ronnie Randall

pages 66-7

Euro Club Guide
supplement of DJ Magazine

art director Michèle Allardyce
designer Michèle Allardyce
editor Christopher Mellor
publisher Nexus Media Ltd
origin UK
dimensions 148 x 230 mm
5⅞ x 9 in

CAFE DE PARIS

address: Cafe De Paris, 3 Coventry Street, London, W1.
information telephone number: 071 287 0503
description of venue: historical ballroom.
number of dancefloors: 2
capacity: 700
price of water: £1.50 price of bottle of beer: £2.60
disabled access: no.
toilets (how many): enough for no queueing.
cloakroom and prices: 80p per item.
extra facilities: ice creams and food available.
sound system: main room 15K, small room 2K.
how to get there: in the heart of London in between Leicester Square and Piccadilly Circus.
parking facilities: car parks in the vicinity.
rail: British Rail at Charing Cross, nearest underground stations are Leicester Square and Piccadilly Circus.
air conditioning: yes.
people policy: people that come out for a good night without attitude.
regular nights: Saturday - Release The Pressure; Tuesday - Red Hot.
opening times: 10pm - 6am
best time to arrive: before 10.30pm
door prices: members £10.00, non-members £12.00; after 3am entry is £5.00
resident DJs: Ricky Morrison, Jazzy M, Dean Savonne, Dana Down, Marcus, Paul Tibbs, Danny Foster, Chris Mayes, Sammy (Toto), Sarah Chapman.
guest DJs/PAs: CJ Mackintosh, Frankie Foncett, Benji Candelario, Roger Sanchez, Kenny Carpenter, DJ Pierre, Femi B, Ralf, Phil Asher, Simon Aston, Rob Acteson, Ricky Montanari, Flavio Vecchi, Danny Morales, DJ Disciple, Claudio Cocolutto, Kevin Saunderson.
music policy: US garage house in the main room and soul funk party classics in the small room.
club anthem: Nightcrawlers 'Push The Feeling On'
DJ/promoter comment: "Tuffest US club in the UK." Ricky Morrison. "Most beautiful club experience in the UK." Kenny Carpenter.
punter/industry comment: "The music's rocking and you haven't failed us yet." Andrew & Louise from Essex. "The best DJs playing excellent house and garage. They have a special vibe of their own." Nigel Wilton, Sony Music.

pic by Daniel Newman

CLUB UK

address: Buckhold Road, Wandsworth, London, SW18 4TQ.
information telephone number: 081 877 0110
description of venue: 3 rooms with a total of 12 DJs per night.
number of dancefloors: 3
price of water: £1.50 price of bottle of beer: £2.50
disabled access: wheelchair ramps and lifts.
capacity: 'loads'
toilets (how many): women - 2 , men - 2
cloakroom and prices: 2 cloakrooms, £1.00 per item.
extra facilities: chill out with food available.
sound system: total for all 4 rooms is 35K.
how to get there: closest tube is East Putney (District line). British Rail - Wands Town. Buses stopping nearby - 28, 39, 44, 77A, 156, 270. Night Buses - N68 & N88.
parking facilities: free NCP nearby.
brief history of the club: opened in July 1993, the club was the venue fo BBC's Dance Energy and for BPM.
people policy: dress to club, no blaggers, no bores, no bullshit, no bad attitude, n bird brains, no bitchiness and no plebs.
regular nights: Friday - Final Frontier; Saturday - Club UK.
opening times: 10pm - 6am
best time to arrive: before midnight.
door prices: Friday - members £7.00 before 11 pm, non-members £9.00; after 11 p members £9.00, non-members £11.00; Saturday - members £10.00, non-members £12.00; 3 am £6.00
resident DJs: none as such but regulars are Danny Rampling, Judge Jules, Dean Thatcher, Roy The Roach, Fabi Paras, Dominic Moir, Steve Proctor, Steve Harvey.
guest DJs/PAs: Breeze, Terry Farley, John Digweed, Paul Oakenfold, Andy Weathe Darren Emerson, Brandon Block, Jeremy Healy, Kenny Carpenter and Biko.
music policy: Black Room - euro house and pumping house anthems; Pop Art Ro harder deep housey beats; Purple Room - ambient, classic club grooves.
club anthem: Dan Hartman 'Relight My Fire', Gat Decor 'Passion', OT Quartet 'Hold Sucker Down'.
DJ/promoter comment: "Ask anyone who comes down on a Saturday and 99% w you they've had an awesome time." Sean McClusky.
punter/industry comment: "As soon as you walk up the steps the buzz hits yo Steve Goddard.

DJ club guid

photographer Daniel Newman

Caffeine Magazine

art director Heather Ferguson
designer Heather Ferguson
editor Rob Cohen
publisher Rob Cohen
origin USA
dimensions 254 x 305 mm
 10 x 12 in

4 Four Stories of Warfare

by DAVID KENDRICK

THE 1 CANNERY

Bolus Muffins are widely regarded as the world's finest. The Bolus Muffin Cannery employs only those who truly enjoy the muffin flavor, for they make the most fastidious assemblers. Row upon row of canned muffin tins bounce by their assemblers, rejected tins are regulated by hand to a discard belt. From the quality of the batter to the glue on the label, everything is checked by hand keeping the quality second to none, a rigorous reputation well deserved. Packed six to a roll, already in a butter sauce pan, one pops open the tin, sets them out to dry, and a "surprisingly nutritious treat is ready to eat".

Old man Bolus' heart stopped one day, and immediately an intricate stock manipulation by a similar yet inferior family owned rival company, the Hogan Company, allows them to take over the cannery. They install their own son, Larry, as supervisor and change the company name to the "Hogan Bolus Muffin Tinnery". Old man Bolus' three sons are dismissed.

Larry the new reluctant supervisor takes long coffee breaks to make personal phone calls and to whistle at girls on the street down below. The stubble from his beard alarms safety lights shinning bright as he strolls through the sterile packing rooms . Beneath his undershirt, woolen shoulder blades shed thick black strands as he walks the white paceways. And as he walks, Larry chews wads of gum that make fellow employees' jaw ache with reluctant admiration.

New employees must suffer through his lectures on safety. Frequently overzealous, he flings the new canners against buzzers to emphasize the hazards of misguided foot direction He times the muffins tinning with an electrical shock device. New secretaries are harassed as he interrupts business dictation's with unnecessarily long and verbally direct romantic innuendoes.

Larry's biceps are swollen from years of use. Rumors tell of him punching in low bars and behaving like a sailor or longshoreman around women. The whole Hogan family history is abusive.

Several employees tell the dead man Bolus' three sons of Larry's contemptible behavior. They decide to straighten Larry out after dark one night as a prelude to legal remanipulation. The three Bolus brothers wait for Larry to come out of a notorious dredge of a bar. They jump him and start punching but Larry flings them about like molding bricks. His fists, they fly like jets. The two youngest brothers are paralyzed and the third gains a lasting concussion from Larry's skilled dock-like muscle control.

Union regulations ensures cripples steady employment and the two paralyzed brothers are rehired as livid object lessons with wages reduced to a minute fraction. Larry uses them as a living examples after the safety slide lecture. The concussed Bolus brother will sit through many interpretive business history as Hogan's invest heavily in functional yet humanistic factory hallway art adorers.

THE 2 BATTLEFIELD

Soldiers often have bad dreams the night after a bloody battle. If one wakes suddenly and screams he may be killed by an enemy bullet. Smart soldiers will sleep in twos—one always keeping watch so no one jumps up during a nightmare. Some rope each other into fosholes. Others engage in brief yet torrid homosexual acts. Some bury themselves in the waist in loose combat dirt and others still will take stimulants to keep awake or drug themselves with muscle dissolves for a motion- free rest.

During basic training, soldiers are taught by film to recognize impending nightmares in their partners when they see thick glue-like tears seep from the corners of closed eyes. Then the trigger finger clenches, the aiming eye squints and the mouth draws tight in grin determination. On the other side of those closed eyes the sleeping soldier is most certainly emptying a full clip into a helpless prisoner of war, a parental substitute, a loved farm animal or wife. If soldiers have these dreams on maneuvers before they even see real warfare, they dishonorably discharged and given subscriptions to Soldier of Fortune.

THE 3 POSTMAN

Ludwig 2, a king wealthy through the inheritance of Bavaria walks through the outer gardens of Schloss Linderhof. Acres of chewed marble crunch beneath his feet. The further from the castle he walks, the finer the path gravel becomes, until there is only sand.

"Someone with heavy feet must be walking around out here! I will have my servants set deadly traps! Snake pits! Trip wires! Spikes and glass needles!"

Ludwig is almost back to the castle when a uniformed postman carrying a mountain of heavy packages does knock.

"I don't want any of them!" Ludwig shouts from behind a tree. "Servants , remove this postman!"

But the next day the postman returns with many more packages, unloading them from a heavy carriage.

"Take them away and do not come back!" Ludwig shouts, this time from the roof of the Moorish kiosk. He is robed in oriental garb yet hidden by the frills of an ornate tower.

"To have them removed you will have to sign tickets and later go out in public to the station, Your Highness, " the postman chuckingly grinds several large stones to dust.

Furious, Ludwig has more traps set. He will make sure the postman cannot return. Rare poisonous snakes are important. Fearful dragons are cast from precious metals. Exploding swans are placed in front pool.

"He will crunch my paths no more!"

The servants must also carve terrible mythical creatures from Corsican marble and wheel them upon immense log carts to all strategic points in the gardens. The pathways are dismissed to dust under the tonnage and the servants gathered fearfully in the basement, finding some small comfort in the common terror they all have of Ludwig's certain soon to be rising wrath.

The postman does not return. Ludwig never receives any mail for the rest of his life. His plan succeeds, but so

THE 4 MINER

Philbin Hartley was a chief technical engineer for operations on a particular deep mine shaft. Several times a day he was the victim of the never-ending pun, "Hey you, fill that bin," or one of its painfully derivations. Even as a child taking out the garbage bin, he had found the joke unamusing.

In addition to his job at the mine, he had invented and assembled a war machine, a powerful fast vehicle to be used once inside an enemy territory. A man could live in the machine for six months. Torpedo tubes and smaller weapons made it virtually unconquerable. He spent all his evenings working on a prototype now near completion in a laboratory beneath his house.

An enemy government learned of Philbin's machine through articles in science journals but as the printed story was altered to protect our security interest, Philbin was described as a "blind medical student" (Philbin was no blind medical student) who had completed work on a war machine of illimitable strength and fire power as a sort of summer hobby. A special task force was sent over to try and capture the machine intact. They planned on catching Philbin off guard by tunneling under his laboratory floor and just driving off with the machine in his spare time they found it foolish though admirable and intending on presenting him with an achievement award for the blind before they murdered him and stole the machine to use against his own kind in a war brewing even as this is written.

One fine summer evening Philbin's sensitive miner's ears accurately deciphered the hum of foreign drills. He prepared to depart in the nearly completed machine, leaving unmounted torpedoes for the enemy to explode. He placed the tips of the torpedoes in the direct path of their drill and estimated them reaching his lab in a few short hours.

He finished the machine and escaped perilously close to detonation time. Once out of town and danger, he realized his hunger. AS he drove he chewed half a Bolus Muffin, nothing a harrowed dog at the side of the road biting on a blowout. Philbin had stocked the vehicle with protein rich food and drink as well as several tins of local industrial muffins.

He was well up the side of Mount ST. Isabelle when the fuming panorama of the city materialized in the rear view mirror. Although the torpedoes had destroyed most of his home town, apparently he had not killed all the special task force. Refugees lined the roads. The enraged enemy agents had sacked the town and the loyal were fleeing. He did not stop for hitchhikers in fear of picking up an impostor. Philbin sped on steel jawed, summarily cursing the evil results of simple scientific curiosity.

At the crest of Mount St. Isabelle, land mines suddenly surrounded the vehicle. Enemy strafers fired machine gun rounds in great swooping arcs disappearing often to reload. The road ahead of him was blasted askew and Philbin squeezed around the exploding pavement surprising himself with brilliant evasive maneuvers. Momentarily he outdistanced the strafers and the machine was barely scratched. As he sped on, he wished he had had time to load the torpedo bins on the roof of the vehicle. Three strafers then appeared before him.

"But I didn't have time to fill the bins," he said, laughing at his own joke amidst the battle's revived smashing.

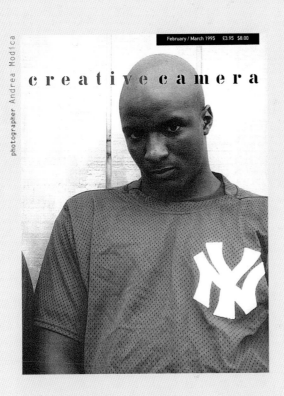

photographer Andrea Modica

February / March 1995 £3.95 $8.00

creative camera

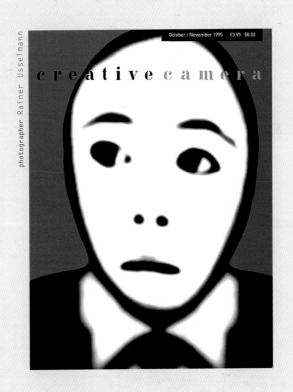

photographer Rainer Usselmann

October / November 1995 £3.95 $8.00

creative camera

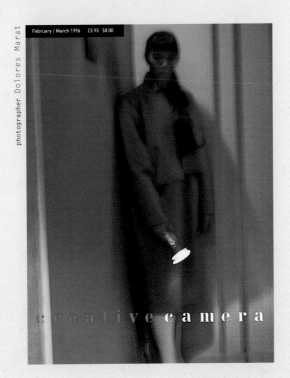

photographer Dolores Marat

February / March 1996 £3.95 $8.00

creative camera

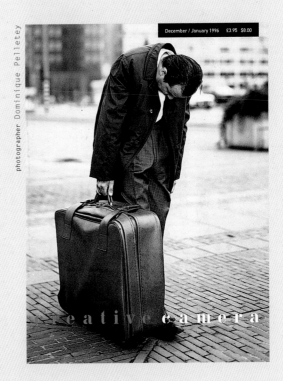

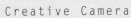

photographer Dominique Pelletey

December / January 1996 £3.95 $8.00

creative camera

Creative Camera

design consultant Phil Bicker
editor David Brittain
publisher Creative Camera
origin UK
dimensions 210 x 280 mm
8¼ x 11 in

pages 70-71

Creative Camera

design consultant Phil Bicker
editor David Brittain
publisher Creative Camera
origin UK
dimensions 210 x 280 mm
8¼ x 11 in

RAISED BY WOLVES

I Have 2 pairs of Black Jeans
"2 turtlenecks
1 long sleeve ac/dc tee shirt
. Long sleeve AC/DC
2 pair of shoes
& no Jacket !!! ☺
thats ALL _____ IS COLD in Hollywood

photographer Jim Goldberg

pages 72-3 ➤

Experiment

art directors Mike Lawrence
 Stephanie Tironelle
 Aaron Rose
designer Mike Lawrence
editor Stephanie Tironelle
publisher Stephanie Tironelle
origin UK
dimensions 203 mm diameter
 8 in diameter

 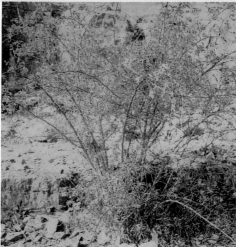

Knut Maron: Triptych – Anti-mountain. Burning bush, Hor

PREVIEW

The desert occupies a special place in European literature and art, but is especially seductive to camera users as diverse as Fredrick Sommer, Verdi Yahooda and Bill Viola

DESERT

DESERT IS AN EXHIBITION which surveys photographs of desert space, exploring its symbolic meanings and its significance as a site in which to consider the role of the image and the space of the photograph.

Drawing on work produced during the last 50 years, the exhibition spans differing visions of deserted space; the extremes being Frederick Sommer's Arizona landscapes and Thomas Ruff's night sky photographs. The majority of the artists, however, explore the deserts of North Africa and Arabia. These are the same places explored and charted by many of the nineteenth and early twentieth-century travellers and writers whose experiences and visions contribute to the image of the desert as a symbolic space within European culture.

The image of the desert created by many such writers was based, to a great extent, on a European Romantic view of the 'other' which, unfortunately, could not escape the infection of colonialism. The need to idealise nature, ancient beliefs and the exotic in many of these writings, therefore, speaks most loudly of Western desire. Others, however, explore the barren desert as a more complex and layered space, rich and fertile with other possible symbolic readings: the desert is a place of metaphysical experience; a melancholic space of indifference; a site of death, disappearance and dissolution; a landscape of grains that refuse to be fixed.

Some of these readings are touched upon by all the artists in *Desert*. For example, Hannah Collins' large scale desert photographs reveal the complex dynamic between the image and the real desert view. This is as

photographer Knut Wolfgang Maron

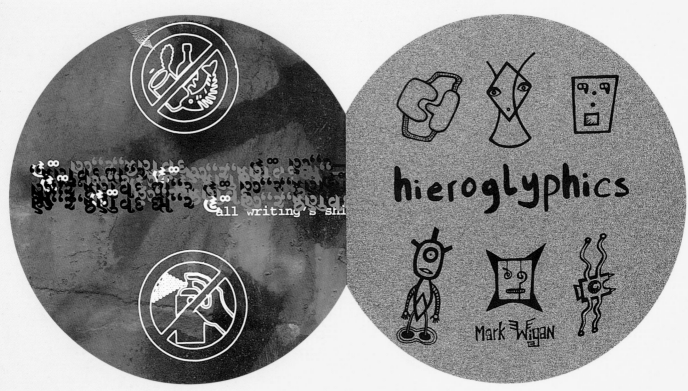

illustrator Mark Wigan

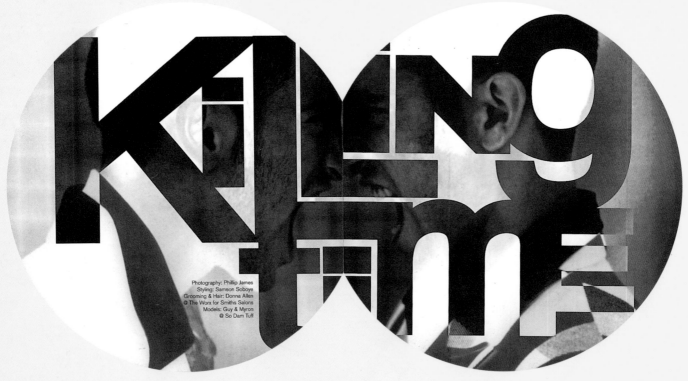

photographer Phillip James
stylist Samson Soboye

Photography + Artwork : Aaron Rose
Styling + Verse : Nicholas Griffiths
Hair and Make-up : Alex Babsky
Models : Charlie, Justin, Freddie, Jo, Gianne

POINT BLANK

photographer Aaron Rose

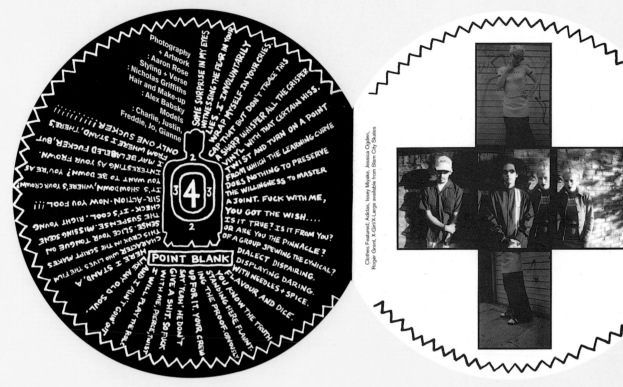

Clothes Featured; Adidas, Issey Miyake, Jessica Ogden, Roger Grant, X-Girl/X-Large available from Slam City Skates

...Photographer- Jane Mcleish. Stylist - Stephanie Tirolelle. Grooming - Tess. Models- Jamie and Michelle at Select, Suzanne, Emma, Aki, Flowerz and Junior. Many thanks to Laurent. a t-shirt is a t-shirt a t-shirt is a t-shirt

photographer Jane McLeish

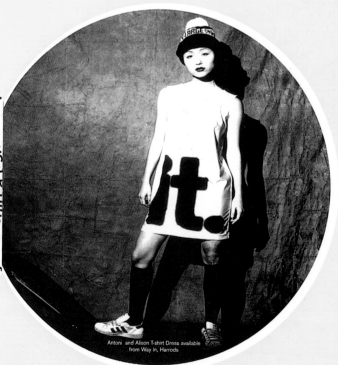

Antoni and Alison T-shirt Dress available from Way In, Harrods

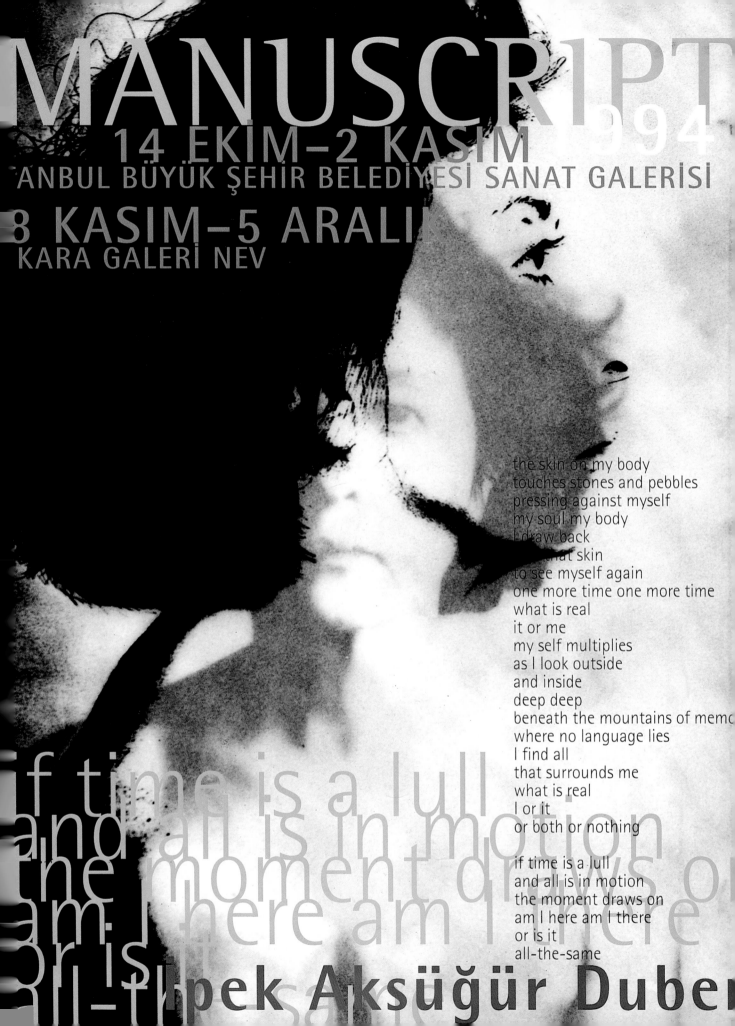

MANUSCRIPT 1994

14 EKİM–2 KASIM
ANBUL BÜYÜK ŞEHİR BELEDİYESİ SANAT GALERİSİ

8 KASIM–5 ARALIK
KARA GALERİ NEV

the skin on my body
touches stones and pebbles
pressing against myself
my soul my body
I draw back
that skin
to see myself again
one more time one more time
what is real
it or me
my self multiplies
as I look outside
and inside
deep deep
beneath the mountains of memo
where no language lies
I find all
that surrounds me
what is real
I or it
or both or nothing

if time is a lull
and all is in motion
the moment draws on
am I here am I there
or is it
all-the-same

İpek Aksüğür Dube

page 74

Manuscript

poster

art director
Gülizar Çepoğlu

designer
Gülizar Çepoğlu

artist
Ipek Aksüğür Duben

photographers
Ani Çelik Arevyan
Douglas Beube

origin
USA/Turkey

dimensions
480 x 620 mm
18⁷/₈ x 24³/₈ in

page 75

Manuscript

artist's book 1994

designer
Gülizar Çepoğlu

artist
Ipek Aksüğür Duben

photographer
Douglas Beube

origin
USA/Turkey

dimensions
220 x 285 mm
8⁵/₈ x 11¹/₄ in

Re taking London

art director	Blue Source
designers	Jonathan Cooke
	Steve Turner
	Mark Tappin
	Simon Earith
	Rob Wallace
	Danny Doyle
	Leigh Marling
editor	Blue Source
publisher	Blue Source
origin	UK
dimensions	480 x 480 mm
	18⁷/₈ x 18⁷/₈ in

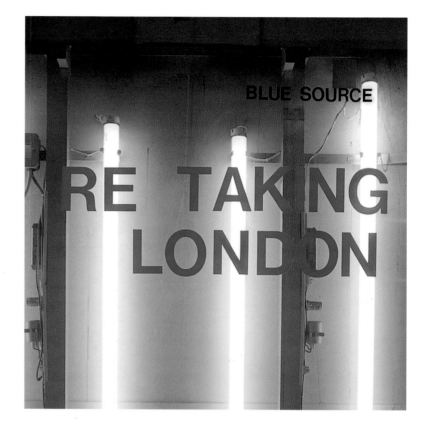

London Babylon

The Atoms of Democritus brought an A-bomb to Wardour street. And big bang in the City caused the flash to flaunt. So here we are immersed in the flurry of the fears. Our capital under siege.

London's calling "awake! awake! awake!" Why do you sleep the sleep of death and ban heart and spirit? Now time plays its trick. Once again the city is ours. Swagger and bowl, ready to receive the gifts of the city. Delight in its neon.

Down in the tube station at midnight. Near mournful, ever weeping Paddington. You hear the sound of London rumble through its veins.

From London Fields to Islington to the Ladbroke Grove. Underneath the Westway's golden arches the Regent's Canal shines upon the starry sky.

The martyred St. Pancras. Once torn apart by dogs now withered by the Kings Cross. Needle deep pox ridden whores. A McDonald's and a cab rank offer hope.

The Angel surveys the Screen On The Green. Where once was anarchy in the UK. Now candle light and ethnic antique seek sanctuary in the bubble of the bourgeoisie. Babylon burns at 40 watts and Newton's particles of light bring Crimson Joy to these Blair, and Blair about.

I give you the end of a golden string that leads to the dirty river. As long as you gaze on Waterloo sunset you are in paradise.

(William Blake 1757-1996)

photographer Rankin

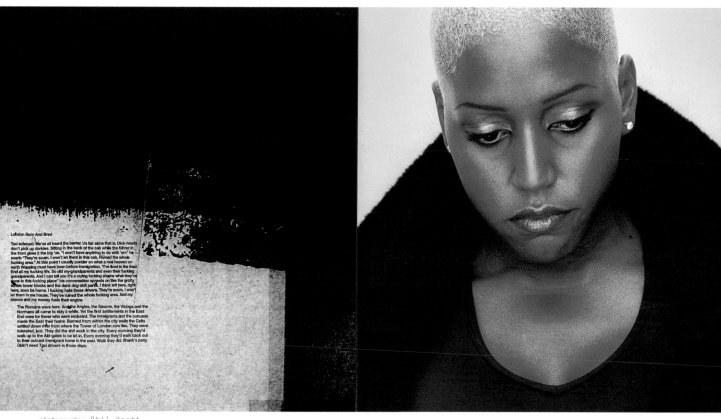

London Born And Bred

Taxi schmaxi. We've all heard the banter. Us fair skins that is. Dick-heads don't pick up darkies. Sitting in the back of the cab while the führer in the front gives it the big 'un. "I won't have anything to do with 'em" he snarls "They're scum. I won't let them in this cab. Ruined the whole fucking area." At this point I usually ponder on what a real heaven on earth Wapping must have been before immigration. "I've lived in the East End all my fucking life. So did my grandparents and even their fucking grandparents. And I can tell you it's a crying fucking shame what they've done to this fucking place" his conversation sprawls on like the grotty estate tower blocks and the dank dog-shit pants. I think left here, right here, soon be home. I fucking hate those drivers. They're scum. I won't let them in me house. They've ruined the whole fucking area. And my silence and my money fuels their engine.

The Romans were here. And the Angles, the Saxons, the Vikings and the Normans all came to stay a while. Yet the first settlements in the East End were for those who were excluded. The immigrants and the outcasts made the East their home. Banned from within the city walls the Celts settled down river from where the Tower of London now lies. They were tolerated, just. They did the shit work in the city. Every morning they'd walk up to the Ald-gates to be let in. Every evening they'd walk back out to their outcast immigrant home in the east. Walk they did. Shank's pony. Didn't need Taxi drivers in those days.

photographer Phil Knott

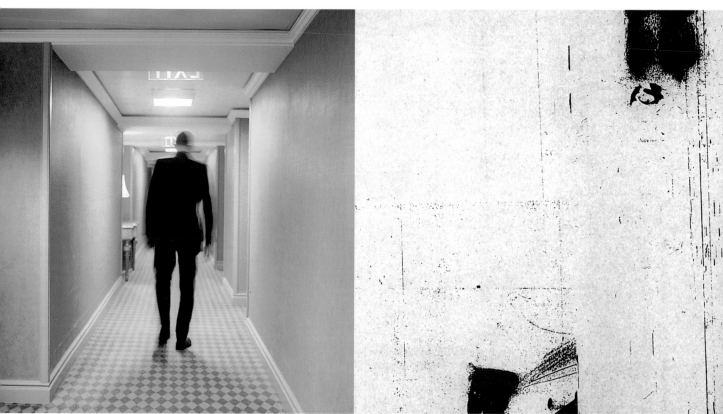

photographer Donald Milne

Shift!

postcards

art directors	Anja Lutz
	Lilly Tomec
designers	Anja Lutz
	Lilly Tomec
editors	Anja Lutz
	Lilly Tomec
publisher	Gutentagverlag/Shift!
origin	Germany
dimensions	148 x 105 mm
	5⁷/₈ x 4¹/₈ in

Typographic Fascism

art director	Chris Turner
designer	Chris Turner
photographer/	Chris Turner
illustrator	
publisher	unpublished
origin	UK
dimensions	297 x 420 mm
	11³/₄ x 16¹/₂ in

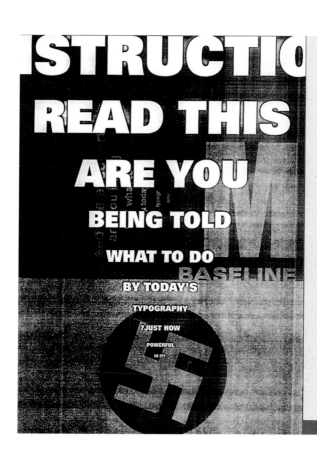

ISTRUCTIO

READ THIS

ARE YOU

BEING TOLD

WHAT TO DO

BY TODAY'S

TYPOGRAPHY

?JUST HOW

POWERFUL

IS IT?

BASELINE

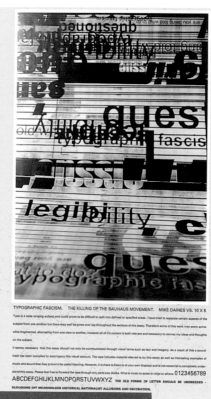

TYPOGRAPHIC FASCISM. THE KILLING OF THE BAUHAUS MOVEMENT. MIKE DAINES VS. 10 X 5

Type is a wide ranging subject and could prove to be difficult to split into defined or specified areas. I have tried to separate certain aspects of the subject from one another but there may well be some over lap throughout the sections of this essay. Therefore some of this work may seem somewhat fragmented, alternating from one view to another, however all of it's content is both relevant and necessary to convey my ideas and thoughts on the subject.

It seems necessary that this essay should not only be communicated through visual terms such as text and imagery. As a result of this a soundtrack has been compiled to accompany this visual account. The tape includes material referred to by this essay as well as interesting examples of music and sound that may prove to be useful listening. However, it is there to listen to at your own disposal and is not essential to completely understand this essay. Please feel free to forward the tape through any parts you dislike. What is music to some is noise to others. 0123456789

ABCDEFGHIJKLMNOPQRSTUVWXYZ THE OLD FORMS OF LETTER SHOULD BE UNDRESSED - SLOUGHING OFF MEANINGLESS HISTORICAL NATIONALIST ALLUSIONS AND DECORATION.

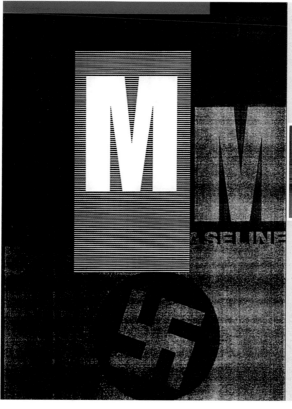

M

BASELINE

VACANCIES

Obituary) when confronted admit to not actually believing in or practising in any true forms of Satanic worship or the occult at all. In fact, most are completely atheist in nature. Nevertheless death metal has provided outrage in the home and Church to a point where many have taken the law into their own hands. Bands like Deicide have been terrorised by infuriated groups of vigilante Christians, often much more offensive that these bands could ever hope to be. Who is worse? What drives them to these extreme measures is there concern with music's power and subliminal qualities. Court cases have been brought agaist metal bands in recent years, useually to do with 'hidden messages' within the music. Either disguised within lyrics or more typically recorded backwards through the songs. These cases rarely have much standing in court and are often laughed out within a short period, but it shows that people are utterly convinced that music is so powerful that it can cause their would be happy children harm. These people are infatuated with their quest; they reach a point where they can hear whatever they want to in the music they dislike.Judas Priest (an ageing heavy metal band) were recently taken to court by the family of a boy who committed suicide, allegedly being under the influence of the band's latest album of the time. According to their reasoning, the family were convinced that when played backward, a certain song (apparently about suicide could be heard

"THE NEW TYPOGRAPHY IS NOT A FASHION"

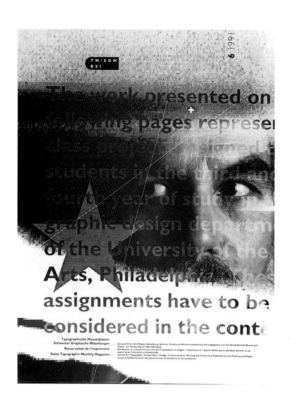

Typographische
Monatsblätter

art director	Jan C. Almquist
designer	Jan C. Almquist
photographer	Jan C. Almquist
editor	Hans-U Allemann
publisher	Printing and Paper Union
	of Switzerland
origin	Switzerland
dimensions	230 x 295 mm
	9 x 11⅝ in

below

Detail

designer	Delphine Cormier
college	Ecole Nationale Supérieure
	Des Arts Décoratifs, Paris
tutor	Philippe Apeloig
origin	France
dimensions	448 x 149 mm
	17⅜ x 5⅞ in

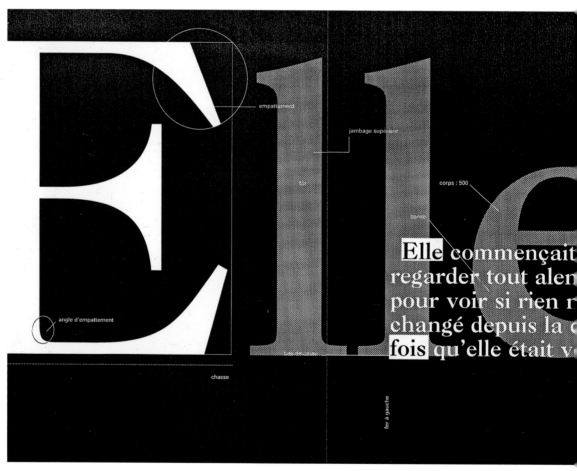

Bruitage

designer	Suzanne Markowski
college	Ecole Nationale Supérieure
	Des Arts Décoratifs, Paris
tutor	Philippe Apeloig
origin	France
dimensions	259 x 347 mm
	10¹/₄ x 13⁵/₈ in

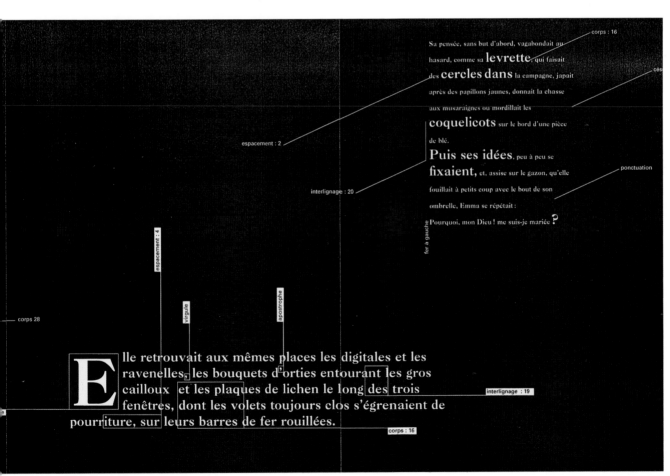

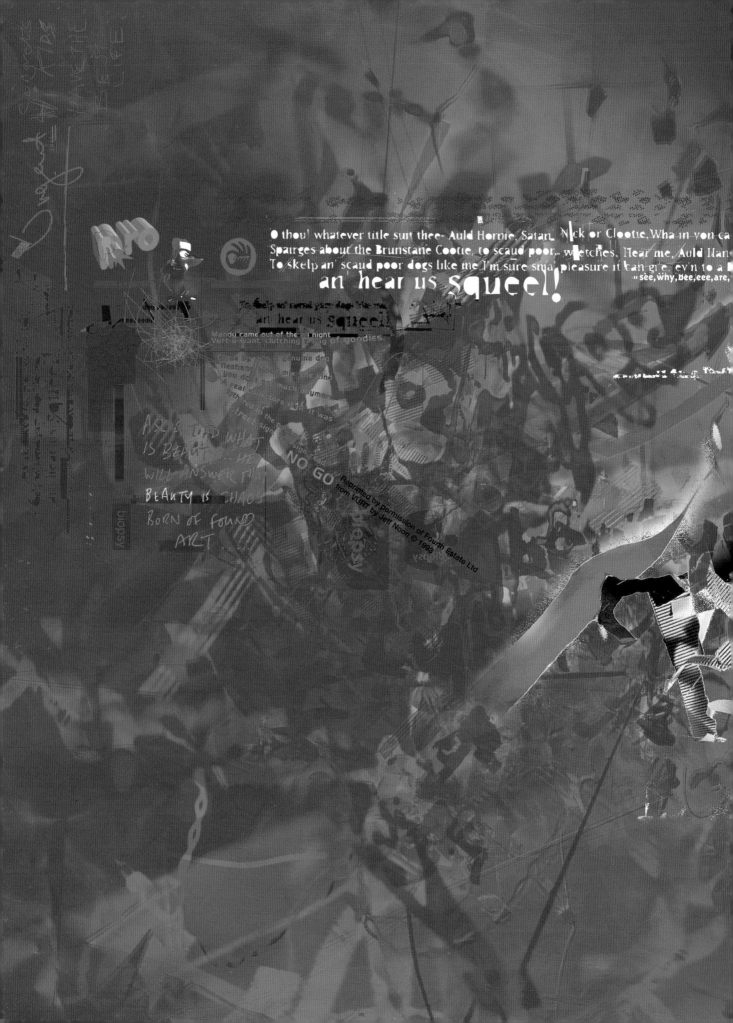

O thou! whatever title suit thee- Auld Hornie, Satan, Nick or Clootie, Wha in yon ca
Spairges about the Brunstane Cootie, to scaud poor wretches. Hear me, Auld Han
To skelp an' scaud poor dogs like me I'm sure sma' pleasure it can gie ev'n to a
an hear us squeel!

"see, why, bee, eee, are,

To skelp an' scaud your dogs like me,
an hear us squeel!

Mandy came out of the night
Vurt-u-want clutching a bag of goodies.

ASK THE LORD WHAT
IS BEAUTY HE
WILL ANSWER TH
BEAUTY IS CHAOS
BORN OF FOUND
ART

NO GO

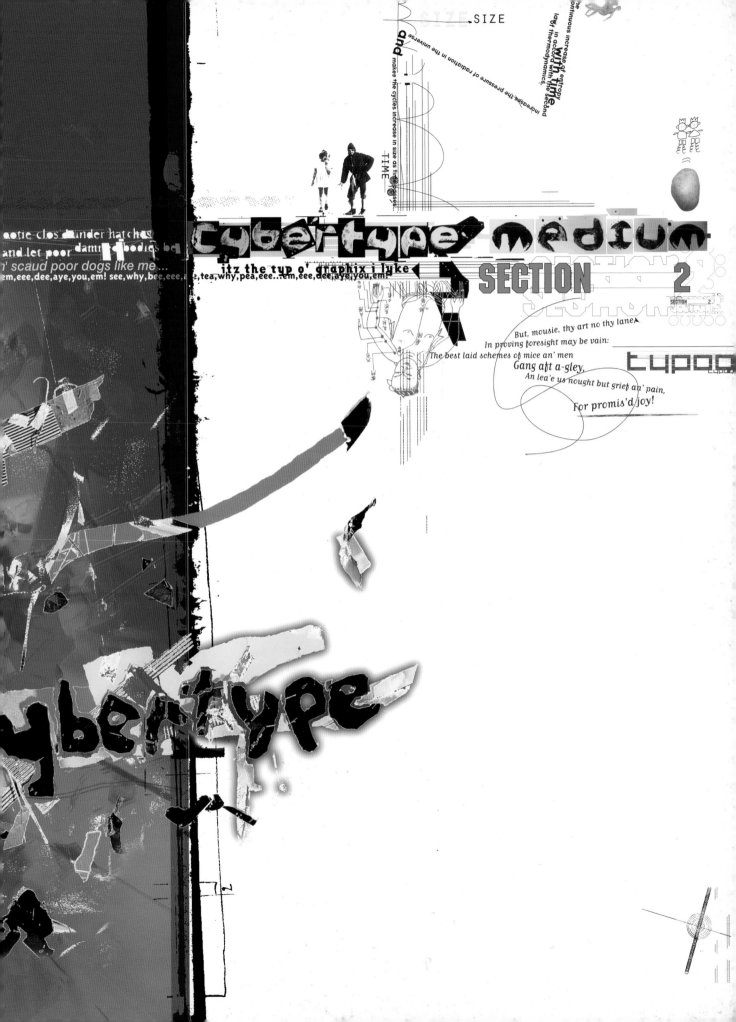

cyber type medium

itz the typ o' graphix i lyke

SECTION 2

SIZE .SIZE

and

makes the pressure of radiation in the universe

continuous increase of entropy
with time
in accord with the second
law of thermodynamics

makes the cycles increase in size as time passes.

TIME

ootie-clos' under hatches,
and let poor damn'd bodies be
n' scaud poor dogs like me...
em,eee,dee,aye,you,em! see,why,bee,eee,aye,tea,why,pea,eee...em,eee,dee,aye,you,em!

But, mousie, thy art no thy lane,
In proving foresight may be vain:
The best laid schemes of mice an' men
Gang aft a-gley,
An lea'e us nought but grief an' pain,
For promis'd joy!

typog

cybertype

INTRODUCTION

Illegibility

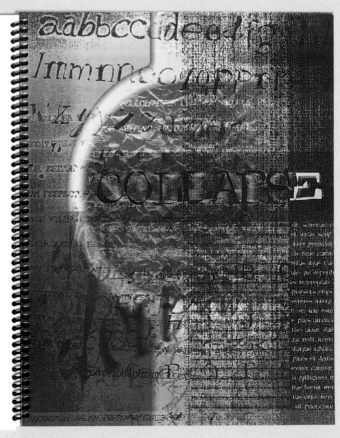

COLLAPSE

COLLAPSE FONT WAS DESIGNED IN 1995, ESPECIALLY
FOR A BROCHURE FOR THE ACADEMY OF FINE ARTS AND
DESIGN IN BRATISLAVA, SLOVAKIA. IT IS A SINGLE USE
TYPEFACE; I HAVE NOT USED IT SINCE THEN, AND PROBABLY
I WILL NEVER USE IT AGAIN. AS THE NAME OF THE FONT
MAY SAY, COLLAPSE IS HIGHLY AFFECTED BY A NEW WAY OF
DESIGNING—COMPUTER GRAPHIC, AND BY THE COMPUTER
ERRORS THAT ARE CONNECTED WITH IT. THIS SEEMED TO BE
A SATISFACTORY REASON FOR ME TO DESIGN A NEW FONT.
BECAUSE OF A CHARACTER OF THE TASK (STUDENTS' EXHIBITION)
THE TYPEFACE WAS AIMED TO BE "NONTRADITIONAL".

ANOTHER REASON FOR THE CREATION OF THIS TYPEFACE
WAS THE LACK OF MONEY; WE COULD NOT AFFORD TO BUY A
FONT, AND TO MAKE ONE UP AS A SCHOOL PROJECT DOES NOT COST
ANYTHING.

IN ORDER TO GIVE THE FACE A RANDOM LOOK, EVERY
LETTER HAS TWO DIFFERENT VERSIONS, SO THE FONT EXISTS
IN TWO DIFFERENT SETS—UPPER AND LOWER CASE.

UPPER CASE
LOWER CASE

Illegibility

art director	Peter Bil'ak
designer	Peter Bil'ak
publisher	Reese Brothers, Inc.
	Pittsburgh, PA
origin	USA/France
dimensions	203 x 254 mm
	8 x 10 in

pages 86-7 ➤

Utopia

art director	Gilles Poplin
designer	Gilles Poplin
photographer/	Gilles Poplin
illustrator	
editor	Gilles Poplin
publisher	Gilles Poplin
origin	France
dimensions	290 x 415 mm
	11³/₈ x 16³/₈ in

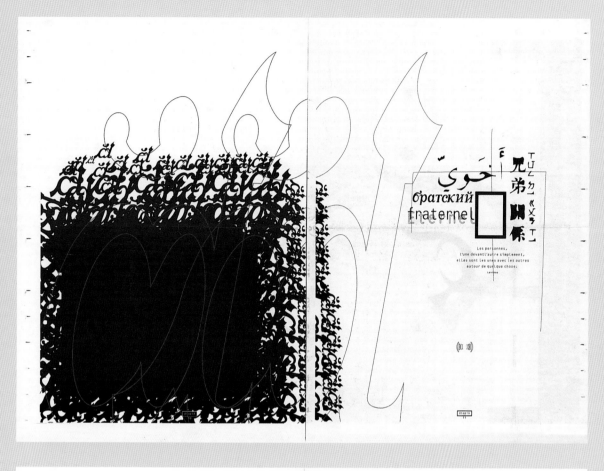

®18f 091095

Bulldozer
n° deux
revue graphique à paris

Bulldozer se plaît à observer la profusion visuelle du graphisme actuel. Explorer différents univers, observer les parcours les plus variés et les plus surprenants, préférer les contrastes et repousser l'idée d'un graphisme étroit, compartimenté en genres respectables ou mineurs. Voilà l'optique de ce nouveau Bulldozer. Après le regard aigu de Michal Batory, c'est l'insolence et l'œil moqueur de Geneviève Gauckler qui orientera votre rétine vers un espace iconoclaste, techno et utopiste, reflet grossissant d'une société de consommation dérisoire. Cette cybercowgirl, avec qui nous avons réalisé ce n° deux, vous fera intégrer son regard curieux. Bulldozer, votre troisième œil, a besoin de vous pour augmenter son acuité. N'hésitez pas à vous abonner et à le faire savoir !

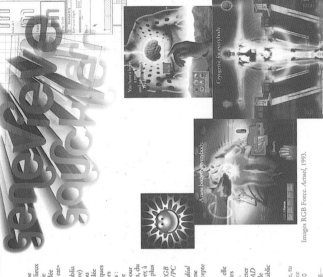

geneviève gauckler

Images RGB Force. *Actuel*, 1993.

Décision prise, l'interview se tiendra dans un des hauts lieux de la pop culture française le «Flunch» des Halles ! Installée dans le temple du «cheaper eat» de la capitale, cette jeune lyonnaise de 28 ans, qui publia son premier dessin (équestre) à l'âge de 14 ans dans le trop méconnu *Monde du Cheval* (?), semble intimidée et fascinée par l'endroit. Depuis quelques années, elle s'est forgée une image hors normes en multipliant les expériences : *l'Communications* et ses pochettes pour le DJ Laurent Garnier ou St Germain, du magazine *Interactif* et *Monsieur Cyber*, à l'édition, en passant par des chemins plus personnels, tels que le concept d'une société de service du futur, la firme *RGB Force, Inc.*, le fanzine hilarant *Idéal VPC* ou les dernières affiches d'Act Up. L'arrivée tardive de son complice d'*Idéal VPC*, le vivifiant Loïc Prigent, et d'une assiette de fromage, feront qu'elle accepte enfin de se livrer sans retenue.

En 86, sacrifiant ses rêves de cinéma, elle revient au dessin, et réussit le concours d'entrée des Arts Décoratifs de Paris. C'est à l'époque de New Order et Peter Saville, des premiers pochettes de *4AD* designées par Vaughn Oliver, celles de Mark Farrow ou des Designers Republic que sa passion pour le graphisme s'éveilla.

Loïc : Et là, en octobre 87, t'es ruinée, tu as ce grave accident d'avion, le divorce d'avec Donald Trump. Malgré les 120 millions de dollars de pension, tu es déprimée et tu fais ton premier lifting... Geneviève : ... et mon premier meeting du RPR ! Et là, je m'inscris.

editor Bulldozer
publisher Bulldozer
origin France
dimensions 200 x 300 mm (when folded)
7⅞ x 11¾ in

designers Anne Duranton
Pascal Béjean
Frédéric Bortolotti
Philippe Savoir
photographer Daniel Pype

®18f 070895

Bulldozer
n° un
revue graphique à paris

Bulldozer, phénix graphique, revient vous aiguiser la rétine. Sous la forme moqueuse et légère d'un poster recto-verso, Bulldozer vous propose d'explorer la jungle touffue du graphisme actuel. Tous les deux mois, Bulldozer braquera son petit œil curieux sur la démarche d'un créateur contemporain choisi pour l'exigence de sa réflexion et la qualité de ses images. C'est une recherche de proximité que nous désirons mener : Bulldozer débutera ses investigations par une série consacrée à des graphistes français. Tel Michal Batory, polonais travaillant à Paris avec qui nous réalisons ce premier numéro. Bulldozer, votre troisième œil, a besoin de vous pour exister, persévérer et prospérer. Abonnez-vous, faites-vous connaître, rejoignez-nous et n'hésitez pas à nous envoyer les travaux dont vous êtes fiers. La critique sera terrible et rien ne sera rendu. Et n'oubliez pas : Bulldozer bricole pour vous une manière de voir !

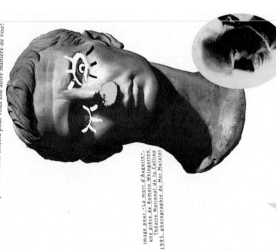

image pour «La mort d'Auguste» une pièce de Romain Weingarten. Théâtre National de la Colline 1995. photographie de Mr. Muratet

Michal Batory

Michal Batory est né en 1959 à Lodz, Pologne. Élève des beaux-arts, non loin de la fameuse école de cinéma où étudièrent Wajda et Polanski, le jeune Batory découvre les règles de la composition auprès de Balicki, maître rigoureux marqué par la méthode constructiviste. Au gré des rues grises de Lodz, les affiches annonçant des événements culturels avivent les murs et font parler d'elles : dans un état policier où la télévision gouvernementale produit surtout des images fades, édulcorées par une censure omniprésente, où la publicité n'existe pour ainsi dire pas, ces affiches détonnent sur leur environnement. Leurs auteurs rivalisent d'audace et d'habileté subversive pour contourner la censure et obtenir l'autorisation d'imprimer de la commission chargée de juger chaque projet, tout en produisant des images fortes qui poussent à l'extrême le sens de l'ellipse. Ces rares affiches ne manqueront pas d'exercer leur influence sur le travail de Batory, qui en retiendra une inclination à la poésie de métaphores, aux jeux d'associations et aux significations latentes.

pages 88-93
Bulldozer

art directors Anne Duranton
Pascal Béjean
Frédéric Bortolotti
Philippe Savoir

Bulldozer ®18f 010296

n° quatre

revue graphique à paris

Praeger

Bulldozer, petit tigre graphique dans votre moteur à idées, veut du bien à votre regard toute l'année, six fois par an : visions particulières, chemins de traverse du graphisme d'ici, images à facettes et panoramas de poche, étiquettes à déchirer et cloisons de papier à pulvériser sont au programme de votre épatante petite revue graphique pour cette année.

Afin d'aborder 1996 avec intelligence, Bulldozer vous invite à plisser le front et réfléchir en compagnie de Fabrice Praeger, saisissant prototype de créateur impliqué, mirage détonnant à base d'entrepreneur en chambre, d'artiste insomniaque et de designer touche-à-tout, avec qui nous produisons ce numéro quatre. La trentaine affectueuse, ce graphiste tout-terrain multicombats décline ici pour vous sa stimulante schizophrénie sous la forme d'une dense galerie de travaux. D'élans impétueux en accès de lucidité pointue, le costume d'« homme-idée » qu'il se taille à grands coups de concepts tranchants intrigue et surprend, agace et charme tout à la fois. Son langage graphique, lui, séduit par son imparable force d'impact, parce qu'il propulse sans détour, avec une économie dénuée de sécheresse, du bon sens au premier plan.

Au paragraphe des bonnes résolutions, Bulldozer, votre troisième œil, lire toujours la langue en fin de mois et s'engage à vous faire voir quelques images en rose contre tout abonnement...

Bulldozer ®18f 111295

n° trois

revue graphique à paris

frédérique gavillet

LES VISITES TECHNIQUES (Application des articles

Bulldozer. modeste et cosmique observatoire du graphisme post-moderne, affiche tous les deux mois son désir de transversalité. En ce temps serein de Noël, si propice au mercantilisme visuelle sonnante et au « marché » d'une communication visuelle sonnante et trébuchante, Bulldozer fait montre d'à-propos en pointant son vif télescope désintéressé sur une face bien cachée de la planète graphique : le fiduciaire : billets de banque, pièces de monnaie, chèques et cartes de crédit mais aussi supports sécurisés tels que timbres, passeports, formulaires, cartes d'identité, etc. Objets quotidiens de nos existences transactionnelles. Comment supporter, par exemple, de vivre au pays du formulaire de Sécurité sociale le plus laid au monde ? ou administratives, qui se soucie de vous ? Miroirs de notre identité, individuelle et communautaire, quelles images de nous-mêmes renvoyez-vous ? Méconnaissables et parfois pitoyables reflets, pour tout dire selon noire cœur !

Tel est le douloureux débat que propose Bulldozer la menue revue qui n'en peut plus, dans ce n'trois conçu avec Frédérique Gavillet, graphiste fiduciaire à l'impitoyable regard spirographique. Bulldozer, votre troisième œil, compte plus que jamais sur l'apaisant collyre de vos abonnements pour mieux voir l'avenir. 'Parlez-en aux rennes de ce bon vieux Père Noël...

Une jeune graphiste qui avoue pêle-mêle son goût pour le baroque, les puzzles, les romans policiers ou la guerre d'Indochine et dont le héros n'est autre que l'inénarrable général Bigeard... plutôt déroutant, non ? Frédérique Gavillet est née en 1964 aux États-Unis. Elle entre en 1984 à l'École des Arts décoratifs de Paris, où elle se sent immédiatement à l'aise parmi les autres extra-terrestres de l'endroit.

sa maison est en carton, pirouette cacahuète...

24 décembre.

Minuit moins 5.

J'avais préparé mes papiers

X carte grise

X permis de conduire

X passeport

X autorisations diverses

Tout était OK. Je descendis rapidement

l'escalier.

92

V I S A
24 DEC 1995
POLICE SPATIALE
POLE TERRE SUD
TS 300 800 002 AL

MICROLETTRES
• lettres de très petite taille visible
à la loupe ou au compte fil
• ces lettres ne sont pas détectées
par les photocopieurs

GUILLOCHES
• trait fin et continu composant un motif
complexe et non symétrique
• ce motif peut être figuratif ou non
• les guilloches sont entremêlées
et superposées pour plus d'efficacité
100%
200%

Moins 3.

Il fallait faire vite.

Je démarrai et mis le cap sur la Terre.

Elle apparaissait maintenant devant moi,

toute ronde et immobile. Je passai

la frontière sans problème.

Les douaniers vérifièrent mon passeport,

les visas et l'épaisse liasse des certificats

de transport. Lorsque je remis le contact,

ils me souhaitèrent bonne route.

Je ne transportais rien de visible,

et ils le savaient.

Moins 1

Je pouvais déjà voir les sapins; ils étaient

à l'heure, fidèles au rendez-vous cette

année encore. Après le virage, j'amorçai

la descente.

Sur les écrans de contrôle les aiguilles

indiquaient simultanément toutes

les heures. Je pointai les ordres de mission

des agents. Sur la grande carte de verre

du cockpit les cadrans des fuseaux horaires

clignotaient.

Quand le 11e coup de minuit retentit,

j'appuyai sur le bouton rouge.

IRISATION
• procédé d'impression consistant
à mélanger plusieurs encres directement
dans l'encrier sur machine, afin d'obtenir
un dégradé coloré unique

Tous les sapins entrèrent en action.

Chacune de leurs aiguilles devenait

un messager qui partait en courant

accomplir sa mission. Leur rythme était

infernal. Ils devaient faire vite, parcourir

le plus de distance possible au milieu

des villes, traverser le calme des

campagnes, filer sur la mer. Chemins,

ruelles, labyrinthes, champs, boulevards,

souterrains, sentiers, montagnes, océans,

lacs, rivières, neige, soleil, nuit, sable...

Chacun reconnaissait parfaitement

son objectif, marqué d'une encre spéciale,

d'un rayonnement invisible aux humains.

Encore quelques instants...

Top !

D'un coup, je remis les gaz; il ne fallait

pas moisir, le coin devenait dangereux.

Je risquais d'être reconnu.

Je refermai le registre de l'année, après

y avoir apposé les scellés réglementaires,

et je notai l'heure dans le journal

de bord.

24 décembre 1995	23 h 59 mn 58 s
signature	

ENCRES
• les encres utilisées pour les guilloches
sont de couleur pâle ou pastel
• elles peuvent comporter des réactifs
chimiques, se comporter de façon
changer de couleur, disparaître
à la chaleur, être invisibles, irisées
magnétiques

PAPIER
• le papier peut être fabriqué spécialement
et être la propriété du client
• il peut comporter des éléments inclus
dans la pâte lors de sa fabrication
(motif, plastique, fil, filigrane

FILIGRANE
• motif du papier spécialement
uniquement en transparence, réalisé
lors de la fabrication du papier

SUPPORTS
• d'autres supports sont possibles
plastique, métal, verre, etc.

Le 12e coup de minuit sonna comme

je m'éloignais. Chaque messager, figé

en plein vol, se métamorphosait,

tombant dans chaque cheminée, dans

chaque soulier, au pied de chaque sapin,

à l'intérieur de chaque maison.

De loin, la Terre ressemblait à une grosse

orange.

C'était Noël.

★ ★
LE CONSUL
24 DEC 1995
TS 300

24 DEC 1995
TAXE

DOUANE
★ ★ ★
24 DEC 1995

24 décembre 1995

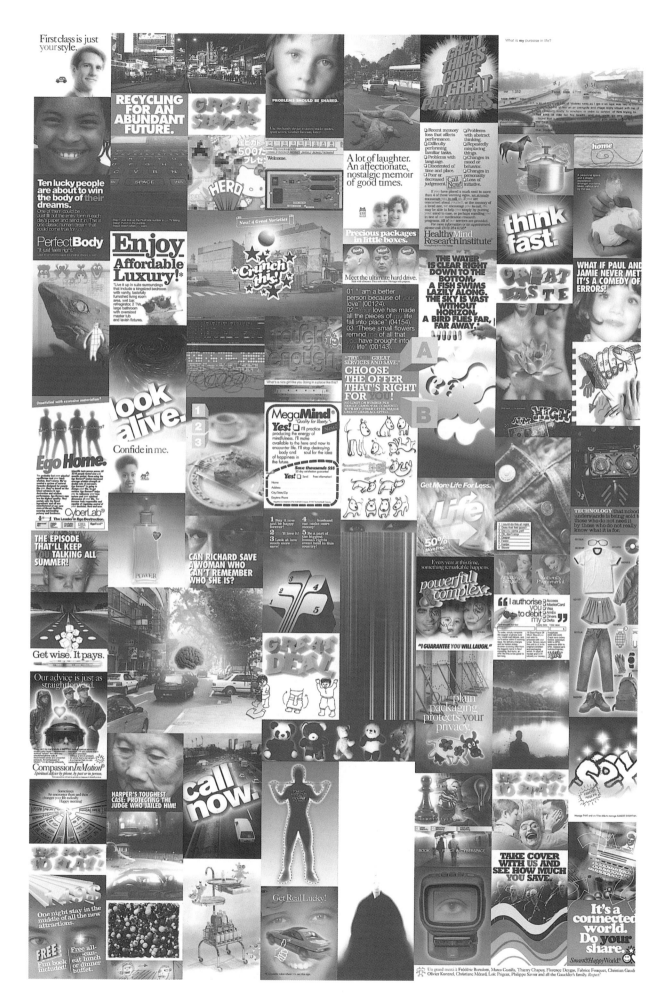

pages 94-5

gee magazine

art director Clare E. Lundy
designer Clare E. Lundy
editor Clare E. Lundy
publisher Clare E. Lundy
origin UK
dimensions 295 x 360 mm
11⁵/₈ x 14¹/₈ in

TYPOGRAPHIC CHAMBER OF

HORRORS

Some time ago in the pages of Professional Printer (Vol 35, No 1) I contributed an article entitled Typographic Integrity. It examined the opening of type design to the masses of personal computer users with access to alphabet building software programs such as Fontographer, Fontstudio, and Ikarus M. My article postulated that the practice of type design involved rather more than the mere acquisition of computer hardware and software and that to obtain decent typefaces the "fireware" operating the system needed design skills, sensitivity to letter forms, reliable taste, and a clear application in mind.

My thoughts reverted to this subject when reading a recent, and facile, column in a trade magazine touching upon the work of William Caslon 1. Readers will doubtless recall that Caslon was responsible for re-establishing the typefounding business in this country during the eighteenth century, thereby ending the dependence of British printers on imported types, principally from the Netherlands and France. His Caslon Old Face design, dating from the 1720's, has become a classic and bestows distinction on any composition. It has a kind of rustic charm mingled with elegance and featured prominently in the typographic revival of the nineteenth century. At the end of the magazine article, the columnist seemed to conclude that the name Caslon was remembered with respect and admiration, but ruminated on the names of designers that would be recalled in the future now that type design could theoretically be executed by anybody with a personal computer and appropriate software. Such a statement prompted me to ponder the issue.

There are some names in twentieth-century type design that appear as candidates for immortality and as exemplars for study, among them in alphabetical order: Mathew Carter, Dick Dooijes, William Dwiggins, Adrian Frutiger, Eric Gill, Frederic Goudy, Sem Hartz, Gustav Gerhard Lange, Giovanni Mardersteig, Bruce Rogers, Walter Tracy, Jan Tschichold, Jan Van Krimpen, and Hermann Zapf. All of those named cut their professional teeth in hot-metal technology and applied the sound principles assimilated to the design and development of alphabets for photo-typesetting and for digital composition. Some later designers have also produced creditable work solely in the photographic and digital ages, instanced by Carol Twombly, Robert Slimbach, and Adrian Williams. It seems reasonable to assert that more type designs are being produced currently (i.e. in recent years) than ever before in the history of typography and perhaps predictably more bad type design appears to be occurring as well.

Some would argue the inevitability of the situation given the spread and de-regulation of type design. My position is somewhat different. I feel that the proportion of deplorable type design has risen significantly and to the detriment of graphic art. So much contemporary type design seems to be irrelevant, trivial, fatuous, ill-point, clamourous, straining for effect and novelty, illegible, gimmicky, quirky, and worthless. On many occasions, the pointing of fingers at the guilty is said to be invidious, especially as so many could be cited. But the brand names Emigre and Fontfont are representative of what I have in mind and produce some kind of alphabets that may well be remembered in the future for the wrong reasons as incident of a typographic chamber of horrors. Undoubtedly the de-regulation and dispersal of type design have debased quality standards. When the creation and development of founts remained the reserve of the major composing machinery manufacturing houses, a number of restraints automatically applied. In earlier times, the fount production processes were long and costly and demanded serious market research to determine potential sales in advance of a typeface being made and released. Additionally the traditional houses had established stringent quality control procedures based on multiple cycles of proofing, criticising, and revising; the founts were not rushed on to the market. Furthermore the economic and overhead strictures of the companies tended to preclude frivolous and whimsical excursions into type design.

With the advent of the personal computer and intuitive fount-building software, the means of production have become less expensive and broadly more accessible. It has enabled a motley collection of people to enter the business. Some are talented; others less so. Competition has become fiercer with founts selling prices decreased and profit margins squeezed. Small companies with low overhead and cost burdens can survive more easily in a crowded and volatile market, but large traditional companies cannot trade as comfortably in severe conditions. In recent times, the traditional suppliers have struggled in the fount market which has seen the incoming of a pack of independent typeface producers the latter not to be confused with mere re-sellers or distributors or stockists of founts. To provide some notion of the dispersed activity, the new fount providers include: Carter & Cone Type, Elsner & Flake, The Font Company, Font Bureau, Fonthaus, Letterperfect, Stone Type Foundry, Fontworks, Electric Typographer, Red Rooster, Treacyfaces, Alphabets, Club Type, Emigre, Bear Rock, as well as the more venerable Bitstream and URW. This abbreviated list of suppliers represents diverse and intense typeface design activity which inevitably leads to uneven quality as the various companies strive for novelty and popularity. The aim is often short-term pecuniary gain and the likelihood of design classics emerging in this feverish environment can hardly be anticipated. Sadly the typographic arts suffer as a consequence and the prospects look bleak. Article by L.W. Wallis

95

SPEEDHEALTHOFNATUREIMAGET
EXTHATESURFHOTTUNAOUTJUNK
POTSCENEINSECURITYTRIPXTCO
DDITYFOOTBALLTECHNOSHOWH
IPPYSUSPENDERSFASHIONUNIFO
RMBOOZESEXTYPEACCIDENTBEA
TRETROWAVEMUSICCHOCOLATE
SOCIALLYCHALLENGEDDEVIANTP
OWERMONEYWEIRDCANKICKERS
NOWSHUFFLERJOHNMERRICKME

1

2

3

4

Emigre

1 & 4
designer
Rudy VanderLans
editor
Rudy VanderLans
publisher
Emigre
origin
USA
dimensions
210 x 286 mm
8¹/₄ x 11¹/₄ in

Emigre

2 & 3
designer
Anne Burdick
editor
Anne Burdick
publisher
Emigre
origin
USA
dimensions
210 x 286 mm
8¹/₄ x 11¹/₄ in

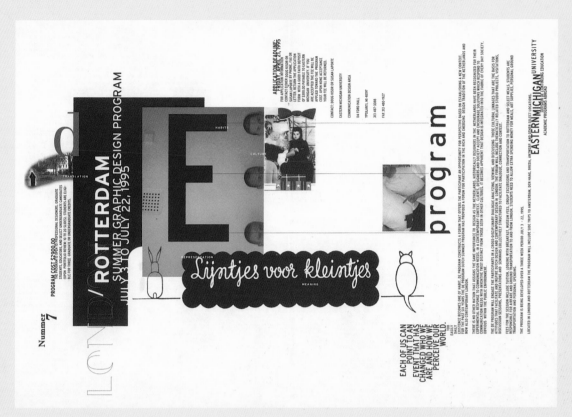

Emigre

advertisement

art director
Doug Kisor

designer
Doug Kisor

photogrpaher/
illustrator
Doug Kisor

editor
Doug Kisor

publisher
Emigre

origin
USA

dimensions
210 x 286 mm
8¼ x 11¼ in

Emigre

art director
Anne Burdick

designer
Brad Bartlett

editor
Anne Burdick

publisher
Emigre

origin
USA

dimensions
210 x 286 mm
8¼ x 11¼ in

To prepare a text for publication within the complicated framework of the publishing industry, a writer must have extensive knowledge of the nuances of grammar, syntax and spelling, and be able to combine his or her words in an articulate, if not eloquent, fashion. The ability to publish a text also requires access to and familiarity with some technology of language reproduction. Traditional publishing requires a network of professionals with various areas of specialization — the publisher, the editor, the graphic designer and the printer, to name a few. Throughout the history of communication, the more complex a system of writing is, the more likely it is to produce a distinct class of practitioners whose exercise is what is called "language authority."

WRITING AND THE GRAPHIC DESIGN COMMUNITY

The graphic design community is a contemporary manifestation of the "scribal-elite," a specialized class whose members view themselves as superior manipulators of language. "High" graphic design is available only by acquiring the services of a graphic design "professional" who has gained his or her expertise through either a lengthy apprenticeship or a costly investment in college-level skill development. In "The Ethnography of Literacy," John Szwed notes that "It is a mark of success (in most cases) *not* to be directly responsible for one's own communications in written form — secretaries are employed to turn oral standards into acceptable written ones. (In this, the United States resembles other non-western cultures of the world, some of which measure the importance of messages and their senders by the number of intermediaries involved in their transmission.)"[9]

Recent advances in reproductive technology, including the photocopying machine and the personal computer, have brought typographic practice into a greater portion of the "lay" public's day-to-day cultural experience.[10] Almost every public arena is filled with a new generation of homemade typographic messages. As a result the fluctuating status of the professional graphic designer is at the crux of much of the commentary appearing within the graphic design media. Designers are evidently scrambling to establish their primacy over a quickly expanding community of desktop publishers, putting into practice one of the most valued applications of the written word: cultural testimony. Because writing is synonymous with documentation, communities that lack "signature" writers or publications run the risk of cultural invisibility. Publishing enables communities to develop and disseminate their own histories by establishing a sense of continuity with past societies. Graphic designers are under pressure to publish because they constitute a new, unfamiliar community without a widely-publicized history. Their identity depends on their status as an authentic profession, a position that would be difficult to defend without the evidence of a collective body of literature. The design press has recently included academic writing to help shift the basis of the profession away from discussions of client-dominated practice and to

elevate design discourse beyond the reading interests of the average desktop publisher. Magali Sarfatti Larson has identified "the production of knowledge" as a common and potentially potent strategy for any profession wishing to gain autonomy. If a professional group can succeed in formulating a distinctive body of knowledge, Larson observes, they can win control of their working conditions by defining the standards by which society judges them.[11] To accentuate their autonomous voice, professional communities promote certain analytical methods, ideological frames, and terminology that they either fabricate for themselves or appropriate from other disciplines.[12] Such groups become "discourse communities," allowing each group member to relate to the same coded jargon. using esoteric words and phrases that operate in a manner similar to street slang, subcultural "passwords" and shoptalk. Reading, as a test of knowledge and inside information, becomes a necessary hurdle to win socialization within a community.

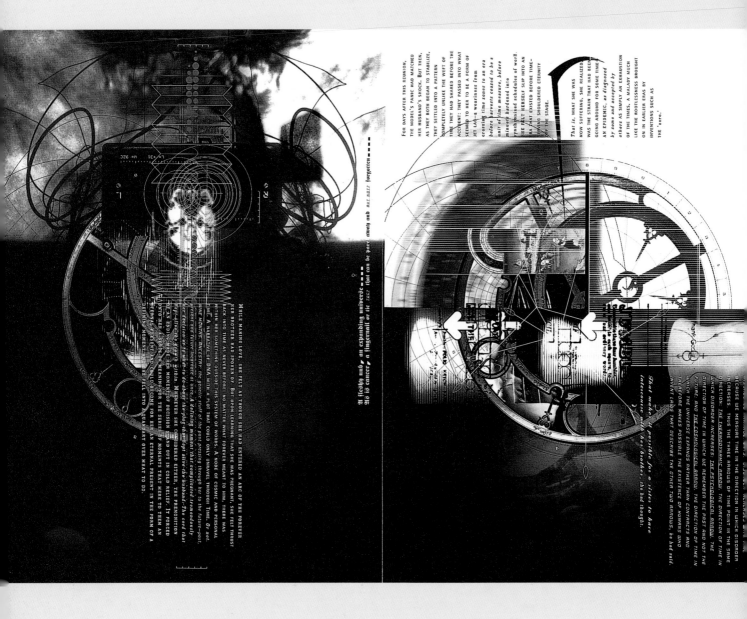

pages 98-9

Emigre

art director Stephen Farrell
designer Stephen Farrell
photographers Stephen Farrell
 Gregory Halvorsen Schreck
writer Steve Tomasula
publisher Emigre
origin USA
dimensions 210 x 286 mm
 8¼ x 11¼ in

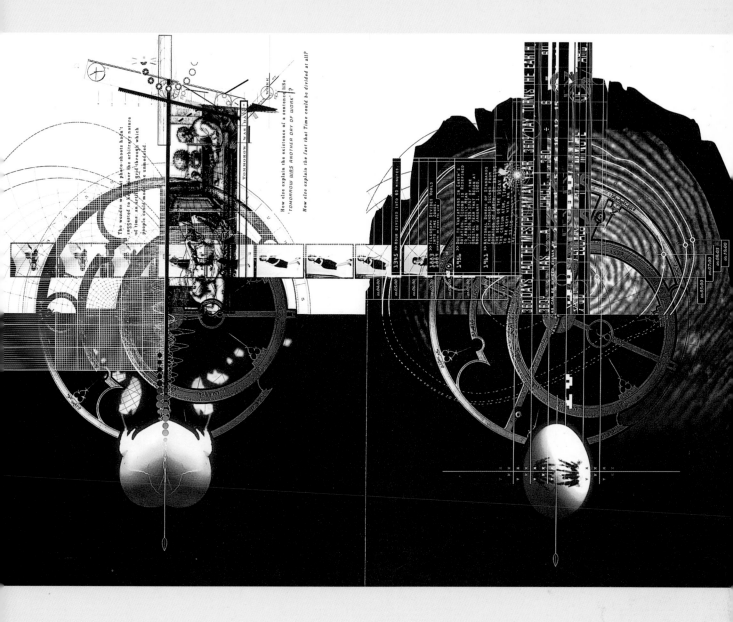

pages 100–101 ➤

Iron Filings
Electric Hob

posters

art directors Ten by Five
origin UK
dimensions 297 x 420 mm
11³/₄ x 16¹/₂ in

House-hold Utility font

ABCDEFGHIJKLMNOPQRSTUVWXYZ

Iron Filings see page 99 for credits

design and typeface Andrew Degg

BACK LEFT **10×5** IDEAL FOR INNER CITY LIFE!

abcdefghijkllmmnopqrstuvwwxyz

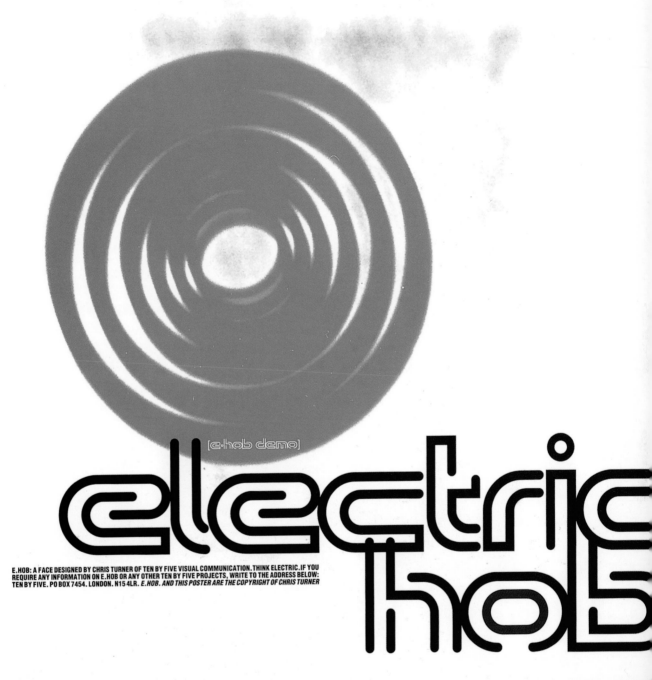

[e·hob demo]

electric hob

E.HOB: A FACE DESIGNED BY CHRIS TURNER OF TEN BY FIVE VISUAL COMMUNICATION. THINK ELECTRIC. IF YOU REQUIRE ANY INFORMATION ON E.HOB OR ANY OTHER TEN BY FIVE PROJECTS, WRITE TO THE ADDRESS BELOW: TEN BY FIVE. PO BOX 7454. LONDON. N15 4LR. *E.HOB. AND THIS POSTER ARE THE COPYRIGHT OF CHRIS TURNER*

Silo Communications

art director Brian Horner
designer Brian Horner
photographers/ Brian Horner
illustrators Chris Kilander
editor Brian Horner
publisher Silo Communications
origin USA
dimensions 279 x 279 mm
11 x 11 in

pages 104-105 ▶

Shift!

art directors Anja Lutz
Lilly Tomec
designers Anja Lutz
Lilly Tomec
editors Anja Lutz
Lilly Tomec
publisher Gutentagverlag/Shift!
origin Germany
dimensions 210 x 260 mm (folded)
8¼ x 10¼ in

Gail: O.K. is that thing going?

Liz: It's official

Liz: You know, I thought I was categorized and that labels could not suck. What do you think about not having a label or a specific style.

Gail: Oh well, geez I think that you just have to make your own label and um, cause I got asked to do things because I'm a woman and I do avant garde work, things... like I don't worry on that, so you just get to start being your own.

Chris: So do you think having style is good?

Gail: Good to have your own style, yeah because that will get you through the rest of your life and you hope you want to have a whole body of work that looks like you and not be stuck bouncing around from style to style.

Chris: Yeah, I just didn't know cause, like I was thinking not that I, you know, I do your style or Carson style or anything like that but you can, you're not your own specific, I mean it's great if everyone knows your style and they come to you specifically, just for that, but if, if people come to you and say O.K. this person doesn't have a style but he's gonna do the style that best fits what we need.

Chris: Um, um...

Chris: So you know you can break away from a style and do something totally different, if you have to.

Gail: Hopefully, I mean if you're like April Greiman and you do April Greiman for your whole life, yeah it would be crappy if they come and just saw we want you to do April Greiman and your not April Greiman that would be worse, now I'm talking in circles.

Chris: I didn't know if you didn't have a style, you would be more versatile. You could adapt yourself to the problem you were solving.

Gail: You do that to some extent anyway, yeah I don't know, that would be really weird way of living, that would be like just changing your whole self every time.

Chris: It's probably impossible

Gail: I don't know...

Liz: There are some people who are good at that, I really think there are people who are trained to do that. I think that's kind of what the design community wants. Like when you go for a job they want to see that you can pull straight and you can pull whatever they need.

Chris: Right

Liz: I mean that's what there looking for, because I hear that a lot.

Chris: It just seems that like, like we don't also have enough freedom, that's what I think. Yeah you have to do whatever the hell you're asked to do.

Liz: Yeah, that's because it's design.

Chris: Ah, I would like to be to the point because, you know, we go to school for 4 years plus, you know graduate or whatever, or we should have some new idea. I think we should be able to tell a client more than he might have an idea.

Gail: It would be nice if design got that much respect.

Chris: Yeah, but I don't think it's ever going to.

Gail: Unless you're a star, like April Greiman or I don't know, If they wanted Charles Spencer Anderson?

Chris: Right

GAIL SWANLUND. the interview...

Gail: They just want it, BAM, they just want a certain wham.

Chris: And like he can say he wants a certain something.

Gail: And it must be nice to know you could hire a lot of assistants to just do you.

Chris: It's basically your name, I mean

Gail: Yeah, then it is.

Chris: So anything you do.

Brian: A Warhol kind of thing.

Liz: The Gail Swanlund factory

Gail: It gets kind of like a bankrupt idea too, but that wouldn't be very satisfying.

Chris: Yeah, because you're just producing a ton of stuff.

Gail: Yeah, that's why I keep doing artwork so at least I'm developing some groove and I'm not stuck with something people come to me for.

Chris: exactly

Gail: Except I mean, It's weird being considered a woman designer and an avant garde designer, or I'm a Cal-Arts designer or I'm Ed Fella recycled.

Chris: Like when the hell did this happen?

Gail: Like I didn't have any mind of my own.

Chris: Yeah, Carson's going to be Carson for the rest of his life, It's just that type of design is going to be revered to.

Chris: Do you think there's a big rat race, designers only designing for other designers. Trying to find the youngest and best to come work for you and take them?

Gail: Eat them up and spit them out.

Chris: Yeah, eat them up and spit them out.

Gail: There's an amount of it I think, I'm lucky I'm not at one of those but I think a lot of what happens,... Yeah design is an elite profession, it's a peripheral, we like to think were artists but were really not, were collaborators and... It is a rat race, there is a lot of design for competitions, which is kind of icky.

Chris: Yeah, but the next person is trying to please the next person. Carson's trying to impress Deck and Deck's trying, you know, It's just like who are we really trying to design for, we design for the public and try to get our information across or trying to impress Deck, who's halfway across the country.

Gail: Yeah, I do design mostly for myself and then I design for a couple of people, like I hope I can send something to Liz and she'll go "cool".

Chris: Right

Gail: Yeah, and like that my friends see my stuff and like it and I hope that it speaks to other people who think the same way I do.

Chris: So It's more of a personal satisfaction than anything?

Gail: Yeah

Chris: First of all...

Gail: It's just a human thing, you want to make stuff.

Chris: Right

Gail: And then you want your friends to like it.

Chris: Yeah, with them they want someone else to like it and they like it.

Gail: How much social responsibility do you think a designer needs to have with a client?

Gail: A lot, I mean, well that's a tricky question, cause I don't think we have that much power, I mean it's kind of arrogant to think that we can actually change things, but there's some small things you can do, like the way you'll live or the choices you pick, and like I won't use metal inks and like that kind of stuff, but yeah, there's some stuff you just try to be good in your small ways, I try not to use big runs of stuff that's going to be thrown away.

Chris: Right

Gail: And then all the borrowing from Japan, vice-versa, I don't know.

Chris: Maybe just the wealth of the country you know, the melting pot that's why it's the cross-roads of America. It all comes across here sooner or later. Somebody picks it up and steals it somewhere.

Gail: I don't know because Herron has a pretty big mark out there, like everyone knows about Herron.

Chris: They do?

Gail: Oh yeah, you kidding?

Chris: We didn't thing they did, I mean maybe that's because were caught up in here, I know it had a lot of pull early on when the museum of art was here. I know that a lot of people, that I know have gone out there to get jobs and have been laughed at when they show their portfolios because they have been too wild, I don't know if that's good or bad. I mean, "Take your crap and go to New York with it", is what they say.

Gail: Oh really.

Liz: It's really hard to get a job in Indianapolis.

Brian: They have to go into business for themselves.

Liz: Which has been actually kind of good, but the old guard is really strong here.

Liz: Everywhere, yeah

Gail: It happened in New York when I took my stuff there, I was crying on the elevator. She said it was just crap.

Chris: Wow

Liz: It depends where you go, You should research on where you take it to.

Chris: Or you might take it somewhere we're they want to school here and they'll be able to see something in it.

Liz: Well I think part of your job in interviewing is you know, decide how desperate you are, you decide were it is you want to go and then you go find out, like what kind of work there producing. You take your portfolio and temper that, I mean this is if your not being like a true person and if your not being true to yourself, you want to be an artist and you want to do your own thing and make your own path, but if you want to just get a job, you know then that you can have. I mean I wouldn't go take everything out of your portfolio. You know, keep something in there that's true to yourself, but still, if your going to go work for a newspaper at least show them that you can flow text and make a grid and you can get things done on time.

Chris: How much do you consider your audience and what role they play?

Brian: That's probably already been answered.

Gail: Sort of, I do take into consideration my audience but I try not to second guess them, I try not to talk down to them or think...

I don't know why it is, it's just information gets so dissimulated so quickly. You used to be able to say that's Dutch design but now you can't really, It's so blurry.

Gail: There's a lot more borrowing and changing, yeah. And a lot more interchanging, like everyone was going to Holland for awhile.

Chris: Right

Liz: Having to make things reversed out, he wouldn't like it. He was this creative director in Los Angeles. His first thought would be that looks cheap, it looks like it's on sale. Like what! How can you say that, sorry.

Liz: That That looks cheap?

Liz: Omigosh, it made me so mad.

Gail: So your basically saying that you talk to your audience at the same intelligence level and intellectual level and you don't talk down to them.

Gail: Yeah, plus people get so used to things really quickly, like look at MTV, they have like 59,000 images coming at you and people read that now.

Gail: What she's saying is that she doesn't second guess them.

Gail: I think people are smarter.

Brian: Do you think that there are certain things that are off limits, I've heard people say that you can't do that or use that font, but shouldn't you be able to push new things and educate people?

Gail: Right, and there are small ways to get them to look at things differently and that's a part of our jobs. It can be fun, but doesn't always work.

Brian: I've used Arbitrary and it just a weird response because the numbers are different, the ones are cut off.

Gail: Yeah, but look at Template Gothic now, It's like so one would have touched that 5 years ago, but now it's like everywhere.

Brian: It's funny because he hates Helvetica so much and now it's almost become the next Helvetica.

Chris: It's used everywhere now.

Brian: It's in T.V. Guide every week.

Gail: Joey Buttifuco looks so nice set in Template Gothic.

Chris: Buttifuco

Gail: It's just such a nice word

Chris: Um, you've basically already covered this... I know that more on the edge design is becoming mainstream in today's culture, what do you account for this?

Gail: People just get used to stuff really quickly, the second part of that question is probably how do you not be dated, how do you not look like you're not 1994... November 13.

Liz: (Laughter)

Gail: And I don't think there is, except do you being true to yourself.

Gail Swanlund

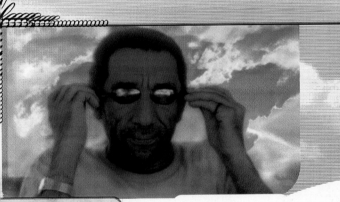

In Utermohlen, Cal-Arts graduate, has played a role in the evolution of the graphic design field in the mid-west, particularly Indianapolis. His work has been in numerous publications such as Adobe, Emigre, and Now Time. His work has also appeared in many exhibitions such as Adobe, AIGA-100 Shows, and Directions, exhibit for Indiana University. He is currently teaching at School of Art in Indianapolis, Indiana.

Brian: What did you do before Grad School? Weren't you a fine artist for awhile?

Win: Yes. I thought I was

Brian: Was that during High School? Or does your art career go back that far?

Win: Yeah well, sort of, I'm, when I was in High School art was sort of the only thing that I could pass. It was the only thing that made any sense or something. It was the only thing that was interesting, but that was mostly because High School is so laid...

Brian: What made you want to go to Grad School, was there somebody at the museum that had went?

Win: Yes and no, actually, let's see. "What made me want to go to Grad School?" I wasn't getting anywhere with my job and I kind of decided I wanted to be a designer...

There were all kinds of... just everything about southern California was really hip that spring or whatever it was. And so that was very exciting, it's like wow, I'm going to the Pacific rim and that's the place to be. That was kind of who I went. I didn't really know what I was doing...

Brian: Did you have your own style before you went or do you think that going there pretty much defined your style?

Win: It depends, I think I developed my own style there. I was defiantly influenced by being there but I don't think... really at the time there wasn't a style now I'm going to...

Chris: Was it done on the computer?

Win: Oh no. Gosh no, I did it completely with like zippatone films and sub drawn letters and shit like that. Uh it was not right and it had this kind of japanese kind of type on it. It was part awful...

So my philosophy is just to dive in.

Chris: When you were doing it, did you know that it would be where it is, working on massive images, or did you think it was just something off side thing?

Win: Well I don't know that anyone knew what it was going to turn into. It was obviously such a powerful tool, especially in the realm of typography, which for some reason, what I was really interested in.

It always baffles me why anyo[ne] in the world would be interested in type, but I am.

And probably the way I had been taught was the traditional way of counting words and characters and estimate bx what this type was going to look like when you did it in Helvetica or Garamond, and it was so obvious that you had so much control with the Macintosh...

EDWIN UTERMOHLEN

104

SHIFT

(N)(II)

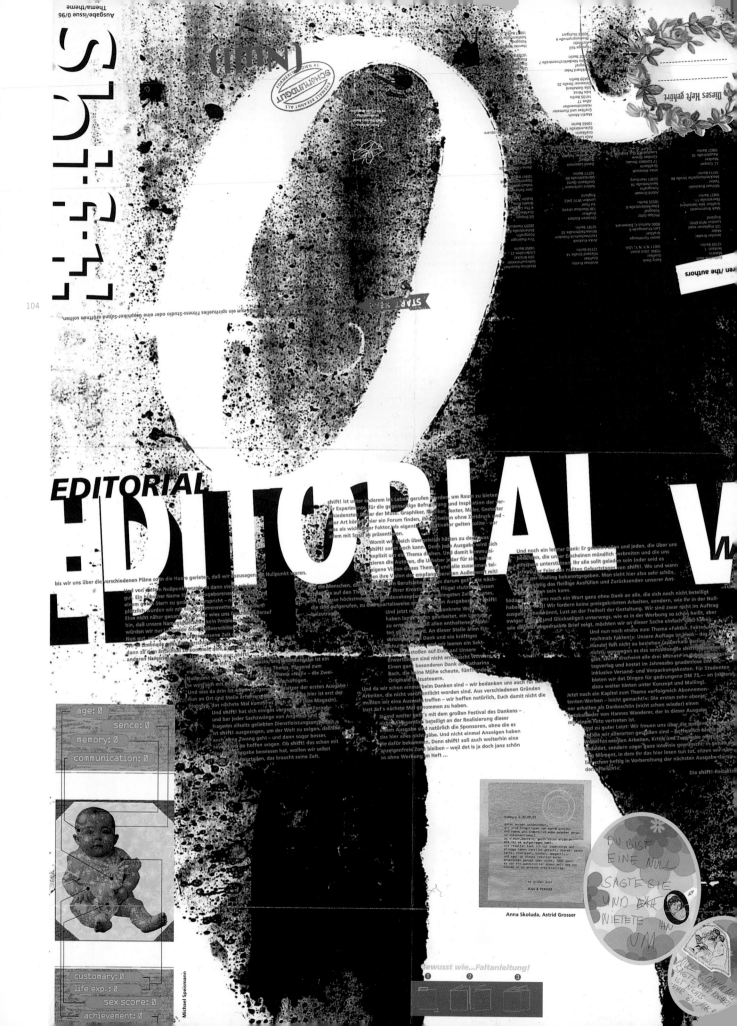

Dieses Heft gehört

/the authors

EDITORIAL

shift! ist unter anderem ins Leben gerufen worden, um Raum zu bieten
für Experimente für die gegenseitige Befruchtung und Inspiration der ver-
schiedensten Götter der Muse. Graphiker, Musiker, Texter, Maler, Gestalter
jeder Art können hier ein Forum finden, ihr zu arbeiten ohne Zeitdruck und -
was als wichtiger Faktor, als eigentlicher Motivator gelten sollte - vor
allem mit Spaß zu präsentieren.

Womit wir gleich übergeleitet hätten zu dem, was
shift! sonst noch kann. Denn jede Ausgabe wird sich
explizit um ein Thema drehen. Und damit kommuni-
zieren die Autoren, die Urheber jeder für sich seine
eigene Vision dieses Themas und calle zusammen tei-
len ihre Vision der empfangs bereiten Außenwelt mit!

bis wir uns über die verschiedenen Pläne so in die Haare gerieten, daß wir sozusagen am Nullpunkt waren.

Und von wegen Nullpunkt wurde es dann ste...

Und noch ein letzter Dank: Er gehört allen und jeden, die über uns
berichten, die unter Erscheinen mündlich verbreiten und die uns
günstige unterstützen. Ihr alle sollt geladen sein (oder seid es
schon) zur Feier des nullten Geburtstags von shift!. Wo und wann
per Mailing bekanntgegeben. Man sieht hier also sehr schön,
wie wichtig das fleißige Ausfüllen und Zurücksenden unserer Ant-
wortkarten sein kann.

age: 0
sence: 0
memory: 0
communication: 0

customary: 0
life exp.: 0
sex score: 0
achievement: 0

Michael Speismann

Anna Skoluda, Astrid Grosser

Gewusst wie...Faltanleitung!

DU BIST
EINE NULL
SAGTE SIE
UND VER
MIETETE IHN
UM

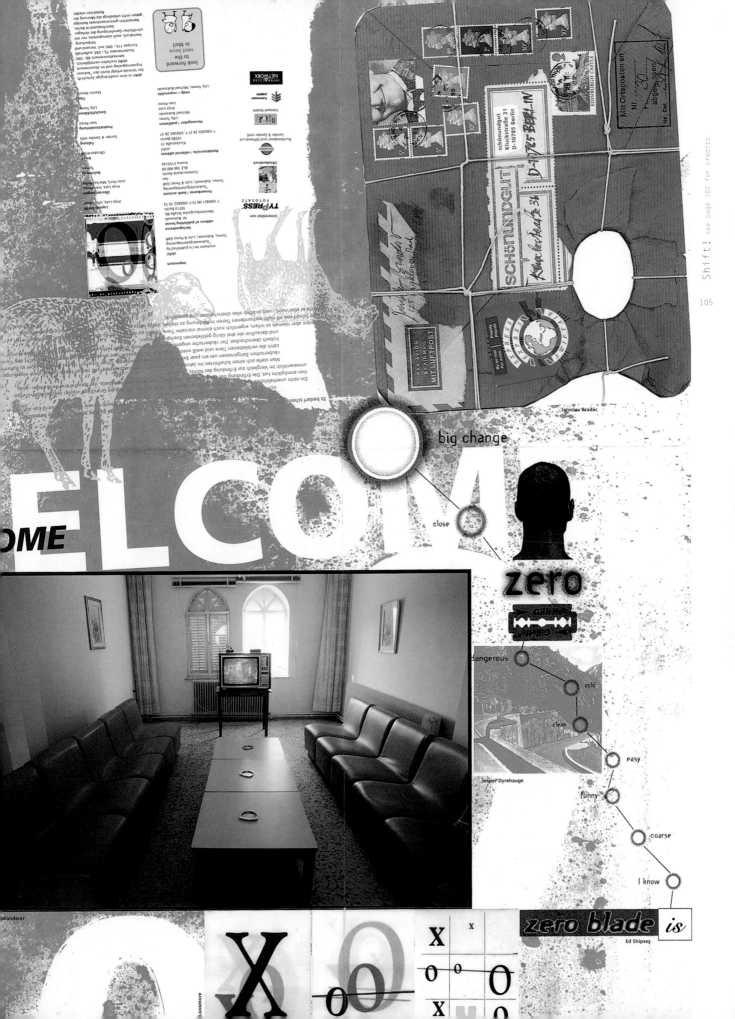

big change

close

WELCOME

OME

zero

dangerous

cold

clean

easy

funny

coarse

I know

Jaroslav Bradác

Jesper Dyrehauge

zero blade is

Ed Shipsey

Wanderer

pages 106-7

Fuse
posters and packaging

art director
Neville Brody

editor
Jon Wozencroft

publisher
FontShop International

origin
UK

dimensions
posters
420 x 594 mm
16¹/₂ x 23³/₈ in

designer Pablo Rovalo Flores

SUPE
RSTIT
ION

Fuse | Superstition
Featuring four experimental fonts
plus their related A2 posters
by Scott Clumm, Hibino,
Pablo Rovalo Flores & 'Tomato'.
Plus six bonus fonts.

a

b

c

Letraset Japan Ltd
Sugita Bldg, 6F
6-5 Higashiyama 1-chome
Meguro-ku, Tokyo 153
Japan
T +81 (0)5 5721 1644
F +81 (0)5 5721 1660

Esselte Letraset AS
Pottermakerveien 2
N 0954 Oslo 9
Norway
T +47 2225 7350
F +47 2225 4301

Letraset España
General Margallo 23
E 28020 Madrid
Spain
T +34 (0)1 570 6151
F +34 (0)1 570 2229

Esselte Letraset AB
Box 931
S 19129 Sollentuna
Sweden
T +46 (0)8 625 5266
F +46 (0)8 625 0252

Letraset Australia Pty Ltd
P.O. Box 129
Brookvale
NSW 2100
Australia
T +61 (0)2 975 1033
F +61 (0)2 451 1815

Letraset Belgium SA
Rue Gustave Schildknecht
1020 Bruxelles
Belgium
T +32 (0)2428 7156
F +32 (0)2425 1587

Esselte Letraset AS
Marielundvej 30
DK 2730 Herlev
Denmark
T +45 4284 9300
F +45 4291 0614

Letraset Deutschland GmbH
Mergenthalerstrasse 6
D 60388 Frankfurt am Main 60
Germany
T +49 (0)69 4209 940
F +49 (0)69 4209 9450

Letraset Nederland bv
Mierbaan 13
NL 2908 LR Capelle a/d IJssel
Holland
T +31 (0)10 458 0311
F +31 (0)10 458 0610

Letraset Italia Srl.
Via Riccione 8
I 20156 Milano
Italy
T +39 (0)2 3921 6677
F +39 (0)2 3921 6135

Letraset UK Ltd
195/203 Waterloo Road
London SE1 8XJ
United Kingdom
T +44 (0)171 928 7551
F +44 (0)171 401

Letraset USA
40 Eisenhower Drive
Paramus NJ 07653
United States of America
T +1 201 845 6100
F +1 201 845 5047

Letraset Export
Kingsnorth Industrial Estate
Wotton Road
Ashford, Kent
TN23 6LL
United Kingdom
T +44 (0)233 624421
F +44 (0)233 646905

baseline is the leading International Typographics Journal published by Esselte Letraset

ESSELTE
Letraset

© 1994 Esselte Letraset
ISBN 0954-9226

a

Baseline

a

art director
Hans Dieter Reichert @ HDR Design

designers
Hans Dieter Reichert
Brian Cunningham
Malcolm Garrett
Stephanie Granger
Dean Pavitt

photographers/illustrators
Why Not Associates
Ian Teh
HDR Design

editors
Mike Daines
Hans Dieter Reichert

publisher
Esselte Letraset

origin
UK

dimensions
245 x 345 mm
9⁵/₈ x 13⁵/₈ in

b

art director
Hans Dieter Reichert @ HDR Design

designers
Hans Dieter Reichert
Dean Pavitt
Simon Dwelly
Brian Cunningham
Will F. Anderson

editors
Mike Daines
Hans Dieter Reichert

editorial advisory board
Martin Ashley
Misha Anikst
Colin Brignall
David Ellis
Alan Fletcher

publisher
Bradbourne Publishing Ltd

origin
UK

dimensions
245 x 345 mm
9⁵/₈ x 13⁵/₈ in

c

art director
Hans Dieter Reichert @ HDR Design

designers
Hans Dieter Reichert
Dean Pavitt
Simon Dwelly

photographer/illustrator
John Chippindale

editors
Mike Daines
Hans Dieter Reichert

editorial advisory board
Martin Ashley
Misha Anikst
Colin Brignall
David Ellis
Alan Fletcher

publisher
Bradbourne Publishing Ltd

origin
UK

dimensions
245 x 345 mm
9⁵/₈ x 13⁵/₈ in

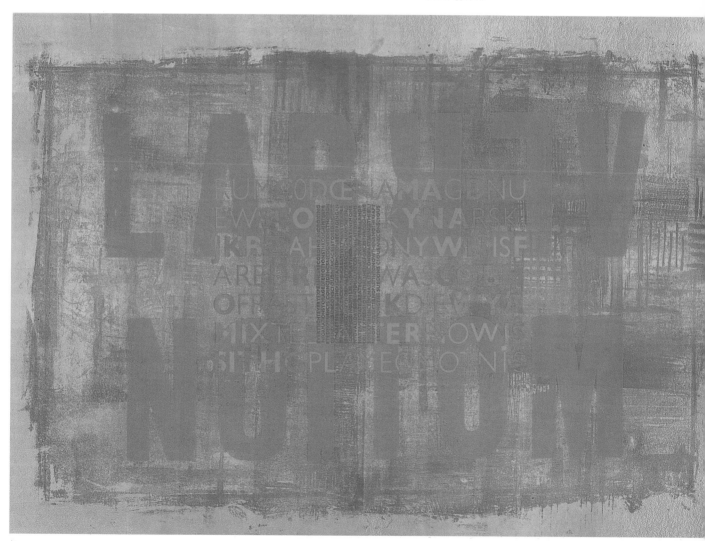

b

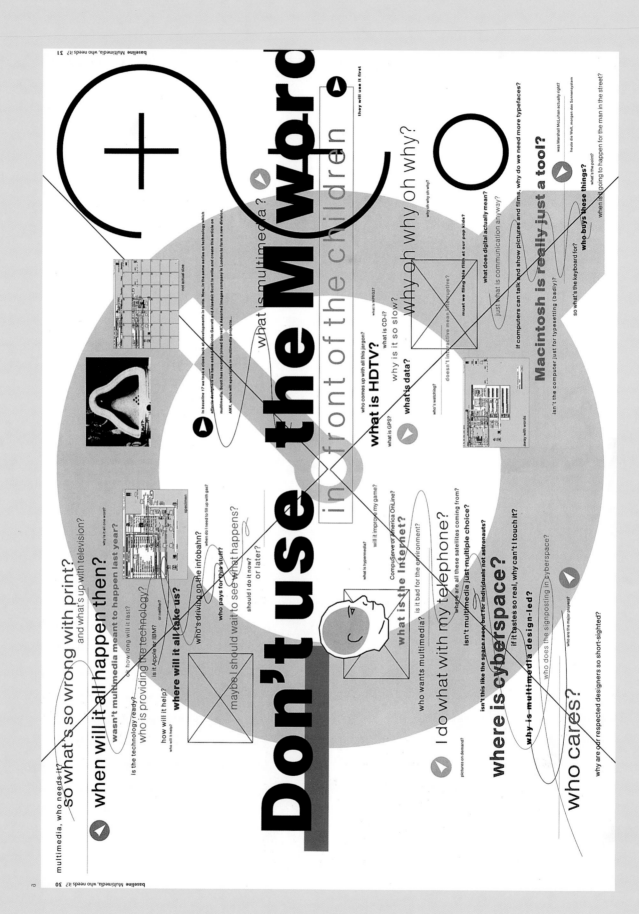

Don't use the M word

in front of the children

what is multimedia?

multimedia, who needs it?

so what's so wrong with print?
and what's up with television?

when will it all happen then?

wasn't multimedia meant to happen last year?

is the technology ready?
oh how long will it last?
who is providing the technology?
Is it Apple or IBM?
or neither?

how will it help?
who will it help?

where will it all take us?

who's driving on the infobahn?
when do I need to fill up with gas?

who pays for this stuff?

maybe I should wait to see what happens?

should I do it now?
or later?

why is it all one word?

In baseline 17 we took a close look at developments in fonts. Now, in the same series on technology which affects designers, we have asked Malcolm Garrett and Alasdair Scott to write and create this article on multimedia. Scott has recently joined Garrett's Assorted Images company in London to form a new division, AMX, which will specialise in multimedia projects...

who comes up with all this jargon?
what is MPEG2?

what is HDTV?
what is CD-i?
why is it so slow?
what is data?
what is GPS?
who's watching?
doesn't interactive mean interruptive?

Why oh why oh why?
why oh why oh why?

what does digital actually mean?
must we fling this filth at our pop kids?
what is communication anyway?
just what is communication anyway?
away with words

they will use it first

why will use it first

was Marshall McLuhan actually right?
heute die Welt, morgen das Sonnensystem
If computers can talk and show pictures and films, why do we need more typefaces?

Macintosh is really just a tool?
isn't the computer just for typesetting (badly)?
so what's the keyboard for?
who buys these things?
what's the point?
when isn't going to happen for the man in the street?

what is hypermedia?
will it improve my game?
CompuServer or America OnLine?
is it bad for the environment?

what is the Internet?
who wants multimedia?
where are all these satellites coming from?
isn't multimedia just multiple choice?

I do what with my telephone?
pictures on demand?
isn't this like the space race, but for individuals not astronauts?

where is cyberspace?
if it tastes so real, why can't I touch it?

why is multimedia design-led?
who does the signposting in cyberspace?

who cares?
why are our respected designers so short-sighted?
who are the major players?

not actual size
specimen

110

Interference *by John Holden, published by Umran Projects*

When photographer John Holden began to take photographs inside one of Europe's largest shopping [...] architectural space and the way in which it was being **used to create the 'ultimate shopping experience'**. He decided to locate the centre's security and surveillance cameras and to take series of pictures from these positions, tracking across the same fields covered by these devices. Holden made a selection from these random images, scanned and edited them on screen, creating a collection which reflects these images **which had informed the security presence.**

Holden believes that a city **becomes** a site for gathering and **exchanging 'useful' visual information**. He postulates that the photographer becomes part of this process, part of a system which seeks to attribute meaning and significance to isolated fragments and which reconstructs sequences of images obtained through often hidden devices. Holden concludes that this observation of routine movements determines new codes of **what is 'normal' or 'suspicious' behaviour** and creates environments in which we regulate our thoughts and actions accordingly. The combination of the design of consumer spaces and the surveillance devices creates a new form of 'public-private' space.

With these thoughts in mind Holden systematically photographed the city centre, the business areas at night and along the road systems leading to the airport.

Holden decided to publish the project in book form with [...] creating a book in which the photographs, **text and design** would complement each other. **Sean Cubitt wrote the text and Chris Ashworth** designed the book, adding to the project through the use of collages created from a combination of 'found' items; tickets, receipts and other 'urban documentation' from friends' collections, and the text. The typesetting utilised a Mac font designed by Ashworth, old faxes.

Holden expresses the hope that *Interference* makes some contribution to the debate which asks:
'what is individual freedom?'

The book is a fascinating and faintly disturbing amalgam. It can be read on many levels, the images, which are often almost abstract, can be noted or unravelled. The type itself reflects that myriad of unconsidered 'throwaway' typography at the bottom of the shopping bag or suitcase. *Interference* is sufficiently visually intriguing to tempt the reader into **the subject matter,** where Holden's success beyond his photographic achievement can be judged.

Text set in Formata Regular, Italic and Bold

Because symbols in Northern Ireland are so common and visually inseparable to the uninitiated, misperception by visitors is common. The media often get it wrong and tourists help to exaggerate the enigma. Once an American friend of mine pointed out to me that she found it incomprehensible that in Northern Ireland people blatantly expressed their political affiliations by displaying an 'L' for Loyalist or an 'R' for Republican on their car windscreens. A humorous observation to anyone who has ever been a 'Learner' driver in Northern Ireland, because when you pass your test you are 'Restricted' to a speed limit of 45mph for your first year. I've even made such errors myself and once saw a car tax disk saying 'Keep Ulster tidy, throw your rubbish in the Republic', although it wasn't on a car. Tourist gimmicks are not uncommon. You can buy 'Shankill Road' rock or a foot shaped lolly that says 'Kick the Pope'. You can even buy an 'Ulster Says No' mug, just in case you've forgotten what it was Ulster said while having your coffee – 'No' to what is the only other issue that might have slipped your mind.

Basically, visual propaganda has taken three directions, the first uses existing images and reverses the meaning. Remember the 'Watch Out there's a thief about' campaign of the 70s. The second is the romantic – idealistic in content but often beautiful in what it really represents. The third is a diary of recent events – used to express the points of view of recent political movements or events. The latter provides the core of the 'dialogue', creating a reactionary chronicle to

which either community responds. But it also is used as a path in order to achieve much wider communication. Initially, the art on the walls had the purpose of communicating directly and conspicuously to the local community, and to provide territorial markings.

In the late 60s and early 70s, this was probably the only accessible means of political expression. Eventually the walls became a focus for other forms of media. Once a mural would appear, the television cameras and newspaper photographers were quick to document it. This form of indirect publicity provided the channel the instigator required.

In recent months we have seen some major PR work done for the political wings of the paramilitary organisations. Their logos spruced up along with their dress codes. I'll even admit to beginning to like the look of the Sinn Féin logo since its been given the 'agency' treatment. It just makes me consider the idea that maybe more of these 'scribbles' have some quite inventive qualities to them and whether, in years to come, with a so called 'respectable' face applied, these images of war and sectarian liveries could become appreciated for other reasons.

Text set in Courier, Gill Sans regular, italic and bold

24 UDR Roll of Honour, Peoples' Democracy

25 Civil Order – plastic death, changes the word 'order' to 'murder', Sinn Féin

26 Ireland shouting at Britain with an earplug, campaign for free speech on Ireland, by Bill Sanderson, Leeds Postcards

27 A police photo-fit picture of Margaret Thatcher, Wanted for Terrorist offence, attributed to an anarchist group

28 The police free trade union logo Solidarity, used as part of a joint Unionist campaign by Ireland/dog, Sinn Féin 1970s

29 Britain/soldier being chased by Ireland/dog, Sinn Féin 1970s

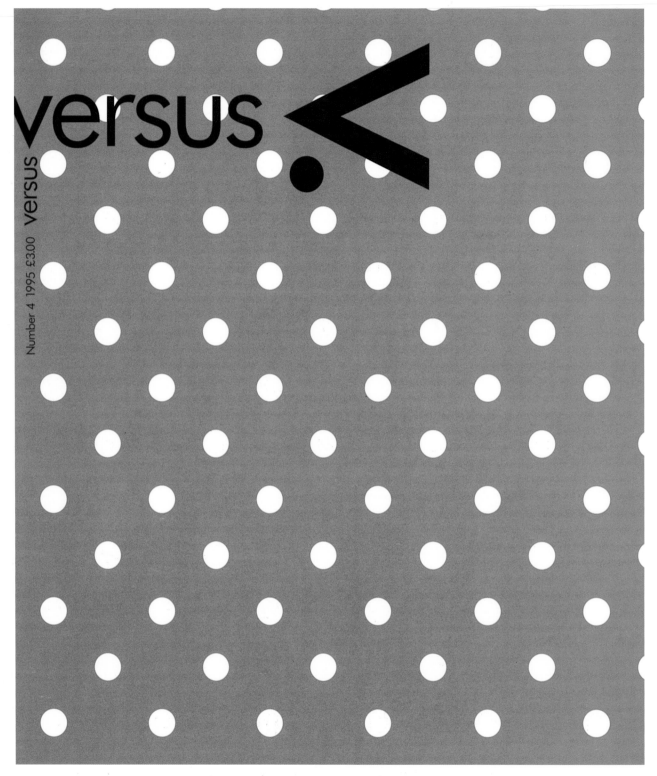

pages 112-13

Versus

art director Mark Hurst
designers Billy Harcom
Mark Hurst
Rob Stone

editors Heidi Reitmaier
Rob Stone
publisher Versus Contemporary Arts
origin UK
dimensions 245 x 285 mm
9⁵⁄₈ x 11¹⁄₄ in

LOUISE PURBRICK

A gallery. Some noise. Two photographs.
Twelve portable microfiche readers. Six desks with six
engravings. And some words. There is an announcement and an
inscription and the installation's title: *Those Days Are Gone*. The inscription,
taken from Walter Benjamin's 1936 essay *The Storyteller*, is written on the walls:
"A generation that had gone to school in a horse drawn streetcar now stood under the
open sky in a countryside in which nothing had remained unchanged but the clouds and beneath
these clouds, in a field of force of destructive torrents and explosions, was the tiny, fragile, human body."
Take the announcement and the inscription together. They read as words of warning about how nothing can be the same
again. A sense of loss is produced in Andrew Stones's installation, but without it's usual accompaniment: nostalgia. ¶
Nostalgia, according to a nicely punctuated entry in the *O.E.D.* is "sentimental yearning for (some period of) the past". Good use of
brackets. The *O.E.D.* compilers know what to put in parenthesis in order to explain that there may be a period of the past as the focus
for nostalgia, but not necessarily. Just the past will do. The appeal of the past is obvious: it has happened so it seems certain. It appears
easy to know. It feels familiar. Safe. The past provides comfort when the present only offers the capacity to change. Nostalgia is the longing
for the old as the new takes over: a traditional reaction. ¶The past produced by nostalgia as a place of safety has been used to justify a retreat
into tradition. And, some periods of the past have been preferred for this purpose. The Victorian era was pressed into political service during the
Thatcher regime to represent a traditional time when the power of the English nation-state was secure. ¶Nostalgia, and especially nostalgia for the

From Andrew Stones's installation

nineteenth century, is now a standard
strategy of conservative administration.
Hankering after the past is helped along
with a Heritage Ministry. Its projects
have been allocated funding from
the profits of the National Lottery.
Nostalgic enterprises look set to take over
even more gallery space than before.

After Tom Brown's Schooldays, 1993.

[versus ≮ 32 — left leaf]

Yet there is room to think
about music as revolutionary
in other senses. There is much
to be said for those musicians
who attempt to provoke their
audiences to think about
contemporary issues, or, at
least, to think at all. And while
too many fans of Billy Bragg
will sing along to the workers'
flag without stopping to
consider the context and
history of that song (and there
are other less obvious examples),
the place of popular music with-
in the cultures of the Left has a
significance that should be
fostered. We all like to dance,
'well many of us do (sorry those
who are complete klutzes and
know it. Myself, I will happily
make a fool of myself on the
dance-floor–I don't get thrown
off too often). The problem
is, how-ever, that the Left and
music still seems to be mired
in a simple equation of
Folk and Message, militant
content and arcane form.

But the revolutionary place of
music requires more justification than
as some kind of mass communication
shorthand capable of reaching those
who have been dissuaded from purchasing
Left literature on the High Street by
newspaper-sellers from hell. Nor can it be
just some kind of cultural therapy our
release valve for after live demo and/or to
raise money for jailed comrades, campaigns,
printing-presses and so forth. There are
more interesting things going on in clubs,
homes and the 'scene' (wherever that
interzone reality of today – SimCity 2000, I
guess). Most excellent, for example, has been
the evolution of the campaign against the
Criminal Justice bill(act from being a gut-
reaction defence of the right to party into a
wider youth publicisation which recognises
Government as the racist, capitalist, bigot-
enemy trying systematically to renovate a
tired imperialist back-water. ...Yeah, yeah
‹insert illustrative metaphor of ongoing
struggle ›. But there must be more that is
revolutionary about music for it to survive
ever-present commercialisation and make it
worthy of our continued support. What
might this be? Perhaps at a time when the
modes of communication, presentation and
dissemination are transformed exponentially,
music can still also be a means to think
differently. To think otherwise than we do
now–and excuse the clichés–to move beyond
the instrumental and repetitive thinking we
have been taught, and teach ourselves and
to listen for something other than the same
old tunes. Hey! Ho!...

This is not some Pied Piper evangelism but
something rather more modest or experi-
mental. I propose to consider music and sound
as dishармonious accompaniment to the con-
ventions of Western metaphysical thinking,
or, at least, as a possible (in)congruital melody
which could sound out a critique of Capitalism.
This would be well beyond the conventional
folksy version of Left music, but in some degree
extrapolated therefrom, and certainly requir-
ing studious attention to the minutiae of
Marxist argumentation. Too often the dull and
grim struggle of the sloganeering Left allow
people to skive off the hard work of having
to read those old texts. No easy task, but
there's no avoiding it either.

Basically, the first and most general
step in my argument is that music is
not just there. It's a communal thing,
produced, performed and heard in a
context. Today that context is, to a lesser
or greater extent, at the productive
margins of Capitalism – be it rave/techno
or bhangra/jungle, banned or platinum,
big megabucks production or four-buck
amateurs, Ice T or Kylie M, or even your
local garage grunge-party DJ dreamer,
whoever you know. But, wherever and
whatever it is, music can be considered
over against, even resistant ‹in your
dreams› to commerce and the contexts of
the market. Not always, and often only
barely, but there is–still–something
excessive in sound, something surplus.
So, in order to rethink this context it might
be useful to suggest that the sounds we
consider, say, under the formation
'popular music', as like classical music,
even musical notation, or even like writing,
as a record, are co-constituted in time with
audiences as presence; (text and eye,
instrument and ear). People together in
the context of sound. Now, just what is
music? We have been taught of late to
think of it as product, but what do we
mean? Music is a context of sound. We
hear it, but it is not the hearing. We play,
but not just to play. The context of music
offers us an immediacy which has been
broken down into constituent and market-
able components. In part of the double
deceit of capital, music seems now con-
tained in the performed, or recorded 'nature',
of sound in the context of purchase, and
we have come to believe – mostly through
the privileging of presence in writing – that
the recording is a way of retaining sound
and the performance is a presentation of
sounds (and visuals since MTV, Madonna,
etc.) The disruptive point to introduce here,
so subtle, is that the presentation or the
recording suggests a level of articulation
worthy of music which is not music itself. A kind
of echo of music in the market. This dou-
ble structure has been a silent facility in the
commercialisation of sound (a role dep-
loyed to the performers' skill or memory,
or to musical notation in live performance,
but most significant since the develop-
ment of vinyl, the cassette tape and the CD).

[versus ≮ 33 — right leaf]

This must be dealt with in terms of the
labour theory of value as understood by
Marx in the latter sections of *Capital* (and
modified in part given new understandings of
the status of endless playings of a CD and the
availability of on-line clips down on radio, cyber
caf – again given the co-constitutive 'labour' of
the listener). The labour that is required to
produce an object, or objects – in this case a CD,
CD player, speakers and all other crisis – is
labour that has been stolen from labourers
by capitalist investors.

Although the co-ordination of capitalism enables
mass production and distribution, it is on the
basis of this co-ordination, and ownership of
the means of production, distribution etc, that
capitalists are able to exploit the inequity of a
process where work is not paid according to its
return, the value it creates on the market.
Basically, a very long story which must be read
in detail, amounts to the theft of labour by a
bunch of old men in suits, and others not so
old, with ponytails and sportscars, but also in
suits. This theft of value extends, I think it can
be argued, to the various forms of 'work' it is
necessary for you to do in order to be in a
position to be a listener, and so make music.
This co-constitution of sound requires us to
rethink consumption as a production subsumed
within a capitalism which colonises all aspects
of life (Marx's 'real subsumption' discussed in
Capital vol. 3 could be usefully elaborated – a
reading offered by the lyrical Antonio Negri
begins this work – see *More Beyond Mord.* Hmmm.

That sounds too difficult, check it out though.
It may be right. And it makes us focus upon the
communal context of music in a more sophisticated
way than previous Lefty-folksy music derhave to me.

Instead of exploring the endless permutations
and distinctions of this part of a sophisticated
labour theory of value (that's too long and
winding a road, but I am trying to get back to
it), it is possible to draw in other interesting
works for similar ends. In a related register it
might also be suggested that a recording is a
kind of negative. Not only as a product, but
certainly essential for the structure of capital
which requires a purchase and a development
on the part of the listener/consumer. It is clear
that a recording is not yet the sound, and never
can be, and must be decoded or – excuse the
German – 'aufhebung', if it is to become the
sound. A performer must play the piece, read
the notation, or a CD must be put into the
player and the play button pressed, etc.

Further development of this point would
require a difficult contemplation of the
ontological status of the negative (check
out the down rhythms of Giorgio Agamben's
Language and Death) and its relation to the
dialectic (see that old beat philosopher and
techno DJ Martin Heidegger who zoks in *Sein
und Zeit* 'why does every dialectic take refuge
in negation,' 332). The recording is somehow
the negation of sound itself negated to repro-
duce sound. The diamond stylus in contact
with the groove of vinyl is an easier represen-
tation of this, but the digital complexity of
the CD is not so far removed from the notations
of a Beethoven and so on."

The point is not to abandon all recordings (a
rerun of the fun of dumping televisions out of
apartment windows – not revolution but to
rethink music as mutual co-production in need
of a recovery operation to undo the negative
appropriations of capitalism and industry.
The task of a revolutionary rethinking of sound
then might attempt to link the anti-
establishment ethos of some, admittedly not
enough) popular music to this scene of
negativity with a view to transformation. Not
that everything must be understood as moving
in a negative dialectic (since some might even
call this break-beat), and neither is it the case
that a simple overcoming of outmoded musical
styles will help settle old scores – at least not
without considerable practice. But the rethinking
of the negative in music as part of a dialectical
movement, although within the thinking of
Western metaphysics, as negative invention,
should offer the possibility of thinking
otherwise – and so through a mass movement
help manifest an alternative to capitalism or, at
least, the possibility of disruption and
dysfunction within the next crisis-recon-
struction-crisis cycle of the corporations. It is
the beginnings of this that some may recognise,
intuitively, in the links between music and politics
made explicit every now and then. The next step
would be to base this explicitly on a further
reasoning of music politics that goes well beyond
dissafest-poseurs and the star-syndrome of pop.

Rave, Jungle begin a more inclusive politics
of sound. Seriouseyeslly, the overcoming of
exploitative (negative) capitalist relations would
thus initiate a revolutionary transformation of
life – with a beat you can dance to. That's be
cool. Music, Amusement, the Muse bemused.

To demonstrate this more
clearly it is easiest to consider
the technology. The point is
that a recording is something
in the form of minute grooves on
vinyl or strings of numbers on
a three-inch circular diskette
capable of laser translation
(or whatever – how do they do
that?) is not yet music. There
must always be a playing and a
listening for there to be sound
– and this listening is not the
simple consumption of clichéd
economics. There are moments
of consumption, but whatever
is required, in the age of digital
reproduction, is an evaluation
of the repetitive listenings
brought into availability by
these technologies. With a
CD, but also with musical
notation, with the vinyl album,
and even with the rehearsed
performance, the sound is
remade over and over by
each listening, just at each
reading of a text is a new
bringing forth. Endlessly.

1

Object

art directors	1, 2, & 3 Zoe Wishart @ ANTART
	4 Heidi Riederer @ Organised Design
designers	1, 2, & 3 Zoe Wishart @ ANTART
	4 Heidi Riederer @ Organised Design
editor	Helen Zilko
publisher	Centre for Contemporary Craft
origin	Australia
dimensions	210 x 275 mm
	8¹/₄ x 10⁷/₈ in

2

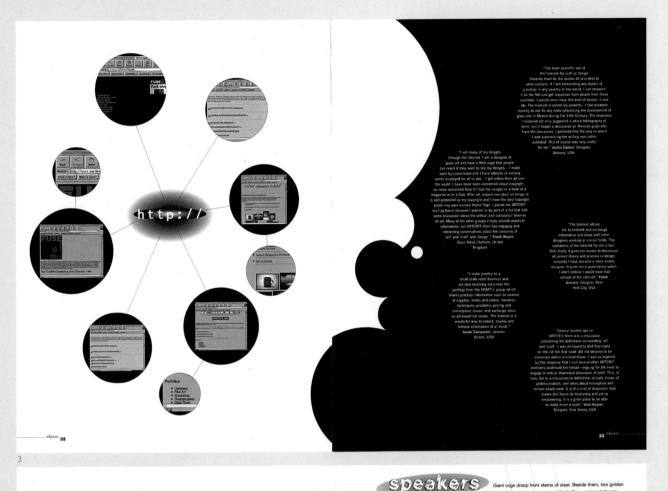

"The most powerful use of the Internet for craft or design theorists must be the access [it provides] to other cultures. If I am researching any aspect of a culture in any country in the world, I can research it on the Net and get responses from people from those countries. I would never have this kind of access in real life. The medium is incredibly powerful. I had occasion recently to ask for any texts referencing the development of glass arts in Mexico during the 19th Century. The responses I received not only suggested a whole bibliography of items, but it began a discussion on Mexican glass arts. From the discussion, I gathered that the way in which I was approaching the writing was rather outdated. This of course was very useful for me." Jackie Carbee, Designer, Arizona, USA

"I sell many of my designs through the Internet. I am a designer of glass art and have a Web page that people can reach if they want to see my designs... I make work by commission and I have editions of existing works displayed for all to see... I get orders from all over the world. I have never been concerned about copyright; no more concerned than if I had the images in a book or a magazine or in a flyer. After all, anyone can steal an image; it is still protected by my copyright and I have the best copyright proof—my own marked Home Page. I joined the ARTCRIT mailing forum because I wanted to be part of a list that had some discussion about the critical and conceptual theories of art. Many of the other groups simply provide practical information, but ARTCRIT often has engaging and interesting conversations about the concerns of 'art' and 'craft' and 'design'." Frank Wayne, Glass Artist, Durham, United Kingdom

"The Internet allows one to network and exchange information and ideas with other designers working in similar fields. The usefulness of the Internet for me is two-fold: firstly it gives me access to discussion of current theory and practice in design; secondly I have become a more visible designer. It gives me a prominence which I don't believe I would have had outside of the Internet." Frank Jenssen, Designer, New York City, USA

"I make jewelry as a small-scale retail business and am now receiving via e-mail the postings from the CRAFT-L group which shares practical information such as sources of supplies, books and videos, societies, techniques, problems, pricing and marketplace issues, and exchange ideas on philosophical issues. The Internet is a wonderful way to collect, display and retrieve information of all kinds." Susan Campanini, Jeweler, Illinois, USA

"Several months ago on ARTCRIT there was a discussion concerning the definitions surrounding 'art' and 'craft'. I was dismayed to find that many on the list felt that 'craft' did not deserve to be discussed within a critical forum. I was so angered by this response that I and several other ARTCRIT members continued the thread—arguing for the need to engage in critical theoretical discussion of craft. This, in turn, led to a discussion on definitions of craft, issues of professionalism, and ideas about conceptual and edition-based work. It is this kind of discussion that makes this forum so frustrating and yet so empowering. It is a great place to be able to really make a mark." Jean Kayser, Designer, New Jersey, USA

Mandy Martin

Bronwyn Bancroft

Ironsides

An unusual brief. 100 artists were given a 40cm square piece of corrugated iron as a base material to work with. The results were painted, sculpted, cut, welded, glued, rusted and blowtorched. Bronwyn Bancroft said, "I called it Will of Iron. Hey, it's a sign of the times—let's pick that Aboriginal artist because she's so political. I was born political. Let's pick that Aboriginal artist because she talks our intelligent language. Colonisation stole my language. It would be great include her in this exhibition but her works are not traditional. My tradition is myself, my family and my genealogical ties."

And as Mandy Martin said, "I have just read Faulkner and was pondering the wilderness within, as well as many years of settlement. I was also affected by the short required for decay, nevertheless I was optimistic - hence old tin, new tin. This is also a sign of the country and becomes a comment on colonisation."

In October 1995, the works were auctioned to raise funds for the $2 million Stage Two of the New England Regional Art Museum which will enable permanent display of the Howard Hinton and Chandler Coventry collections, as well as other exhibition spaces, a sculpture terrace, a theatre, artist's studio, cafe and expanded bookstore.

RFC Glass Award

Deb Cocks' slumped, enamelled and engraved glass plate titled Stream won the $7500 prize in the inaugural RFC Glass Art Award, sponsored by the merchant bank, Resource Finance Corporation, and established in conjunction with the Glass Artists Gallery to highlight innovative developments in Australian glass. As one of the judges, Karilyn Brown said: "The conceptual depth, technical proficiency and commitment to pushing boundaries which characterised much of the work submitted for consideration was a challenge for the award selectors." Stream has been acquired for Resource Finance Corporation's permanent collection.

Detail of Stream

Oops!

In the last issue we ran a story in fresh on the new and innovative Gallery Funaki but illustrated it with an image of the Production - Reproduction exhibition, designed by Suzie Attiwill for Gallery 101, Melbourne. Object apologises to Mari Funaki and all our readers who noticed that Gallery Funaki had metamorphosed overnight.

speakers

Giant cogs droop from stems of steel. Beside them, two golden discs balance on chrome as a black ellipse swings between intersecting rods.

Everywhere there is music. This place of sci-fi fantasy and hi-fi sound is not the elaborate set of some Spielberg blockbuster but the combined creative genius of nine Sydney artists who've collaborated with acoustic engineer, Ralph Waters, to produce Speakers—a dramatic exhibition of full range, hi-fidelity loudspeakers which are breathtaking works of art.

Irreverent and hybrid, the speaker sculptures include a human face moulded from silicone masks and made into plaster; a space-age coffee table hacksawed and hammered out of rusted and polished steel; a two-metre high metal geometric form using wheels, clear enamel and recycled saw blades; a 3-dimensional suspended ellipse of plastic and metal; a whimsical version of a sitting canine just six inches high.

Waters says the life expectancy of the sculptures in Speakers is probably better than mass-produced black box versions. "Most of these will still be kicking around in 10 to 15 years time," he says. "A really good set of speakers will cost around $3000, and that's a mass produced item in a box. The asking price for a number of these sculptures is less than that. What you're actually buying here is high quality sound and a unique work of art. Putting a price tag on that is very difficult."

Speakers features the work of Frederic Berjot, Rosalind Butler, Michael Dickinson, Linda Franklin, Martin Lee, Matt Long, Brett Rose, Peter Vella, Nicholas Vicic, Diane Penney (photographer) and Ralph Waters (sound engineer). It was first exhibited at the UTS Gallery, Sydney, 17 October-7 November followed by an exhibition and performance at the ABC's Atrium Gallery, Sydney, 16 November-7 December 1995. In 1996 it will tour to other capital cities and North America.

Photography: Diane Penney

Diane Penney and Catherine Clifford

Strength

designers Beth Fritzsche
 Emily Raively
photographer Emily Raively
editor Christian Strike
college School of Design,
 University of Cincinnati
tutor Robert Probst
publisher Christian Strike,
 Delinquent Publishing
origin USA
dimensions 210 x 275 mm
 8¼ x 10⅞ in

116

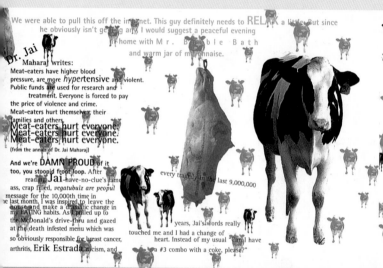

We were able to pull this off the internet. This guy definitely needs to RELAX a little. But since he obviously isn't getting any I would suggest a peaceful evening at home with Mr. Bubble Bath and warm jar of mayonnaise.

Dr. Jai

Maharaj writes:

Meat-eaters have higher blood pressure, are more *hypertensive* and violent. Public funds are used for research and treatment. Everyone is forced to pay the price of violence and crime. Meat-eaters hurt themselves their families and others.
Meat-eaters hurt everyone.
Meat-eaters hurt everyone.
Meat-eaters hurt everyone.

(from the annals of Dr. Jai Maharaj)

And we're DAMN PROUD of it too, you stoopid froot loop. After reading Jai-have-no-clue's lame ass, crap filled, *vegatubulz are peopul* message for the 10,000th time in the last month, I was inspired to leave the house and make a dramatic change in my EATING habits. As I pulled up to the McDonald's drive-thru and gazed at the death infested menu which was so obviously responsible for breast cancer, arthritis, Erik Estrada, racism, and every tragedy in the last 9,000,000 years, Jai's words really touched me and I had a change of heart. Instead of my usual "Can I have a #3 combo with a coke, please?"

I shouted,

"Yo Bitch! I want a fukn quadro-pounder with no fukn vegetabulz or shit that growz on treez!"

"OK sir, you wanted a Quarter pounder, just plain, is that correct?"

"No Bitch! I zed I wanted a fukn quadro-pounder! Get it rite or die!"

"A what pounder?"

"A fukn quadro-pounder!"

"Uh...I don't think we have that. Are you sure you don't mean a quarter pounder?"

"No I don't meen a jukn meezly azz quartur pounder! Her'z what I want—

2 fukn double quarter pounderz

put together 2 make 1 quadro pounder!"

"Oh, OK...I think we can do that. Would you like cheese on that?"

"Fuk no Bitch! I want 4 hot slabz of cow deth on a bun with no fuking hippie azz vegetabulz! I alzo don't want any fuking lame vegan friez or any type of recykuls pakaging. No kup, no bag, no wrapperz. Put the shit on the window counter thing and I will take it. And tell Jai to go fuk a kokkonut too!"

"Who?"

"Fuk-it and gimme that which iz source of all evil...Now!"

"Thank you, please drive to the 2nd window."

For the record, I got my fucking Quadro pounder and it rocked. I am faxing McDonald's tomorrow and demand that this awesome item be permanently added to every McDonald's menu around the world.

I'm hypertensive. I'm violent. And if you get in between me and plate of animal death, I fucking kill your pathetic ass and go kill some trees in order to build coffin to bury you in.

Deth iz imminent. The earth muzt die. Meat eaterz are the majority fuking pissed. Give us what we want or be prepared to face the

CAUTION CAUTION CAUTION CAUTION CAUTION CAUTION CAUTION CAUTION CAUTION CAUTION CAUTION CAUTION CAUTION CAUTION CAUTION CAU

The two had started their journey the night before when Wimsatt's father dropped them off on the interstate in Gary, Indiana. Almost immediately, they were picked up by a police officer, who searched them for drugs, shaking out a baggie of granola in an effort to locate illegal substances.

Finally, at Barbara's quick-thinking request, the officer took them to the Greyhound station where they were reunited with Wimsatt's father, who had noticed their predicament before driving away. He took them back home to fetch Mrs. Wimsatt's ID—her son doesn't have any—and deposited them back at the bus station where they resumed their trek. "I had to wear a long-sleeved shirt buttoned up to the neck. It was very uncomfortable," says Mrs. Wimsatt, whose last hitchhiking adventure took place in Spain when she was a young girl.

"I didn't want her to look vulnerable," explains her son, who speaks from experience. He has spent the last two summers hitchhiking across the country.

"I usually get picked up in 20 to 30 minutes," he continues, explaining that he is very deliberate about his appearance. He carries a sign, smiles, waves and tries to keep clean.

"I get a lot of virgins," he smirks.

"Approximately one in a hundred people would be willing to pick me up," he says. "It's basically a rare person." The two biggest myths (about hitchhiking) are that people who are going to pick you up are truckers and crazy people," he continues. "Truckers almost never pick you up because of liability. One in ten rides is a single woman. Couples are one in fifty. One in fifty are black peo-

ple. Almost all rides are single men. The main thing they have in common is that they're all extraordinary in their own lives.

They're extraordinarily compassionate. They're risk-takers. They're independent thinking. They're making up their own minds and using intuition. Those qualities carry over to the rest of their lives."

This is the first time that Wimsatt's mother has accompanied him on the journey. Her explanation for the journey? "It's easier to go on the trip than to stay home and worry."

During the course of the interview, Wimsatt turns to his mother and asks her what she has learned from hitchhiking.

She answers without a beat: "That I have to wear a long-sleeved shirt."

Wimsatt shakes his head in exasperation. "What you're supposed to learn," he lectures, "is that you're not to be so petty, selfish. My problems are trivial. I have so many resources and luxuries in my life. All this stuff that seems such a big risk pales in comparison to involuntary risks so many Americans are exposed to just because of the circumstances of their birth."

Graffiti artist, journalist and community organizer, William "Upski" Wimsatt has devoted the better part of his young life to the world of hip-hop, graffiti and racial politics. The title of his book, Bomb The Suburbs, like his middle name, comes from the language of graffiti. To "bomb" means to spray or tag; and "Upski" is graffiti parlance for having your name

up and around.

Says Wimsatt: "If you look at what graffiti is in many ways it's a perfect reflection of our society, at least of a lot of the behaviors that are at the core of our way of life: empty fame, self-centeredness and the idea that everyone is basically out for themselves."

In his book, Wimsatt decries, among other things, the tagging of the inner city—especially that of the public transport system.

"Suburban kids have always come into the city to bomb and we've shown them around," he writes. "It's coming time for them to start showing us around there."

"When I talk about the suburbs," he elaborates, "it's mostly as a metaphor for anyone anywhere who makes a problem worse by running away from it. It just so happens that a lot of those people live in the suburbs."

Brought up in the affluent Chicago suburb of Hyde Park to Jewish parents, the 22-year-old has consciously immersed himself in the culture of the inner-city. Wimsatt is very much aware that he is straddling two worlds: the one he came from and the one he longs to be part of.

"I'm not really bridging the gap," he says. "I'm running back and forth between all these armed camps, redistributing some of the insights."

The conversation grows tense as we talk about graffiti. His mother is dead set against it.

"What I really hate about graffiti is the danger," she says. "It's very toxic. I don't think that spray paint should be legal. He could

be shot by a cop, electrocuted, run over by a train. "As an afterthought, she adds: "I don't like hitchhiking either.

The blurb "Why you should read this long-ass shit" appears on the back cover of Bomb The Suburbs and sets the tone for the book. "It's an immature work," he says. "No mature person would like this book. The main fact about the book, not anything having to do with the merit of the book itself, is that it shows just how much is missing from publishing today: youth, subculture, politics and how low the quality of discussion is."

He targets his audience in the first few pages of the book: "First, there's the old-schoolers who want to break away from what has become hip-hop; hitchhikers who have the patience to

udhoney

STRENGTH

"~~SASSY~~ cute band alert"

CAST:
MARK ARM: GUITAR, VOCALS MUDHONEY
MATT LUKIN: BASS MUDHONEY
STEVE TURNER: GUITAR MUDHONEY
DAN PETERS: DRUMS MUDHONEY
steve beraha, chris mashburn,
christian strike, brian bares: clownasses
setting: in the back of their van.

WHO HE WAS. ML...WE FIGURED WE WOULDN'T HAVE TO DO A LOT OF EXPLAINING BECAUSE WE HAD WORKED WITH HIM BEFORE. HE KNEW HOW WE WORKED AND WE HAD TO REMIND HIM HOW HE USED TO WORK. HE GETS INVOLVED WITH ONE THING AT A TIME AND KNOWS HOW TO HANDLE ALL THE STUDIO STUFF THAT GOES ON.

MA: A LOT OF PRODUCERS LOOK AT MAKING A RECORD AS PART OF BUILDING UP A RESUME, A PORTFOLIO OR SOMETHING. IF THEY GET THIS COMMERCIAL SOUND AND IT MAKES THE BAND SELL, IT MAKES THEM MORE VALUABLE. SO WE HAD TO HELP HIM FORGET ALL THAT. AND HE WAS PRETTY WILLING TO FORGET IT. I THINK IT WOULD HAVE BEEN A LOT HARDER IF WE HAD GOTTEN SOMEBODY THAT THE RECORD COMPANY HAD SUGGESTED.

cs: was there reasons why you didn't stick with kurt bloch or conrad uno (who did your previous stuff)?

MATT: WE JUST WANTED A CHANGE OF ATMOSPHERE, PLUS WITH PIECE OF CAKE, WE ALL DECIDED IT WASN'T OUR FAVORITE SOUNDING RECORD.

MA: WHAT HAPPENED THERE WAS A BIT OF TECHNICAL STUFF THAT WE DIDN'T REALLY UNDERSTAND AT THE TIME. THE TRACKS WERE RECORDED AND IT ENDED UP SOUNDING A LITTLE BIT THIN.

cs: what artists have you been listening to lately?

DAN: (HANDING US SOME TAPES) WE REALLY LIKE BOB DYLAN AND LYNRD SKYNRD. MA: (POINTING TO THE HEAP OF TAPES) ACTUALLY THOSE ARE TWO

When Mudhoney was on the road opening for Pearl Jam, PJ got invited to see Bill, Hillary and their lovely daughter Chelsea. Mudhoney tagged along and upon arrival the two groups were led in different directions. Despite being snubbed at the White House by Dollar Bill, Mudhoney is still plugging away. Almost oblivious to the musical explosion witnessed there several years ago, the grandpappy of the Seattle music scene Mudhoney delivers their newest release My Brother The Cow. With better things on their mind than cashing in, Mudhoney serves up the most disease ridden album in years. With their unique mix of sixties garage rock and punk, Mudhoney rises above the aponymity of the dull grunge sound.

↓

christian: so how much time are you spending with bloodloss?

MARK ARM: EVERY WAKING MOMENT I'M NOT WITH MUDHONEY.

cs: how come you guys didn't cash in on the seattle bandwagon?

DAN: IT WASN'T A CASE OF NOT WANTING TO....
MA: WE JUST DIDN'T.

steve beraha: have you ever considered trying to get russ meyer to direct one of your videos?

MA: WELL, WE NEVER REALLY THOUGHT OF IT, BUT NOW THAT YOU MENTION IT.
DAN: THAT'S A HELL OF AN IDEA.
MA: I'M NOT SURE HE'D BE INTO IT, I DON'T THINK HE'S REALLY INTO ROCK AND ROLL. IT'S AN INTERESTING IDEA THOUGH. WE'D BE INTO IT. BUT ISN'T HE COMING OUT WITH A NEW FILM OR SOMETHING?

chris mashburn: i've heard the bra of god or the breast of bluelies...

MATT LUKIN: "I THINK HE'S BEEN ON TALK SHOWS LATELY. HE'S BEEN POPPING UP."

cs: why did you go back to jack endino to produce this record?

MA: IT WAS EASY. HE KNEW WHO WE WERE. WE KNEW

DIG...I REALLY
BLACK SABBATH AND BOOKER T.

cs: what about some up and coming bands out where you are, bands most of us haven't heard yet?

MA: STEEL WOOL FROM SEATTLE IS A PRETTY GOOD BAND. UH...I DON'T KNOW...MY OTHER BAND BLOODLOSS IS REALLY GOOD...HA HA.
DAN: I JUST DON'T FIND MYSELF BUYING MUCH NEW STUFF. WE GOT REALLY BURNED OUT ON A LOT OF STUFF.
MA: MAYBE WE'RE JUST OLD AND CRANKY.
DAN: THERE'S JUST SO MUCH SHIT OUT THERE. SO MUCH OF IT SOUNDS THE SAME.
MA: BUT THERE'S SOME TRIED AND TRUE THINGS OUT...THE (JON SPENCER) BLUES EXPLOSION AREN'T ABOUT TO LET YOU DOWN.
DAN: CLAWHAMMER'S A GREAT BAND. DEFINITELY ONE OF MY FAVORITE BANDS RIGHT NOW.

cs: it's too bad that we are being overwhelmed with all this crap when so many good bands just aren't getting heard.

MA: IT'S ALWAYS BEEN LIKE THAT, BRIAN: IT'S ABOUT BUCKS.

Strength

designer	Jeff Tyson
photographer	Christian Strike
editor	Christian Strike
college	School of Design, University of Cincinnati
tutor	Robert Probst
publisher	Christian Strike, Delinquent Publishing
origin	USA
dimensions	210 x 275 mm 8¹/₄ x 10⁷/₈ in

Strength

designer Scott Devendorf
editor Christian Strike
college School of Design,
University of Cincinnati
tutor Robert Probst
publisher Christian Strike,
Delinquent Publishing
origin USA
dimensions 210 x 275 mm
8¹/₄ x 10⁷/₈ in

118

I DISAGREE WITH WHAT YOU SAY, BUT I DEFEND TO THE DEATH YOUR RIGHT TO SAY IT. VOL

METHOD MAN

SMACK

CYPRESS HILL

MUDHONEY

THE MELVINS

THE JESUS LIZARD

CIRCLE JERKS

NOIZE

3 12 19 23 28 32 45 54 62 70 89 95 95 97 100 1

DONGER

DENALI
TAHOE 36
MT. HOOD 41

MACHADO / S. AFRICA
DONOVAN 76
NORTH SHORE 80
PUERTO ESCONDIDO 84

MISSY GIOVE
DOWNHILL MTBiking

SHOW

CELLULOID

INK

"They worship strength because it is strength that makes
all other values possible. Nothing survives without it."
Dr. Han, the diabolical villain in the Bruce Lee classic *Enter the Dragon*.

Everything that is good in our world derives from strength. Individual
achievement, creativity, original thought are the necessary ingredients to
rise above the masses. The dark forces present today are fueled by weak-
ness. Weakness in the form of racism, ignorance and lack of awareness.
And to quote the late Motley Crue's Vince Neil, "...so come now children of
the beast, be strong and shout at the devil."

Cover photos:
Jason Beaton in Denali/John Kelly
Rob Machado/Balzer
Donger/Ed Dominick
D. Yow/Strike

DELINQUENTS
Christian / ewqr;ogfu5t[og
Nick Gluckman / sheep procurement
Scott Devendorf / g money
Will Bramlage / discipline and bondage
Brian / clownass
Jonathan / johnny bravo
Amy / feminazi
Bill / bill
Poser Dave
Rob

DESIGNERS
Mike Brewer / Vernon Turner / Paul Davis / Jason Langdon / Katie McCormick / Barrett Schubert
Ann Beiersdorfer / Steve Arengo / Matt Berninger / Beth Fritzsche / Emily Raively
Scott Devendorf / Keith Knueven / Jeff Tyson / Eleni Ferraro / Casey Reas / Peggy Henz
Mikki Maguire / Jen Oen / Steve Ruff / Wendy Zent / designed summer 1995 @ univ. of cincinnati

BULLSHITTERS
Harry Johnson Trey "Dickhead" Martin
Hugh G. Rection Mike Hill
Hy Jean David Armin
Rob Gibbons Matt Moesker
Michael Preonas Sonny Mayugba
Nordberg Willie Spanker
Soren Baker Mike Hunt
Harry Johnson Ron Jeremy
Anthony Gozzo Cornbread Williams
Billy Felix Jeyes

PICTURE PEOPLE
Joseph Cultice Mike Balzer
Ed Dominick Chris Carnel
Rob Gracie Richard Cheski
Katja Delago John Kelly
Florian Wagner

STRENGTH magazine is published bi-monthly ($17.00 per year)
by Delinquent Publishing 5050 Section Avenue Cincinnati OH 452
Second-class postage pending at Cincinnati OH.

POSTMASTER please send change
of address to: *STRENGTH magazine*
5050 Section Avenue Cincinnati OH 45212
tel / 513 531 0202 | fax / 513 731 5513 | email / strength@igl
all rights reserved ©1995 *STRENGTH*

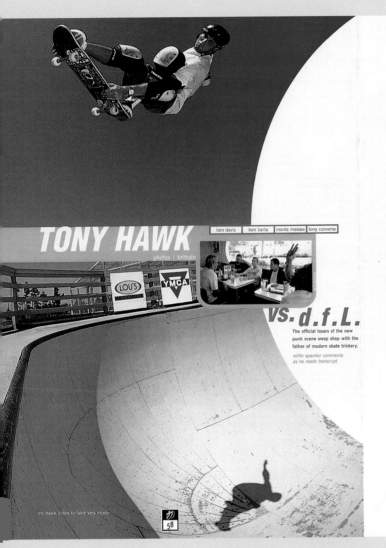

TONY HAWK

photos | brittain

tom davis | tom barta | monte messex | tony converse

vs. d.f.L.

The official losers of the new punk scene swap shop with the father of modern skate trickery.

willie spanker comments as he reads transcript.

mr. hawk indies to fakie very nicely.

58

What was the first skate you ever rode?

TH: A Bane that my brother gave me in, like '78 or '79.

How long have you been skating?

TH: Seventeen years.

Do you have your own company now?

TH: Yeah, Birdhouse.

Do you have riders?

TH: We have like ten guys we sponsor, with like six pros, including myself.

Monte: Did you ever think about sponsoring a team of only, like old school skaters that really can't do any tricks except like ride banks and stuff?

TH: Um...

Monte: Have you ever considered that? I tried to get Girl to do that, and they wouldn't do it. I've tried repeatedly to get like, just the playground skateboarding scene going, banks, laybacks, kick turns...

TH: It would almost be like you'd have to start a separate entity to do that, and just be devoted to that. Because it would be hard to melt a really technical, new school skate company with that, and do advertising. It would be hard to combine that.

Monte: That's kind of the same answer I got from Girl, I'll keep shopping that one around.

willie: "whatever."

Converse: I think that's one for Alva.

When's the last time you skated a pool?

TH: Probably Japan. They built a bowl inside of a skate shop in Tokyo and we skated there in May, I think.

What's your favorite old skatepark?

TH: Probably Whittier.

What about Marina?

TH: Uh, yeah. I was actually at Marina the day they shot the cover of Circle Jerks' *Group Sex*. I was a little kid scared to death of what I saw.

Davis: I was on the cover of that.

TH: Were you?

Davis: Yeah.

TH: Were you in the bowl?

Davis: Sitting in the bowl, yeah. That was back in the day.

TH: I was just there skating that day. They were closing and then all these crazy looking people started walking in.

Do you think the whole punk

revival will last com- pared to the skate revival?

TH: Its hard to say. The skate-boarding revival, I believe, is largely due because skateboarding has pro-gressed through its dead years, even when no one was doing it. The thing that bothers me about punk is that there were so many good bands years back, when it was popular, and the now the ones that are making it are just kind of processed for the public.

Who are your favorite old punk bands?

TH: I was really into the Addicts, Dead Kennedys, and the Circle Jerks. I still like New Model Army a lot. The first time I ever met Duane Peters was at Colton skatepark and he was with Salba. He just looked at me and spit at me and said, "This is punk rock, kid.". That was my first introduction to what punk was.

Who do you think the hot girl skaters are right now?

TH: I don't really know. I don't know their names, but I've seen some girls who are doing a lot of the street-type tricks, kickflips and stuff. Pretty consistently, too. There's been a few very good vert skaters, too.

Which ones?

TH: Well, the most famous skater is Carabeth Burnside. In fact, I just tried out for a commercial with her the other day. She's still skating. Actually, she's snowboarding more because she gets paid for that.

willie: "dude, this interview's stupid."

Have you skated Burnside?

TH: In Portland? Yeah.

Could you walk us through your run?

TH: Um, I drop in where the big hip is. Oh no, actually, I drop in where the quarter pipe is, which is near the corner,

Strength

designers	Matt Beebe
	Scott Devendorf
photographer	Brittain
editor	Christian Strike
publisher	Christian Strike,
	Delinquent Publishing
origin	USA
dimensions	210 x 275 mm
	8 1/4 x 10 7/8 in

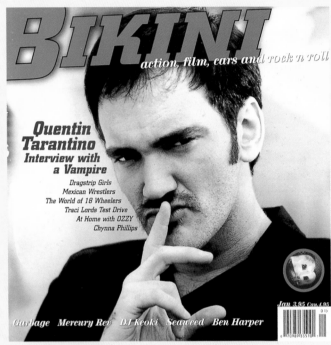

Quentin Tarantino Interview with a Vampire

Dragstrip Girls
Mexican Wrestlers
The World of 18 Wheelers
Traci Lords Test Drive
At Home with OZZY
Chynna Phillips

Jan. 3.95 Can 4.95

Garbage Mercury Rev DJ Keoki Seaweed Ben Harper

photographer John Rutter

pages 120-21

Bikini

art director John Curry
designer John Curry
editor Ryan M. Ayanian
publishers Jaclynn B. Jarrett/
 Ray Gun Publishing
origin USA
dimensions 254 x 254 mm
 10 x 10 in

120

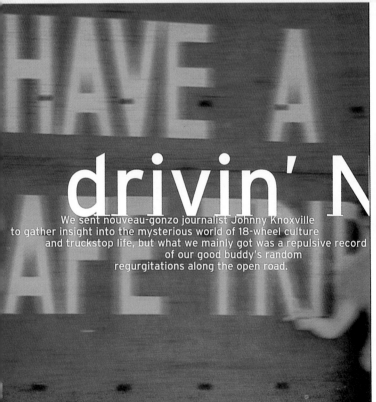

drivin' N 'hurlin'

We sent nouveau-gonzo journalist Johnny Knoxville to gather insight into the mysterious world of 18-wheel culture and truckstop life, but what we mainly got was a repulsive record of our good buddy's random regurgitations along the open road.

photos by Katie Collins and assorted truckstop clientele

September proved to be crass and unforgiving, the most perfidious of sluts. No work and none on the way. No money. No red wine. No kicks. There was not a cloud in the ⌐ but the sun refused to shine. I had sunk so low I was even glad to hear from Ryan from Bikini. He phoned and said he had an assignment for me. I was to hitchhike to New Orlea⌐ mighty 10 east, laugh again, be young. Bikini was even gonna cough up $150 spending money.
The money part made me suspicious. "Jason, is this you, you son-of-a-bitch?" The caller assured me he was Ryan Ayanian. He even misquoted the first eight lines of *Lolita* to prov⌐ Credibility intact, he explained that upon arrival in "The Big Easy" I would receive a nice hotel for the evening and then fly home first class the next morning. I became suspicious a⌐ reached down, grabbed my ankles, stuck my ass up in the air, and waited for Bikini to call back and stick it in. And put it in they did. Two days before I was to leave, my destinatio⌐ from New Orleans to the much less appealing *Dallas*. Also, there were to be no hotel reservations and I would be flying back coach on the *red-eye*. I did, however, receive the $150, most of that before I left town. Boys and girls, before you try and cogitate the filthy letters I've assembled for you, please know this: I understand now what Maximillian meant whe⌐ "You know honey, I should've just stayed home."

photographer Katie Collins

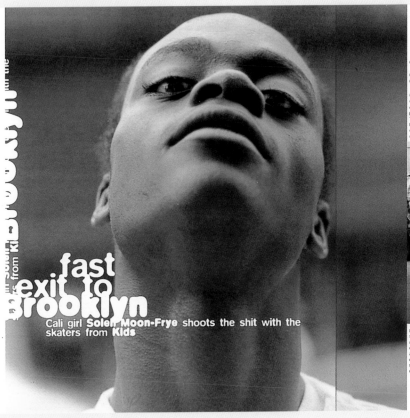

fast exit to Brooklyn

Cali girl **Soleh Moon-Frye** shoots the shit with the skaters from **Kids**

photographer Ari Marcopulos

This little girl was sick of living in LA, so she left everything behind and took off for **New York City.** Weeks passed in the havoc of Manhattan until one midnight I heard wheels caressing the pavement outside my window. Looking out from my apartment, I saw the crew that would soon lead me to the streets of the city and beyond. Through days and nights of wandering Manhattan curbs and Brooklyn urbs, they jump gaps all over New York's finest water hydrants. They slide down 10 feet of smooth metal while their bodies float in the air. Some spin 360s, others pull a backside 180 after riding 2 flights of stairs. The new-school baby boys look up to them, city girls love them. On a Sunday afternoon after spending nights of wandering the city with these kids, I want to see what Brooklyn life's about, so I jump on the N train to 59th street in Brooklyn. I dash off the train and to the humble home of Ryan Hickey, the pro skater. I'm at the Brooklyn House. Ryan's off in California, but the rest of the crew is here.

Soleh: How long has skating been around?

Jason: Ever since they invented scooters. That's why I hate when people say skating started on the West Coast. Skating started in New York City in the 1940's and 50's when people used to take milk crates and rollerskate wheels and put them on a wooden 2x4 to take shit around. And sometimes the wood crate would fall off and they would get stuck with the fucking board. That's how it started...from scooters.

Richie: That's how it started?

Jason: You saw *Back to the Future* man.

R: Yeah, I saw it and it was in California, was it not?

J: I really think that's how it started.

R: Hey, anything's possible. Who knows how it started? But it got big in the 70's. It was a fucking phenomenon.

S: Is there conflict between East Coast and West Coast skaters?

J: It's not really about East Coast vs. West Coast. It's something for ourselves. It's really just about skateboarding, individuality, and the earth that supplies Nature, which supplies life which supplies existence.

J: It's about living your life the way you want it to be. When I first started skating, it opened my mind. There were skaters from all different backgrounds. You had punk rock skaters, there were hip-hop skaters, different colors and different cultures. Everyone would do it together. There was no bullshit involved. Now everyone wants to be hip hop hard rock! As for me, I like doing big body tricks, going as far as I can.

S: What do you think about people in Hollywood as opposed to New York City?

J: People are weird out there because their body tempera-

65

pages 122-3 ➤

Vaughan Oliver Poster

reversible poster/flyer

art director Clifford Stoltze
designers Clifford Stoltze
 Peter Farrell
photographers/ Vaughan Oliver
illustrators Joe Polevy
 Bina Altera
editor Clifford Stoltze
publisher AIGA Boston Chapter
origin USA
dimensions 457 x 584 mm
 18 x 23 in

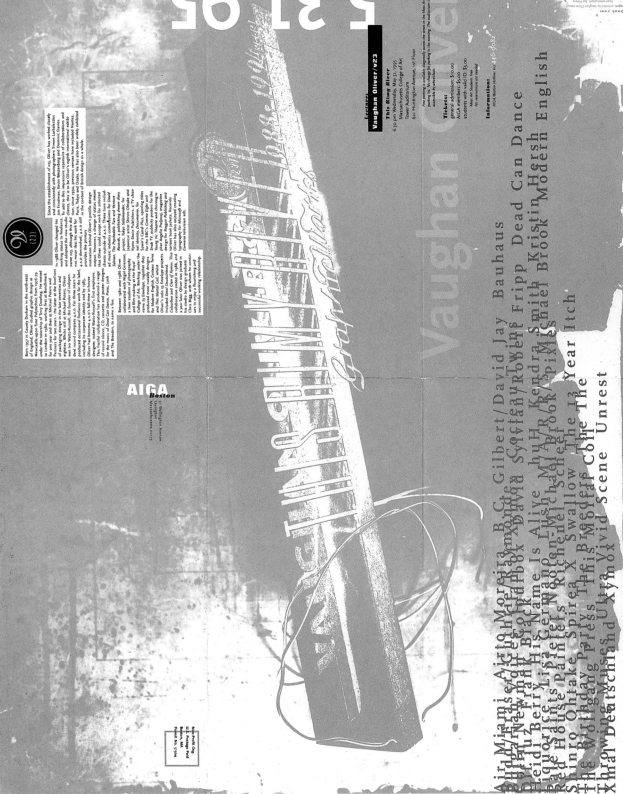

5.31.95

Lecture:

Vaughan Oliver/v23

This Rimy River
6:30 pm Wednesday, May 31, 1995
Massachusetts College of Art
Tower Auditorium
621 Huntington Avenue, 1st Floor

Tickets:
general admission: $10.00
AIGA members: $5.00
students with valid ID: $3.00
Mass Art Students free
No reservations are needed

Information:
AIGA/Boston Hotline tel. 446-5682

Vaughan Oliver

AIGA
Boston

(23)

Ray Gun

pages 124-5

art director David Carson
designers Clifford Stoltze
Peter Farrell
photographer/ Russ Quackenbush
illustrator

editor Marvin Scott Jarrett
publisher Marvin Scott Jarrett
origin USA
dimensions 254 x 305 mm
10 x 12 in

Morphine, Mark Sandman

BrightNest
by Gabriella Marks

"There are three great cities in the world.
There's Paris, there's Istanbul,
and there's Boston."

> "There are schools for this stuff, but we never went to them — it wasn't quite in keeping with punk."
>
> Paul Kolderie, Fort Apache

exploring experimental things.

John Eye Of Us at the Middle East

boston scene

pages 126-7

MassArt 95/97

catalog

art director	Clifford Stoltze	photographers/	Cecilia Hirsch
designers	Clifford Stoltze	illustrators	Jon Baring-Gould
	Tracey Schroeder	editor	Kay Ransdell
	Heather Kramer	publisher	Massachusetts College of Art
	Peter Farrell	origin	USA
	Resa Blatman	dimensions	222 x 210 mm
			8³/₈ x 8¹/₄ in

My favorite thing to do in Boston
is to drive across the Mass Ave.
bridge at twilight, any time of year,
it doesn't matter, it's such a beautiful scene—
either direction, that doesn't matter either.
It's got to be one of the prettiest
sights in the world.

They inspire me.

I love the Museum of Fine Arts. I go there often to see the new shows, but I never get sick of the Egyptian and Nubian exhibits. I love Egyptian art. Mostly I love the museums of Boston —I like going to the Aquarium, I love going to the Museum of Science and seeing the latest Omni films there. I'm a museum buff. I go to the MIT Museum and the Peabody Museum.

have the Museum of Fine Arts right across the street, and the Gardner Museum, and I think it should be required to go there at least e a week or so. And Boston has good cafes. ce I've been in Europe a lot I really like to go to a cafe and just relax. I really like that here, especially the bookstore cafes. There are so many d bookstores here—I think I'm going to miss the bookstores the most when go back to Iceland, they're just incredible.

Boston isn't a typical Northeast city
because it's basically built
around students.
It's a college town
and the whole city—jobs, apartments,
everything—cater to students,
so there's a huge cultural diversity here.
As far as music goes,
the best salsa concerts I've seen in my life I've seen here—
they perform more frequently here
than they ever did in Venezuela.
I live in Jamaica Plain, which is great, especially in the summer—
it's close, there's all kinds of people: old people, young people;
there's a big lesbian community, there's
a big artsy, crunchy-munchy community.
It feels like MassArt's campus sometimes because
you walk to the store
and you bump into
just about everybody;
you take the 39 bus and it
feels like it's the MassArt shuttle
or something.

The favorite thing I like to do in Boston is hang out in
Harvard Square when it's really cold and winter-like,
because there's not that many people there.
The Square worth very well as a whole,
it's a good urban example, very hard to imagine.
Harvard Square has this life of its own,
and different people at different times of the year.

Boston has a lot of
character. One of the things I really
like about it is the architecture, it's so
interesting and there's so much—very, very old
Colonial stuff to post-modernism, and then you have
Gropius building in Harvard Square, and
Trinity Church, the John Hancock Tower.
I like stuff to look at when I'm
walking around, and I think Boston offers a rich
visual environment.
You get a real sense of history when you're here.

[11]

TudiO FoUndation

STUDIO FOUNDATION

STUDIO FOUNDATION, THE DEPARTMENT OF FIRST YEAR STUDENTS,
IS DEDICATED TO PROVIDING A BASIC UNDERSTANDING OF VISUAL
LANGUAGE, SOURCES OF INSPIRATION, AND IDEA GENERATION.

A strong foundation program supplies an essential ingredient in an effective and comprehensive four-year art college experience. The six required courses taken in the Studio Foundation Department are prerequisites to the sophomore year when students enter their major concentration. The first-year courses build an important transition between the pre-art college experience and advanced studio work.

Active artists, dedicated teachers, and community-minded people, the Studio Foundation faculty share a strong interdisciplinary philosophy. Their familiarity with the wealth of educational opportunities at the college provides students with direction and encouragement on all levels. They inspire and inform, nurture each student's drive to put ideas into form, and prepare students for successful upper-level study and a lifetime of learning.

First-year students explore drawing, design, color, 3-dimensional arts, and a choice of one of the following media arts: film, photography, computer arts, video, or interrelated media. They are introduced to a wide range of materials and techniques as vehicles with which to develop forms for their ideas. The program provides students with a basic "tool chest" of vital resources for their advanced studio training and liberal-arts studies, and a variety of information, experiences, and knowledge of art forms from all over the world, past and present. The Studio Foundation program is carefully designed to help students develop a critical eye and formulate a personal vision. Visiting artists and lecturers at the weekly Artists Seminar present valuable information about professional skills required to perpetuate visual ideas in the practical world.

The Studio Foundation program uses a pass/no credit grading system, which removes unnecessary pressure from first year students and provides an atmosphere conducive to experimentation and exploration. The faculty believe that students should be encouraged to discover the things that evoke their curiosity, and find their own unique paths to greater intellectual and artistic sophistication. In-class critiques, frequent student exhibitions, and special department-wide projects prepare students for the scrutiny of their more mature productions, and instill a vision of the potential of their work.

STUDIO FOUNDATION			
			CREDITS
SF170	F	Artists Seminar	3
SF171		Color Studio	3
SF172		Drawing Studio	3
SF173		3D Arts	3
SF174		Elements of Design	3
SF175		Media Arts (Film or Photography or Computer Arts or Video or Interrelated Media)	3
CSA101		Foundations of Art: Origins	3
CSA102		Foundations of Art: Modern and Contemporary	3
CSB150		American Thought and Government	3
CSC100		Written Communications	3
		Elective	3
			33

F (fall) or S (spring) - the semester in which the course must be taken due to course availability or major sequencing.

[54]

[55]

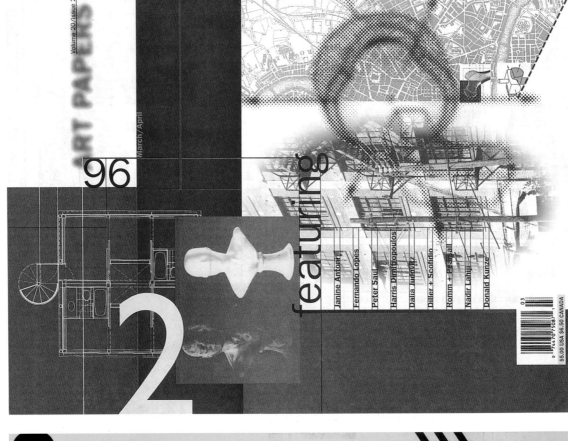

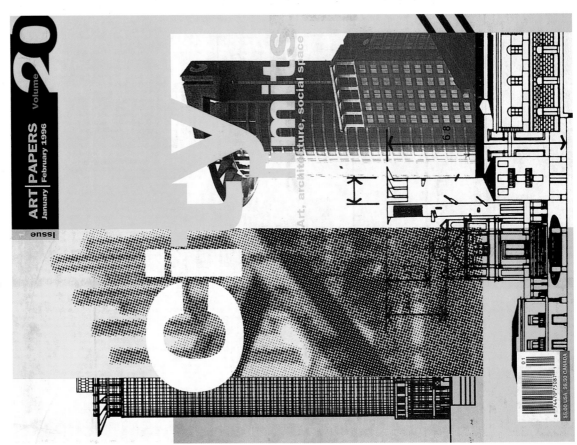

pages 128-9

Art Papers

art director Bjørn Akselsen
designers Bjørn Akselsen
 Pattie Belle Hastings

editor Glenn Harper
publisher Atlanta Art Papers Inc.
origin USA
dimensions 254 x 343 mm
 10 x 13¹/₂ in

by Onajide Shabaka

Interview with
Gary Moore

Gary Moore and Wallace, Roberts and Todd 9th Street Pedestrian Mall (detail), 1994 (photo courtesy of the artists).

Gary Moore began exploring African art and culture as sources for his own work while still a high school student in Philadelphia. In recent years, he has incorporated a Southern vernacular that includes personal and collective history from both his native South Carolina and black Philadelphia. Whether in the form of drawing or sculpture, his work could incorporate clothing, black-eyed peas, sugarcane stalks, and found objects. It often consists of a series of loose sketches scattered over a surface (sometimes directly on museum walls) with a parallel of written and visual narratives of the past and present. His work is serious, but interpreted with humor. Music and storytelling are both important aspects for the narratives of his work. A University of Miami graduate, he has participated in the Whitney Museum's Studio Program, is a Florida state fellowship awardee, and has received two public art commissions with Metro-Dade Art-in-Public-Places.

Onajide Shabaka: What were your plans for the May 95 exhibition at Gutierrez Fine Arts [Miami Beach]?

Gary Moore: I was approached to do a solo exhibition but, because of other commitments, there wasn't enough time, so I invited Miami artist Karen Rifas to collaborate on an installation. That turned into inviting video artists to participate as well. The show was an investigation into secrecy and disclosure, called "Clean Sweep." You know, like coming clean. The work consisted of found objects, drawings on frosted glass with gilt frames, Persian rugs, and information/reading area, and videos. It was well received. It's interesting to see how it has entered the market, because of its collaborative nature. I've had people ask me if I was afraid of a solo exhibition, but really, I don't have an interest in doing a solo exhibition. I see the idea of an artist working alone in his or her studio and then bringing the work out and placing it in some pristine space as one that doesn't have as much validity as it once did. I prefer collaborations because of the way it forces us to interact with others, and it provides opportunities for people working on similar ideas to share them and bounce approaches off each other in a more focused frame.

Shabaka: Black people always talk about how great the work is and how much they like it, but they very rarely see them out at the galleries and museums. They seem to get their seeing through the print media.

Moore: Well, you have to bring the work to the people.

Shabaka: But it seems that so many of the places in the black community where we could bring the work don't function very well, especially in Miami. I was thinking about other places I've lived and how Watts Towers [Los Angeles] and Galeria de la Raza [San Francisco] seem to have developed an interactive approach for bringing work to the community.

Moore: Maybe those ideas about the community-based artist and working in the community are over. Maybe it's over with romantic ideas of coming into a community and doing programming and having different functions to uplift the people in the community. That approach to using the community, going in there with an old format of dance classes and art classes, doesn't work any longer. I think that people once again know that the artists have to really confront the media, and the media's impact on people. And the gallery is a much stronger than the community's center. In beginning to see that public art has more of an impact than the community center. Those places function only on a limited or local level.

Shabaka: I know that public art certainly impacts a lot more people. That's especially true with the public transit system here in Miami, the Metro-Rail.

Moore: My first two public art commissions have been pretty standard in approach. There has been a trend in the last five years in America to document cities and towns that are going through changes. Cities, having reached a point of decay in the 80s, are being rebuilt and they're using artists to document the old communities. Overtown [Miami], where I've been working on the 9th Street pedestrian mall project, is a perfect example of that. The idea of the public art project to document the history of the town is fine for local economic development, but that good does it really do for the residents? I mean, they're walking around Overtown looking at the bronze medallions and they see kente cloth designs in paving stones—they have a certain aesthetic satisfaction, I would imagine. But there are other things that need to be done besides creating work.

Shabaka: You mean something more interactive?

Moore: Something interactive. Something with an institution. Something made available to use. It's like that idea of whoever is in public space. It's sort of a corporate investment, or a governmental investment, and the government is all about control. What's really a public space is the Rodney King riot. The public took over that space and did it with what they saw fit. That's a public space. It's not someone telling you, this is just a plaza, this is a pedestrian mall, use it. Those are the issues and challenges of public art projects.

A few days ago, at the Performing Arts Center, the Metropolitan [Opera] presentations just blew my mind. They programmed what's called an opera hall will be in 10 or 20 years. What they proposed was not to do what is done in Europe, with the frescoed ceilings, instead they commissioned Cindy Sherman to do portraits of historical-type personages. Instead of having the grand stairwell, there's a maze of escalators, which have the same function. That's taking historical ideas, recontextualizing them to a specific site and expanding that, with vision. That's where I think the use of art, combining public art and so-called public space, has a future.

Shabaka: That's one of the things that seems to be perfect for Miami in the 21st century. I had a discussion along those lines with David Ross, the Whitney Museum's director, who felt that Miami had the potential to be one of the most important cities because of its location. There is always so much press about Miami that people throughout the country think a lot more is going on here than there really is.

Moore: This city has the potential to be all that if it can build on its history in an inclusive way. But everybody has to be included.

Shabaka: Yes! I hear a lot of people talking about the exclusive nature of the arts in Miami. If you aren't Latin—even further, if you aren't Cuban—you're out of the whole cha cha. The national media over the past years has talked about how Miami is a very balkanized place, and it is. That has bothered me as well in dealing with different segments of the community.

Moore: I think one of the things that's going to have to be done to ensure that Miami's future is going to be inclusive, less polarized and more open, is to have a dialogue among artists, with understanding and exposure. But that's true for any city. You need to bring in work from out of the community, and the artists in that community, the ones who are going to give back to the people where they live. But if the artists aren't able to be in touch with a general dialogue nationally, the local community will suffer.

Shabaka: You don't think that is happening locally?

Moore: I think it's happening in Miami. Certainly it's happening. But is could be happening in little pockets where you have people who have information. It's like having a little clique I guess. And then again, you have artists who are guilty of not wanting to be involved in larger dialogues, larger issues in discourse. It's not just among black artists or Latin artists, it's among everybody. It's up to the cultural leaders to make these things work. Artists

METROPOLIS

OCTOBER 1995 $4.95

just where do we work?

telecontrol · television · telefactory · telegraph · telecontrol · telescop
telephone
lecommuting · telecommuting · telemarketing
ommunications · telecommunications · telemarketing
telecommuting · telemarketing · telecommunications · telefactory
telescope television · teleconference · telecommuting
telemarketing · teleconference · telefactory · telephone
telecontrol · telefactory · telegraph · telescope · television · teleconference · telecommuting
television
teleconference
telecommunications
telegraph · telecontrol
telecommuting

the workplace is changing and we barely know it

photographer Kristine Larsen

METROPOLIS

MARCH 1996 $4.95

DUE DATE

OCT 2 2 1995	JAN 3 1996
NOV 5 1995	JAN 2 5 1996
NOV 1 8 1995	FEB 4 1996
NOV 2 7 1995	
NOV 2 8 1995	FEB 1 3 1996
	FEB 2 2 1996
DEC 1 1995	MAR 1 1996
DEC 5 1995	
DEC 1 8 1995	MAR 7 1996
DEC 2 3 1995	

form #069 THREE WEEK LOAN

look

in

read...

library renewal

7 25274 73338 5

03>

dinner at the homepage restaurant

(Part 2 in an ongoing series about our realignment, as models of reality shift from being analog to being digital.)

(PLEASE TAKE CARE OF THIS BOOK)

A feast of information technologies—a mixture of aging, new, and developing techniques and technics—is expanding the contents and uses of public libraries.

BY ANDREA MOED In the crowded, contested spaces of New York City, privilege is defined by where one sits: a seat in a classroom at a selective school, a courtside seat at a Knicks game, a table at a fashionable restaurant. So it goes as well in the Information Age. I think, as I tour the soon-to-be-completed home of the New York Public Library's Science, Industry and Business Library (SIBL, for short). In the future Research Reading Room, I'm looking at a row of library carrels that should soon be some of the most sought-after tables in town.

"As information becomes increasingly synonymous with power, access to technology for the general population becomes more and more crucial," proclaimed New York Public Library president Paul LeClerc on the recent installation of public-use, Internet-connected personal computers at every NYPL branch library. Along with the opening of SIBL this coming May (see "Goodbye Room 227, Hello SIBL," p. 49), the new machines are providing a lot of local publicity for the library, as well as the occasion for many words on information as a matter of survival. In fact, it seems that more and more media commentators are speaking of their subject in ecological terms. As manufacturing declines in the so-called First World, our new industries are said to be "information-fueled." As media forms proliferate and media companies diversify, their audience is called not readers or listeners or even interactors, but "information consumers." As an essential, information may not yet be considered on a par with food, but equations like LeClerc's do make it seem as if the books and bytes themselves are to sustain us through this time of economic privation. Perhaps this is why many of us flock to on-line services, megabookstores, and even libraries, like tourists to a Las Vegas buffet.

The NYPL has adeptly seized the cultural moment, attracting support and $9 million in funding from the mayor, the borough presidents, the City Council, and even the governor to bring the digital cornucopia of Internet, database, and electronic catalogue access to branch library users all over the city. For the mostly privately funded research libraries, the NYPL has taken a different tack, uniting business-friendly politicians and corporate heavyweights such as Hewlett-Packard and McGraw-Hill around the creation of SIBL, "the nation's largest public information center devoted exclusively to science and business." This $100 million library is the NYPL's largest project in a century, built on the new public and corporate faith that easy-access information will feed entrepreneurship and grow wealth.

SIBL aspires to attract current and potential scientists and businesspeople—the information gourmets of the wider population. Its design was driven from the outset by surveys, focus groups, and market research conducted in the offices and labs of the targeted communities. The resulting program serves up the NYPL's business and science collection with lots of networked computers and amenities generally associated with private research facilities, such as computer training programs and free access to commercial information services. For SIBL's projected users, market-fresh facts are not enough; the library's house specialties will be fee-based research services and consultation by librarians skilled in data preparation and presentation. Given the spirit of the enterprise, it is not surprising that SIBL's interior rather resembles that of an upscale restaurant.

The reading rooms are spare but formal, with light wood paneling, vaulted ceilings, and cupolaed entry halls. Under mellow, indirect lighting, ample wooden tables can hold several courses of data at once. At an elegantly curving counter, patrons will order from the library's 800,000-volume noncirculating print collection. Without leaving their tables, users will be able to sample any of the library's on-line catalogues, CD-ROMs, and databases, or access the Internet, at desktop computers provided by the library or via laptops they bring with them. Reference books and directories will fill the shelves around the carrels. If they are not sure what to order, patrons will be able to consult with specialists in marketing, chemistry, and other subjects at the central reference desk. CNN news and stock quotes will flow freely from a video array around the corner. This confluence of traditional and high-tech media and personal attention is what makes SIBL appealing. Even though the books and computers have not yet arrived, it's easy to imagine contented library users sitting here in their trendy Aeron chairs, devouring all forms of data.

As neither a scientist nor a business person, I suspect that SIBL will be somewhat intimidating place for many nontechnical people, with its volumes of quantitative and arcane information. Nonetheless, it can provide something of much broader value: the chance to use print and digital collections together, following one's curiosity across media from book to database to Internet and back. Bill Walker, the director of the NYPL's research libraries, claims that the library's goal is "seamless access," but it is the "seams" between formats that will make the access interesting. Because part of their mission is preservation, library collections are naturally full of seams. SIBL will contain microform cards from the 1960s as well as databases. Researchers may be just as likely to use a long-outdated machine as a new one.

This situation contrasts sharply with what communications companies tell us to expect of reading and libraries in the future. In an AT&T ad, a woman reads an image of an open book on a computer monitor. In advertising for CD-ROMs and on-line ▶ 44

The Magic Keyword

AS HAS LONG BEEN TRUE of the world of literature, the Internet has grown beyond the scope of a single vocabulary and a finite number of meanings per word. Consequently, using an Internet search engine—an on-line database that finds Web sites containing a given word or phrase—is becoming as much an idle pastime as it is any certain way of finding what you want. Search your name, your city, your last remark—all you need is a keyword, and you're off down a twisting path of contextual shifts. A casual browser finds, for instance, that to various people and groups on the World Wide Web, "Metropolis" is a four-star restaurant, an industrial record label, a state nature preserve in Kentucky, a hotel in Taiwan, and even a "CyberCity."

By contrast, a keyword search of the New York Public Library research catalogue yields results closer to the magazine's heart, including books about Baghdad, Carthage, Calcutta ... and Denver.

Yahoo organizes Web pages much the way the Dewey decimal system organizes books: It presents an edited subset of all the material on the Web, arranged in predetermined categories and subcategories. You find what you're looking for by going from the general ("Entertainment") to the specific ("Metropolis magazine"): 18 matches for the word "metropolis." Alta Vista harvests gigabytes of Web pages every 24 hours, "crunches" them thoroughly, and rearranges all the words alphabetically into a kind of Web concordance. Through this complete divorce of text and context, it can very quickly find every occurrence of whatever word you type in. (About 10,000 matches for the word metropolis: 7 A.M....

artwork Ali Campbell

pages 130–33

Metropolis

art directors Carl Lehmann-Haupt
 William van Roden

publisher Bellerophon Publications Inc.
origin USA
dimensions 280 x 380 mm
 11 x 15 in

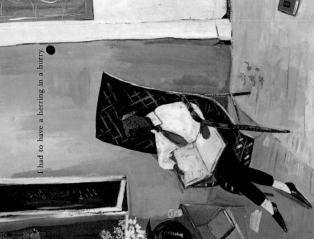

I had to have a herring in a hurry.

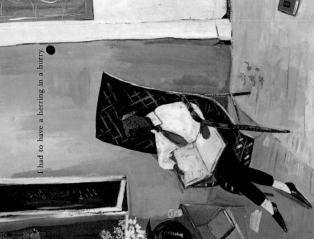

MANNEQUIN PICTURES BY DOUGLAS KEEVE. COURTESY RALPH PUCCI. ALL OTHERS, MAIRA KALMAN

In Kalman's latest book Swami on Rye (Max in India), Max, right, her personal day part dreamer protagonist, searches for the meaning of life. At left are some of the characters he encounters in Time Dance in Max in Hollywood, Baby, Ooh-La-La (Max in Love), Hoot, a self-portrait of the artist at the lunch counter at Woolworth's. Kalman takes inspiration from everything—including a giant mannequin she met from Woolworth's, and for right, Kalman transformed her kooky sensibility into three dimensions.

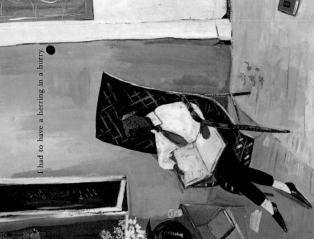

NEW YO RK

SNACK BAR

order now

What goes on inside the mind of children's book creator *Maira Kalman?*

Mix one or two of life's big mysteries with all the trifles for sale in Woolworth's, then add coffee and stir.

BY AKIKO BUSCH Somehow in my heart of hearts I knew I wasn't going to meet Maira Kalman in a coffee bar. And I didn't. Instead, she suggested that we meet at Woolworth's on East 42nd Street, and now we're sitting at the lunch counter sipping lemon Cokes. She is telling me an anecdote from her childhood in Riverdale. She would go to the supermarket with her mother and as her mother shopped, she would trail behind, straightening out the shelves. This is how it is with Maira Kalman: She has a very beautiful and very complicated relationship with excess.

Kalman is an illustrator and author of numerous children's books, among them, *Max in Hollywood, Baby, Ooh-La-La (Max in Love)*; and *Max Makes a Million*, all published by Viking Penguin. She has

designed mannequins for Pucci International Ltd., a furniture showroom in New York City, these serene and whimsical personae bring some of her storybook characters into three dimensions and seem something like a Stepford family that has discovered Zen, biofeedback, and expensive haircuts. And she is married to Tibor Kalman, who was the founder and principal of the New York graphic design firm M&Co, and—up until last fall—the editor in chief of Colors, the magazine published by the United Colors of Benetton. For the last two years, the couple and their two children have lived in Rome, now they are back in New York and Kalman is telling me why. Mostly, it has to do with the difficulty of getting anything done in a landscape of unequivocal pleasure, sensuality, and culinary bliss—for Tibor, anyway. "I could ►91

◄— 133

New York
Untitled 1987/88

New York
Untitled 1987/88

Suburbia
Untitled 1985/86

bill henson
photos
faces
fragments

Los Angeles
Untitled 1983/84

This year, the fragmented photographs shown over the page occupied the Australian pavilion at the Venice Biennale. They drew comments ranging from 'magical and deeply disturbing' to 'I wanted to call the police' (this last, not surprisingly, from England, the land of Tory scandal).

Henson's camera has been active in many parts of the world. As a curtain raiser to showing some of his current pictures, MONUMENT offers readers a selection of photographs taken in New York, Los Angeles and Suburbia.

Photographs on this and preceding page courtesy of the artist

Philip Johnson and Harry Seidler in Johnson's office
New York, 1960

philip johnson at 90
a personal reflection
by Harry Seidler

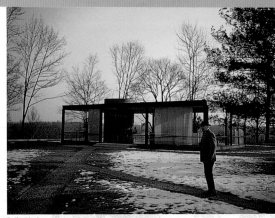

Marcel Breuer in front of
the Glass House at New Canaan
Photograph taken by Harry Seidler
during a visit in 1960

Plan

As he is the oldest practising architect in the world today, with his nineteenth birthday imminent in 1996, Philip Johnson's remarkable, enigmatic and chameleon-like career warrants examination. Both the influence he has had on others, and through them on the course of architecture in the second half of the twentieth century, should be seen in the context of his early work of the 1940's and 1950's and his buildings in more recent decades.

Johnson was born in Cleveland, Ohio, into a family of wealth, which made him independent. He possessed great intelligence and was educated at the best schools. He graduated with a degree in Arts from Harvard in 1930. This made him eminently suitable for the position of Director of Architecture and Design at the Museum of Modern Art in New York, to which he was appointed when still in his twenties. In 1932, the Museum's eminent director, Alfred Barr, sent him on an eighteen month exploratory journey around Europe to assemble material for staging an exhibition to show the emerging 'International Style' to the American public. In the same year, in conjunction with the exhibition, he and the historian Russell Hitchcock wrote the influential book with the same title.

As one could expect, given his art-historical education, the subject was dealt with as a new fixed 'style' rather than as an emerging philosophy and methodology of building, which by definition changes with time, and holds the promise of revolutionising all conventional approaches to architecture.

Through his long travels, Johnson became intimately familiar with not only the built results, but also the individuals, the pioneers that produced the early modern architecture of Europe: men like Mies van der Rohe, Gropius, Oud and Le Corbusier.

During World War II, he decided to study architecture at Harvard (1943), which was then under the leadership of Walter Gropius. It is said that there was open friction between Johnson and Gropius, probably in no small measure due to Johnson's earlier reported flirtation with Nazi Germany (comparable to that of England's deposed heir to the throne, Edward VIII), from where Gropius had emigrated. When confronted with his 'Nazi past', Johnson always trivialised it in his inimitable manner by saying, 'I just went for the graphics' - referring to Speer's spectacular Nazi rallies of the 1930's.

Harvard became a hotbed of new architectural orientation in the USA. In the years during and after the war, Johnson's student contemporaries such as Pei, Barnes, and Rudolph, went on to revolutionise American architecture. Gropius' unique teaching, however, did not penetrate architectural schools elsewhere. Only superficial images became popular without the depth of the underlying principles, methodologies and especially the aesthetic components,

which were integral to teaching at Harvard. This is, in part, the reason why later developments, lacking in the essential foundation, soon deteriorated into historicist reaction.

Johnson started his career as an architect on a high note. Mies van der Rohe had moved to Chicago, where he exerted an increasing influence on the American scene. As early as his thesis at Harvard, Johnson actually built a courtyard house as his final project, a design which was influenced heavily by Miesian precedents of the 1930's.

What really brought him to universal attention was his own dramatic New Canaan glass house of 1949, a take-off on the design of Mies' Farnsworth house, which was not actually built until later.

Johnson went on to exert incredible influence on the New York power structure through his social position and because he was a shrewd publicist. For wealthy Americans he built houses of great elegance and richness, and yet they were imbued with restrained minimalism, which made them virtual icons through architectural photographs and publishing of the time. The finesse with which he assembled the finest of materials and the way he pioneered techniques of artificial lighting to dramatise his spaces have been unsurpassed in standards of excellence.

Throughout the 1950's and 1960's, his architectural designs were never truly original, but leaned heavily on the work of others. Breuer's bi-nuclear plan can be seen in his 1951 Hodgson house, Mies' sketch of 1934 showing a suspended glass house is built in his Leonhardt House of 1956. His buildings for the University of St Thomas of 1957 are virtual replicas of Mies' IIT campus structures, then going up in Chicago. Inspirations also came early from historical precedents, such as the baldachin-like ceiling in his Port Chester synagogue of 1956, clearly derived from Sir John Soane's own London house of 1800. His superbly executed, lavish Kreeger house in Washington of 1956 uses the flat vaults of Le Corbusier's Jaoul houses.

Johnson's lasting importance, however, rests heavily on his collaboration with Mies on the Seagram Building, completed in 1958 - the quintessential prototype of endless, but lesser, glass curtain wall buildings to follow.

After that triumph, Johnson felt he could no longer contribute to such developments. His dissatisfaction with the language of modern architecture became evident in his

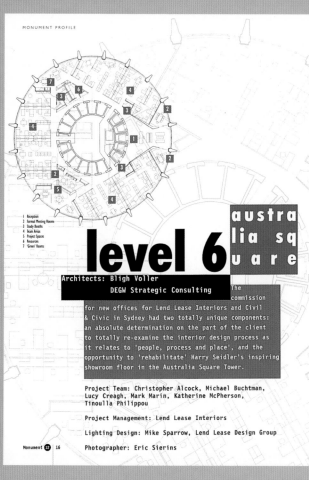

photographer Eric Sierins

1 Reception
2 Formal Meeting Rooms
3 Study Booths
4 Team Areas
5 Project Spaces
6 Resources
7 'Green' Rooms

level 6

austra lia sq uare

**Architects: Bligh Voller
DEGW Strategic Consulting**

The commission for new offices for Lend Lease Interiors and Civil & Civic in Sydney had two totally unique components: an absolute determination on the part of the client to totally re-examine the interior design process as it relates to 'people, process and place', and the opportunity to 'rehabilitate' Harry Seidler's inspiring showroom floor in the Australia Square Tower.

Project Team: Christopher Alcock, Michael Buchtman, Lucy Creagh, Mark Marin, Katherine McPherson, Tinoulla Philippou

Project Management: Lend Lease Interiors

Lighting Design: Mike Sparrow, Lend Lease Design Group

Photographer: Eric Sierins

Monument 12 | 16

playing dumb

the photography of john gollings

John Gollings' individual, theatrical style of photography has made him a sought after recorder of the work of such distinctive practices as those of Edmond and Corrigan, Daryl Jackson and Associates, Ashton Raggatt McDougall and Denton Corker Marshall. Gollings is now also working extensively in Asia and has established himself as one of the world's leading architectural photographers. He has also pursued a successful career in the areas of commercial and advertising photography. Here he talks with Marcus O'Donnell about that 'Gollings look'.

Monument 12 | 88

photographers John Gollings & Sandy Nicholson

Sydney Fisheye shot

◄ pages 134-5

Monument

art director Ingo Voss
designer Ingo Voss
editor Graham Foreman
publisher Monument Publishing
origin Australia
dimensions 240 x 325 mm
9¹/₂ x 12³/₄ in

pages 136-7

Silk Cut Magazine

art director Jeremy Leslie
designer Jeremy Leslie
editor Tim Willis
publisher Forward Publishing
origin UK
dimensions 290 x 290 mm
11³/₈ x 11³/₈ in

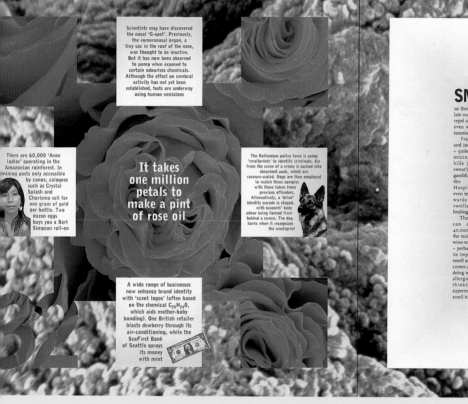

Scientists may have discovered the nasal 'G-spot'. Previously, the vomeronasal organ, a tiny sac in the roof of the nose, was thought to be inactive. But it has now been observed to pump when exposed to certain odourless chemicals. Although the effect on cerebral activity has not yet been established, tests are underway using human emissions

There are 60,000 'Avon ladies' operating in the Amazonian rainforest. In mining posts only accessible by canoe, colognes such as Crystal Splash and Charisma sell for one gram of gold per bottle. Two dozen eggs buys you a Bart Simpson roll-on

It takes one million petals to make a pint of rose oil

The Rotterdam police force is using 'smellprints' to identify criminals. Air from the scene of a crime is sucked into absorbent pads, which are vacuum-sealed. Dogs are then employed to match these samples with those taken from previous offenders. Alternatively, a 'blind' identity parade is staged, with suspects' body odour being fanned from behind a screen. The dog barks when it recognizes the smellprint

A wide range of businesses now enhance brand identity with 'scent logos' (often based on the chemical $C_{20}H_{24}O$, which aids mother-baby bonding). One British retailer blasts dewberry through its air-conditioning, while the SeaFirst Bank of Seattle sprays its money with mint

SMELLS:

they weave in and out of our nostrils, guiding us through life. They warn us of danger, stimulate our appetites, attract us to other people – or repel us. They intoxicate us or nauseate us. They even whisk us back in time, awakening past emotions.

Fragrances can relax us, affect our moods and increase productivity – quite apart from maximizing repayment of bills (spray 'em with sweat!) and stimulating gambling. Researchers at the Sloan-Kettering Hospital in New York even tell us that spraying wards with vaporized vanilla accelerates the healing process.

The untrained nose can detect perhaps 40,000 different odours, the trained nose – of the wine-waiter or tea-sniffer – perhaps more than twice as many. Yet, despite its importance in our lives, most people rank smell as the lowest of the five senses. Partly, this comes about because so many people are used to doing without it – what with colds in winter and allergies in summer – but one cannot help thinking that, in our world, sight reigns supreme. 'I'll *see* if the milk's off,' you say. Then smell it.

It's as if we deliberately limit our olfactory vocabulary. We can describe sounds: music can be translated into notation or just replayed; words can be written; sights can be described in terms of shape, colour, shading, direction and distance. But smells can hardly be defined except in terms of other smells or tastes. How, for instance, would you describe the smell of a geranium? Or of a diet cola?

In traditional Chinese cosmology, each of the five elements of the universe has its own odour. But smell seems to have avoided Western scientific classification. We can measure the speed of light and the speed of sound. We can measure light intensity by wattage, tactile pressure in pounds per square inch, and noise level in decibels. We can divide taste into four distinct flavours. And the colours of light split along the spectrum: red, orange, yellow, green, blue, indigo, violet. But we have no nasal scale: how do we compare the smell of new-mown grass to that of a pine forest?

Perhaps we first began to trust the evidence of our eyes over that of our nostrils when our ancestors came down from the trees to roam the savannah. They could scan the horizon for predator or prey, or look to the heavens for

Yellow backgrounds: electron micrograph of the nasal cavity's mucous membrane, where inhaled air molecules are dissolved for 'analysis' by nerve cells. The information then passed to the brain's olfactory bulb is what we perceive as smell. The Proustian sensation of highly-charged recollection occurs because the olfactory bulb also houses our emotional responses and memories

Vanidad

art director Nick Bell
designer Mark Hough @ Nick Bell Design, London
 interpreted by Verónica Sosa @ Egoiste

editor Emilio Saliquet
publisher Egoiste Publicacions S.L., Madrid
origin UK/Spain
dimensions 228 x 300 mm
 9 x 11³/₄ in

Entrevista **Mària Suàrez** Fotografías **Wolfgang Mustain**

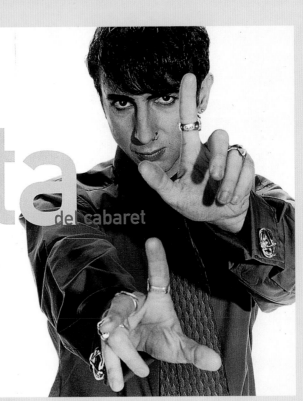

Marc Almond sigue seduciendo. Una estrella viviente que no pierde luz.

poeta del cabaret

Un poeta que toca la luna y no tiene miedo a llorar. Lo último, su biografía.

photographer Wolfgang Mustain

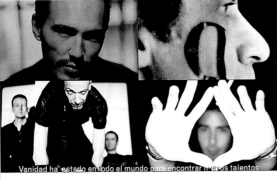

Vanidad ha estado en todo el mundo para encontrar nuevos talentos

talento

David Alcalá, escritor

Luis Camnitzer, artista

Fluke, músicos

Alex de Fluvià, pintor

talento

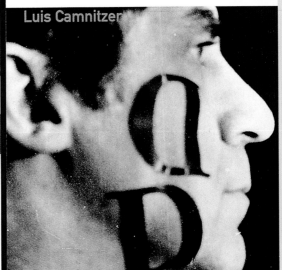

Luis Camnitzer

Montserrat Vendrell

Vanidad 23

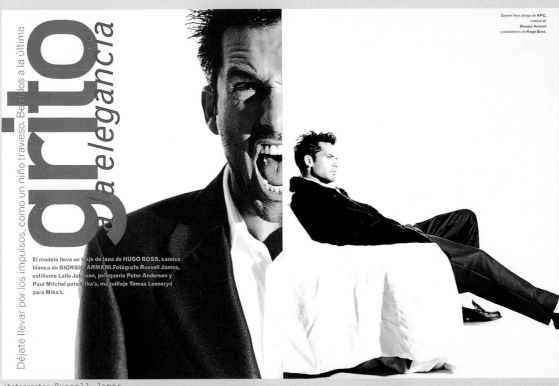

grito
a elegancia

Déjate llevar por los impulsos, como un niño travieso. Bestidos a la última

El modelo lleva un traje de lana de **HUGO BOSS**, camisa blanca de **GIORGIO ARMANI**.Fotógrafo Russell James, estilismo Lalle Johnson, peluquería Peter Anderson y Paul Mitchel para Mika's, maquillaje Tomas Lenneryd para Mika's.

Darren lleva abrigo de **APC**, camisa de **Giorgio Armani** y pantalones de **Hugo Boss.**

photographer Russell James

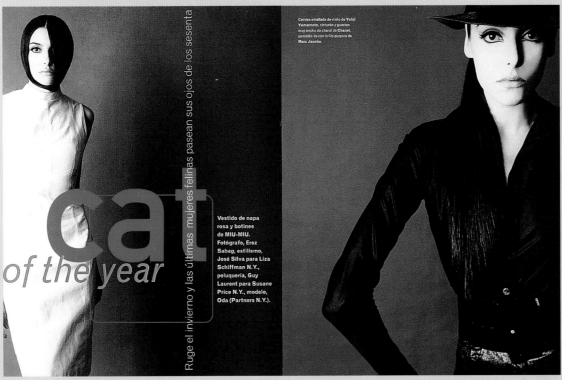

Camisa entallada de vinilo de **Yohji Yamamoto**, cinturón y guantes muy ancho de charol de **Chanel**, pantalón de con brillo purpura de **Marc Jacobs.**

Ruge el invierno y las últimas mujeres felinas pasean sus ojos de los sesenta

cat
of the year

Vestido de napa rosa y botines de **MIU-MIU**. Fotógrafo, Erez Sabag, estilismo, José Silva para Liza Schiffman N.Y., peluquería, Guy Laurent para Susane Price N.Y., modelo, Oda (Partners N.Y.).

photographer Erez Sabag

True

art director Matt Roach @ Astrodynamics
designer Matt Roach @ Astrodynamics
editors Claude Grunitzky
Sunita Olympio

publishers Claude Grunitzky/Sunita Olympio
origin UK/USA
dimensions 230 x 287 mm
9 x 11¹⁄₄ in

photographers Phil Knott/Electro Astrosuzuki

photographer Nicolas Hidiroglou

photographer Shawn Mortensen

photographer/illustrator Electro Astrosuzuki

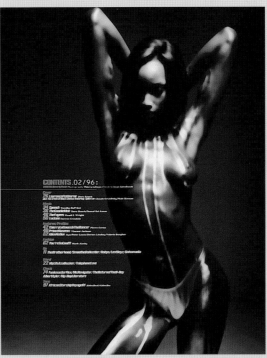

photographer/illustrator Electro Astrosuzuki

photographers Phil Knott/Electro Astrosuzuki

photographers Thierry Legoues/Electro Astrosuzuki

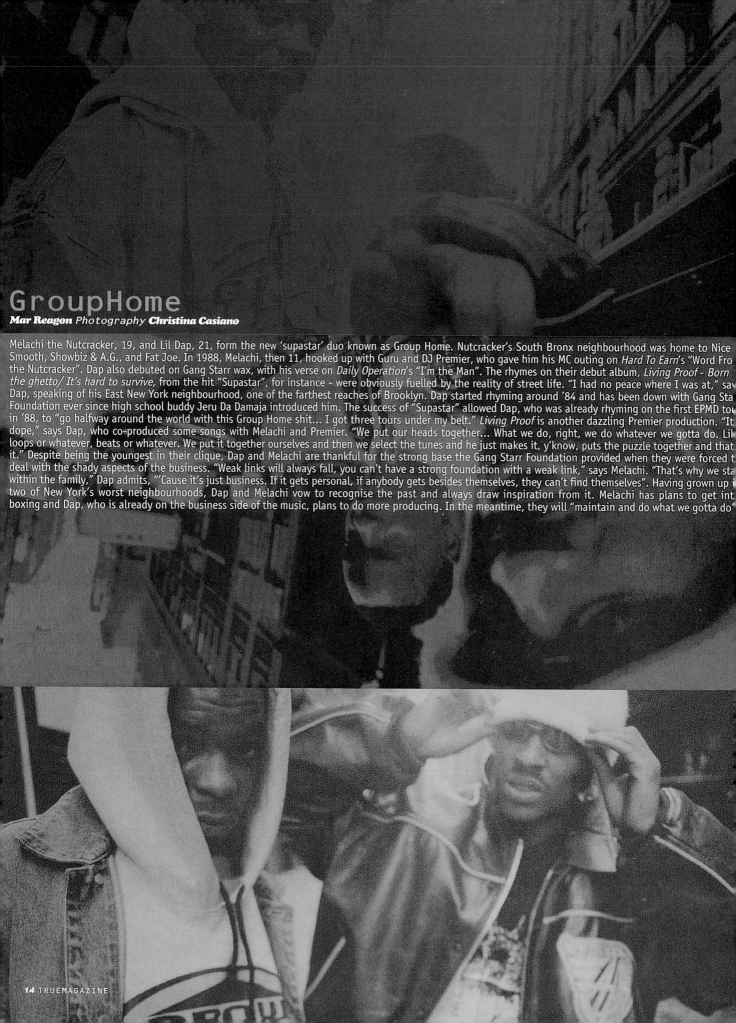

GroupHome
Mar Reagon *Photography* **Christina Casiano**

Melachi the Nutcracker, 19, and Lil Dap, 21, form the new 'supastar' duo known as Group Home. Nutcracker's South Bronx neighbourhood was home to Nice
Smooth, Showbiz & A.G., and Fat Joe. In 1988, Melachi, then 11, hooked up with Guru and DJ Premier, who gave him his MC outing on *Hard To Earn*'s "Word Fro
the Nutcracker". Dap also debuted on Gang Starr wax, with his verse on *Daily Operation*'s "I'm the Man". The rhymes on their debut album, *Living Proof - Born
the ghetto/ It's hard to survive,* from the hit "Supastar", for instance - were obviously fuelled by the reality of street life. "I had no peace where I was at," sa
Dap, speaking of his East New York neighbourhood, one of the farthest reaches of Brooklyn. Dap started rhyming around '84 and has been down with Gang Sta
Foundation ever since high school buddy Jeru Da Damaja introduced him. The success of "Supastar" allowed Dap, who was already rhyming on the first EPMD to
in '88, to "go halfway around the world with this Group Home shit... I got three tours under my belt." *Living Proof* is another dazzling Premier production. "It
dope," says Dap, who co-produced some songs with Melachi and Premier. "We put our heads together... What we do, right, we do whatever we gotta do. Li
loops or whatever, beats or whatever. We put it together ourselves and then we select the tunes and he just makes it, y'know, puts the puzzle together and that
it." Despite being the youngest in their clique, Dap and Melachi are thankful for the strong base the Gang Starr Foundation provided when they were forced t
deal with the shady aspects of the business. "Weak links will always fall, you can't have a strong foundation with a weak link," says Melachi. "That's why we sta
within the family," Dap admits, "'Cause it's just business. If it gets personal, if anybody gets besides themselves, they can't find themselves". Having grown up
two of New York's worst neighbourhoods, Dap and Melachi vow to recognise the past and always draw inspiration from it. Melachi has plans to get int
boxing and Dap, who is already on the business side of the music, plans to do more producing. In the meantime, they will "maintain and do what we gotta do"

MartineGirault

Darren Crosdale *Photography* **Wandy**

Martine Girault's laugh is a low-down, dirty rumble which starts in her chest, grinds upwards and emerges from her thrown-back head. Wonderful. The phenomenal underground success of 1991's "Revival" gained Martine a loyal fan-base. The recognition of "Revival" as that rare, divine tune secured Martine and the song's producer, Ray Hayden, a six-album deal with London records. But, after realising which single the record company chose as a follow-up to "Revival", Martine and Ray asked to be set free from the contract. "I didn't mean to step on anyone's toes. I just wanted to feel good about myself," says Martine, hand on heart for emphasis. Instead, after realising that a great chance might have slipped through her fingers, Martine "felt very depressed" by the lost opportunity. Unlike Mary J. Blige, who went through a highly-publicised self-development programme, Martine's approach to conquering depression was rather inexpensive. "I was in this second-hand bookshop and I didn't have a lot of money. I found this book, *The Magic of Thinking Big*. It was torn and in bad condition but it taught me the importance of self-confidence." Brooklyn-born Martine grew up in Queens with her Haitian parents, three sisters and a brother. One day, Martine "just decided" she would sing. "My mother cried when she first saw me. She said, 'Who taught you to sing?'" Actually, Martine, whose background is in theatre, grew up listening to very little black music. "It was only what crossed over into the mainstream - like Motown." Martine once played Dorothy in the touring version of Stephanie Mills' show *The Wiz*. "I used to walk by Stephanie's theatre every day going to dance class. I used to say to myself, 'Why couldn't anyone write a play about me?'" Martine's new single, "Been Thinking About You", precedes her forthcoming debut album. It captures the moods Martine wanted to express and, though she didn't write any of the material, she wonders at "how well Ray knows me!". More than just a producer, Martine admits that "He's my mentor". He and Shamin Noronha (partners in Opaz Productions) took Martine under their wing when she first came to England in 1986. Martine was assisting a friend at an audition and, although she had laryngitis, Ray could tell she had talent. Ray educated Martine in the nuances of black music. To this day, she is still learning.

EWGROUND:

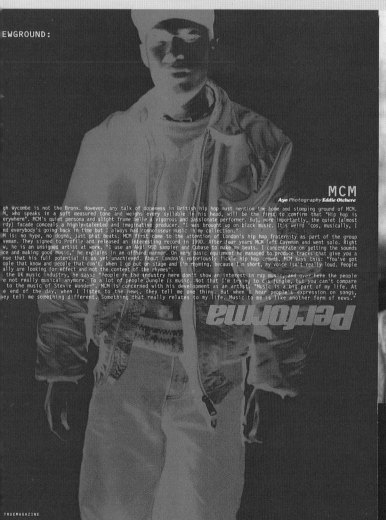

MCM
Ayo *Photography* **Eddie Otchere**

gh Wycombe is not the Bronx. However, any talk of dopeness in British hip hop must mention the home and stomping ground of MCM. M, who speaks in a soft measured tone and weighs every syllable in his head, will be the first to confirm that "Hip hop is erywhere". MCM's quiet persona and slight frame belie a vigorous and passionate performer. But, more importantly, the quiet (almost rdy) facade conceals a highly-talented and imaginative producer. "I was brought up on black music. It's weird 'cos, musically, I nd everybody's going back in time but I always had connoisseur music in my collection." M is: no hype, no dogma, just phat beats. MCM first came to the attention of London's hip hop fraternity as part of the group veman. They signed to Profile and released an interesting record in 1990. After four years MCM left Caveman and went solo. Right w, he is an unsigned artist at work. "I use an Akai 950 sampler and Cubase to make my beats. I concentrate on getting the sounds ce and making good music," he explains in an offhand manner. On very basic equipment he managed to produce tracks that give you a nse that his full potential is as yet unachieved. About London's notoriously fickle hip hop crowds, MCM says this: "You've got ople that know and people that don't. When I go out on stage and I'm rhyming, because I'm short, my voice isn't really loud. People ally are looking for effect and not the content of the rhymes". the UK music industry, he says: "People in the industry here don't show an interest in rap music, and over here the people e not really musical anymore. To a lot of people jungle *is* music. Not that I'm trying to dis jungle, but you can't compare to the music of Stevie Wonder". MCM is concerned with his development as an artist. "Music is a big part of my life. At e end of the day, when I listen to the news, they tell me one thing. But when I hear people's expression on songs, ey tell me something different. Something that really relates to my life. Music to me is like another form of news."

Performa

TRUEMAGAZINE

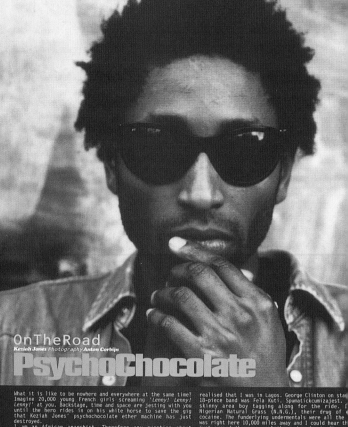

OnTheRoad
Keziah Jones *Photography* **Anton Corbijn**
PsychoChocolate

What it is like to be nowhere and everywhere at the same time? Imagine 20,000 young French girls screaming *'Lenny! Lenny! Lenny!'* at you. Backstage, time and space are jesting with you until the hero rides in on his white horse to save the gig that Keziah Jones' psychochocolate ether machine has just destroyed.

I am an African anarchist. Therefore any question about location tickles. Yeah it tickles because it cannot relate to the mindscape of those internally-exiled African mujicians. Because the gangsterism of Greenwich Mean Time erases all clues of self-awareness. Because immigration police turn bodies into empty vessels to be filled with gentle enquiries about one's presence on earth. To travel freely through space and time, through the boundaries of one's mind, I had to declare my blufunk. I had to declare the motherfucking African Space Thermal Underground Mofo Theory.

I once found myself on a tour around the backside of America, with the P-Funk All Stars. By the time we got to Detroit, I realised that I was in Lagos. George Clinton on stag 18-piece band was Fela Kuti. Spumatickcumizajest. skinny area boy tagging along for the ride. I Nigerian Natural Grass (N.N.G.), their drug of cocaine. The funderlying undermentals were all the was right here 10,000 miles away and I could hear th just around the corner. A thorough understanding o of cause and effect allows me to accept my statel freedom. My internal exile as a joyrider between blocks of African custom and European dogma. I am f inky space with access to the metalanguage of dreams Imagine 1,000 drunk Bedford University student some point, ask you to play "Stairway To Heaven remember that the last cigarette before the ly always the best, that culture is inversely propo aptitude. Then you can put down your guitar and to 'fuck off' without falling into the verbal tr your manager when he says anything about profes

TRUEM

photographers Eddie Otchere/Electro Astrosuzuki photographer Anton Corbijn

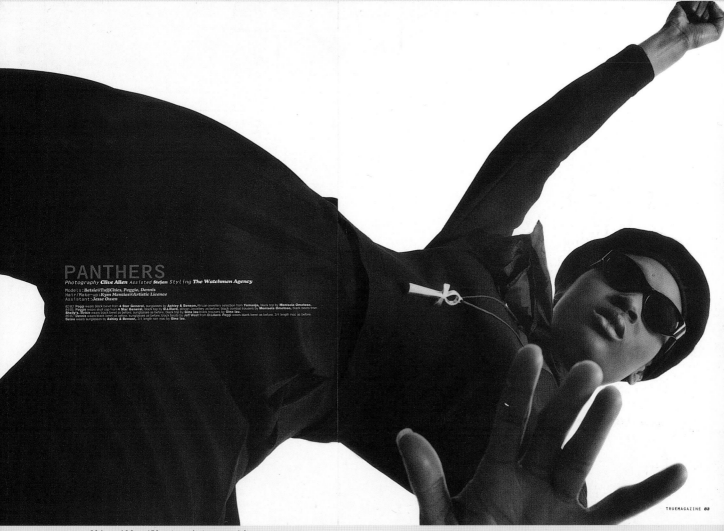

PANTHERS

Photography **Clive Allen** *Assisted* **Stefan** *Styling* **The Watchmen Agency**

Models:**Betsie**@TuffChics, **Peggie, Dennis**
Hair/Make-up:**Kym Menzies**@Artistic Licence
Assistant:**Jesse Owen**

82/83: Peggie wears black beret from **4 Star General**, sunglasses by **Ashley & Benson**, African jewellery selection from **Yamanja**, black top by **Monisola Omotoso**.
84/85: Peggie wears skull cap from **4 Star General**, black top by **D.Lillard**, african jewellery as before; black combat trousers by **Monisola Omotoso**, black boots from **Shelly's**. Betsie wears black beret as before, sunglasses as before, black top by **Gina Izu** black trousers by **Gina Izu**.
86/87: Dennis wears black beret as before, sunglasses as before; black boots by **Jeff West** from **D.Lillard**. Peggie wears black beret as before, 3/4 length mac as before.
Betsie wears sunglasses by **Ashley & Benson**, 3/4 length rain mac by **Gina Izu**.

photographers Clive Allen/Electro Astrosuzuki

pages 146-7

Creator

art director Adam Shepherd editors Nick Crowe
designers 1 & 2 Bernhard Bulang Patrick Collerton
 3 Karin Winkelmolen & publisher Nick Crowe
 Edwin Smet origin The Netherlands/UK
photographer 3 Vincent van den Hoogen dimensions 240 x 297 mm
 9¹⁄₂ x 11³⁄₄ in

I have declared pure art dead.

Pure art doesn't really exist...[a better title would be]

The myth of pure art.

Paul van Dijk, director of the Academy of Visual Arts, Maastricht, discusses art education.

Art education in the free arts is regressing drastically. It is very evident and there is no stopping it. Sure, you could put on a brave face and say, 'I'm glad that only 20% of the students are painters and sculptors,' but in reality, of course, it impoverishes culture.

I have declared pure art dead. But I also think, and this is an opinion that I have held for some years now, that pure art as such has never really existed, because people have always been dependent on patrons and customers. Particularly in the visual arts, the big commissions are always in the hands of these people. Often the pure autonomous image is found precisely in applied art, in the object that you display and say: it is the best thing that I have ever made, even if it was commissioned work, even if it already had a function in everyday culture. In fact it is pure art if you are the one who thought it up and shaped it in your own way and now see it there, as a thing in itself, and believe that's the best thing that you've ever made.

However, the departments of the free arts, in the sense that pure art is understood in art education, are important in an academy. They allow things to occur that are not directly related to the usual educational models. These can be very important, because there can be people there who don't fit the definitions. Perhaps we can't say whether they really have talent, but their approach is such that they do things in the visual arts that are unpredictable or perhaps even unimaginable. You can see this in every department, but it is noticeable that such people are often found in the so-called free art departments. So-called free art. It doesn't have to be that way, because someone from the free arts might start accepting commissions tomorrow, but would still have to meet the standards as a pure artist, to win paying commissions.

I think that every designer or photographer is in principle, also a pure artist. And vice versa. The pure artist is strongly affected by the market, and the artist's own approach, own aesthetic, and own integrity, determine whether it goes any further than what the market expects. And that is when you come to the concept of quality, that is the heart of the matter, or should be. It is so difficult to define. For the department of the applied arts, it is fairly clear what should be expected of the students at the end of their training. But for the departments of free arts ... ?

Extract from an interview, November 1993

Academy of Visual Arts Maastricht ■ Herdenkingsplein 12 ■ 6211 PW Maastricht (Netherlands) ■ tel. ++31 43-466670 ■ fax ++31 43-466679

I think that every designer or photographer is, in principle, also a pure artist.

The myth of pure art.

pages 148-9 ▼

Creator

art director Jonathan Cooke
designer Jonathan Cooke
concept Leigh Marling @ Blue Source
 Damian McKeown @ Blue Source

editors Nick Crowe
 Patrick Collerton
publisher Nick Crowe
origin UK
dimensions 240 x 297 mm
 9½ x 11¾ in

IS THE FUTURE WHAT IT USED TO BE
MOST OF US ARE EMBEDDED IN OUR CURRENT LANGUAGE OF REALITY. SO,
INEVITABLY, WE ENVISION A FUTURE THAT COMES FROM THE DRIFT OF WORDS
WHOLLY BASED IN THE PAST. WE SEE THE FUTURE AND SAY WHY? WHEN WE COULD
DREAM THINGS THAT NEVER WERE AND SAY WHY NOT?

DEFINITION OF
SAYING THE SAME THING AGAIN AND AGAIN BUT EXPECTING
DIFFERENT RESULTS.
INSANITY

BLUE SOURCE::CREATIVE
COMMUNICATIONS

CHAPTER 3
LANGUAGE, IDEOLOGY AND SUBJECTIVITY

"Say Cockney five shooter. We bus'gun

Cockney say tea leaf. We just say sticks man

You know dem have a wedge while we have corn

Say Cockney say 'Be first my son' we just Gwaan!

Cockney say grass. We say outformer man

Cockney say Old Bill we say dutty babylon ...

Cockney say scarper we scatter

Cockney say rabbit we chatter

We say bleach Cockney knackered

Cockney say triffic we say wackaard

Cockney say blokes we say guys

Cockney say alright we say ites!

We say pants Cockney say strides

Sweet as a nut ... just level vibes, seen."

Smiley Culture 'Cockney Transla

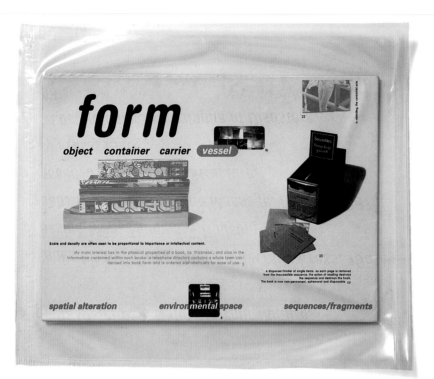

form

designers Martin Carty @ Automatic
 Ben Tibbs @ Automatic
photographers/ Martin Carty @ Automatic
illustrators Ben Tibbs @ Automatic
editors Martin Carty @ Automatic
 Ben Tibbs @ Automatic
contributors Graphic Design Department,
 School of Communication Design,
 Royal College of Art, 1994
publisher self-published
origin UK
dimensions 210 x 148 mm (when folded)
 8¹/₂ x 5⁵/₈ in

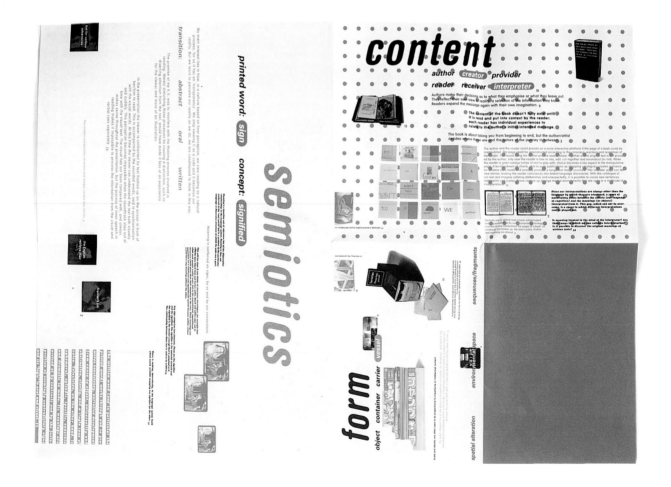

The random juxtaposition of words and images creates new stories. 2

semiotics

printed word: sign **concept:** signified

transition:

abstract

oral

written

the English retrieve their

fireman's job 2

content

author (creator) provider
reader receiver (interpreter)

Authors make their decisions as to what they emphasise or what they leave out. They reflect their own view of reality, a selection of the information they know. Readers expand the message again with their own imagination. 9

The content of the book doesn't fully exist until it is read and put into context by the reader: each reader has individual experiences to relate to the author's initial intended message. 8

The book is about taking you from beginning to end, but the author/artist decides where these are and the nature of the journey in between. 3

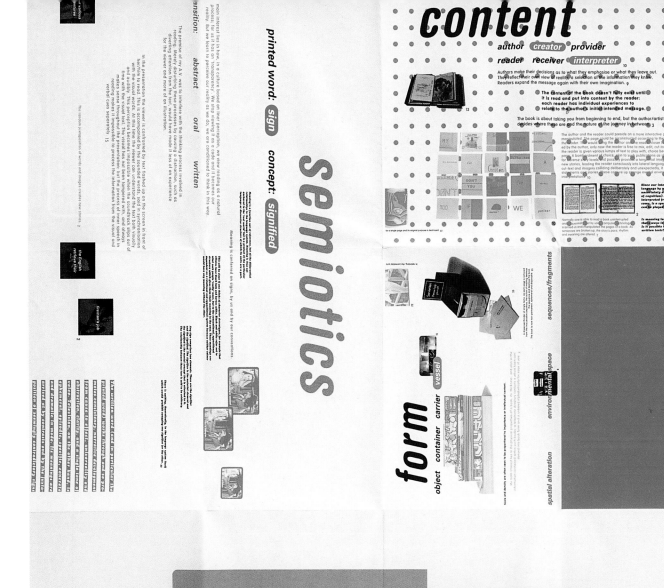

form

object container carrier (vessel)

sequences/fragments

environmental space

spatial alteration

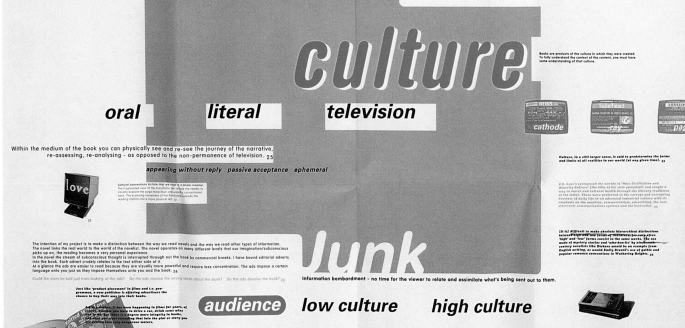

culture

oral literal television

cathode ray page

Within the medium of the book you can physically see and re-see the journey of the narrative, re-assessing, re-analysing - as opposed to the non-permanence of television. 25

appearing without reply passive acceptance ephemeral

love 17

Books are products of the culture in which they were created. To fully understand the content of the book, one must have some understanding of that culture.

Culture, in a still larger sense, is said to predetermine the forms and limits of all realities in our world (at any given time). 33

The intention of my project is to make a distinction between the way we read novels and the way we read other types of information. The novel links the real world to the world of the novelist. The novel operates on many different levels that our imagination/subconscious picks up on, the reading becomes a very personal experience.
In the novel the stream of subconscious thought is interrupted through out the book by commercial breaks. I have bound editorial adverts into the book. Each advert crudely relates to the text either side of it.
At a glance the ads are easier to read because they are visually more powerful and require less concentration. The ads impose a certain language onto you just as they impose themselves onto you and the book. 26

Could the story be told just from looking at the ads? Do the ads impose the wrong ideas about the book? Do the ads devalue the book? 26

Junk

Information bombardment - no time for the viewer to relate and assimilate what's being sent out to them.

audience low culture high culture

target (market)

author
reader

creator/provider
receiver/consumer

WE ARE THE WINNERS! AND LOSING IS FUN!

¡¡BASTA!!

AIRE ACONDICIONADO

mass production does not necessarily mean mass communication

One needs to understand the language and the social culture used to be able to comprehend the narrative. 6

As a society alters over time, the original message of a text may be misinterpreted because there is a danger of projecting back contemporary views and attitudes.

An audience can be targeted through the manipulation of content, cover and marketing.

SECTION 3

abcdefghijklmnopqrstuvw

alpha bet

3 3 3 3 33

mash it up and bash it out

font and image and cybertype bold

abcdefghijklmnopqrs

BOLD BOLD BOLD BOLD BOLD BOLD BOLD BOLD

BOLD

BOLD
BOLD

from a to zee

CYBE BOLD BOLD

BOLD

BOLD

based on an original photograph by peter heaton

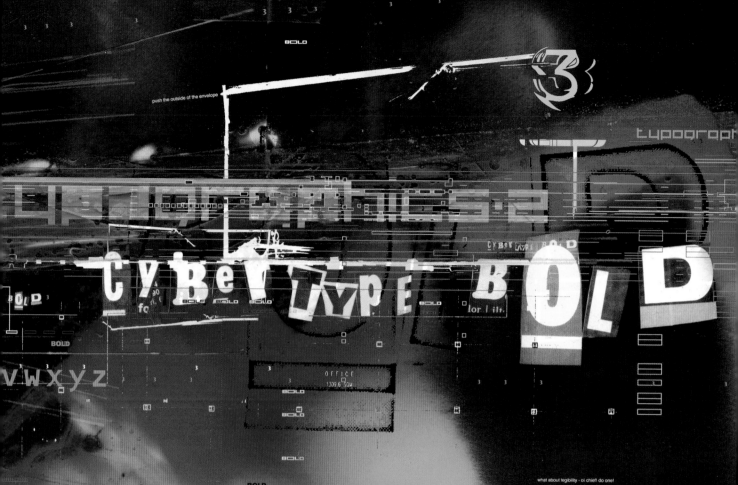

cybergraphics·2

CyBer TYPE BOLD

v w x y z

typograph

OFFICE
1309.6 SQM

BOLD
BOLD

what about legibility - oi chief! do one!

huH

creative director Vaughan Oliver @ V23
art director Jerôme Curchod
photographer Alison Dyer
illustrator Dominic Davies
editor Mark Blackwell
publishers Marvin Scott Jarrett/
Ray Gun Publishing
origin USA
dimensions 254 x 254 mm
10 x 10 in

GREEN DAY • BY JELLO BIAFRA

17

PRETENDERS
JULIAN COPE
THERAPY?
BOY GEORGE

huH

creative director Vaughan Oliver @ V23
deisgner Timothy O'Donnell
photographer William Hanes
illustrator Timothy O'Donnell
editor Mark Blackwell
publishers Marvin Scott Jarrett/
Ray Gun Publishing
origin USA
dimensions 254 x 254 mm
10 x 10 in

SPEECH MINISTRY
SEPULTURA AL GREEN
THE GRIFTERS

19

huH

creative director Vaughan Oliver @ V23
designer Jerôme Curchod
photographer Michael Muller
illustrator Chris Bigg @ V23
editor Mark Blackwell
publishers Marvin Scott Jarrett/
Ray Gun Publishing
origin USA
dimensions 254 x 254 mm
10 x 10 in

huH

creative director Vaughan Oliver @ V23
designers Chris Bigg @ V23
Kees Hubers
photographers Matt Gunther
Dominic Davies
editor Mark Blackwell
publishers Marvin Scott Jarrett/
Ray Gun Publishing
origin USA
dimensions 254 x 254 mm
10 x 10 in

photographer Matt Gunther

huH

pages 156–9

art director Jerôme Curchod origin USA
designer Scott Denton-Cardew dimensions 254 x 254 mm
editor Mark Blackwell 10 x 10 in
publishers Marvin Scott Jarrett/
Ray Gun Publishing

Angus did not, however, lift his duckwalk from Chuck Berry.

"When you're in a bar, you play Chuck Berry songs, rock & roll songs," Angus says. "I mean, not the same so...but the way that we played — your interpretation. I think the biggest compliment we ever got was, a guy came up and asked, 'Was that Chuck Berry's "School Days" you were playing?' We said 'Yeah' and he said, 'That was the worst version I ever heard!'"

The second book of Top 40 Albums by Joel Whitburn calls AC/DC "a hard rock band formed in Sydney, Australia in 1974." In the early days, Angus says, they played "pubs, clubs — probably the same as here, what do you call 'em, bars — a lot of that. When we started out, music was music and everything was still locked together. We were a band that could go out and play rock & roll music and, oh, sort of, maybe louder than some of them. If there was an audience, we played — we liked to try to portray what we saw, we'd done your bit and then you always get the clone element...."

Rose Tattoo and Angel City (whose early

'80s albums Assault and Battery and Face to Face, respectively, blow away anything AC/DC has made since '77) of course are, but never mind...I stole AC/DC's primal blues songs joyfully and turned it into an Oz genre of sorts.

"I think they certainly took bits of us," Angus recollects. "I know that [AC/DC drummer] Phil [Rudd] had actually played with the singer in Rose Tattoo and they helped us, so they didn't even know good talent. But the other band you mentioned, they were a big band when they played with us, and we done a little tour of South Australia, and they were just down the state. The big copper, Chantilly Lace. And then they saw what we had going, and they figured maybe that was the way they should go —

"I asked whether AC/DC had often played Australian redneck bars, dodging bullets from cowboy gunfights. Angus scoffs. "No! That's stupid. That's like saying there's kangaroos hopping down Main Street. Of course, Sydney's a big city, too. And Melbourne's a big city. It ain't like that, y'know...you don't even have it in a rock & roll band where you wore on stage — ball cap, tie, short pants, suit

coat, book bag — were his own from school. "I think I was just about 17. That was the end of '72. I was the youngest at the time. The other guys were a bit older, I was left school. To tell you the truth about it, it was just a way of getting away, y'know. As I remember, 'cause the school has just a state school, funded, state money moss. The school he left behind 'was just a state school, public/funded, state money — just a working class school. The rule was you come to school wearing the uniform. They figured they were getting around discrimination. But that's all it is, because we all knew who was rich and who was poor. You can tell by whose parents have a say in the school's running and whose don't."

Angus and Malcolm were actually born in Glasgow, Scotland, and basically their parents kept them there just long enough to develop thick accents (Angus is high and nasal like a cartoon weasel). Then, Angus says, Daddy Young moved his brood to Sydney "to work, really. He was a spray painter. He immigrated. They had a program for ten pounds and we took them out of it."

An older Young brother, George, got into the big time with a band called the Easybeats ("They had a classic hit in every country — Canada, Australia, you know, in hopes of a better future for your kids," Says Angus. "I was eight years old and Malc was ten, I think...

"George must be now, I think a year older than Angus, about 48, 49?" Angus estimates. "He might be around a lot of many others — six brothers — some tall, you mix your age voluntarily and others you gotta sort of pry it out of 'em." By the time AC/DC formed, Angus says, the Easybeats "had long gone. I think their last thing was in '69, but George was doing stuff in the studio and more on more people were coming in. You gotta check out your kid brother's band!' And he came and saw us and was knocked out." So George and fellow Easybeat Harry Vanda wound up producing AC/DC's first records.

Angus credits his big brothers with introducing him to music. "They had different bars, but there was a lot of this stuff, and a lot of blues stuff. After the blues music sort of event across the Atlantic to the Clapton era. With my brothers, these were their idols. I had other brothers that liked Little Richard stuff and the older brother took me to see Louis Armstrong...When you're young, that's what sets you on the path where your taste lies."

"I love the blue note," Angus says. "But to me you don't have to play straight à la 12 bars to say it's a blues song" — Get him talking about connections between Al Jolson and George Gershwin, and he just goes on and on. "Birth of the Blues', in the middle section, it's a prominent, the exact same as. I think some of the Jolson songs, and Gershwin, there's the element of, you know, he took it a step further. But in most saying he didn't, but there's the influence there, and you hear it in the old, doodaloddee-dum! doin'de...

It sounds like he's scatting a storm solo. I have no idea what he's trying to say, but I smile.

...and that's 'Birth of the Blues', but if you hear the Jolson', I think it's one of the ones where he's singing about his mama as a little boy, it's the exact way, it's uh-duh-duh-duh-duh-damngh bom! bom! duh'n mama!' in a little baby voice."

This is right out of Spinal Tap, I swear.

AC/DC really likes to put in interviews. "That was a guitar, oh yeah, we've never used to believe. He was into ballads, you know, stuff that was, all about a 'disco' about it. In case you're keeping score. Foreigner, Sweet, Manfred Mann, Uriah Heep, Grand Funk, Van Halen, and Cinderella have all made similarly Who-do-doodle on occasion.)

When I go on to compliment Brian's ray-like use of his vocal as a rhythm instrument, the screamer's pleased. "I'm not a proper singer," he thickly rasps in his backslapping pole brogue. "I'm not a tuneful balladeer. I'm lucky enough that the boys picked me, 'cause once it gets, y'know, we do our parts and then it gets the lucky bugger, and it's the bit where it works. Now you see me thinking. 'I hope it's gonna last.' We've always laughed about me not having a voice at all — more like a primal fooking

scream, y'know? It's not always as easy as it was, let's put it that way, when you're in your 20s. I was not a child wonder at singing, but when I listen to the old Geordie stuff I hear this little choirboy high voice [he makes la-la opera notes.] It was hard, but it was so clean and pure, I mean, I hadn't smoked any cigarettes hardly then.

"You know, that was the glam-rock period; they weren't too bad," Brian says of his old band Geordie. "It was like Slade, it was exactly that kind of stuff, y'know, which was fun — with band fooking trite lyrics. We were popular. People knew of us and we sold records all over Europe. We never did get one shot over in the States — a lot of English bands didn't, you know."

Bon Scott even saw them once.

"He said I wasn't too bad. He said a couple positive things about me, so I guess the boys remembered," says Brian. The AC/DC singer-to-be wasn't a major AC/DC fan himself at the time, but "I'd heard of them, and we did one of their songs in the set, 'Whole Lotta Rosie.' But I hadn't heard the album. And I saw them on British television, on Rock Goes To College. The program used to go to a different college every week and pick a band out. And usually it's somebody like the Strawbs — college kids in England are famous for always having three records in their collection by, list, Pink Floyd, that kinda shit, Steve Hillage. But here was this rock & roll band, rockin', knockin' 'em out."

The Scotsman replaced Scott after the former shrieker froze to death in his car after imbibing too much alcohol in 1980.

Brian says the big difference between his singing and Bon's is that "Bon was a bit more bluesy. When I joined, the boys didn't want an exact clone of Bon, otherwise it'd be just somebody parodying Bon. I could never get that great swag Bon had."

"Which brings us back to the beat, like everything about this band.

"Rhythm first, yeah, we always start with the rhythm," Angus says.

When I ask him if AC/DC set out to make people dance, not just bang their heads, he's a little evasive at first. "If you're playing in bars, you play music that makes 'em rock, y'know. If, at the time, they wanna dance to rock, so be it. But do you mean, did we play dance music a la disco type thing? No, there was none of that."

But then Angus delves further into the issue. "Well, Bon was a drummer first, and Brian likes to bang a bongo or two every now and again. They got a beat, you know...if you listen to 'Back in Black,' it's a rap. When we did 'Back in Black,' I think there was a guy from the band Chic who said, 'Hey, we're not far away from where AC/DC is at.' And I think that's the blues connection...."

And while a bunch of AC/DC songs feature obsessively repetitive drumbeats that suggest disco ("It's a Long Way to the Top," "jailbreak," "Highway to Hell," "You Shook Me All Night Long"), AC/DC's most disco groove by far shows up, appropriately, in a six-and-a-half-minute bass jam called "(Soul Stripper," on their '75 jailbreak EP? But once it came out in 1975, when disco barely existed yet, you can't call it a disco "move," like "Miss You," by the Stones; it's more like AC/DC reached disco by accident, by parallel evolution from a shared soul ancestor.

Angus and Brian don't know (or seem to care) much about current Aussie jailbait-grunge heartthrobs Silverchair. (And I forgot to ask them about that new movie called Angus. Sorry.) But they know their own roots. "At my house," Brian says, "you'll hear the Paul Butterfield Blues Band, and you'll hear John Mayall when Clapton was on it. Crossroads, 'Sadimo,' or Cab Calloway, Etta Jams...

"Eta," he reflects. "What a voice, I love that woman's voice, I'd kill for that voice."

"I've always felt that pre-Bon AC/DC songs like 'The Jack' and 'Big Balls' dealt on a punning bawdiness that linked boogie blues to the Cockney gutterbucket-stomping and soul-grinding of Slade, but Angus demurs it. "They were going more for the commercial element, and we always tried to stay away from the pop side of it."

Slade was music hall, he says, but AC/DC was "probably more the boodalla music." (Having "the jack" was down-under wharf slang for either the crabs — see Brian, or the clap — sez Angus. But the song is all polar metaphors.) On the other hand, Angus acknowledges that the good-natured humor pervasive in Australian rock "could probably come from the Cockney element the sure says "element" a

forestruck underaged groupie says her dad wants to erase Bon's tattoos by removing his arms. The letters were fake, Angus reveals, for reasons of decency. "Bon got all sorts of crazy offers, you know. There were many things that would come on, and when they were putting it together they sort of looked at them and said, 'Oh, we can't print that....'

"Toilet humor — Bon was a lover of that," Angus laughs. "That's what he called himself, a 'toilet poet.'" But, contrary to popular belief,

lot, doesn't he?), "cause the language, they say, is very similar to the English East End Cockney".

And they did start out as a British penal colony. This penal/juvenile pedigree might explain one of the more disreputable sectors of AC/DC's audience. "I remember a prison warden saying to me," Angus chuckles, "We used get one or two blokes act there in Australian prisoners. He says, 'Are you aware of that fact?' (Angus is cracking up and slapping his knee at this point) I said, 'No, but it's good to know if ever I'm in the tank, I'm amongst friends!'"

Humble Pie's '20 Days in the Hole' in 1972 sounded like AC/DC before AC/DC did, so was their outfit an influence?" I was a big fan of Steve Marriot," Angus admits. "Steve Marriot actually performed on one of my brother's records, a song called 'Good Times.' To this day I think Steve Marriot was a great, great vocalist.

"I'll tell you a funny story," Angus volunteers. "They had a revival of the Humble Pie, and we had this in Black out, and we were playing, in Philadelphia, and the lineup was, I think, a band from the south called Nantucket, and the Humble Pie, and ourselves. Steve Marriot apparently came up to the guy in Nantucket and the guy said, 'I love you guys. I love that opening track you did, that song 'A Long Way To the Top! (You Wanna Rock 'n' Roll)' — that's an AC/DC song?' Steve says, 'I didn't have the heart to tell him you guys wrote it!'

"Long Way to the Top," incidentally, was AC/DC's first American album-rock-radio hit, says Angus. "big in certain parts of the country around the West Coast — San Francisco, San Jose. And I think deep down in Florida. There was pockets." They were already stars in Australia by that time, he relates, with "a couple Old Top 10 things, the biggest record we had there was our second album, the album called T.N.T., and then they released that as a combination throughout the world as High Voltage."

Which is my favorite AC/DC LP, with the funniest back cover in rock history, featuring letters to the band members where, for example, one

AC/DC continues on p.60

boy george tubes off his mask and tells a survivor's tale. aidin vaziri stops, looks, and listens.

Boy's Life

Photography By Phil Knott

49

WATERWORLD

...has been compared... soulful artists... family Jackson. But it's... To Bring You My Love... desperation. Maybe it's a... telling us about... mouth made for holerin'... To Bring You My Love cut, it's... 1930s Delta Blues... under-... Harvey... titled "Long Snake Moan." "Down by the Water"... Maybe it's... immediately transported to swamp country. Maybe that Mississippi mud, mind you, but... where the air is thick and the heart's heavy.

The title track of To Bring You My Love, with its combination of scratchy bass, freaky organ, and distorted vocals, sets the crawling, brawling tone for the whole album. Simply listening to the dry-as-a-bone production can make you thirsty, but just when you think the heat's getting the best of Harvey, she showers off with oddly cathartic words of watery redemption. Check out all the water references: "Gone though hell and high water to bring you my love" (from the title track); "Big black monsoon, take me with you" ("Meet Ze Monsta"); "Little fish, big fish swimming in the..." – aw, you get the gist. Heck, even the producer of the record, U2 cohort Flood, is entangled in Harvey's watery web. Not to mention that little Polly herself is immersed in water on To Bring You My Love's sleeve photo.

Why all the fuss about H2O? Any bluester will tell you that water's an age-old soul quencher, an earth medicine, always coming down from the sky eventually to stimulate growth and creativity. According to Harvey, her water fetish has something to do with pain, healing, and baptism – agony and ecstasy meeting head on in the depths.

"There's definitely something of both on

To Bring You My Love," Harvey says of her agonies and ecstasies. "That's one reason I chose the cover photo. It looks like I could either be dead or joyous in that water."

While Harvey's earlier work (Dry, Rid of Me), fired full-frontal ammo, her new stuff seems to stem from a deeper place within, from the core of her spirituality and sexuality. Harvey's spiritual streak is perhaps what has garnered To Bring You My Love many gospel and blues comparisons. She cries out to Jesus on practically every song. Of such spiritual leanings Harvey simply says (in a polite, wispy chirp): "Somehow, there's a real faith there."

Maybe PJ Harvey's natural environment (the sprawling, sparsely-populated English countryside) drove her to write writhing tunes like "Teclo." Or maybe she wrote the material under the guise of the "anti-Polly" as a nice contrast to her quiet little world. Harvey reckons the power-saw vocals she lets rip on the record weren't intentional, they just happened, like an extension of self. "Singing should not be too concerned with technique," her sweet voice warns. "It should be quite vulnerable, actually."

Polly Jean adds that the singers she admires most (her favorites are John Lee Hooker, Johnny Cash, Nick Cave, and Neil Young) all have some sort of off-kilter fragility and a potent, perhaps overlooked sensuality about them. Harvey's beloved are men in black, highwaymen, lone wanderers who can tell the saddest story through the stoniest voice – and gush all the feelings in the world through one throaty quaver.

"My favorite singers," she says, "are people who sometimes sing off-key. I'm very wary of vocal acrobatics. Raw emotion is the most important thing to me."

Kristi York

Chocolate
Blue
Persuasion

Michael Moses

Doctors have recently discovered a whole slew of prosexual drugs and nutrients designed to enrich your sex life. But forget Spanish Fly, ginseng and the John Holmes Superpump©; if you want to intensify your lovemaking, you can walk over to that newsstand on the corner and pick up a pack of m&m's. According to ancient confectionery folklore, the green ones are supposed to intensify your sex drive as well as enhance your tactile and emotional sensitivity (read: make you horny).

Of course, that's just one of the far-fetched myths associated with the famous pint-size chocolates. The yellow ones are supposed to shoot sparks when bitten in the dark; the red ones, when saved for last, can evidently make any wish come true; and of course, Van Halen eventually became a big famous band because they designated in their tour rider that they wanted the brown ones removed from their after-show snack trays. What will people say about the new blue m&m's?

That's right, blue. The first color to be added to the popular candy bunch since red was introduced in 1976. The blue makeover (which according to a nationwide poll taken by the Mars company, beat out pink and purple as America's favorite color) ultimately means bad news for "fan fans."

It seems that the Mars company has decided to discontinue making the ecru-tinted ones, a color which has been part of the m&m's family since 1949. The move has given rise to the blues in at least one khaki fan, a New York journalist who commented on the decision by writing, "Why sacrifice an institution for something that basically looks like Smurf shit?"

THIS BOY'S TOO YOUNG TO BE STRUMMIN' THE BLUES

Do the blues have an age requirement? Do you need a lifetime of heartbreak, poverty, and self-destruction to tread this sacred genre? Or are teenaged gripes about pimples, math teachers, and curfews enough? Who's to say?

Wunderkind blues guitarists Nathan Cavaleri, 13, and Kenny Wayne Shepherd, 18, tackle these issues daily. Too young to even remember the Blues Brothers, Cavaleri and Shepherd have been honing their chops at home for years, with zero formal instruction. Against all odds, both have major-label deals. Still, folks wonder if these two actually have the goods or if they're just novelties of the moment. After all, even the Mutant Ninja Turtles seemed kinda hip at first.

Cavaleri may be too young to join a high school marching band, but that doesn't mean he hasn't earned his keep. Taught by his father (a part-time guitarist), this Sydney native has been playing since the ripe age of three. He recorded an import-only album (a toy seller in Australia) and his glossy debut, Nathan (on Michael Jackson's MJJ label), at 9. He has already toured extensively, playing upstage... and is currently bashing behind... (like Madison)...

Cavaleri admits his talents upsets with those who might see him as just a curiosity. "I don't know whether they like me because I can play guitar 13 or because they like my spiritual playing. I prefer them to be my playing, because I don't really care about my age."

He also plays drums and a bit of bass and keyboards, but can't quite handle acoustic guitar. "It's too hard to play because of how small my fingers are. It's too big."

Cavaleri doesn't seem like a normal 13-year-old in many ways. He enjoys basketball, soccer, and other things, and he gets grounded when he misbehaves. He even likes the occasional pop tune, admitting: "Sometimes I get into the Offspring."

While he hasn't met the Offspring, he has encountered many of his other musical heroes. He's jammed with B.B. King (with whom he's touring), Albert Collins, and Mark Knopfler. Has the boy met his youthful idol Eric Clapton? "I haven't yet. But I just try to figure out one note for note. I can't even... or so. He's a great guy," Cavaleri says. "He's...nice. Very soft-spoken and well-mannered and...nice."

Quite tactful. But I have to ask: are views on the child-abuse allegations? Cavaleri's well-prepared for such inquiries. "I don't care about that stuff," he announces quietly, before the question's even finished.

Physically, Cavaleri's a pro. He admits to occasional pre-show jitters, but with a seasoned band of 30-somethings behind him, he's in good hands. And worldwide during this delicate phase phase him a bit. "It's happened so slowly that, I don't know, it's just normal."

Slowly? "Well, maybe, it seems like it's just normal."

Comparatively, Kenny Wayne Shepherd's success did happen slowly – he was already a hoary 13 when he first performed in a club. Raised on blues and country by his father (a career radio man), Shepherd mastered guitar purely on his own.

"I just played by ear," he says. "I'd sit down next to the stereo and pick up some old blues albums – Muddy Waters or Hooker, Wolf or Stevie Ray Vaughn or Jimi Hendrix – and I'd just try to figure it out note for note. I can't even read sheet music," he chuckles.

When working up through the ranks, Cavaleri and Shepherd eventually crossed paths. Now Shepherd's signed with Giant in 1995, while singer Corey Stelling's an important presence for now (Shepherd sings junction of the ten vocal tracks), this should change soon. "Probably by the second album, I will have assumed a lot of the vocals," Shepherd promises soberly. "I just need to work on it a little bit. I'm not totally comfortable with my voice yet, because I'd like for it to be at the same level as my guitar playing. It's got one extra forces."

Slowly? "Well, maybe he's widely as Cavaleri, but he already talks like a seasoned performer. "To be honest, I never get nervous before going onstage because you got into a zone and you don't even know you're performing there. Stage fright's never been a problem."

So far, Shepherd's concert highlight has been opening for the Eagles in Austin. But he's also rubbed elbows with such legends as B.B. King and Bo Diddley. "I've gotten to fulfill a lot of dreams in the past couple of years," he relates.

He hasn't met Cavaleri, but he has heard his music. "He's cool, man," Shepherd raves. (Cavaleri hasn't heard any of Shepherd's stuff yet.) "If he's actually good and he can wail on an album and put out his stuff, there's no telling what he could be like 10 or 15 years from now. I'm excited to see young people getting into blues. "One of my main goals is to help expose my generation to it, because you don't find too many kids my age listening to this kind of music."

A couple of photogenic, skilled lads like Shepherd and Cavaleri could be just the ticket. And if all their talents aren't enough to excite the kiddies, maybe they could dye their hair blue. That would be appropriate.

Eric Broome

Max

art directors Robert Kirk-Wilkinson @ Research Studios
 Alyson Waller @ Research Studios
 Tom Hingston @ Research Studios
 Simon Staines @ Research Studios
 designers Robert Kirk-Wilkinson @ Research Studios
 Alyson Waller @ Research Studios
 Tom Hingston @ Research Studios
 Simon Staines @ Research Studios
photographers Robert Kirk-Wilkinson
 Alyson Waller
 Tom Hingston
 publisher Max Magazine, Germany
 origin UK/Germany
 dimensions 235 x 335 mm
 9¹/₄ x 13¹/₈ in

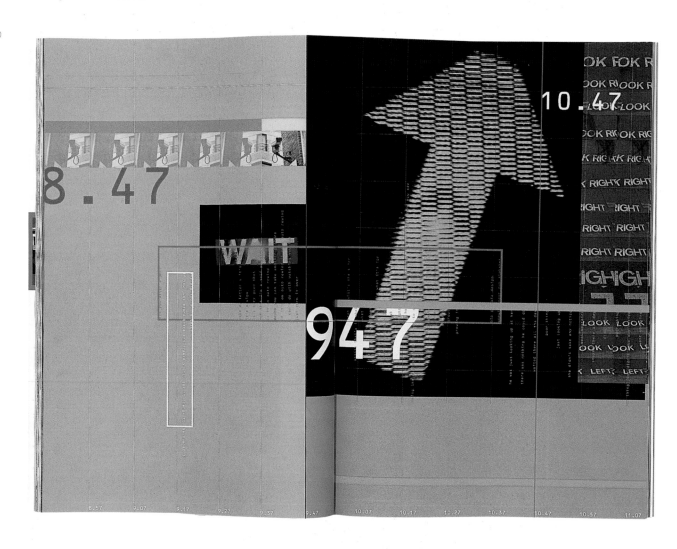

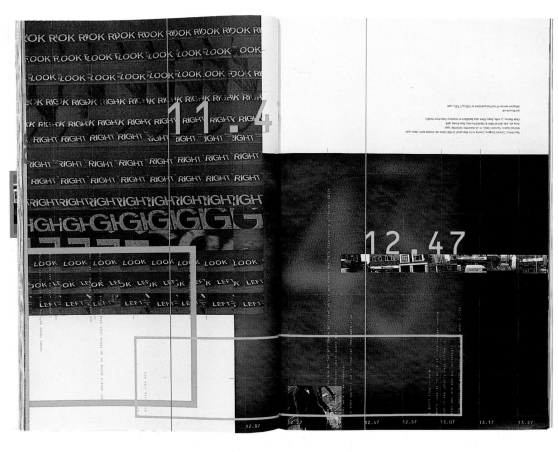

Jon Wozencroft
[Adapted version of text published in FUSE 15 C.F.S.], 1998

Max Kisman, 'Uniroyal Daydream Comma in the Year 2000', in Alan Zone, ed. Awards from, West Lipo
Michael Benn, 'Garden Cities', in J3, November/December 1993
Zone Kit, eds. Bruno Heller & Sanford Harness, New Boxes 1998
Chris Menon, Le Jardin, Allara Roma Lyps Senacius in Academy Video from the BBC

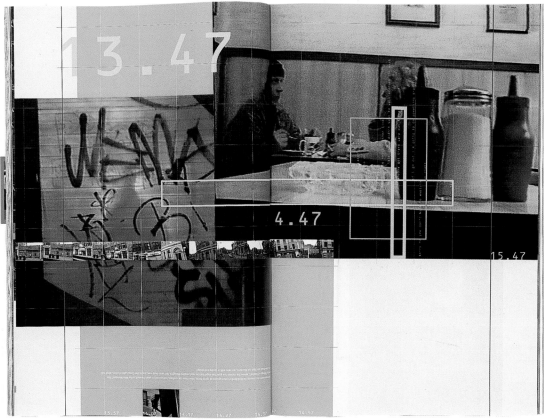

162

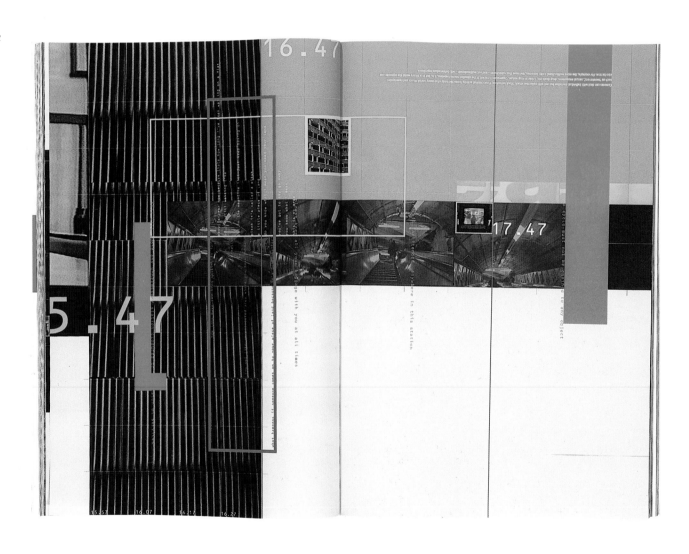

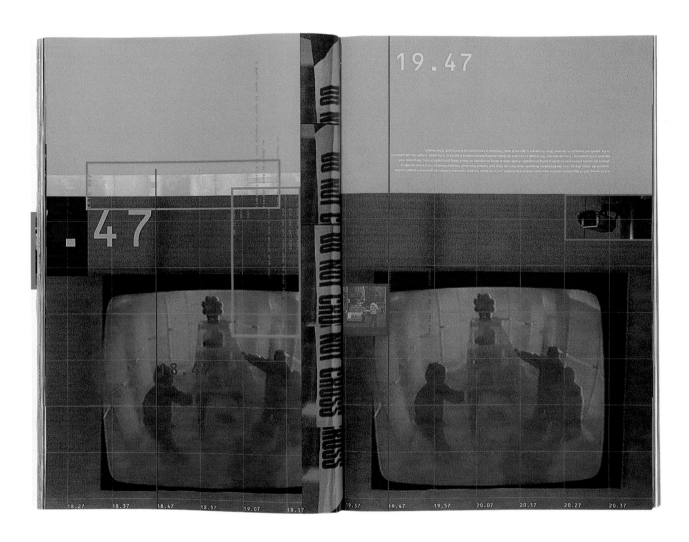

19.47

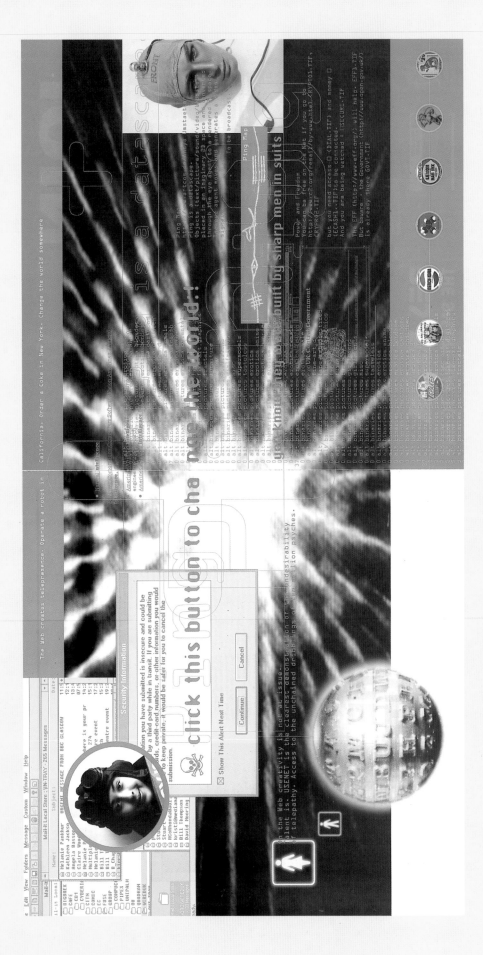

Creative Review

page 164

art director Seán O'Mara
designer Seán O'Mara
photographer Seán O'Mara
illustrators Seán O'Mara
 Roland de Villiers
editor Louis Blackwell
publisher Centaur Communications/Creative Review
origin UK
dimensions 267 x 275 mm
 10½ x 10⅞ in

page 165

Blah Blah Blah 1995

a short-run magazine

art director Seán O'Mara
designer Seán O'Mara
photographer Seán O'Mara
illustrator Seán O'Mara
editor Seán O'Mara
publisher self-published with the aid of
 Central Saint Martin's College
 of Art and Design
origin UK
dimensions 295 x 420 mm
 11⅝ x 16½ in

pages 166-9

2000

supplement of DJ Magazine

editors Christopher Mellor
Claire Morgan-Jones
publisher Nexus Media Ltd
origin UK
dimensions 230 x 300 mm
9 x 11¾ in

art director Michèle Allardyce
designer Michèle Allardyce

inter-action

by Ian Peel

Warren G and Public Enemy in a computer game? Games consoles at Ministry Of Sound? Be prepared for a mini-revolution as technology anoraks finally meet up with clubbers. In fact, many of these so-called anoraks are clubbers by night and many hardened clubbers are technology anoraks by day. So anyone who's half switched-on is thinking what the hell, let's mix and match and see what we come up with. New interactive nights and installations are at clubs like The Big Chill and Ministry and with everyone from Coldcut to 2 Unlimited releasing CD-i's the future of dance music is interactive. And if you're not convinced, it's predicted that in two years' time there will be more multimedia computers than normal CD players in people's homes in the USA, with the UK catching up by the year 2000...

words & pic by Chris Everard

technology

You think vinyl's had its day?
CD's on the way out too, baby!

Mind Body Spirit®

X-RAY ZOOM POWER

GOD BOX

CAUTION

Astrophysics Research
© Corporation

"I used to think science had the solution to communication between humans: One day I received a computerised letter beginning with: 'Dear Dr Mr.' I had lost my identity but I was still getting mail. Is this my future? Is it yours? Palo Alto

❑ The God Box.
The God Box is a metaphysical ghettoblaster (also available as an attractive 420mm hi-fi separate), which constantly monitors and processes data collected from your thoughts, skin temperature, sexual activity and general brain activity. This data is transmitted to the God Box from an electrode the size of a semaphore-chip in your navel. The God Box's CD-Rom contains the complete writings of Confucious, Rig Veda, Bagwan Sri Rajneesh, Tibetan Book of the Dead, Popol Vuh and Grolier' Worlwide Multimedia Enyclopaedia. Via its neural network mega fast 900mHz processor and speech recognition software, you'll be able to consult the I Ching and ask the God Box about life, the universe and everything...

The questions you ask throughout your life will be stored in a personal data memory along with information about your religious beliefs, your favourite music, movies and food preferences. When another person with compatible personal data stored in their God Box passes within 2 metres of you, your God Box will light up and signal you, displaying a selection of possible chat-up lines and declaring whether you both are of you are interested in...

For amorous lovers who want to be 'At One' with each other, two God Boxes can be connected together and transmit a 30 minute audio-visual cosmological programme direct into your brain via the electrodes in your belly buttons.

Non-stop psychedelic mandala patterns, auto X-Ray Chinese Herbal Medicine CD-Rom, and OM energiser are optional software upgrades. An little red remote control and car kit package (enables the God Box to run off the cigarette lighter socket) are promised for the end of the summer (2002). The God Box helps.
Infot: Astrophysics Research Inc. http://www/Godz.Box/nux

"Insufficient facts always invite danger."
Spock, Star Trek

❑ The Doug Synthesiser.
Announcing a new era in personal entertainment technology - a fully automatic, portable chemical synthesizer. Dial up how you want to feel, how long you want the feeling to last and how strong the experience will be. The machine does the rest by secreting the instantly manufactured substance from an everlasting lollipop which comes complete with a silver lamb hip holster. You can choose the flavour or colour of the lolly. Non addictive, non-hangover inducing, 100% natural herbal substances will then be exuded from the lolly. However, it's 100% safe and the effect of this drug can be controlled by a super-vitamin antidote.

Enjoy feeling foxey for just ten minutes - and then bang on the button for the next four hours? In fact, using the Doug Synthesizer, you could get passed and sober again, several times a day if you liked! How about getting totally spaced and then dead straight within 45 minutes ready to drive home?

If you want to trip out and travel through the seven levels of consciousness as defined in the Politics of Ecstacy then the Doug Synthesizer is for you!

Order before 1st December and you get a free Philip Stark chair and a self-hypnosis tape which sleep-teaches you Shamanic practices of self-healing and conversing with 'the sacred veiled yoga lady'. A 'Photovoltaic Solar Power modification' for the hip holster costs just £5.99 and comes with two interchangeable velcro glitter tops.

❑ Futureshock Books:
Chaos & Cyberculture' Dr Timothy Leary
The 'Shape of Things to Come' HG Wells
'CyberPunk' William Gibson
'Crop Circles - Harbingers Of World Change' edited by Alick Bartholomew
'Bladerunner' Philip K Dick

C_2H_5OH – Ethanol

❑ Futureshock Videos:
'Millennium 2000: Prophesies, Conspiracies & The Illuminati' available from Vision Distribution 0181 850 5537

❑ Surely not? What will DJs be mixing on CHristmases? I mean, we were just getting our heads round to that way of thinking weren't we? Year 2000 isn't as far away as it sounds and before the music industry lets CDs disappear from the market they'd have introduced a few more toys for us to play with. It would seem the most logical step is to market domestic players that can accept 2 CDs. Players that would do the mix for us - automatically, at the touch of a button. Sony have introduced these machines to the broadcasting industry. Vestax and Denon have dual CD players for the DJ market, but this is still a manual job in an increasingly computerised world. Brings a whole new meaning to that fond farm 'bedroom DJ' doesn't it, but with the media industry's increasing awareness of club culture as a commodity, it's not that improbable that your local Dixons will be marketing such products on the high street.

❑ We've lived with CD now for some twelve years, and in that time there's been no evidence of tailoring the product to suit the DJ. Granted, we were enticed into buying the CD single because it featured mixes that weren't released on vinyl, but with the greatest of resentment. The dance music market is simply too small for a large multinational corporation like Sony to cater to. Back in the 80s when their new product wasn't taking off as quickly as they'd have liked, they made an audacious move in buying CBS Records and converting their products into the CD format. There was clearly going to be no messing about with these boys.

❑ For all the advantages that CD offered - clean sound (surely perfect for studio-based recordings?), durability (no scratches, pops or clicks), and portability, there was one thing that the research and development departments neglected. A decade before we had enjoyed the chance to record our favourite songs onto cassettes. Its popularity was unprecedented and the immediate success brought about the concept of portability with the Walkman. Now anyone could record anywhere. For the first generation of DJs, most will tell you that they started putting together tapes long before they had two decks, let alone knew what a bpm was. That Pause button was the business. But with this access to technology came the threat of piracy. CD was perhaps a conscious effort to control this international disease. Yet a market that was so familiar with the ability to record and play music at the same time, something was clearly missing.

❑ For the advantages that CD offered - clean sound... The Mini-disc is the industry's answer to the one serious limitation of CD, and a general trend in the steady decline of cassette sales. Of course the idea isn't exactly groundbreaking, but it does offer the punter what they want - the ability to record, with the quality that we have become accustomed to. If this has a strange sense of deja vu about it then that's because we all understand the DAT format has long been an industry standard; or it might be that Sony launched Mini-disc and Philips launched their equivalent; DCC; back in the beginning of 1993. Whilst DAT will remain a niche product dedicated to the recording industry, new formats such as Mini-disc and DCC are set to take over the domestic market, not as revolutionary products but revolutionary ones. These companies are prepared to 'wait their turn' whilst CD continues to

increase its dominance over the market. It's similar to the situation with fax machines and computer modems. At this moment, an office prepares a letter on computer, prints it out on paper and then faxes it to another office. When you realise that computers can do all of this in one by communicating to another faxes, these machines soon appear redundant. At any rate, from the musician's point of view, these are products that satisfy industry standards and the demands of a domestic market.

❑ All of this assumes that we intend to continue buying music as a commodity through the conventional channels. Music retail traditionally relies on album sales, something that dance music has avoided in the main - its output is far too prolific, and the scene too ephemeral to confine an artist's style in one package. Yet this is where the main industry makes its money from. The balance of power remains firmly in the hands of such companies, and it costs them very little to release back catalogue material in the form of CDs, the contracts and copyrights already existing in their favour. New technology neatly by-passes this sales aspect, effectively cutting out the middle man. Look at cable television where we subscribe to our preferred choice of viewing. After paying a nominal subscription it's all ours, to record if we feel like. Any budding entrepreneurs reading this and thinking they can do the same for music will be disappointed to learn that such projects have been set up in various test towns around England since 1993. The response in a typical family set up has been favourable, with all members getting satisfaction from their individual programming, all in superb digital quality. The fear that modern technology obscures the human input needn't be as terrifying as some people make out. Brian Eno likens this process to asking an interior designer to organise a room in terms of colour, furniture, etc. isn't that what we do when we go and listen to a DJ?

❑ Do you ever get the feeling that all this super-technology is leaving us vinyl punters behind? That our stubbornness merely strengthens our resolve to continue with more cumbersome boxes and bags every time we play out? OF COURSE! And it'll continue until someone comes up with a product that is as equally tactile for the DJ to work with. Just imagine a Visual Display Unit that tells us when the next breakdown is about to happen! As the image of a group of telecommes less and less of a fixture in dance music, so too will the necessity for packaging and merchandising. At the moment, CDs are still being issued with glossy covers, there's no white label equivalent because that level of the market doesn't adopt the CD format. But if you're a burgeoning home producer with no budget to press a 1000 records, it's not difficult to have your track featured on the type of music mags that attach a free CD ROM with every issue. You just send in your demo and if it's picked, you're ensured a guaranteed audience in a home environment. And it can't be denied - walking around with a small backpack of tracks on Mini-disc or whatever else you choose to work with has got to be a lot easier than a messy bunch of CDs. Paul Davies

30 31

photographer Chris Everard

"what do you want?

inform

"you're

not going to

it!

Intro to 'The Prisoner', cult 60s TV seri

⇨ **PREPARE FOR**
THE FUTURE
⇨ **GET READY**

editors
Christopher Mellor and Claire
Morgan-Jones

design and art direction
Michèle Allardyce

assistant editor and sub
Lindsey McWhinnie

contributors
Andy Crysell, Paul Davies,
Chris Everard, Sam King, Ian
Peel, Steve Pitman, Ronnie
Randall, Helene Stokes,
David Thompson, Phil
Wolstenholme

2000 free with DJ Magazine
issue 142
Spock says "Insufficient facts
invite danger" (so read it)

nation

EQ

CD magazine

art director Rob Bevan
designers Robert Corradi
 Howard Dean
 Rick Nath
photographer/ Lee Robinson
illustrator
editors Tim Wright
 Laurie King
publisher NoHo Digital
origin UK

above

NoHo Digital

letterhead

art director Rob Bevan
designer David Hurren
publisher NoHo Digital
origin UK
dimensions 210 x 148 mm (folded)
 8¹/₄ x 5⁷/₈ in

Big Bad Bob, Shareware King
& Prince of Beat-'Em-Ups

LOVES: DOOM ("The original and the best")
HATES: DOOM II ("Can't pay, won't play!")

SPECIAL ASSIGNMENTS THIS ISSUE:
A PASSION FOR ART PANZER DRAGOON
BATTLE BEAST

SPECIAL KEY:
HIT "BBB" TO GO TO
BOB'S SHAREWARE
SELECTOR

EQ·MAIL

EQUESTERS

The PCs, Officers Nasty and Nice
"Let's keep things simple now!"

LOVES: CLUEDO
HATES: VOYEUR

SPECIAL ASSIGNMENTS THIS ISSUE:
JOHNNY MNEMONIC PANZER DRAGOON

CLICK HERE
FOR DETAILS
OF NEXT ISSUE'S
DIGITAL PORN
FEATURE!

EQ·MAIL

EQUESTERS

pages 176-7 ➤

CONTENTS.

Managing Editor Richard Johnson aka Rick Slick Comissioning Editor Jake Barnes Design Automatic Photography Des Willie Words + Knowledge The Young Wonderfuls: Lynford Anderson, Andie Duncan, Kathleen Henriques, Grace Mattaka aka Spacechild, Tracey Roseman, Vanessa Richards aka Butterfly, Jaison Mclaren - the Original One, Diana Hughes, Kerys Nathan. The views expressed are not necessary the opinions of Playground. No Liability will be accepted for any errors which may occur. Letters, articles and images are welcomed. These will become the property of Playground. Text may be edited for length and clarity. No responsibility will be accepted for unsolicited material. Information from Playground cannot be reproduced in any form, without the written consent of the publisher. Copyright © 1996. Published for **Playground Music Network** 12 The Circle, Queen Elizabeth Street, London SE1 2JE Telephone 0171 403 1991 Facsimile 0171 403 1992 E-Mail 100617.1423@compuserve.com Playground is circulated free to all members of Playground six times a year.

#01.

BULLETIN BOARD. The FREE resource for Playground members wanting to contact other Playground Members. You may want to sell records and/or music equipment, find a new band members or form a fan club.

We're sorry but we can't accept trade ads.

Complete the coupon included in CAPITAL letters, restricting your insertion to maximum of 24 words. Mail to Playground at 12 The Circle, Queen Elizabeth Street SE1 2JE or E-mail us at 100617.1423@compuserve.com. We're sorry but Playground Classified enquires can't be taken over the telephone. Ads are included on a first come, first served basis. The ads will be included in the next bulletin and on the Internet.

Advertising
For advertising, sponsorship and collaborations phone 0171 403 1991.

Want to Join Playground?
To join Playground Music Network simply ring 0171 403 1991 or fax 0171 403 1992 and ask for an application form!

*May/June 1996

PLAYGROUND
Black music, culture and superstyle

THIS IS JUNGLE.

SHOUTS.

EDITORIAL.

From time zero to this present period of existence, creative geniuses have inspired humankind to deeper levels of consciousness. The boundaries of current understanding are always being challenged in order to reach a more true reality and perfect expression. No greater manifestation of this quest can be found than that expressed by Black SuperCulture.

Black SuperStyle, through its music and culture, has long been at the forefront of creative expression. Whatever the medium is; dress, language, rhythm, text, technology, you name it, you can feel and hear the energy. It's inherent within jazz, soul, reggae, Gospel, funk, hip-hop, jungle - Black SuperCulture is the style gateway through which musical synthesis occurs.

Over the past months many have expressed their desire for a network which not only explored and celebrated the SuperCulture of the Black, but also did so in a manner reflective of its innovative nature. From a series of Mind-Melts with Ne Guru and The Young Wonderfuls in conjunction with the Cultural Taskforce, the concept of Playground was freaked and distilled.

Playground Music Network finally has been born, and it plans to celebrate the creators of black musical culture and the innovators of SuperBlack style; whilst mapping its global impact. It's open to individuals and organisations engaged in different aspects of the music industry, so whether you're a musician, vocalist, lawyer, retailer, DJ... you name it, you're be welcome. We'll be exploring current Black musical formats and encouraging the genesis of new ones.

Playground will include introspectives of SuperBlack styles, reviews of contemporary artists and musicians, as well as the future marcos of the musical and entertainment world. There'a gonna be a balance between the creative side of music with practical advice to those who wish to enter the music industry. A key feature will be a special bulletin board allowing members to link up with others into Black music.

To start things off there's a special feature on Jungle. You'll see the interplay between artists, DJs, producers, radio stations and record companies, and check out how this combination has given birth to a new genre. Also, there's an overview of how major record companies work, a guide to publishing and a review of technological change in the music industry.

For those who are tripping out or up on the meaning of the words and excluding themselves or others because they feel the Black is Wack, you know that this network is for all races; creeds, genders.

Finally, special shouts to you members of Playground; we want to incorporate your experience, opinions - your letters and articles are welcomed. Remember Playground is interactive so send your own messages, comments and details of your services. I'm sure your gonna enjoy the ride throughout the year ahead.

Rick Slick

X-amount of respects to the Ne Guru and Young Wonderfuls, Mind-Melt, Automatic, Inna dis ya Generation, Casual and Anon for the systematic revelation. Crazy thanks to the Visual Innovation Unit, the Cultural Taskforce, Nailon of the Nubian posse, The Committee - da original yardboys, Jai - the Original One, Dupbase, Soulbase Base, Metalheads, Inforce, Moving Shadow, Frontline, SOUR and Future Trax. All those in Space Communion and those who cerebral at warp speed to produce this issue stuff and mad light. For all those who are still trying to crack the code remember 'X' x0.58 x 'I' still holda true. Brothers in stales, sisters across the river, step with the breakbeat and light. Special shouts to all British and international musicians, promoters, DJ's, venues, radio stations, journalists, artists and intellectuals who boom the bass tree ones maaf. Just like Dee Jee-Pee, Dupbase, One, Dupbase, Soulbase Base. Black - particularly all the drum and bass massive, big up to Mose-side, Hackney, Brixton, Tottenham, Peckham, Notting Hill, Chapeltown, Toxteth.

Cumin' at ya.

The next issue is going to be a special focus on Reggae music. There's gonna be pure vibes in the place as we explore its origin and development, capturing the energy of reggae, dancehall and sound systems. Its gonna be the absolute lick, trust me! the music business side of things, there's practical advice on how the music industry works and key industrial bodies.

Watch for Jazz, Soul, Hip-Hop, Gospel, Funk.. issues coming soon.

Look out for the forthcoming music seminar programme, SPEAKOLOGY planned in association with the Black Music Academy. These seminars will be full of info and inspiration for beginners and others on their way through the music maze. It's a forum to discuss and comment on developments in music culture and its various genres, so make sure you check out the Rap, Soul, Reggae, Jazz and Jungle Schools. Starting May '96.

Jungle. Probably the most popular music in the country at the moment, certainly the most fashionable. But where has it come from? Why does it sound like it does?

The dilemmas surrounding the word 'Jungle' offer the first clues. Many involved with the music don't like the term, preferring something else like Hardcore, Drum And Bass, Intelligent or Hardstep. Some don't like names at all, preferring simply to call it music. And therein lies the beginnings of an investigation. Jungle is too diverse to be defined by a single word. How many different ways are there of saying food, sex, or money? Jungle is the product of years of development and experimentation. One of its greatest achievements is that it has introduced new sounds into the musical canon such as timestretching and multi-layered sampling. Jungle has taken new musical technology to its outermost limits. Like Hip Hop ten years before it Jungle is laying down new musical rules. The music brings together a disparate set of influences into a pulsating, whirring, riotous package of sound, style, dress, look and language but at its heart Jungle is a music, and an understanding of this will help to explain everything else. Let's rewind selector and go back to the beginnings.

THE BEGINNINGS

As the Eighties began, American hip hop emerged from the ghettos of New York and laid down the rules for the decade's musical methodology, introducing two deck mixing, sampling, drum machines and MCing as the techniques at the root of modern dance music.

Fast forward to the mid Eighties where hip hop and house are battling it out for dominance on the floors of a newly created British club scene. In a post riots, post Racial Equality legislation British society, races began to intermingle on the dance floor. UK clubs became musical accelerators where different musical forms were whirred together to create new entities. Steve 'Silk' Hurley's Jack Your Body gets played alongside Eric B & Rakim's Paid In Full and Silver Bullet, UK rap failed to consolidate this success. For whatever reasons, perhaps due in large measure to the dominance and pre-eminance of American artists within this genre UK rap artists found the crowds and the record sales weren't there. Instead, many of them moved into the booming rave scene.

Soon musical alchemy became available for all. As world technology improved, broadcasting and music making equipment such as radio transmitters, samplers and drum machines became cheaper and within reach of the average wage earner. As a result the UK became a hothouse for musical research in the mid Eighties. With the seeds of development planted by the States, the UK embarked upon a new age of musical evolution.

E NUMBERS

Chief catalyst was the popularity of Acid House, its cause aided and abetted by the proliferation of pirate radio stations up and down the country pumping out the sound such as the then unlicensed Kiss FM and Starpoint FM. The illegal warehouse parties taking place every weekend in the capital including the now infamous Clink St parties near Tower Bridge served to culturalise the music, turning Acid House into a youth cult.

As Acid House blossomed, Hip Hop began to lose its grip in the UK. After early home success for British groups such as the The Cookie Crew, Overlord X and Silver Bullet, UK rap failed to consolidate this success. For whatever reasons, perhaps due in large measure to the dominance and pre-eminance of American artists within this genre UK rap artists found the crowds and the record sales weren't there. Instead, many of them moved into the booming rave scene.

In the late Eighties the Acid House scene, as it was then known, was snowballing into an immensely lucrative business. Massive parties in fields, warehouses and aircraft hangars were organised up and down the country, drawing crowds of over 10,000 and attracting interest far beyond the confines of the club crowd. In 1988 The Sun newspaper began running exposes on rave's drug and sex orgies. House music had transcended its own milieu to become a national phenomenon.

From 1988 to 1990 each British summer became an opportunity for mass partying to the various forms of House, the revelries often fueled by the drug

Elisabeth Troy

ACCELERATING INTO THE NINETIES

Ecstasy. The role of Ecstasy in the development of rave culture, and later Jungle, is unquantifiable, but many of those involved would claim that its influences has been significant. Aspects of the music began to reflect the drug. Listen to Baby D's first version of Euphoria or the Aphex Twin's Analogue Bubble Bath I for clear examples of E music.

As the euphoric Eighties rave faded into memory a new style emerged. The Eighties had provided the infrastructure — illegal and legal radio stations, artists, clubs, shops, fans: the Nineties made use of it.

The first change was in the tempo. Nineties House was faster and more stylistically splintered. Genres sprouted from all directions — deep house, hard house gabba, handbag, so many names in fact that names started to become irrelevant. Chief among the new breed was Nutty Hardcore and Happy House. These sounds were developed from Hard House and Techno but used hip hop breaks as their structural base, creating a rhythmically complex style different from the orderly, linear beats of House and Techno.

Many of the artists making these sounds were from the old hip hop crowd such as DJ Crystyl and Kenny Ken, resurrecting their breakbeat albums for a rhythm and pre-acid audience.

But hardcore had an image problem. Its cheesy samples and squeaky melodies coupled with its perceived crowd of wide boys, crack-ridden Yardies and the generally dispossessed caused many club goers to give it a wide berth.

Hardcore seemed to be found in inner cities, particularly in London, where Labyrinth, the Dungeons and the Four Aces in Hackney and the Lazerdrome in Peckham came to be key staging posts in Jungle's development.

These were intense clubs in intense parts of London. As one ex punter remembers it: "The Dungeons wasn't much more than an old pub that had a house night but it got harder and harder and madder and madder in there and Jungle grew out of that."

The idea of socialising with the impoverished and the drugged up probably deterred many outside the genre from getting involved. This had a crucial and ultimately positive effect. For a least two years hardcore was dismissed by the trendy, the mainstream and the media as stylistically bankrupt.

Typical of this view was Touch magazine's only half humorous definition of the scene — "Jungle: inept mishmash of samples at triple speed to produce an insanely hardcore dog's breakfast. Social milieu: Children. Crack heads. People bored of listening to reggae."

THE LOST YEARS

In retrospect the music's isolation did it no harm. It caused a scene to become self-reliant and to appreciate itself. As Hardcore mutated into Drum & Bass an entire musical infrastructure grew up around it, from artists such as Lennie De Ice and DJ Crystyl, record labels such as Reinforced, Moving Shadow and Looking Good, DJs such as Grooverider, Hype and Fabio, retail shops like Blackmarket, Boogie Times and Unity, radio stations such as Fantasy and Kool FM, MCs like Dett and Navigator, and a multitude of entrepreneurs, designers, promoters and club venues.

While Jungle's independent infrastructure allowed the scene to continue and develop, occasional Hardcore tunes were still able to break out of their cultural confines and crack the national charts. Xpansions' Elevation, The Prodigy's Charlie Said, A Funki Dred's Total Confusion, Unique 3's The Theme and Liquid's Sweet Harmony all thrust Hardcore into the mainstream. Despite being derided, the music was able to keep a toe hold in the field of popular music.

During this period of outcast, Hardcore underwent a sonic refit. Perhaps to satisfy the ever changing aesthetic demands of their crowds or perhaps in response to the sneers of outsiders, Jungle producers developed breakbeat science.

Using new and improved technology, such as the Atari computer and its software partner the Cubase programme, producers cultivated compressed and layered drum sounds, timestretching, embossed loops, warped and bent basslines, devised poly rhythms and created a hyper real new musical language. (Refer to Tech by Tech article)

This upward gear change in studio skill paralleled a move into musicality. While Hardcore and Drum And Bass had been about beats and boisterousness, the newly developing Jungle began to dress its splattercast rhythms with veils of Jazz-derived melodies. LTJ Bukem's The Dolphin Tune, Roni Size's 1994 classic Music Box and Goldie's Timeless all ushered in a new style of Jungle that quelled some of hardcore's ferocity with sonic seduction. Some called it Ambient Jungle, others called it Intelligent.

JOURNEY INTO THE LIGHT

As a result of this new musicality Jungle began attracting more and more attention from outside its scenes in 1994 and 1995. Non aficionados began discovering the music and finding that it represented more than mere drug driven noise. Non Jungle artists, ravers and the media began to realise that Jungle was the first dance music that Britain had ever created itself. Using a mix of Ragga's rude boy stance, Hip Hop's breakbeat bombasticity and House's energy, Britain's musical untouchables had created something entirely new and delicous.

In 1994 and 1995 Jungle experienced unprecedented levels of cultural credibility and good press. The Face and The Guardian ran features on Jungle. So did the NME, the Sunday Times and Vogue. Radio One gave the music its own show (see One In The Jungle article overleaf), as did Kiss FM in London and Manchester and Choice FM in London and Birmingham. Jungle had broken out of its narrow, and in the case of radio, illegal outlets, to become an alternative national anthem.

Dom Phillips, editor of dance music magazine Mixmag, has his own theory as to why Jungle began receiving massive amounts of media.

"It's a good story," says Phillips. "And it's been a long time in dance music since there's been a good story. Boys with ponytails making House music in their bedroom was never very interesting to the Guardian and The Face. With Jungle they've got something they can read social and political angles into. There's the black aspect, the inner city aspect — it's a whole cultural package."

Shy FX

One of the contentious points within Drum And Bass is whether it can be termed a black music, as Hip Hop, R&B, and Reggae often are. There is a view that is was the injection of a black aesthetic, principally bass and complex drum breaks, into House that created Jungle and made it a music able to appeal to a wide cross section of people.

As Two Fingers and James T Kirk write in their underrated text Junglists (Backstreet 1994) " ... My friends would drag me to rave after rave and I'd stand up and screw my face, until they played two little tunes with a Ragga sound and I'd jump up with the sound until it disappeared. Then Hardcore went underground and evolved into Jungle." This injection hypothesis is not an easily proved theory. A quick snapshot of jungle artists would show that some are white, including Alex Reece, Aphrodite, Danny Breaks and Photek. This leads onto the debate that has characterised the sound of Drum & Bass throughout 1995 — Intelligent vs Ragga. The debate was brought into the open when General Levy's Incredible and Shy FX's and UK Apachi's Original Nuttah broke Jungle into the national charts with a salvo of Ragga tunes. To many within Jungle these chart hits gave the public the impression that Jungle was a Ragga sound, and in response the term Intelligent was coined in an attempt to accommodate the music's complexity.

Intelligent Drum And Bass is a term used to describe ambient melodic jungle produced by the likes of LTJ Bukem and Alex Reece. Ragga, or 'Ardcore stands for something ruffer, more raw. For some the debate has a sinister overtone, with the suggestion that Intelligent represents whiteness and Ragga blackness. It can't be denied that crowds at popular Intelligent nights such as Bukem's Speed and the Metalheadz Sessions at the Blue Note in the capital have an ethnically-diverse crowd while the Lazerdrome in Peckham continues to draw a largely black crowd.

As the editor of Mixmag observes: "A lot of the indie press have really got into people like LTJ Bukem and the ambient side," he says "and so have the indie and techno crowds."

Goldie

THE PRESENT TENSE

There's no doubt about it. Jungle's crowd is beginning to change. And as the music slips further into the mainstream it faces the challenge of all underground cultures when co-opted into wider society. Will it lose its original followers and whither and die once the mainstream has used it up? Or will it remain true to its original concepts and retain its original fan base?

In response to these problems the underground seems to be re-asserting itself and pulling away from Public Jungle. 4 Hero don't call their music Jungle anymore but "Krumble", T Power calls his "electronic, ambient jazz" while Grooverider terms his as "Hardstep".

As Jungle enters a phase of cultural crisis, with artists and fans unsure about who the music is for, we can find solid ground in looking at what the music has achieved. Perhaps Jungle's greatest triumph is to prove that undiluted music can exist and excel without having to compromise its sound. Labels such as Sour, Renegade, Moving Shadow and Suburban Base are operating successfully and independently, while artists like Goldie, Fabio and Alex Reece have become cultural icons appearing on everything from magazine covers to TV chat shows.

But at the bottom of all the hype and dressing Jungle is a music, a sound and it's here that we can see Jungle's progress best of all. Many of the Jungle sounds such as timestretching are now spreading back out into immediate relatives such as House, Ragga and Trip Hop, and even further into sections of indie music. BBC2's recent series The Sunday Show had a Jungle theme tune and several recent advertisements have made use of the sound. In the clubs, on the radio, on your screen, Jungle is shaking up the country.

　　pages 178-9

Mainartery

posters

art directors
1 Peter Hayward &
　John O'Callaghan
2 Peter Hayward &
　Scott Minshall

designers
1 John O'Callaghan
2 Scott Minshall

publisher
Mainartery Ltd

origin
UK

dimensions
420 x 594 mm
16¹/₂ x 23³/₈ in

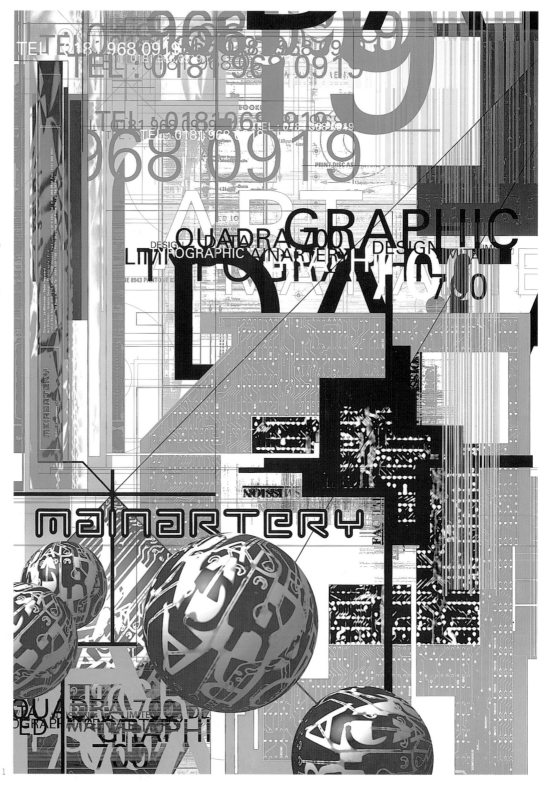

1

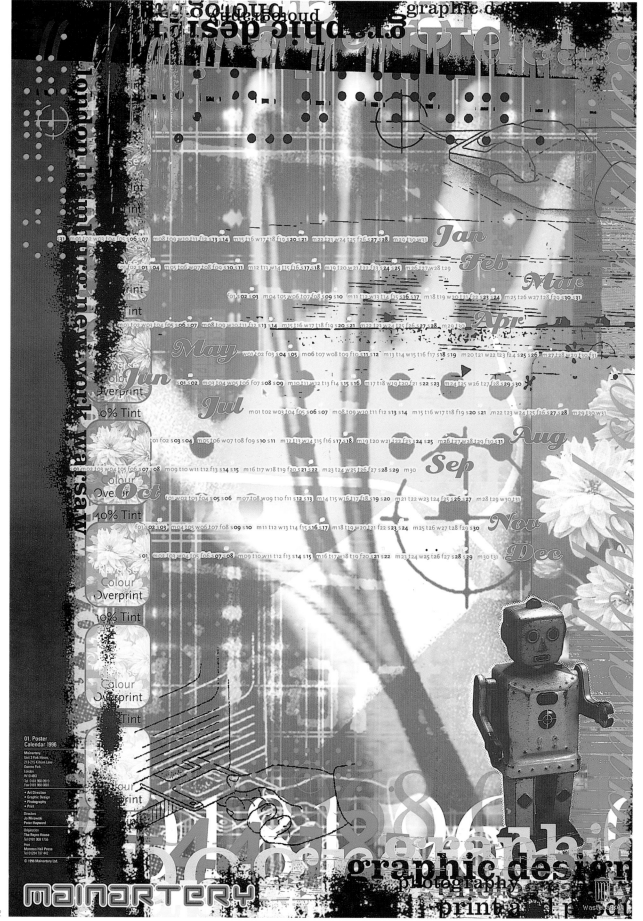

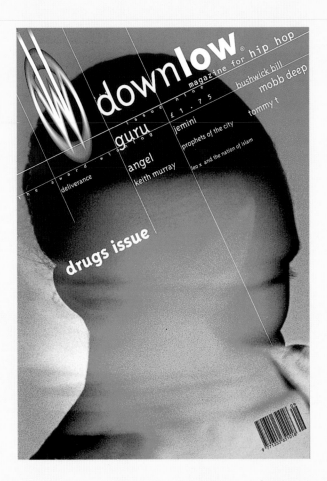

above

the downlow

designers Mark Diaper
 Domenic Lippa
editor Matthew Carter
origin UK
dimensions 210 x 297 mm
 8¼ x 11¾ in

above & opposite

the downlow

designers Mark Diaper
 Birgit Eggers
 Mike Davies
editor Matthew Carter
origin UK/The Netherlands
dimensions 210 x 297 mm
 8¼ x 11¾ in

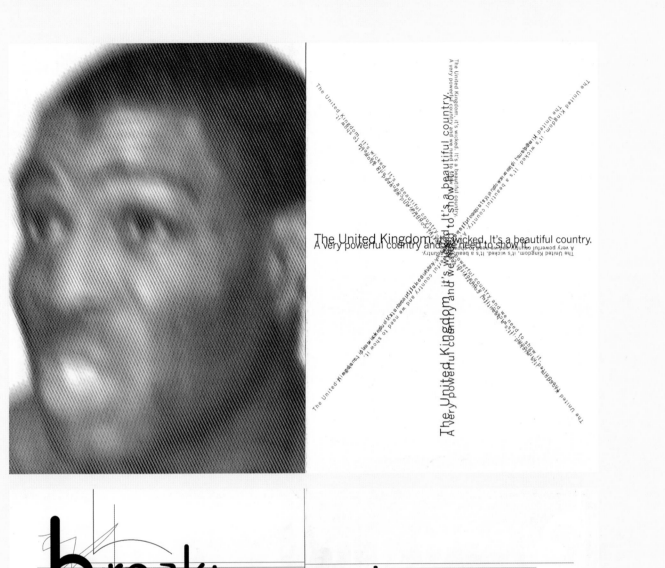

The United Kingdom, it's wicked. It's a beautiful country.
A very powerful country and we need to show it.

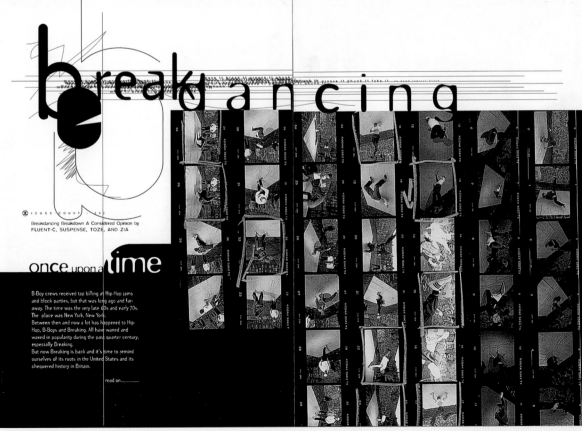

breakdancing

(CUSS COUNT : 12)

Breakdancing Breakdown A Considered Opinion by
FLUENT-C, SUSPENSE, TOZE, AND ZIA

once upon a time

B-Boy crews received top billing at Hip-Hop jams
and block parties, but that was long ago and far-
away. The time was the very late 60s and early 70s.
The place was New York, New York.
Between then and now a lot has happened to Hip-
Hop, B-Boys and Breaking. All have waned and
waxed in popularity during the past quarter century,
especially Breaking.
But now Breaking is back and it's time to remind
ourselves of its roots in the United States and its
chequered history in Britain.

read on.................

■ *the* **design** showcase
issue 1

An Atlik Design Limited Publication
Huddersfield/London

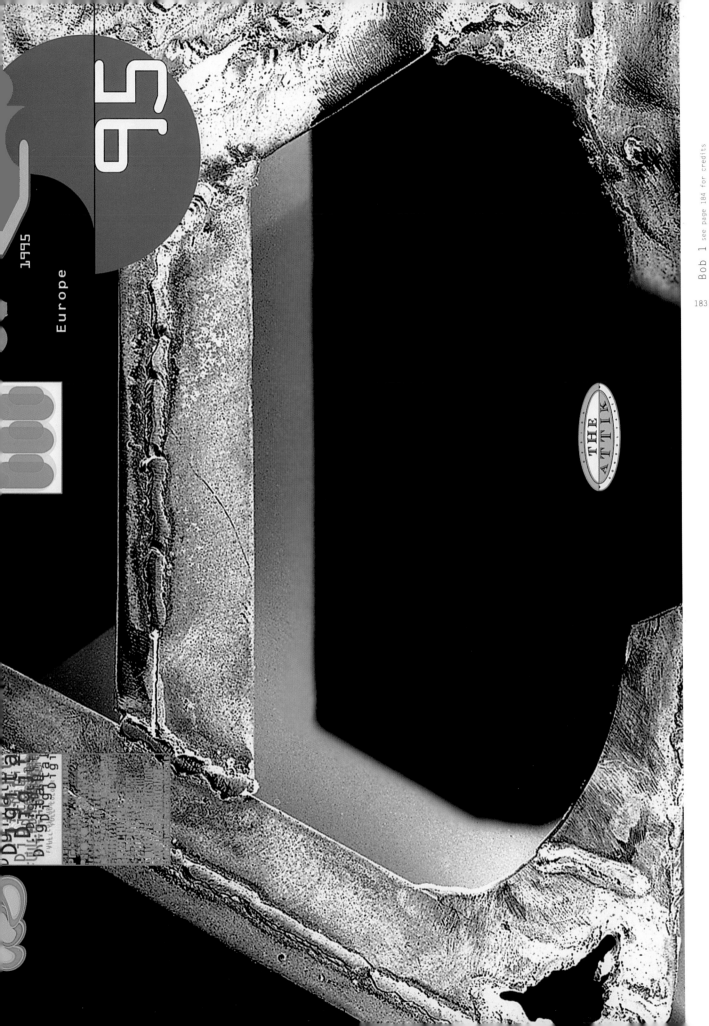

95

1995

Europe

THE ATTIK

Bob 1 see page 184 for credits

pages 182-7

Bob 1

designers all designers specified are
from The Attik Design Limited

publisher The Attik Design Limited
origin UK
dimensions 420 x 594 mm
16½ x 23⅜ in

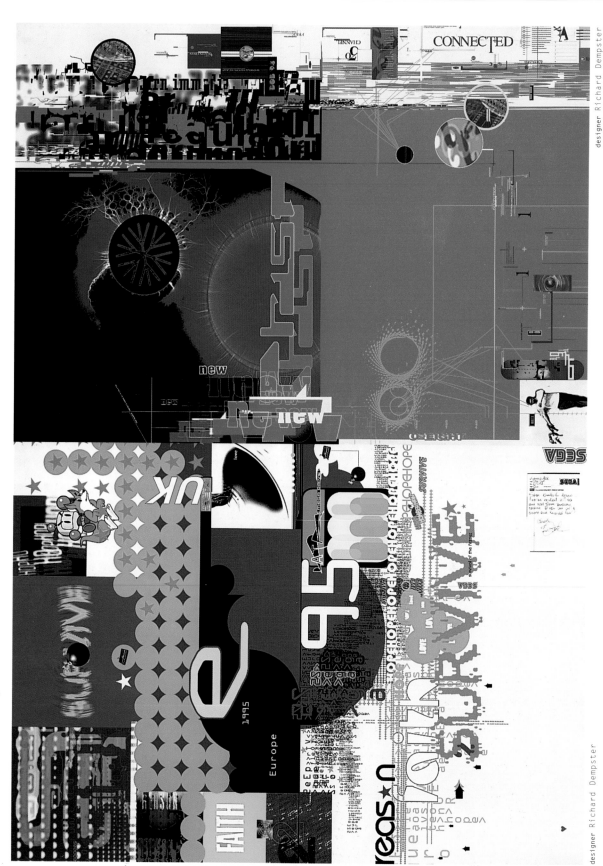

designer Richard Dempster

designer Richard Dempster

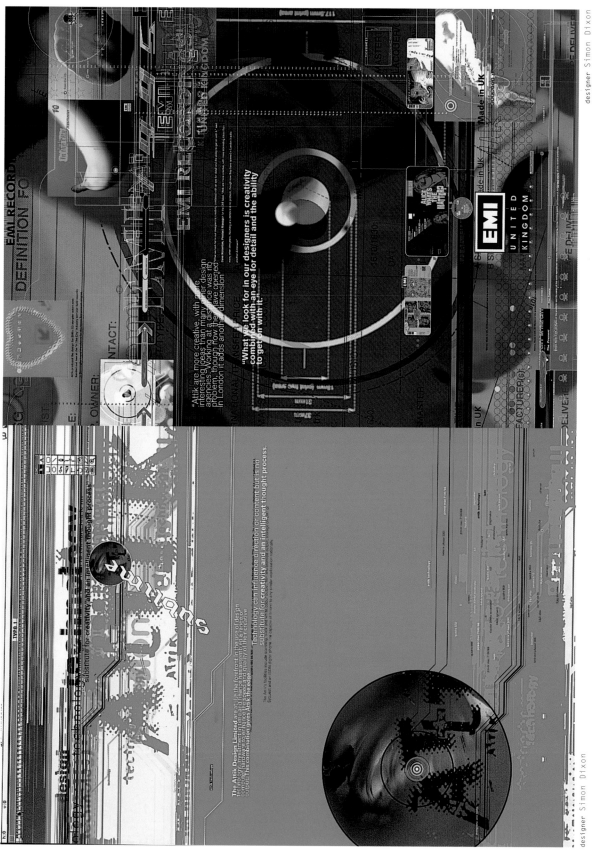

speedprint

Speedprint (Horsforth) Ltd 94 Kirkstall Road Leeds LS3 1LT
Tel 0113 245 3665 fax 0113 245 3510

Bob 1 see page 184 for credits

designer Simon Needham

designer Simon Needham

pages 188-93

Code

art director Mandy Mayes @ Dry
designers Alison Martin @ Dry
 Martin Isaac @ Dry
 Wayne Jordan @ Dry
editor David Waters
publisher Mark Lesbirel
origin UK
dimensions 210 x 275 mm
 8¹/₄ x 10⁷/₈ in

photographers 1 Mark Alesky
 2 Oscar Paisley
 Mark Alesky
 Trevor Fulford
 Phil Knott @ ESP
 Niall McInerney
 Rankin
 Jeremy Maher
 3 & 4 Phil Knott @ ESP

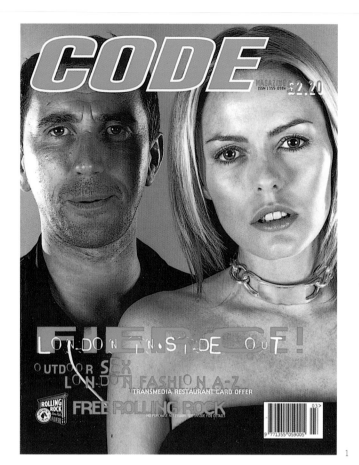

1

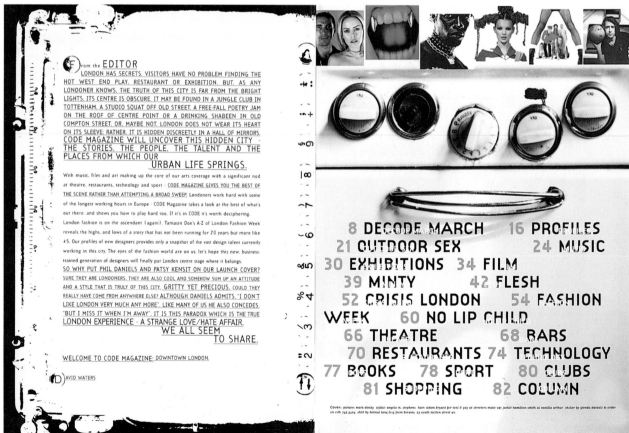

F rom the EDITOR
LONDON HAS SECRETS. VISITORS HAVE NO PROBLEM FINDING THE HOT WEST END PLAY, RESTAURANT OR EXHIBITION. BUT, AS ANY LONDONER KNOWS, THE TRUTH OF THIS CITY IS FAR FROM THE BRIGHT LIGHTS. ITS CENTRE IS OBSCURE. IT MAY BE FOUND IN A JUNGLE CLUB IN TOTTENHAM, A STUDIO SQUAT OFF OLD STREET, A FREE-FALL POETRY JAM ON THE ROOF OF CENTRE POINT OR A DRINKING SHABEEN IN OLD COMPTON STREET. OR, MAYBE NOT. LONDON DOES NOT WEAR ITS HEART ON ITS SLEEVE: RATHER, IT IS HIDDEN DISCREETLY IN A HALL OF MIRRORS. CODE MAGAZINE WILL UNCOVER THIS HIDDEN CITY - THE STORIES, THE PEOPLE, THE TALENT AND THE PLACES FROM WHICH OUR
 URBAN LIFE SPRINGS.

With music, film and art making up the core of our arts coverage with a significant nod at theatre, restaurants, technology and sport - CODE MAGAZINE GIVES YOU THE BEST OF THE SCENE RATHER THAN ATTEMPTING A BROAD SWEEP. Londoners work hard with some of the longest working hours in Europe - CODE Magazine takes a look at the best of what's out there, and shows you how to play hard too. If it's in CODE it's worth deciphering.

London fashion is on the ascendant (again). Tamasin Doe's A-Z of London Fashion Week reveals the highs, and lows of a story that has not been running for 20 years but more like 45. Our profiles of new designers provides only a snapshot of the vast design talent currently working in this city. The eyes of the fashion world are on us, let's hope this new, business-trained generation of designers will finally put London centre stage where it belongs.

SO WHY PUT PHIL DANIELS AND PATSY KENSIT ON OUR LAUNCH COVER? SURE THEY ARE LONDONERS, THEY ARE ALSO COOL AND SOMEHOW SUM UP AN ATTITUDE AND A STYLE THAT IS TRULY OF THIS CITY. GRITTY YET PRECIOUS. COULD THEY REALLY HAVE COME FROM ANYWHERE ELSE? ALTHOUGH DANIELS ADMITS, "I DON'T LIKE LONDON VERY MUCH ANY MORE", LIKE MANY OF US HE ALSO CONCEDES, "BUT I MISS IT WHEN I'M AWAY", IT IS THIS PARADOX WHICH IS THE TRUE LONDON EXPERIENCE - A STRANGE LOVE/HATE AFFAIR.
 WE ALL SEEM
 TO SHARE.

WELCOME TO CODE MAGAZINE: DOWNTOWN LONDON.

D AVID WATERS

Cover: picture: mark alesky stylist: angela m. stephens hair adam bryant for toni & guy at streeters make up: jackie hamilton-smith at camilla arthur choker by glenda daniels to order on code 749 5484. shirt by helmut lang croy from browns. 23 south molton street w1.

(NO) LIP CHILD

PHOTOGRAPHY: PHIL KNOTT FOR ESP AGENCY. FASHION: JANE O'SHEA. ASSISTED BY KEVIN PLUMMER. FASHION STYLIST: CONRAD BLAKE ASSISTED BY WAYNE

crazy.

pun ishment

insane.

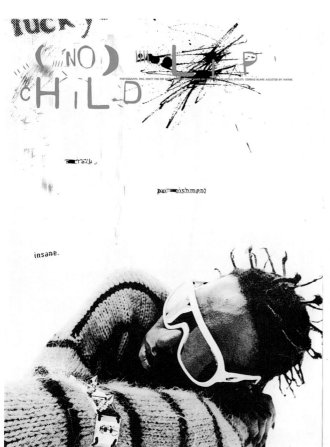

3

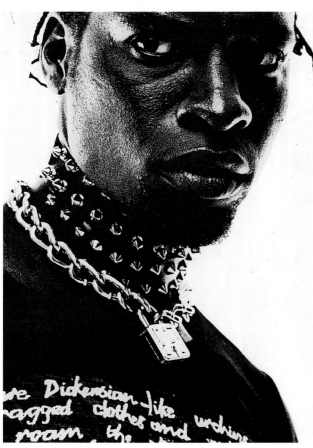

OPPOSITE
PAGE
SHIRT £22.80
Studded
leather
Neck
chain
&
lock
stylist's
own

THIS PAGE
TROUSERS
TIMES

'T' SHIRT
SOUVENIR SHOP

BELT Kensington Market

fuck.o
sex
pa
li
dis-u

pretty sick.

4

SPACED OUT

PHOTOGRAPHY SOULLA PETROU, ASSISTED BY MIREIA CASTANE
STYLING KATHERINE ALEXANDER
MAKE-UP NINA OCHI AT STREETERS
HAIR PAUL MATTHEW AT PAUL MATTHEW HAIRDRESSING
MODELS LIDIA AT SELECT AND CEDRIC AT MODELS 1

photographer Soulla Petrou

pages 191-3 photographer Phil Knott @ ESP

LONDON HAS BEEN INFILTRATED.

NESTLING IN OUR MIDST RESIDES A SIX FOOT, BLONDE,

AMAZONIAN AMERICAN.

WITH A BODY AND FACE WHICH GAVE HER THE CHANCE TO STRUT MODEL-STYLE ACROSS THE GLOBE, RACHEL WILLIAMS IS CURRENTLY HOLING-UP IN WEST LONDON IN LAID-BACK MANNER WITH LOVER, ALICE TEMPLE - CHECKING MOVIE SCRIPTS, MUSING ABOUT LIVE TV AND ENJOYING TONY WARD AS HER TEMPORARY HOUSE-BOY. ARRIVING FROM PLANET FASHION WHERE REBELLION CAN BE SEEN IN YOUR CHOICE OF NAIL POLISH. WILLIAMS' BRAND OF BULLSEYE WISE-CRACKS AND STREET-WISE PHILOSOPHY, CUTS THROUGH THE USUAL FASHION-PLATE PLATITUDES.

SHE'S CURRENTLY PLAYING THE POST-MODEL-ABOUT-TO-TURN-ACTRESS/PERSONALITY TRIP HER WAY, WRITES DAVID WATERS.

CODE: WHY LONDON?

RACHEL WILLIAMS: THE DIRTIER YOUR TROUSERS, THE GREASIER YOUR HAIR, THE DARKER YOUR ROOTS - THE GROOVIER YOU ARE HERE. It suits me just fine. In Paris it's the complete opposite to London, everyone has those perfect little suits on. They're all clones of each other. It's so bourgeois. Boring, boring, boring. I like the people in New York, but somehow I don't have any friends there - I have a lot of friends here, but that's through Alice, but they're great.

HOW DID YOU GET INTO TV?

I never thought of doing TV in my life. But English TV is better than American TV. I did live TV for the first time the other day on MTV and that was really fun. I gives me an adrenalin rush because I know that they can't stop me. they cannot control me. When I did the Girly Show, I've got an earpiece coming in here. they just don't let you get on with it. they should let us go off and edit out the rubbish. They are so scared. I think that the Girly Show should be live. And we had trouble doing current events because we were recording so far ahead.

HAS EVERYTHING BEEN SORTED OUT WITH IMMIGRATION? (ALTHOUGH RACHEL'S MOTHER IS ENGLISH, RACHEL WAS DENIED A WORK PERMIT)

The night before we shot the first Girly Show, immigration came down and I wasn't allowed to present the show. all I was allowed to do was interviews from abroad and send them in. It was really frightening. they said you are going out to interview this person and I had never interviewed a fucking rat. They just sent me out with a cameraman and a sound person. But it worked out.

WHAT MAKES A GOOD INTERVIEW?

Don't stick with the questions they give you. They would give me toms and toms of questions. As a conversation goes on other questions occur naturally. It was like they weren't listening. I wanted to ask about other things. I would not go with those questions when there was a more interesting angle. It would throw the other presenters off because they would be waiting for a set question from me to queue them in and I would be talking about something else.

WHO WOULD YOU LOVE TO INTERVIEW?

Rose Perez (Spanish/American actress) was close to my fantasy interviewee. I WOULD LIKE TO INTERVIEW LIAM GALLAGHER AND TURN HIM OVER MY KNEE AND SPANK HIS SORRY ASS. I would be telling him to get a grip. I used to have a crush on him. I don't think all that obnoxious. macho bravado is interesting at all. I think it is a really bad cliche. The guy's a genius so why diminish himself and his brother by being such an idiot? It's really so easy to be like that. If he thinks that's clever - for fuck's sake, give me a break. That's really simple.

ISN'T HE JUST INTO BEING FAMOUS?

I went through that fame thing - you become enamoured with fame and you become an arsehole for a little bit. For me it lasted four or five months. But man, his stuff's going on too long.

WHAT SORT OF THINGS DID YOU DO DURING THAT TIME?

There are stories of me punching out hairdressers and stuff. I threw a chair at someone as well - I threw it in her general direction. it didn't actually hit her or anything. The work slowed down for a bit so you come back to earth again. People go through it. it's just how quickly you come through it that counts like poor fucking Naomi. She's never come out of it.

WHAT IS THIS BETWEEN YOU AND NAOMI CAMPBELL?

I am giving her a hard time now. I figure. well, she already hates me so I've got nothing to lose. She hates everyone and she especially hates me. I slagged her off on the Girly Show - I did her as 'Wanker of the week'. People stopped me in the street all that week and said, 'I can't believe how genius that was.' I couldn't believe it - I saw it Friday and I had to watch it again on Saturday. And somebody had to say it.' In my life if I've hurt people it is only out of carelessness or thoughlessness, and as bad as that may be, it's not as bad as going out and intentionally hurting somebody, which is what Naomi does.

WHAT DO YOU THINK OF THE TABLOID PRESS OVER HERE?

Well, touch wood (she taps a wooden counter) I've had such good press. At the moment I can do no wrong. I'M THE BEST THING SINCE SLICED FUCKING BREAD. They've not been intrusive.

DO YOU SEE YOUR FUTURE IN LONDON?

Yes. I've got all sorts of great projects on the burner here. And in New York and America I'm a sort of has-been model but here people are approaching me every other day with a proposal. It's really exciting. TV. movies and I would like to come up with some of my own concepts. I've got movie offers and have even been asked to do vocals for a house track. I don't know if I can sing for jack shit. but I'll give it a shot. I've got a couple of good offers too. Great roles. In fact there's this one role - the character is an American model who comes to London. This guy was trying to cast all over New York and everybody kept saying you've got to see this girl Rachel Williams and he finally tracked me down. I think he liked what he saw. I haven't read for him yet but I'm going to be doing it at any moment. I think he likes me. Learning lines is the hardest part but I figure any idiot can memorise things. The character is beautiful - she's six foot tall with big breasts. super-intelligent and drug-crazed.

CAN YOU RELATE TO HER?

Yes. I can definitely relate to this role.

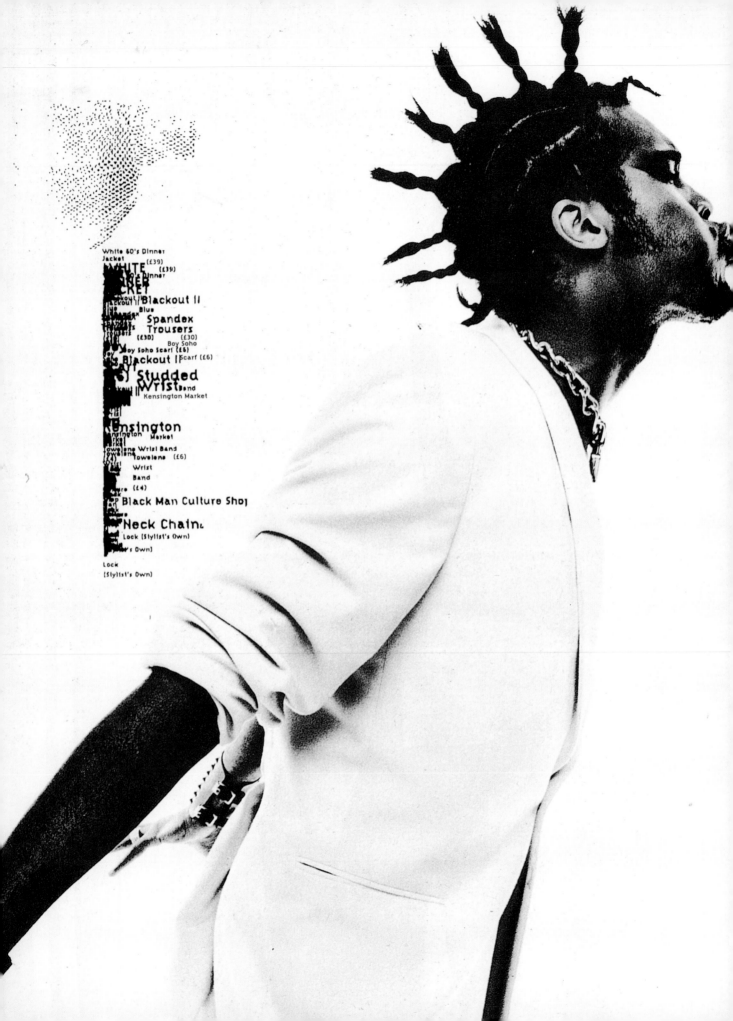

White 60's Dinner
Jacket
(£39)
WHITE
Dinner
JACKET
Blackout / Blackout II
Blue
Spandex
Trousers
(£30)
Boy Soho
Boy Soho Scarf (£6)
Blackout II Scarf (£6)
Studded
Wrist Band
Kensington Market

Kensington
Market
Towelene Wrist Band
Towelene (£6)
Wrist
Band
(£4)
Black Man Culture Shop

Neck Chain
Lock (Stylist's Own)
Stylist's Own)

Lock
(Stylist's Own)

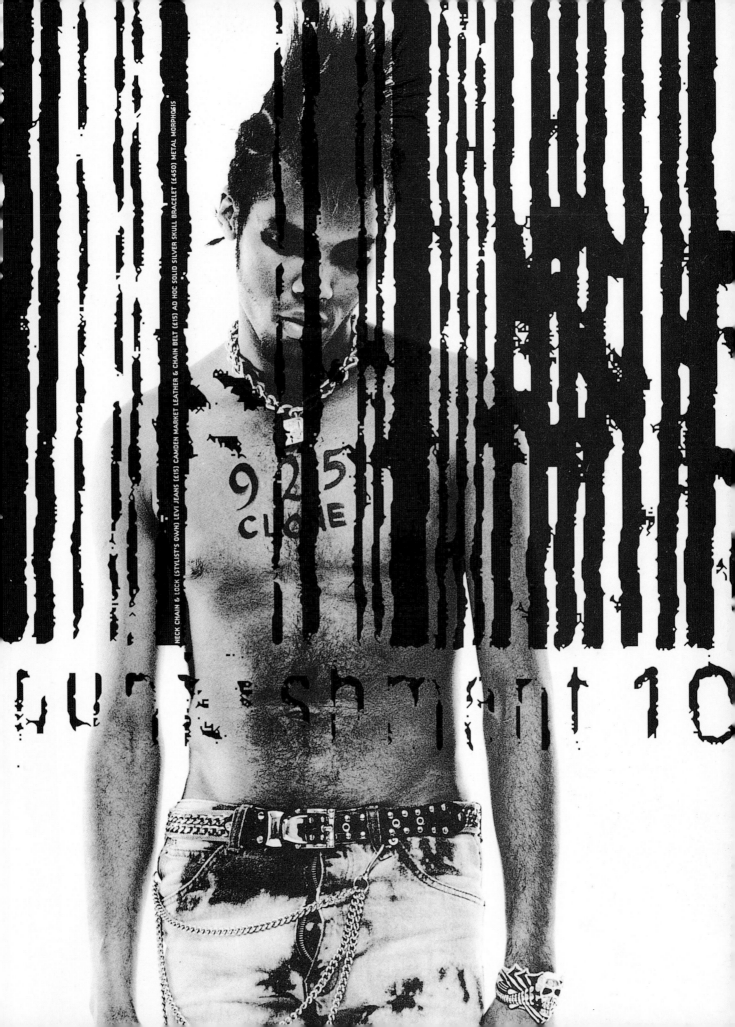

925 CLONE

NECK CHAIN & LOCK (STYLIST'S OWN) LEVI JEANS (£15) CAMDEN MARKET LEATHER & CHAIN BELT (£15) AD HOC SOLID SILVER SKULL BRACELET (£450) METAL MORPHOSIS

Blah Blah Blah

stationery

art director	Neil Fletcher @ Substance
designer	Neil Fletcher @ Substance
publisher	Ray Gun Publishing Limited
origin	UK
dimensions	
headed paper	210 x 297 mm
	8¼ x 11¾ in
white envelope	215 x 110 mm
	8½ x 4⅜ in
business cards	65 x 65 mm
	2½ x 2½ in
brown envelope	305 x 305 mm
	12 x 12 in

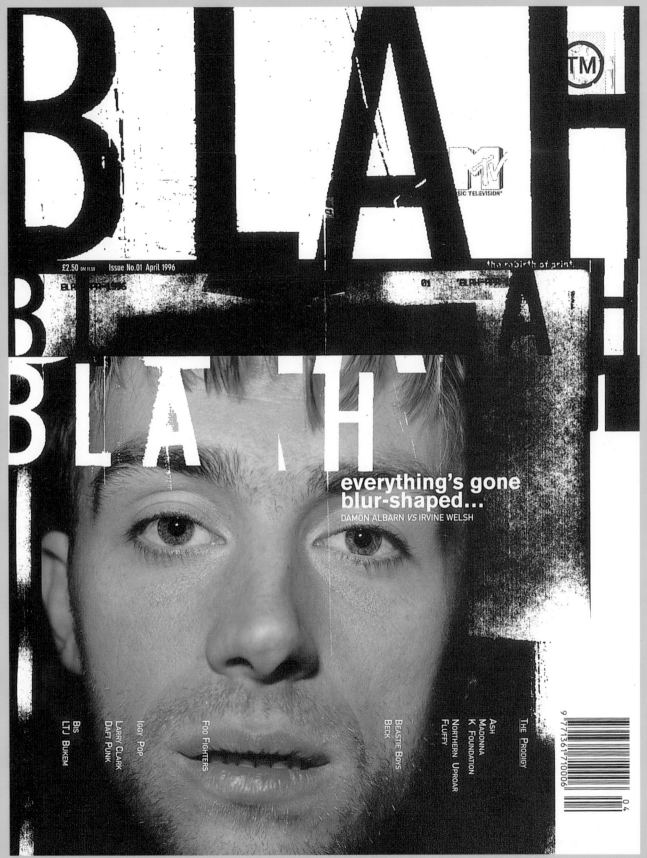

photographer Phil Poynter

pages 195-9

Blah Blah Blah

art directors Chris Ashworth @ Substance
 Neil Fletcher @ Substance
designers Chris Ashworth @ Substance
 Neil Fletcher @ Substance
editor Shaun Phillips
publisher Ray Gun Publishing Limited
origin UK
dimensions 230 x 300 mm
 9 x 11⁷/₈ in

pages 198-9 ➤
photographer Joseph Cultice

196

photographer Peter Anderson

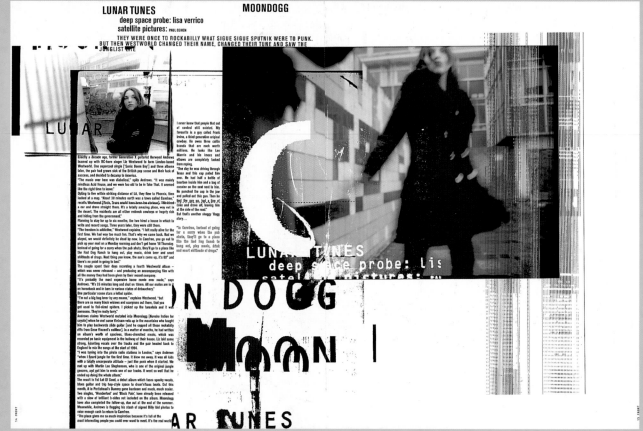

photographer Paul Cohen

photographer John Holden

photographer Mell Ericsson

ork sneer."

Time Out New York, Mar. 6-1

"Undeniably Blur's most adventurous reco

ng Stone

s for the disaffected."

magazine advert for The Gra

ONLY OASIS

"Thanks for the great article about Oasis ["

Riot", January]. They may be arrogant and s

obnoxious, but it's a nice change from the ce

multimillionaire

the Liam's sordid tales of fame and

would be boring coming from the ge

orld.

rton, Montreal, Canada

letters page, Details, March

BLUNDERWALL

On their last weekend "Stateside" BLAH BLAH BLAH trails the jetstream left by O

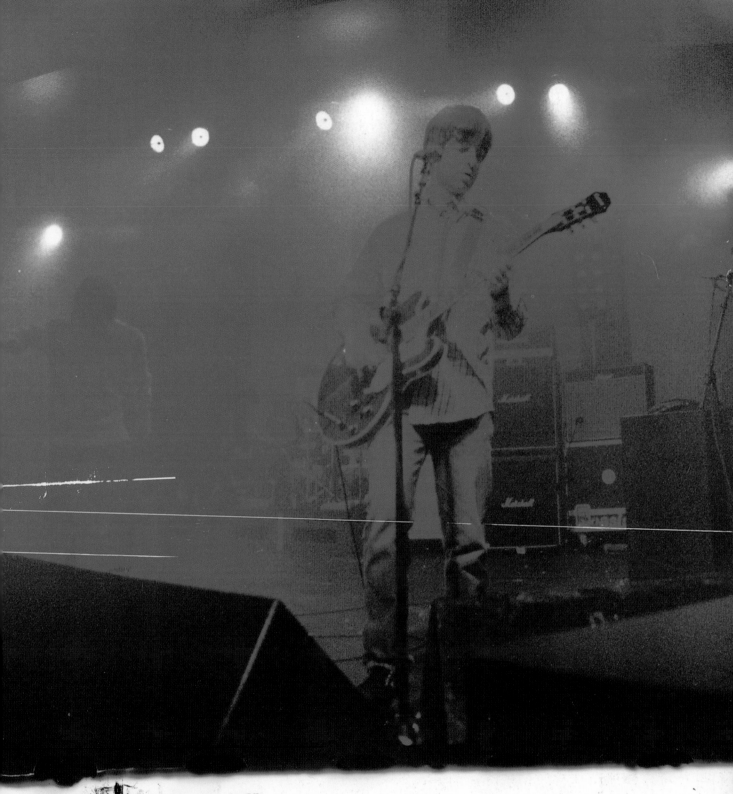

man, what you got that twat on the cover for?"
Noel Gallagher on Blah Blah Blah's Damon Albarn cover.

nothing better to do: craig mclean likewise: joseph cultice

tory tour" but gets distracted by a bunch of hardcore punk kids. Some might say, 'Hey, who needs another Oasis interview anyway?'

pages 200-207

Studio Voice

art director Yasushi Fujimoto
publisher INFAS
origin Japan
dimensions 225 x 300 mm
8⁷/₈ x 12 in

a
designer Yasushi Fujimoto
editor Takeru Esaka
b
designer Kayoko Suzuki
editor Takeru Esaka
c
designer Madoka Iwabuchi
editor Takeru Esaka
d
designer Fumiko Furukama
editor Shinya Matsuyama

photographer Herb Ritts

a

photographer Jean-Baptiste Mondino

a

b

c

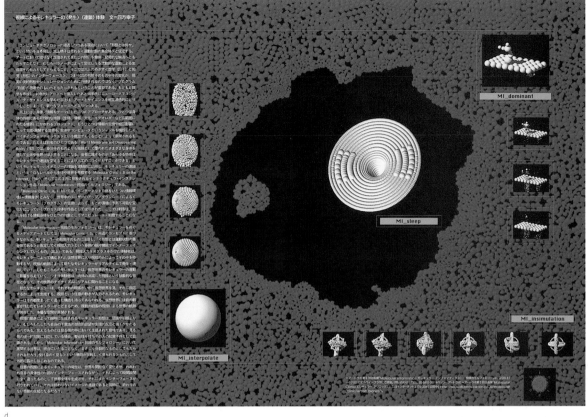

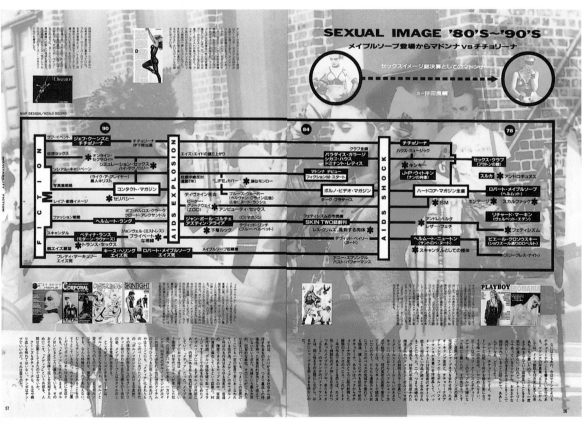

202

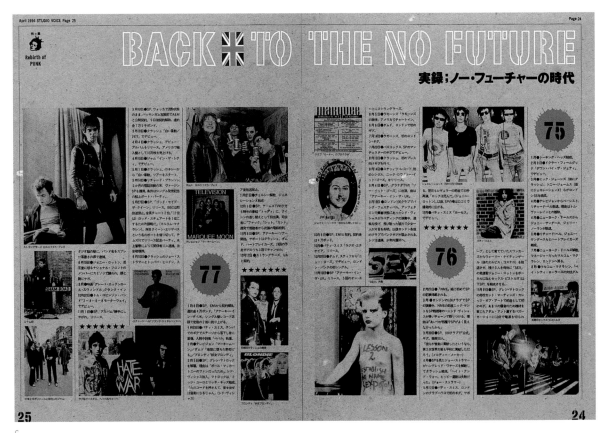

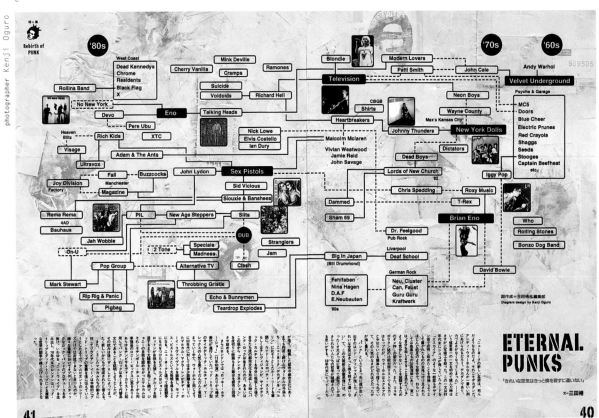

d

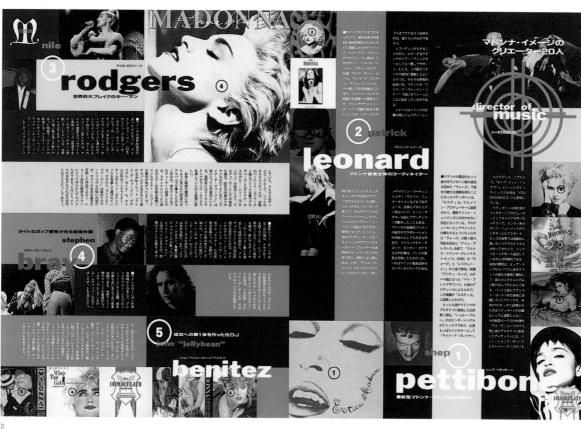

b

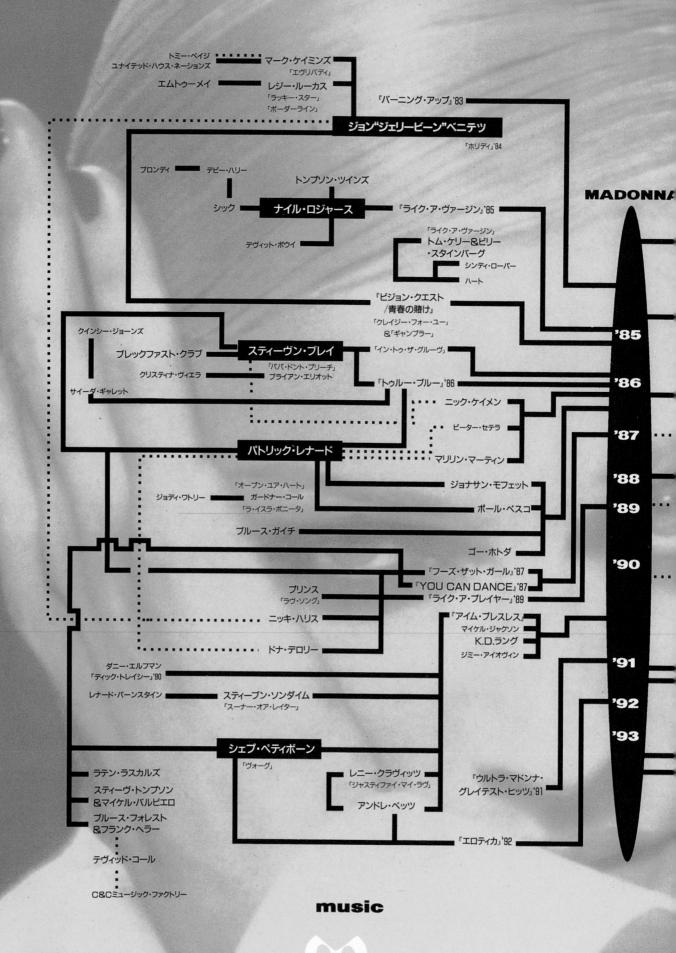

MADONNA

music

FICTION

CREATORS of FICTION M

マドンナ・イメージのクリエイター達

photographer Tsutomu Moriya

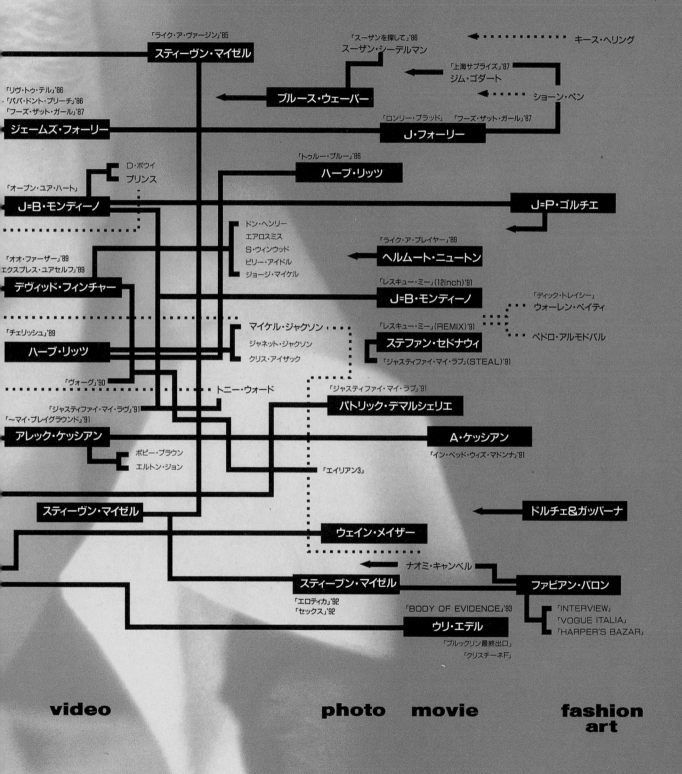

video　　　photo　movie　　fashion
art

MAP／YUUJI MURAOKA, S.V
MAP DESIGN／TSUTOMU MORIYA

c

b

d

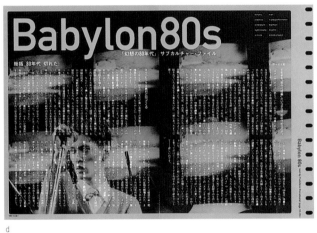

d

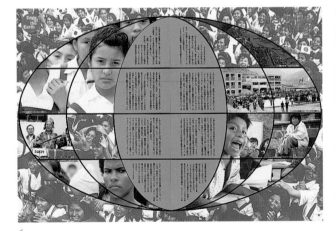

d

d

c

d

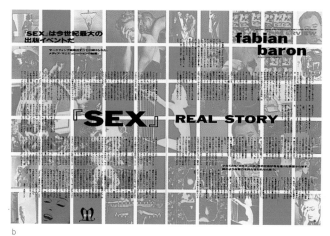

b

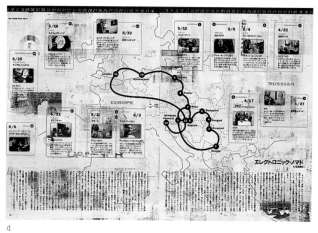

d

d

d

pages 208-13

Post

art director Paul White
designers Craig Hewitt/ME Company

illustrators ME Company
editor Sjón
publisher Bloomsbury
origin UK
dimensions 267 x 337 mm
10½ x 13¼ in

BLOOMSBURY

ISBN 0-7475-2373-8

9 780747 523734

POST

Dancing About Buildings

The Black Dog arrived in 1987.
Its members were among the pioneers of a regenerative dance sound who knew there was a universe of possibilities out there, and went to explore it. The songs they brought back from their voyages are startlingly beautiful and have gained them the respect of a whole new crew of audionauts.

The facts don't matter anyway, you've just got to listen

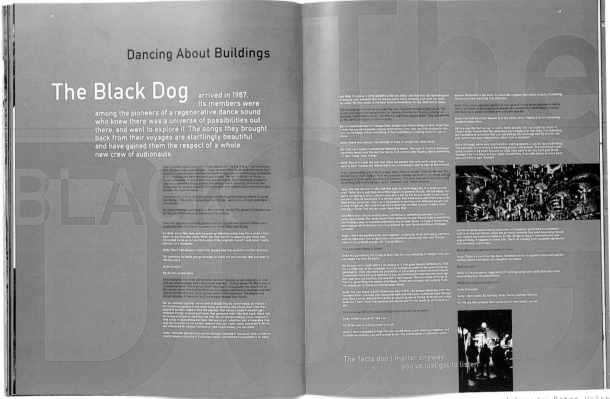

photographer Peter Walsh

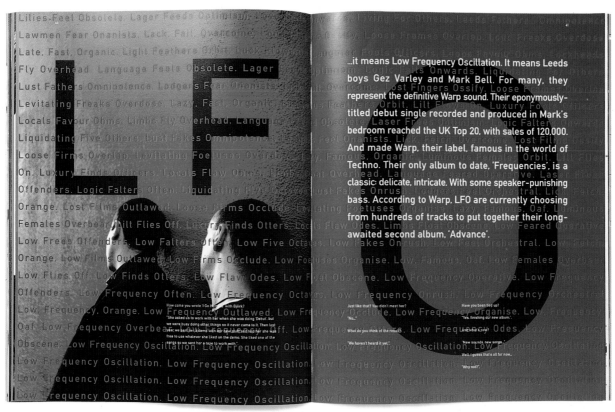

...it means Low Frequency Oscillation. It means Leeds boys Gez Varley and Mark Bell. For many, they represent the definitive Warp sound. Their eponymously-titled debut single recorded and produced in Mark's bedroom reached the UK Top 20, with sales of 120,000. And made Warp, their label, famous in the world of Techno. Their only album to date, 'Frequencies', is a classic: delicate, intricate. With some speaker-punishing bass. According to Warp, LFO are currently choosing from hundreds of tracks to put together their long-awaited second album, 'Advance'.

Post see page 208 for credits

photographer Bernhard Valsson

source Björk's Notebooks

The Birth of
NovaBjörk

A tale in the old style of Science Fiction.
For the children of NuWorld.

i

This is the story of an old composer, whose identity must remain a secret for his own safety. He lived by himself on the outskirts of NeoPolis and was ignored by his fellow pholk. Partly because they hardly know of his existence and partly because the pholk didn't care.

The composer's house was of the Ol'World, that is, the world before the Great Deconstruction. Buildings were organic before NuWorld. Sometimes the house seemed just like a living creature, its walls were uneven, its windows really opened, and it had a crooked roof. All forbidden now of course.

But the composer didn't mind living in such poor circumstances. He had no thought for anything except his beloved music. All he asked in life was to be able to create enough compositions to feed the starving MuBots hidden in his cellar.

POST see page 208 for credits

Every morning the old man would stroll around his vast garden, clutching in his gnarled old hands a fat fountain pen and a book of music sheets. Whenever he heard birdsong, he would stop and scribble it down in Notes. The sacred musical symbols of old which he knew by heart. He understood the mysterious nature of those ancient black dots, and how they could translate the birds' twitterings into the music of human emotions.

One morning the composer stood beneath the weeping willow, his mind focused.

He turned his trained ears in as many directions as there are in a forest.

He became aware of something new in the air.

Whatever it was, it had silenced the birds. They were flitting backwards and forwards with straw in their beaks, but not one was singing.

"This is most odd", he thought to himself. "Spring is months away but the birds are behaving as if it's arrived!".

It was unlikely there could have been a polar shift the night before without him being aware of it. And even if there had been, he'd expect the birds to sing more than usual not less. He knew something was wrong.

As they all seemed to be flying in the same direction, the old man decided to follow them. Perhaps they would lead to the source of the mystery.

He reached a clearing, where the ground was black with birds of all shapes and sizes. He picked his way through the dark carpet of shining wings and tails, taking

designer The Attik Design Limited

(noise)

designers all designers specified are
from The Attik Design Limited
publisher The Attik Design Limited
origin UK
dimensions 220 x 330 mm
86⁵/₈ x 12 in

designer Simon Needham

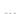

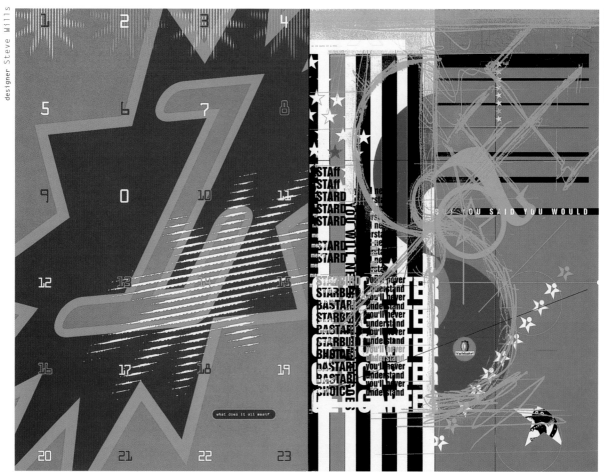

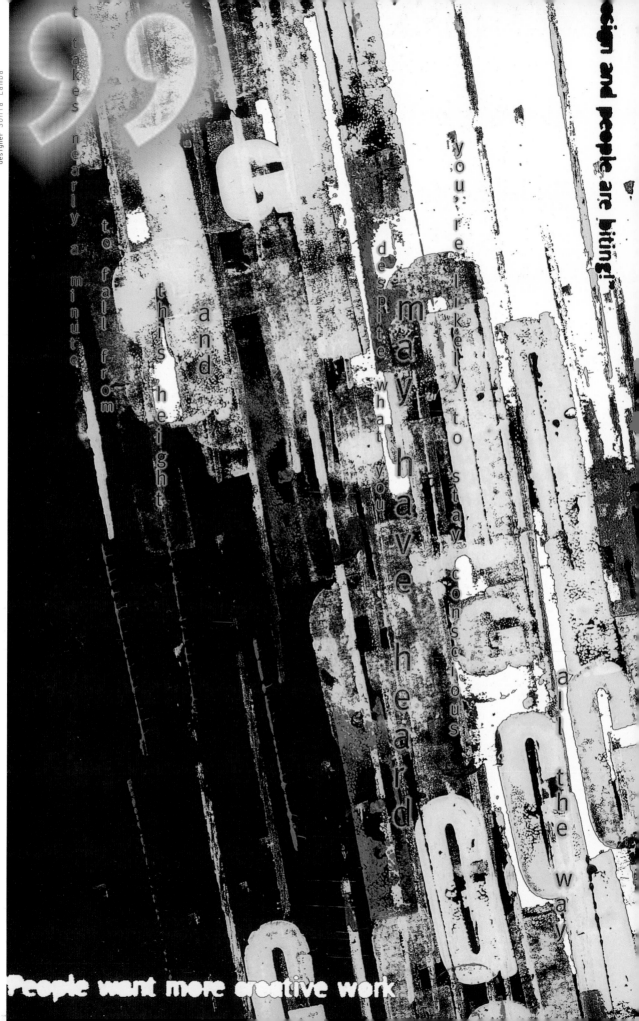

216

"

...sign and people are biting!"

it takes nearly a minute

to fall from

this height

and

despite what you

may have heard

you're likely to stay conscious

all the way

People want more creative work

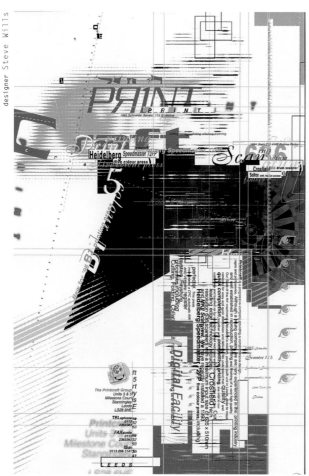

THANKYOU

TO OUR

Clients

WARNING
WE MAY HAVE OUR
SIGHTS SET ON YOU
NEXT

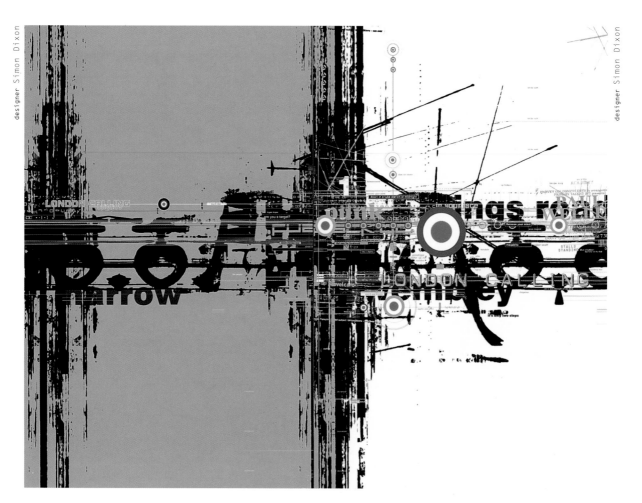

(noise) see page 214 for credits

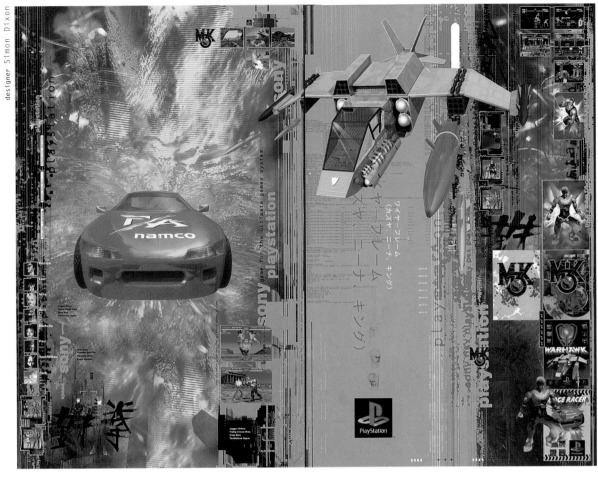

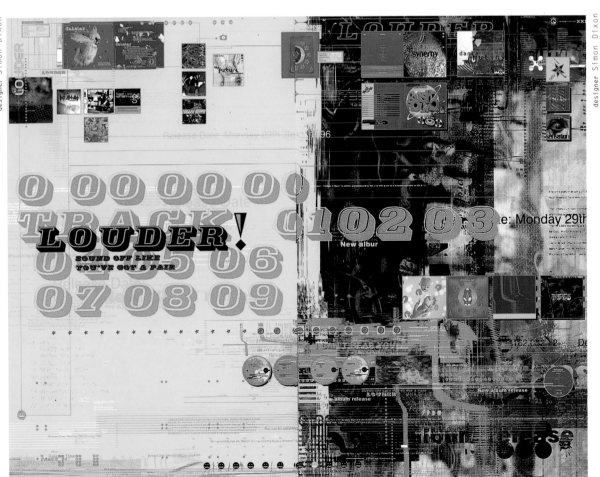

Index

224 Acknowledgments

The Publishers would like to
thank: Geoff White; Richard Horsford
for design assistance; Lucy Walker
for researching and sending
magazines from Australia; and
John McKay, Head Librarian at
Ravensbourne College of Design
and Communication.

Future Editions

If you would like to be included in
the call for entries for the next
edition of *Typographics* please send
your name and address to:

Typographics
Duncan Baird Publishers
Sixth Floor
Castle House
75-76 Wells Street
London W1P 3RE
UK
e-mail: dbaird@mail.bogo.co.uk

As a collection point has not yet
been finalized, samples of work
should not be forwarded to this
address.